"I hope that all who are concerned about the troubles of the Middle East will read this book. It is immensely readable and a magnificent piece of work which reflects Alan Hart's close relationship with Israeli and Palestinian leaders. We are in terrible trouble in the Middle East. The book explains how we got here and how we could move forward. The tragedy is hurting Palestinians, Israelis and the rest of the world. All who wish to engage in finding a way forward will be helped by reading this book."

CLARE SHORT, MP
and International Development Secretary
in Prime Minister Tony Blair's government
until her resignation over the invasion of Iraq

"Perhaps the biggest perplexity of the current world political scene is the acceptance by most western countries of the respectability of the State of Israel. This puzzling state of affairs has developed over many decades and it has apparently long been forgotten, firstly by most Jews, that Zionism, which begat the State of Israel, is a total desertion of Jewish religious belief and values, and secondly by the world at large, that Zionism was founded on a cold blooded policy of colonialism, ethnic cleansing and terrorism. It is perhaps premature to expect the world to come to its senses within the near future, but writing as an Orthodox Jew I hope and pray that the Zionist State of Israel is recognised for what it is and that firm but peaceful pressure be brought to bear for the whole flawed concept to be brought to an end. A pre-requisite for this is a correct historical view and Alan Hart in his chillingly revealing and very readable account of the intrigues of the Zionist political development has made a tremendously valuable contribution to this cause."

RABBI AHRON COHEN

D1599363

ZIONISM
THE REAL ENEMY OF THE JEWS

VOLUME I: THE FALSE MESSIAH

ZIONISM
THE REAL ENEMY
OF THE JEWS

VOLUME I
THE FALSE MESSIAH

BY

ALAN HART

CLARITY PRESS, INC.

ISBN: 0-932863-64-7
 978-0-932863-64-5

In-house editor: Diana G. Collier
Cover: R. Jordan P. Santos

Library of Congress Cataloging-in-Publication Data

Hart, Alan, 1942-
 Zionism : the real enemy of the Jews / Alan Hart.
 v. cm.
 Includes bibliographical references and index.
 Contents: v.1 The false Messiah
 ISBN-13: 978-0-932863-64-5
 ISBN-10: 0-932863-64-7
 1. Zionism--History. I. Title.

 DS149.H41245 2009
 320.54--dc22

 2008054300

**First edition published in hard cover in the United Kingdom
in 2005 by World Focus Publishing.**

Clarity Press, Inc.
Ste. 469, 3277 Roswell Rd. NE
Atlanta, GA. 30305, USA
http://www.claritypress.com

An epic story dedicated to everyone working for justice and peace in the Middle East

TABLE OF CONTENTS

VOLUME I

THE FALSE MESSIAH

AN APPEAL TO THE AMERICAN PEOPLE

Dear America,

If all of our children, wherever they live, are to have the prospect of a future worth having, the world needs America's *best*, not what it had under the neo-conned regime of President George "Dubya" Bush—its *worst.*

This Englishman, who first began to ask himself why things are as they are in the world when he was covering the war in Vietnam, knows America well enough from coast to coast to have a good idea of what your best is.

Deep down you Americans are the most idealistic people on earth. This suggests to me that if all of you were properly informed about why what is happening in the Middle East is happening, you would want to make your democracy work to cause your government to play its necessary and leading role in stopping the countdown to catastrophe for all of us. I believe, for example, that if all Americans had been properly informed long ago about the cause and effect relationship of Israeli occupation and Palestinian violence, there would have been, long ago, pressure on Congress and the White House for an end to Israeli occupation of Arab land grabbed in the 1967 war. In that event the conflict in and over Palestine, which I describe as the cancer at the heart of international affairs, could have been cured and would not now be threatening to consume us all.

> **If Americans had been properly informed about the cause and effect relationship of Israeli occupation and Palestinian violence, there would have been pressure for an end to Israeli occupation of Arab land long ago.**

In 1974 I spent some time alone with His Royal Highness Prince Phillip at Buckingham Palace. I was there to try to persuade him to persuade Her Majesty The Queen to consent to a royal premier for *Five Minutes To Midnight,* a film I had made on global poverty and its implications for all. We talked for more than two hours, mainly about the state of the world in general, and the state of Britain in particular. At a point H.R.H said: "If I was prime minister, I would hang trade union leaders from lampposts." (Perhaps today he would say that he would hang bankers and those who failed to regulate them). As soon as I got home, I typed a short note to him. I thanked him

for his time and suggested that it was not a good idea to hang trade union leaders from lampposts. He replied by return. He didn't mean what he had said to be taken literally. He was, he wrote, "exaggerating to make a point."

Sometimes it is necessary to exaggerate to make a point, so (deep breath!) here goes.

The problem, dear Americans, is that many of you are too uninformed to make your democracy work for the purpose of giving expression and substance to your idealism. And many of you are uninformed about conflict in the Middle East not because you don't want to know, but because you have been misinformed by the corporate-controlled mainstream media, which has been described as the "Israeli-occupied" media.[1] (During Israel's war on Hamas in the Gaza Strip—in my view an awesome and shocking display of Israeli state terrorism—the mainstream American media's reporting was for the most part indistinguishable from Zionist propaganda, big lies as well as little ones). On my visits to America over the years many, many Americans said to me, "We know we're not getting the truth from our own mainstream media." That being so, my question is—Why then do so many of you continue to let your views be shaped by the mainstream media's take on what is happening in the Middle East?

After 9/11 most if not all Americans asked, "Why do they hate us?" For very many Americans, "they" were more or less all Arabs and Muslims everywhere. What would Americans have learned if, instead of rushing to declare his war on global terrorism, President Bush had caused that question to be addressed seriously?

The short answer—the long one is in this book—begins with the statement that the overwhelming majority of all Arabs and Muslims everywhere do not hate America or Americans. (A truth is that for decades very many Arabs and other Muslims would, if they could, have migrated to America to enjoy a better life there. Today, however, the number of Arabs and other Muslims who would opt for American residence and citizenship if they could is greatly reduced because of the fact, sad but true, that the monster of Islamophobia is on the prowl across the Land of the Free and licking its lips). What almost all Arabs and Muslims everywhere do hate is American foreign policy—its double-standards in general and, in particular, its unconditional support for Israel, which ignores UN resolutions, demonstrates its contempt for international law and human rights conventions (continued occupation, torture, targeted assassinations and collective punishment are part of this package), and resorts to state terrorism.

What almost all Arabs and Muslims everywhere do hate is American foreign policy—its double-standards in general and, in particular, its unconditional support for Israel

To put "anti-Americanism" into its true Arab perspective, I offer this thought. If it had been possible for an American President to wave a magic wand and have Israel back behind more or less its borders as they were on the eve of the 1967 war, with a Palestinian state in existence on

the Arab land from which Israel had withdrawn as required by UN Security Council Resolution 242, and with Jerusalem the capital of two states, the U.S. would have had, overnight, with one wave of that magic wand, the respect, friendship and support of not less than 95 per cent of all Arabs (and very probably that of almost all Muslims everywhere). And if the President had also pressed the Arab regimes to be serious about democratizing their countries, the U.S. would have become their champion, truly admired, as it was when President Woodrow Wilson was in the White House.

As professors John J. Mearsheimer and Stephen M. Walt argued in their groundbreaking book *The Israel Lobby and US Foreign Policy*, unconditional support for Israel is not in America's own best interests. In fact it's not in anybody's best interests including those of the Jews of the world.

My only quarrel with the Mearsheimer and Walt book is its title. For reasons this book makes clear, the phenomenon of their title is not an Israel lobby. It's the Zionist lobby, and I'll get to why it should be called by its proper name in a moment.

Mearsheimer and Walt's work improved to some extent the prospects for informed and honest debate about who must do what and why for justice and peace in the Middle East, but an actual resolution of the conflict in and over Palestine needs the citizens of America to be better informed than they are about much more than the Zionist lobby's influence on American policy for the Middle East.

Above all Americans—American Jews especially—need to know that almost everything they've been conditioned to believe about the making and sustaining of the Israeli/Palestinian conflict is not true They need to know, for example, that Israel and the Palestinian refugee problem were created, mainly, by Zionist terrorism and ethnic cleansing. And they need to know, again for example, that Israel's existence has never—ever—been in danger from any combination of Arab military force. Zionism's assertion that Israel's Jews have lived in constant danger of being "driven into the sea" was the propaganda cover that allowed Israel (a Zionist, not a Jewish, state) to get away where it mattered most, in Europe and America, with presenting its aggression as self-defence and itself as the victim when, actually, it was and remains the oppressor.

The problem with the truth of history as it relates to the making and sustaining of conflict in and over Palestine is that it's pregnant with extreme danger because it could provoke anti-Semitism[2] throughout the mainly Gentile nations of the Judeo-Christian or Western world, which is where most Jews live. There is, however, a way to exorcise this extreme danger. It is by giving the truth its necessary global context, not only to show that consequences have causes, but also to explain, among other things, the difference between Judaism and Zionism. Knowledge of the difference is

Knowledge of the difference between Judaism and Zionism is the key to complete understanding of the conflict and who must do what, and why, for justice and peace.

the key to complete understanding of the conflict and who must do what and why for justice and peace.

Judaism is the religion of Jews, not "the" Jews because not all Jews are religious. Like Christianity and Islam, Judaism has at its core a set of moral values and ethical principles. As holocaust survivor Dr. Hajo Meyer states in his book, *An Ethical Tradition Betrayed: The End of Judaism,*[3] these values and principles put Jews "at the forefront of humanitarian and socially constructive endeavors" throughout much of history. (In his book my dear friend Hajo expresses his dismay at what he sees as the "moral collapse of contemporary Israeli society and the worldwide Jewish community as a whole." He compares Israel's current policies with the early stages of the Nazi persecution of Germany's Jews. He stresses that he is not seeking to draw a parallel between Israel's current policies and the Nazis' "endgame"— the slaughter of six million European Jews. He is merely trying to point out, he says, "the slippery slope" that eventually led to this catastrophe, and the necessity of "foreseeing the possible consequences" of a policy that oppresses and marginalizes the Palestinians in their own homeland).

Even the shortest definition of Zionism must begin by recognising that there is what might be called "spiritual Zionism" and "political Zionism". In the sense that they look to Jerusalem as their spiritual capital or center, all Jews who are religious could regard themselves as spiritual Zionists. The Zionism of this book's main title and substance is political Zionism.

It is Jewish nationalism in the form of a sectarian, colonial enterprise which, in the process of creating in the Arab heartland a state for some Jews—mainly by terrorism and ethnic cleansing as noted above—made a mockery of, and demonstrated contempt for, Judaism's moral values

Political Zionism made a mockery of, and demonstrated contempt for, Judaism's moral values and ethical principles.

and ethical principles. (Judaism insists that the return of Jews to the land of the ancient Hebrews must await the Second Coming of the Messiah. Zionism said, in effect: "We can't wait for Him. Zionism is the Messiah.") As this book makes clear, prior to the obscenity of the Nazi holocaust, political Zionism was of no interest to more than a minority of the Jews of the world and was opposed by many.

Supporters of Israel right or wrong conflate Judaism and Zionism because the assertion that Judaism and Zionism are one and the same enables them to claim that criticism of the Zionist state of Israel is a manifestation of anti-Semitism. Often, almost always these days, the accusation that criticism of Israel is anti-Semitic is a form of blackmail intended to silence criticism of, and suppress informed and honest debate

about, the Zionist state and its policies. The reality is that Judaism and political Zionism are total opposites, and knowledge of the difference is the key to understanding two things:

> 1. Why it is possible, with good reason on the basis of all the facts, to be passionately anti-Zionist—opposed to Zionism's colonial enterprise—without being, in any way, shape or form, anti-Semitic.

> 2. Why it is wrong to blame all Jews everywhere for the crimes of the hardest core Zionist few in Palestine that became little Israel, and then Greater Israel.

It's worth noting that virtually all Arabs and other Muslims have always known the difference between Judaism and Zionism. And it can be said without fear of contradiction that throughout much of their history, Arabs and other Muslims were the best protectors of Jews in need of sanctuary. It was Zionism's colonial enterprise that poisoned the relationship, though not—perhaps I should say not yet—to the point at which most Arabs and other Muslims blame all Jews for Zionism's crimes.

It is wrong to blame all Jews everywhere for the crimes of the hardest core Zionist few in Palestine that became little Israel, and then Greater Israel.

Jews, all Jews, also need to know the difference between Judaism and Zionism. Am I suggesting that many don't know it? Yes. A truth of today, or so it seems to me from conversations with Jews, is that very many if not most of them have no idea of what Zionism actually is, both in ideological principle and in practise in Palestine from the early years of the 20th century to the present. And there are two main reasons for this apparent lack of awareness. One can be explained by the awesome success in propaganda terms of Zionism's *Nakba* denial. *Nakba* is the Arab word for catastrophe and shorthand in Arab terminology for Zionism's ethnic cleansing of Palestine in 1948. Zionism denies the ethnic cleansing. The other main reason is that many Jews of the world don't want to know the truth of history as it relates to the creation of the Zionist state of Israel and the Palestinian refugee problem (in much the same way, some might say,

Many Jews of the world don't want to know the truth of history as it relates to the creation of the Zionist state of Israel and the Palestinian refugee problem.

as Americans, some or many, don't want to know what really happened to the native Indians of America). In the Prologue to this book, *Waiting for the Apocalpyse,* I seek to explain, empathetically, why to date many Jews have not wanted to know the truth of history.

So why do I assert that all Jews need to know the difference between Judaism and Zionism?

The sleeping giant of ant-Semitism is being re-awakened in many of the nations of the Western world in which most Jews live, and a prime cause of this re-awakening is the behaviour of the Zionist state of Israel and its extraordinary (some would say insufferable) self-righteousness. As we shall see, prior to the obscenity of the Nazi holocaust many of the best Jewish minds of the time feared that Zionism, if it was allowed to have its way, would at some point provoke anti-Semitism. These fears were given a fresh public airing by a most remarkable Israeli, Yehoshafat Harkabi, in 1986. He was the longest serving Director of Israeli Military Intelligence and was universally respected. In the Prologue I quote from his book, *Israel's Fateful Hour*. He warned of the danger of Israel becoming "a factor in the rise of anti-Semitism".

A prime cause of the re-awakening of anti-Semitism is the behaviour of the Zionist state of Israel.

It's my view that after the Nazi holocaust, and because of it, the giant of anti-Semitism most likely would have gone back to sleep, remained asleep and, in all probability, would have died in its sleep—IF Zionism had not been allowed by the major powers, first Britain, then America, to have its way, as Balfour put it, "right or wrong".

What, really, is the basis for believing that anti-Semitism is on the rise?

The increase in the desecration of synagogues and graves and other Jewish symbols, verbal abuse and assaults on Jews are indicators. But what may be far more sinister is the growing number of Europeans and North Americans who are now beginning to speak negatively about Jews at dinner parties and behind other closed doors. The more it becomes apparent that the Zionist state of Israel is the obstacle to peace on any terms most Palestinians and other Arabs and Muslims could accept, the more this antipathy will grow, with the real danger that it will break out and manifest itself as violent anti-Semitism. It's my view, which I know is shared in private by some eminent Jews in Europe and America, that if the monster of anti-Semitism does go on the rampage again, it might well start its journey in America.

If the monster of anti-Semitism does go on the rampage again, it might well start its journey in America.

But what actually happens in the future will depend a great deal on whether or not the vast majority of Jews who live in the nations of the mainly Gentile Judeo-Christian world are prepared to come to grips with the fact that Zionism is, as the title of this book asserts and its substance demonstrates, their real enemy. If they can and do, and are then prepared to end their silence on the matter of Israel's behaviour, they will, by distancing themselves from Zionism, best protect themselves from a charge of complicity (if only by default) in Zionism's crimes. Silence is not the way to refute and demolish such a charge.

I am aware that many Americans, including American Jews, might honestly believe they are serving the best interests of the Jews by refusing to address the foundational Zionist myths, but I say they are wrong, dangerously wrong. All, including the corporate-controlled mainstream media, who refuse to come to grips with the truth of history and, in particular, the difference between Judaism and Zionism and thus why it is perfectly possible to be passionately anti-Zionist without being anti-Semitic, are helping to set up all Jews to be blamed for the crimes of the relative few.

As surely as day follows night, the Zionist lobby and other supporters of Israel right or wrong will make an awesome effort to limit distribution of this book in America, and to cause the informed and honest debate it was written to promote to be suppressed. The less this attempt is allowed to succeed, the more all citizens of America will be empowered to give substance to their idealism, to make their democracy work for justice and peace in the Middle East. Success in that endeavour would effectively drive a stake into the heart of the monster of anti-Semitism and kill it for all of time.

Author's Note

The story this book tells is constructed on the documented truth of history and insights gained from my own engagement with the conflict in various capacities over more than three decades. I was, for example, the first Western correspondent to the banks of the Suez Canal with the advancing Israelis in the Six Day War of June 1967. And over the years I enjoyed intimate access to, and on the human level friendship with, leaders on both sides of the Arab-Israeli conflict. I am probably the only person on Planet Earth to have enjoyed a special relationship with the two leaders I regard as the greatest opposites in all of human history—Golda Meir, Mother Israel, and Yasser Arafat, Father Palestine. (I made a BBC *Panorama* profile of the former and wrote a book about the latter). In telling the whole, unexpurgated story of the creation of the Zionist state of Israel and how it became a threat not only to the peace of the region and the world but also to the best interests of Jews everywhere and the moral integrity of Judaism itself, I've quoted from my private conversations over the years with leaders on both sides. My aim in doing so was to provide an extra degree of real and rare insight.

Given its length, three volumes for the American serialized edition with perhaps a fourth in due course, some might ask: "Why such a big enterprise?" And some might add, "Do you seriously believe that more than a handful of Americans will be bothered to take the time and make the effort required to read three or even four volumes?"

I am, of course, aware that because of its length this series does require a serious commitment of reading time, and therefore effort, during the 18 months or so in which all three or possibly four volumes will be published. How can I possibly justify such a call on readers' time? My answer is in two parts.

I believe the reward for this effort will be an understanding, probably for the first time ever for very many Americans, of how all the pieces of the most complex and complicated jigsaw puzzle fit together and, therefore, an understanding of why the Palestine problem is the cancer at the heart of international affairs, and what must be done and by whom, if it is to be cured before it consumes us all.

The length of this work is also to do with the nature of the challenge I set myself. To tell the truth needed for real understanding, I had to re-write the whole story of the making and sustaining of the Arab-Israeli conflict, replacing Zionist mythology with the documented facts of history. To make complete understanding possible, it was also necessary for me to put regional events into their global context. The latter includes, for example, what went on behind closed doors in London, Paris, Washington and Moscow. All of that would be a mission impossible in a single volume.

To date in the mainly Gentile Judeo-Christian or Western world we have had only a first draft of history, one constructed on Zionist mythology. This series offers a second, one that exposes Zionist mythology for the propaganda nonsense it mainly is.

And there's a little something I'd like to add here by way of encouragement for what is sometimes called the general reading public. This book is written in the conversational style of the television reporter and to some extent reads more like a novel than a conventional historical work. This is to make the story accessible to all—i.e. not just a relatively small number of academics and other professionally interested people. I can also report that since the publication in the UK of the first hardback edition of this work in two volumes, I've received a good number of messages from so-called ordinary people of all faiths and none, telling me they thought the book is "an easy read" and a "page-turner". There was even a rabbi who called me to say, with great good humour, that I was to blame for his lack of sleep. He told me he had taken my book to bed to read a little each night but that when he started he couldn't put it down.

In the UK I had to set up my own publishing company to get the first hardback edition of this book in two volumes to the retail market place; and this despite the fact that my literary agent had on file letters of rare praise for my work from the CEOs of some of our major publishing houses. One CEO described my manuscript as "awesome... driven by passion, commitment and profound learning." This letter added, "There is no question it deserves to be published." But all in the UK were too frightened to publish this book out of fear of offending Zionism too much and being falsely accused of promoting anti-Semitism and, possibly, finding themselves on the receiving end of an organised boycott of all their authors and titles. It didn't matter that my book is actually the opposite of anti-Semitic, and contains my call, as a Gentile, for the Jews to become a light unto nations by demonstrating that right can prevail over might and that there is a place for morality in politics.

Acknowledgments

My access to the documented truth of history was assisted by the named authors from whose work I have quoted. I thank them all and eight in particular for the special quality of their original research. The eight are: Lenni Brenner, Alfred M. Lilienthal, the writing duo of Larry Collins and Dominique Lapierre, Seymour Hersh, Stephen Green, Yehoshafat Harkabi and, most notably, Avi Shlaim.

I am also indebted to Ilan Pappe. He and Avi Shlaim are Israel's two leading "revisionist" (which means honest) historians. Ilan's own latest book, *The Ethnic Cleansing of Palestine*,[4] a seminal work documented in chilling detail, was not available for me to call upon when I was finalizing the content of my own Volume One; but I make reference to his work in a footnote to my Chapter 10 which is titled *Zionist Terrorism and Ethnic Cleansing*. Ilan and I have become dear friends and allies in common cause and regard ourselves as being, with a small band of others including Avi Shlaim, on the hottest frontline in the war for the truth of history. Ilan is at the very top of Zionism's official "S.H.I.T" (**S**elf-**H**ating **I**sraeli **T**raitors) list, and we both think I would be up there with him, ahead of 6,999 others, if I was an Israeli. In one of our first conversations Ilan said he thought Zionists were more frightened of my book than any other because of its title. His latest book, he said, they could rubbish in their usual way. "Your book," he added, "is a real problem for them because its main title, *Zionism, The Real Enemy of the Jews*, is *the whole truth* in seven words." The many hours of his precious time Ilan gives me for analytical conversation helps greatly to keep my own thinking refreshed and finely tuned. His most generous endorsement of my work is on the back cover of this volume. (There was,

> **Ilan Pappe: "Your book is a real problem for them because its main title, *Zionism, The Real Enemy of the Jews*, is *the whole truth* in seven words."**

however, one point on which Ilan censured me. He said that I was, and all others were, wrong to use the term **"diaspora"** as in Jewish diaspora. His argument, with which I fully agree and actually develop in this book, is that diaspora implies that the Jews of the world have a biological and ancestral connection to the ancient Hebrews and thus an historical claim to the land of Palestine that became Israel. In reality they—almost all if not quite all the Jews of the world—have no such connection or claim. Most believe they do, but they don't. With good grace Ilan accepted that when I use the term Jewish diaspora it is for convenience).

That this book is now published in the United States is due entirely to the vision, courage and commitment of Diana G. Collier, the Editorial Director of Clarity Press, Inc., and Clarity's editorial board. I cannot find words adequate enough to express my thanks to Diana and my respect for her. Courage of the kind she and her colleagues have demonstrated is extremely rare in the publishing as well as the mainstream media world.

And I must thank my dear wife, Nicole Marie Louise, to whom I have been married for 47 years. Only a lady as remarkable and as loving as she is would have allowed her husband to put everything on the line, including his home and perhaps even his life, in order to tell the truth of history. Whenever I am asked why I do what I do, I quote my dear friend Hajo Meyer. At breakfast one morning after he had been one of my guests on a debating platform in London, I asked him why at the age of 82, and given that he is vilified by Zionism's propaganda hit men, he continues to serve in the frontline of the war for truth and justice. He replied, "The first person I see every morning is me."

My dear wife understands that I, too, need to be able to live with myself.

Alan Hart, 2009

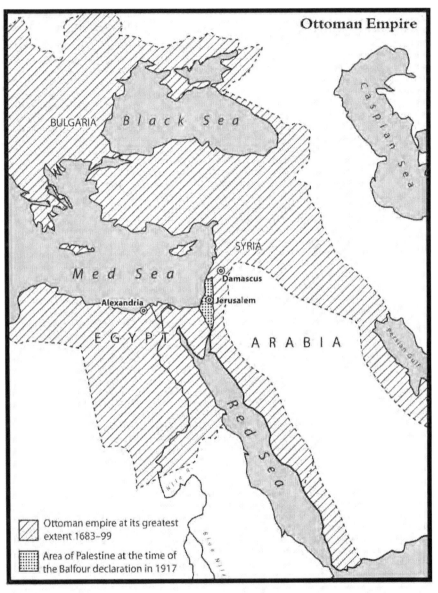

Ottoman (Turkish) ownership of Arab land Balfour gave away to Zionism.

WAITING FOR THE APOCALYPSE

"And he gathered them together into a place called in the Hebrew tongue Armageddon. And the seventh angel poured out his vial into the air; and there came a great voice out of the temple of heaven, from the throne, saying, 'It is done.'"
From the New Testament of the Bible (King James Version), the Book of Revelation Chapter 16, verses 16 and 17

The place called Armageddon by the ancient Hebrews is in present day Israel. It was taken and renamed by them during their conquest of a part of Canaan, the name in the Bible by which Palestine was first known to the world.

In the Arabic tongue of its previous and original owners, the Canaanites, the first known ancestors of some of the present day Palestinian Arabs, the place was called Megiddo.

It was on account of its strategic location—close to mountains including, beyond the Sea of Galilee, the Israeli-occupied Syrian Golan Heights of today—that Megiddo became the famous battlefield of Palestinian history.

According to the New Testament, Armageddon is the place where the kings of the Earth under demonic leadership will wage war on the forces of God at the end of world history.

In the context of the modern Arab-Israeli conflict, Armageddon as the symbolical battlefield of the Apocalypse implies the end-game in a fight to the finish between:

- the Jews of Israel, in number today about six million and perhaps more, a figure which includes the religious and other zealots of the illegal settlements of Greater Israel (on Arab land seized in 1967); and

- the Arabs of the region and Muslims worldwide, in number about 1.4 billion and rising, getting on toward a quarter of humankind;

- with diaspora or non-Israeli Jews, the majority of Jews in the world who live as citizens of many nations, facing a truly terrifying dilemma about what to do to protect their own best interests. (The non-Israeli Jews of the world are believed to number about 16 million; and there are more Jews in America than Israel).

In the context of the whole story this book has to tell, I say that only a professional optimist or a certifiable idiot would dismiss completely the possibility of a final solution to the Arab-Israeli conflict being signalled by the formation of mushroom clouds of atomic dust and debris, mixing as they spread with the vapours of biological and chemical weapons.

For those readers who believe that such a scenario is unthinkable, I recall what was said to me by Golda Meir, in a filmed interview for the BBC's *Panorama* program, when she was Israel's prime minister.

At a point I interrupted her to say: "Prime Minister, I want to be sure I understand what you're saying... You are saying that if ever Israel was in danger of being defeated on the battlefield, it would be prepared to take the region and even the whole world down with it?"

If ever Israel was in danger of being defeated on the battlefield, it would be prepared to take the region and even the whole world down with it.

Without the shortest of pauses for reflection, and in the gravel voice that could charm or intimidate American presidents according to need, Golda replied, "Yes, that's exactly what I am saying."[1]

Though Israel's leaders never talked about it in public, we both knew that Israel possessed nuclear warheads and, in secret association with South Africa's apartheid regime, was developing the missiles to deliver them. Implicit in what Golda said was that Israel, in a doomsday situation, would be prepared to use its nuclear weapons in a defiant farewell gesture.

Three years after Golda's revelation of her state's doomsday option, during the early panic on the Israeli side of the 1973 (Yom Kippur) war, two Israeli missiles were armed with nuclear warheads and targeted.

The targets were Cairo and Damascus, the capitals of Egypt and Syria.

At the heart of the unexpurgated story of the struggle for Palestine there is a terrible and tragic irony. In summary for now it comes down to this: Contrary to what Israelis and most people of all faiths and none in the Western world have been conditioned to believe by Zionism's brilliant myth makers, Israel's existence has never to date been in danger.

Not in 1948.

Not in 1967.

And not even in 1973.

The myth of poor little Israel in danger of annihilation was created to give Zionist diplomacy the best possible chance of preventing the Jewish state being pressed to be serious about peace on terms which would provide the dispossessed Palestinians with an acceptable amount of justice. Yes but... It has to be acknowledged that the myth would not have been sustainable without empty and stupid Arab rhetoric about destroying the Jewish state. The irony is in the prospect of Israel, having said "No" to peace on a number of occasions when it was there for the taking, being defeated in the future as a consequence of the ultimate explosion of Arab and Muslim fury—the product of unending humiliation—generated by Zionism's unshakable commitment to the notion that might is right.

Unfortunately, this commitment is endorsed by many of the pork-barrel politicians in the U.S. Congress—the House of Representatives and the Senate; and by tens of millions of born-again American Christians who are variously described as "conservative", "evangelical" and "fundamentalist", and who claim to be the "moral majority" in the Land of the Free. The bible-thumping shepherds of these flocks actually want the Armageddon scenario to be played out. They pray and, in political alliance with Zionism's own zealots, work for it to come to pass. They are convinced it will because, they say, such an endgame is in accordance with God's plan.

Consider the spine-chilling words of Pastor John Hagee, one of the most influential voices of Christian fundamentalism in America, influential enough to enjoy more or less instant access by telephone to American presidents and Israeli prime ministers. He leads the congregation of the Corner Stone Church in San Antonio, Texas, where he performs with a mass choir and a deafening band in front of six cameras which take his Sunday morning show live to the nation. In early 2006, he founded Christians United for Israel, (CUFI). Pastor Hagee was among those interviewed by the BBC's Stephen Sackur for a remarkable radio documentary broadcast in May 2002. Like many American politicians and commentators, Hagee had subscribed to the notion—Zionism's latest deception—that Israel's all-out offensive against the Palestinians on the occupied West Bank was part and parcel of the global war against terrorism declared by President Bush.

Sackur's programme, *A Lobby to Reckon With*, was honest investigative journalism at its very best. His mission was to explain why it was no longer accurate to talk about the Zionist lobby as the main influence on American policy for the Middle East. There was now a more powerful lobby, one that had been formed, effectively if not institutionally, by the Zionists joining forces with the born-again Christian right. That being so, it was more accurate to talk about the pro-Israel lobby of both. As Sackur observed, it is an alliance of "the two best organised networks in the U.S."

In his preaching to the faithful on the Sunday morning of the BBC recording, Pastor Hagee reaffirmed that "God entered into an eternal covenant with Abraham, Isaac and Jacob that the nation of Israel would belong to the Jewish people forever", with Jerusalem as "the eternal capital of the Jewish state."

American Christians, the pastor proclaimed, would stand with Israel through "thick and thin". After the service the admirable Sackur wanted to know why. The following was Pastor Hagee's answer as broadcast.

The Jewish state was something born in the mind of God and we as a people believe the scripture, and the scripture says very clearly that God created Israel, that God is the protector and defender of Israel. If God created Israel, if God defends Israel, is it not logical to say that those who fight with Israel are fighting with God? We are seeing in my judgement the birth pangs that will be called in the future the beginning of the end. I believe in my mind that the Third World War has begun. I believe that it began on nine-eleven. I believe that we're going to see an escalation of the Islamic influence all over the earth, and God in his sovereign grace is going to stand up and defend Israel, and the enemies of Israel are going to be decimated.

That, said Sackur, was "a very black and white, good against evil representation of global conflict", which some listeners might consider to be "inflammatory and dangerous."

Unruffled and courteously Pastor Hagee replied:

"No, it's not dangerous. When you know the future, there's no reason to consider it inflammatory. It's going to happen."

A report in *Monitorworld (The Christian Science Monitor)* for the week of 6–12 March 2004 noted that a 2002 survey showed "59 percent of Americans believe that the events in the Bible book of Revelations will occur in the future." The report, by Jane Lampman, a staff writer, was headlined: THE END OF THE WORLD: THE DEBATE HEATS UP. She wrote that while fundamentalists were a minority of American Christians, "the interest in end-times prophecy has spread beyond their circles and is not only shaping people's lives, but even influencing United States foreign policy, say supporters and critics."

At about the same time as Pastor Hagee was making his prophesy, the most disingenuous Israeli leader, former Prime Minister Binyamin Netanyahu and the man who might be Israel's prime minister again when this volume is published in America, was insisting that Israel was engaged in a "biblical battle". He made that declaration to the biggest ever rally of British Jews in London. Hoping to become prime minister again, Netanyahu was on a tour of selected Western capitals. His main purpose was to promote the message that Yasser Arafat was the Palestinian Hitler, Saddam Hussein and Osama Bin Laden rolled into one, and should be dealt with accordingly. As the leader of the Al Qaeda network responsible for the nine-eleven terror attacks on America, Bin Laden was the prime target of President Bush's "war on terrorism." Netanyahu had been the first Israeli leader to jump on the nine-eleven bandwagon as the means of crucifying

Arafat. The most interesting question about Netanyahu—readers might like to keep it in mind as the story unfolds—is this: Does he know that much of what he speaks is complete and absolute propaganda nonsense, or does he really believe what he says? (According to a report in *The Jerusalem Post* of 7 April 2008, Netanyahu said the following to a conference of American Evangelicals in Jerusalem. "Israel has no better friends in the world than Christian Zionists. This is a friendship of the heart, a friendship of common roots and a friendship of common civilisation.")

The equation is a truly terrifying one:

Bigotry, Zionist + Christian + Islamic = Armageddon (noting that some and perhaps many Muslims would claim that the bigotry on their side is a response to Zionist aggression and Christian fundamentalism). The forces of all three are on the rise.

Just how many would die and how much of the global environment would be polluted and destroyed by the fallout in the event of an apocalyptic endgame in and over Palestine are matters for speculation. But that it could happen is reason enough for every man, woman and child on planet Earth to be aware that they have a stake in what is happening in the Middle East.

The struggle for Palestine is not only the longest running conflict in all of human history—it started more than 3,000 years ago. It is by far the most dangerous.

In my experience of living the Arab-Israeli conflict—as a foreign correspondent for ITN as well as the BBC's *Panorama* program, and as a participant at leadership level in the secret diplomacy of the search for peace—there were many chilling moments of 20th century revelation. All of them contributed to the insight I hope this book provides.

When I conceived the need for it there were, I believed, two main questions to be addressed.

The first was: Who can stop the countdown to Armageddon?

The second was: What can be done, and by whom, to prevent the sleeping giant of anti-Semitism, now stirring, from waking up with sufficient vigour to go on the rampage again?

As we shall see, the two questions are connected. If the countdown to Armageddon is to be stopped, the sleeping giant of anti-Semitism has got to be destroyed once and for all time. I mean that it will not be enough simply to put him back to sleep again. The stake has got to be driven into the monster's heart.

This book has two central themes.

One is how the modern state of Israel, the child of political Zionism, became its own worst enemy and a threat not only to the peace of the region and the world, but also to the best interests of Jews everywhere and the moral integrity of Judaism itself.

The other main and related theme is why, really, the whole Arab and wider Muslim world is an explosion of frustration and despair waiting for its time to happen.

I am, of course, aware that the monster of Islamophobia is on the prowl in many Western nations and licking its lips. One of my hopes is that

the truth of history this book seeks to represent will contribute to ending the ignorance and therefore the prejudice which feeds this particular monster. Because the fundamental issues with which this book is concerned are so sensitive and controversial, and because they have never been placed before the general public in a way that makes possible truly informed and rational debate about the obstacles to peace, I wish to make the following statement in order to leave readers in no doubt about where I am coming from.

The Israel I am writing about in this book is not a Jewish state. I mean it is not one governed in accordance with the moral values and ethical principles of Judaism. If it was, it could not have behaved in the way it has since its unilateral declaration of independence in 1948 which, as we shall see, was a defiant act against the will and wishes of the organised international community and triggered the first Arab-Israeli war. The Israel I am writing about in this book is a *Zionist state*. And the Zionism it represents (political Zionism as previously defined) has used and abused Judaism for political purposes

For those readers who are not intimately familiar with the terminology of the conflict I should point out that the Zion of spiritual Zionism is Mount Zion in Jerusalem. As invoked by political Zionism's founding fathers it is the symbol of the "return" of Jews to land occupied and ruled for a relatively short time by their alleged ancestors—the ancient Hebrews, the first Israelites—about a thousand years before the birth of the carpenter's son who became the Christ of Christian mythology. Many Jews will be outraged by my use of the term alleged in the context above, but real history obliges me to stand by it.

The physical return of Jews, one possible but woefully inadequate definition of political Zionism, was a deeply flawed concept. Return implies that all the Jews who returned to create the modern state of Israel were biological descendants of the Hebrews of the ancient kingdom of Israel. If that had been the case, they would have had at least an arguable claim to some of the land of Palestine. But it was not so. Most if not all the returning Jews were foreign nationals of many lands who became Jewish by conversion to Judaism centuries after the fall of the ancient Jewish kingdom and what is called the "dispersal" into "oblivion" of its people. To put it bluntly but accurately, most if not all the Jews who returned to create the Zionist state had no rights whatsoever to the land of Palestine. Though it is still not politically correct to say so, the notion that there are two peoples with an equal claim to the same land does not bear serious examination. The fact that Israel exists does not mean that the Zionist claim on Palestine was a legitimate one. As we shall see, the matter of Israel's legitimacy is one of the devils in the detail of the politics of peacemaking.

The distinction between spiritual and political Zionism is not only the key to understanding as previously explained, it is also critical to understanding what I call the Jewish predicament. That is my shorthand phrase for the unspeakable dilemma that confronts many if not most Jews of the world because of the Zionist state's behaviour. Objectively that behaviour can be described as brutal and cruel, driven by self-righteousness of a most extraordinary kind, without regard for international law and human rights conventions and which, all up, makes a mockery of the moral values and ethical principles of Judaism.

The distinction between spiritual and political Zionism is critical to understanding the Jewish predicament.

A hint of how troubled some British Jews are by the Zionist state's behaviour was contained in an article on 28 October 2001 in *The Independent On Sunday*. The article, written by Andrew Johnson, was headlined BRITISH JEWS AT ODDS AFTER RABBI CRITICISES ISRAEL'S "COLONIALISM". It was the story of how a "passionate argument" had broken out in the pages of *The Jewish Chronicle* after a prominent liberal London rabbi, Dr. David Goldberg, had spoken some of the unspeakable in public. Goldberg, the author of a popular introduction to Judaism, *The Jewish People, Their History and Their Religion*, had said that Israel's "colonisation" had left many Jews "questioning their unconditional support for Israel." He then said: "It may be time for Judaism and Zionism to go their separate ways." Perhaps the most remarkable statement ever made by a diaspora Jew.

Goldberg: "It may be time for Judaism and Zionism to go their separate ways."

Eastern European in origin, political Zionism was born in Switzerland after a long pregnancy in the womb of Mother Russia, the Russia of the Tsars, in 1897. (Hereafter when I use the term Zionism I mean political Zionism. When I mean spiritual Zionism I will say so).

In 1897 Zionism represented only a small, even insignificant number of Jews in the world. At its foundation Zionism's public commitment was to strive "to create for the Jewish people a *home* in Palestine secured by public law." But Zionism's real and unproclaimed commitment was to the creation of a Jewish *state*. The difference between the two concepts, home and state, was profound. By implication a Jewish "home" was, or for political and propaganda purposes could easily be presented as being, something much less than a state—i.e. a recognised Jewish presence which, because it possessed no sovereignty, would not pose a threat to the well-being and rights of the indigenous Arab population of Palestine. The truth is that Zionism's founding fathers lied in public about their real purpose. And why they felt the need to lie can be simply stated.

From its beginning the Zionist enterprise required some if not all of the indigenous Arab inhabitants of Palestine to be dispossessed of their land, their homes and their rights. In other words, and as we shall see, to achieve

its objective Zionism had to commit a crime—that of ethnic cleansing.

Zionism's founders had to lie about their real objective because to achieve it, Zionism had to commit a crime—that of ethnic cleansing.

In my understanding of history, I mean real history as opposed to Zionist, North American and Western European mythology, that crime, the terrible injustice done to the Palestinians, would not have been committed if three related things had not happened:

• if Britain, out of desperation, had not played the Zionist card in the course of World War I;

• if Adolf Hitler and his Nazis had not come to power in a defeated and humiliated Germany;

• and if then, during World War II, six million Jews had not been exterminated by the Nazis; this most dreadful happening being the climax to the persecution of Jews over more than two thousand years.

The second World War was in part (I think a large part) the consequence of Britain and France, in the course of the first one, refusing to take on board the wisdom of a good and truly enlightened man—Woodrow Wilson, the 28th President of the United States of America, who had the misfortune to be many, many years ahead of his time.

Some truths are so obvious, apparently, that they are never stated; and because they remain unstated, the cause of understanding is not well served. One such unstated truth is this: It was not the Arabs who slaughtered six million Jews, it was Europeans in Europe. But it was the Arabs as a whole, and the Arabs of Palestine in particular, who, in effect, were punished for a European crime.

In my analysis the extreme self-righteousness that is the hallmark of Zionism is a mask for suppressed guilt on account of the injustice done to the Palestinians and, also, fear rooted in the past of the future.

One of Zionism's greatest achievements for the first five decades of Israel's existence was convincing the Western world that anti-Zionism and anti-Semitism are the same thing. They are not.

As Lenni Brenner, the anti-Zionist Jewish writer put it in 1983 (emphasis added): "*Zionism is not now, nor was it ever, co-extensive with either Judaism or the Jewish people.*" The quote is from Brenner's book, *Zionism in the Age of the Dictators—A Reappraisal.*[2]

Zionism's amazing propaganda success helps to explain why Western governments and the mainstream media were content to regard Zionist mythology and objective history as one and the same thing when, in fact, they are two vastly different things. That in turn helps to explain why still today there is not nearly enough understanding in the Western world, in North America especially, of how the Arab-Israeli conflict was created, what fuelled and sustained it and why to date, stopping the final countdown to catastrophe for the region and the world has been a mission impossible.

It is inevitable, as surely as night follows day, that Zionists will accuse me of being anti-Semitic. I am content in my belief that no individual of sound mind who reads this book could come to such a conclusion.

When I set about the task of writing this book I had in front of me two signed photographs from (in my opinion) the two greatest opposites in all of human history. (They are among the souvenirs of my television reporting days). One was of Golda Meir, Mother Israel. The other was of Yasser Arafat, Father Palestine. Arafat signed with his "Best wishes". Golda's inscription was "To a good friend, Alan Hart".

Because I am a *goy* (non-Jew), Golda's inscription meant a great deal to me. It also assisted me to put down Zionist bigots when, on public speaking tours across America, they accused me of being anti-Semitic. In television and radio studios, and sometimes on other public platforms, I would produce the photograph of Golda, read aloud the inscription in her own hand, and then say to my accuser, "Do you really think that this old lady was so stupid that she could not have seen through me if I was anti-Jew?"

I had in front of me two signed photographs: one from Yasser Arafat, Father Palestine, signed with his "Best wishes"; one from Golda Meir, Mother Israel, inscribed "To a good friend, Alan Hart".

I also want to say that I will not be bothered if such a charge is made against me because I would recognise it for what it was—an attempt to smear me for the purpose of discrediting my work. Against the ever-present background of the obscenity of the Nazi Holocaust, making the false charge of anti-Semitism is the Zionist way of trying to discredit and preferably silence any non-Jew who dares with justification to criticise Zionism and Israel. Because the slaughter of six million Jews in Germany and Nazi-occupied Europe was a European crime, there is nothing that makes greater moral cowards of European politicians and media people than fear of being labelled anti-Semitic. In my judgement the most perceptive passage ever written on this subject is to be found in Alfred M. Lilienthal's amazingly well-documented book, *The Zionist Connection II, What Price Peace?*, first published in 1978 before the Cold War ended. In his chapter headed *Exploiting Anti-Semitism*, Lilienthal wrote this:

> Nothing has accounted more for the success of Zionism and Israelism in the Western world than the skillful attack on the soft under-belly of public opinion—Mr. Decent Man's total repugnance toward anti-Semitism. The charge of this bias, instantaneously bringing forth the spectre of Nazi Germany, so totally pulverizes the average Christian that by contrast calling him a Communist is a pleasant epithet. It was the Christian revulsion toward anti-Semitism in the wake of Hitlerian genocide, not the superiority of Zionist over Arab rights, that first created and then firmly entrenched the Israeli state, even permitting the occupation

of conquered territories in the face of the UN Charter and international morality.[3]

As we shall see, all of the most perceptive and the most devastating of Zionism's critics were and are Jews. The most perceptive of them all was Ahad Ha-am, the pen name of a Russian Jew we will meet later (and whose words were the inspiration for *The False Messiah* as the title for this volume).

As a matter of fact the term "anti-Semitic" is hardly ever used in the correct or proper way. When Jews make the accusation with right on their side, what they really mean is that the person they accuse of being anti-Semitic is anti-Jew. In reality Arabs as well as Jews are Semitic peoples or Semites. Somebody who is anti-Semitic is therefore somebody who hates Jews *and* Arabs. With that qualification made, I will stay with the Western tradition and use the term anti-Semitic as though it has only one meaning, anti-Jew.

My own position has been a matter of public record for many years. In my book *Arafat, Terrorist or Peacemaker?*, first published in the UK 1984 and subsequently in America as *ARAFAT*, I said I regarded the Jews, generally speaking, as the intellectual elite of the European civilisation, and the Palestinians, generally speaking, as the intellectual elite of the Arab world. I went on to say that what Jews and Palestinians could do together in peace and partnership was the stuff that real dreams are made of. I even dared to suggest that together in peace and partnership Jews and Palestinian Arabs could give new hope and inspiration to the world.

The main purpose of the book in which I first expressed those thoughts was to put a great and exciting truth into the public domain. It was a truth I had discovered during my first period of privileged and unique access to Arafat when, at the start of 1980, I became the linkman in a secret exploratory dialogue between him and the one Israeli leader of the time who seemed to be serious about peace.

My hope was that the truth represented in *Arafat, Terrorist or Peacemaker?* would open some closed minds and make possible for the first time—in the Western world especially—a rational debate about the way to peace in the Middle East.

Until the first publication of my book about Arafat and his struggle, Israel and its unquestioning and very influential supporters in the media, in America especially, had succeeded in getting the Western world to accept Zionism's version of who and what the Chairman of the Palestine Liberation Organisation (PLO) was. In this version Arafat was not merely a terrorist, he was the personification of all evil. The most dangerously deluded of Israel's leaders—Menachem Begin, who had made the transition from terrorist leader to prime minister—had convinced himself and his followers, and proclaimed to the world, that Arafat was the reincarnation of Hitler. Such a man, said the Israel of Begin (and Shamir and Netanyahu and Sharon), was one the Jewish state never could or ever

By the end of 1979, Arafat had done everything that could be done to prepare the ground for peace with Israel.

would do business with. And thanks to the efforts of Henry Kissinger while serving as President Nixon's Secretary of State, Israel had seen to it that no American administration could do business with Arafat and his PLO so long as Israel said "No".

The truth represented in *Arafat, Terrorist or Peacemaker?* was this: By the end of 1979—repeat 1979, nearly a quarter of century ago!—Arafat had done in principle everything that could be done on the Palestinian side at leadership level to prepare the ground for peace with Israel.

It was a truth Begin's Israel did not want to hear or be heard, but the facts supporting it were impressive, and were recognised as such by President Carter. He understood that Arafat really was serious about wanting to make peace on terms which any rational government and people in Israel would accept with relief.

The facts in summary were these. Before 1979 was out, only months after Egypt's separate (and actually disastrous) peace with Begin's Israel, Arafat had persuaded the Palestine National Council (PNC), the Palestinian parliament-in-exile and the highest decision-making authority on the Palestinian side, to be ready to make an historic compromise for peace with Israel. The compromise was unthinkable to all Palestinians, but given Israel's military superiority in the region—an even more overwhelming fact of life after Egypt had been taken out of the military equation—it was, Arafat insisted, a compromise they had to make if they were to obtain an acceptable minimum of justice; "something concrete" as Arafat himself put it.

The historic compromise required the Palestinians to recognise Israel inside more or less its borders as they were on the eve of the 1967 war and make peace with that Israel in exchange for the return of less than 23 percent of all the land that was rightfully theirs. Put another way, peace on that basis, to provide for Palestinian self-determination in **The historic compromise required the Palestinians to recognise Israel in exchange for the return of less than 23 percent of all the land that was rightfully theirs.** a mini-state on the 23 percent of occupied land from which Israel would withdraw (the West Bank including Arab East Jerusalem and the Gaza Strip), required the Palestinians to renounce for all time their claim to the other 77 percent of their land.

That was the basic "land for peace" arithmetic of the historic compromise. And it was in accordance with the letter and the spirit of UN Security Council Resolution 242 of 22 November 1967, which Israel had said it accepted and would honour.

For Israel there was, however, a far greater prize on offer. There was something even more important than peace that Israel craved. It was the only thing the Zionist state could not take from the Palestinians by force.

The cover name of that thing was recognition, meaning recognition of Israel's "*right to exist*". The question I have never seen asked let alone answered in literature of any kind about the Arab-Israeli conflict is this: Why, actually, was it so important for Israel's "right to exist" to be recognised

by the Palestinians? The answer, which has its context in the pages to come, is this: In international law and because of the circumstances of its creation, Israel was NOT a legitimate state and therefore did NOT have the right to exist. In international law only the Palestinians—not the United Nations or any other earthly or even heavenly authority—could give the Zionist state the legitimacy it craved.

Only Palestinian recognition of Israel's "right to exist" can give Israel legitimacy in international law.

From that perspective the historic compromise required the Palestinians not only to make peace with the Zionist state but, by doing so, legitimise it—i.e. legitimise Zionism's theft of Arab land up to more or less Israel's pre-1967 borders.

For a people emotionally committed to "driving the Jews into the sea"—a rhetorical, empty and stupid threat Arafat and his leadership colleagues never made—the historic compromise was a completely unacceptable proposition.

And that, as I revealed in *Arafat, Terrorist or Peacemaker?* was why it took the PLO leader six long years—from 1973 to 1979—to sell it to the PNC. To do so he had to put his credibility with most of his leadership colleagues on the line and his life at risk.

As it actually happened, Arafat committed himself to a policy of politics and historic compromise with Israel in 1973, but he knew that if he put the policy to a PNC vote then, it would have been rejected by an overwhelming majority.

Over the six years from 1973 to 1979, on an individual basis, Arafat summoned to Beirut from all over the world the 300 members of the PNC. And in one-to-one conversations with them behind closed doors he made his case for the historic compromise with Israel. The initial response of most PNC delegates was outright rejection of their leader's policy. Some told him to his face that he was a traitor to their cause and would be seen as such by their masses. Some warned him that he would be assassinated if he continued to advocate such an unthinkable compromise. Arafat refused to consider the prospect of political defeat. He listened patiently to each and all of the rejectors and then told them to go back to their places in the Palestinian diaspora, to think carefully and deeply about what he had said and, when they had done that, to visit him again. When they returned he worked them over again. And again. The measure of his success at the end of his marathon effort to turn the PNC around was counted in votes: 296 for his policy of politics and compromise, 4 against.

On public platforms Arafat appeared to all Western observers as a man with little or no charisma of the kind that is essential for effective leadership. Yes but... the private Arafat was something else. The private Arafat had his own very special brand of charisma and the magic of it worked through his relationships with people on an individual basis or in small groups behind closed doors—when he did not have to play to public galleries.

By the end of 1979 he had performed a miracle of leadership. Over time I got to know well all of his senior leadership colleagues including his critics and opponents. The one thing they all agreed on, as did every other Palestinian to whom I talked, was that only Arafat could have persuaded the PNC to be ready to make the historic compromise needed to bring the longest running and most dangerous conflict in all of human history to an end.

What Arafat needed thereafter—to enable him to deliver the historic compromise—was a serious negotiating partner on the Israeli side; a leader who was prepared as a first step to do what all of Israel's leaders had vowed they would never do: recognise and negotiate with the PLO for the purpose of making peace on terms that, following an end to Israeli occupation of Arab land seized in the 1967 war, would see the coming into being of a Palestinian state with Arab East Jerusalem as its capital. This, plus compensation for those refugees who would never be able to return to their homeland because of Israel's existence, was the Palestinians' irreducible minimum demand and need in the name of justice. A demand and a need that not even Arafat the miracle worker could compromise.

On the face of it, because of the real leadership Arafat had demonstrated, a peaceful resolution of the Palestine problem was there for the taking by—it bears repeating—the end of 1979.

That was President Carter's judgment and he was right.

Begin's Israel responded with two initiatives.

The first was a political one to block an attempt by President Carter to recognise the PLO and bring it into the negotiating process.

The second was a military one—the invasion of Lebanon all the way to Beirut—to liquidate Arafat and his leadership colleagues and replace them with Israeli puppets. If Begin's Israel had achieved all of its invasion objectives, the puppets would have been installed in Jordan when King Hussein had been overthrown.

It was in between those two Israeli initiatives that I became by chance the linkman in a secret exploratory dialogue between Arafat and Shimon Peres. (The story of what my mission revealed about the agony of any rational Israeli leader who wants to be serious about peace has its place as appropriate in the pages to come).

Peres was then the leader of Israel's Labour Party, the main opposition in Israel's fractious parliament, the Knesset, to Begin's Likud-dominated government. Begin's policy was to go on creating facts on the ground—more and more illegal Jewish settlements on occupied Arab land—to prevent any meaningful manifestation of Palestinian self-determination.

At the start of my unofficial shuttle diplomacy the hope almost everywhere behind closed doors, especially in President Carter's White House and the UN Security Council, was that Peres would succeed in denying Begin a second term in office by winning Israel's next election. My role in the time remaining before that election was to try to develop enough understanding between Arafat and Peres so that when Peres became prime minister, he could engage in open dialogue with Arafat to get a real peace process going.

The expectation everywhere, including in Israel itself, was that Peres would beat Begin at the polls. But in the event Israel's amazing (many would say mad) system of proportional representation gave Begin the first crack at cobbling together a coalition government. He eventually succeeded and, confirmed as prime minister for a second term, he appointed General Ariel Sharon (the "bulldozer") as his Defence Minister. From that moment the invasion of Lebanon all the way to Beirut was on.

In the context of the whole story, only one conclusion is invited by Sharon's invasion of Lebanon in 1982. What he and all of Israel's hardliners feared most was not Arafat the terrorist but Arafat the peacemaker. The one thing Zionism did not want was a Palestinian leader who was interested in compromise and who, given the opportunity, could deliver it. Negotiations with such a Palestinian leader would require Zionism to abandon its Greater Israel project (i.e. the retention of most Arab territories occupied in 1967).

Zionism did not want a Palestinian leader who was interested in compromise and could deliver it. Arafat's real crime is that he outwitted Zionism to bring about the regeneration of Palestinian nationalism.

Arafat's real crime is that he outwitted Zionism to bring about the regeneration of Palestinian nationalism. In the script written by Zionism's leaders and effectively endorsed by the political establishments of the Western and Arab worlds, that regeneration was not supposed to happen. Why not emerges from the pages to come.

Arafat Terrorist or Peacemaker? was first published nearly two years after Israel's invasion of Lebanon and Sharon's failure to destroy the PLO—its leadership and its infrastructure. I was naturally pleased that my call for Israel to face up to reality had echoes there. The loudest echo was in a remarkable book written by Yehoshafat Harkabi. It was a most important book because Harkabi was nothing less than Israel's foremost authority on the subject of the Arab-Israeli conflict. He was that because of his work experience. He was the longest serving of Israel's Directors of Military Intelligence, known in their world of secrets by the acronym of the job description—DMI. In that capacity Harkabi had provided the strategic assessments which justified Israel's policy of seeking to impose its will on the Arabs by force. But with time and events Harkabi had found himself being moved to question the fundamentals of Israeli policy and the assumptions on which they were based.

In 1986 Harkabi, a prolific writer by then, published his magnum opus, in Hebrew *Hachraot Goraliot*. Two years later it was translated and updated for the English-speaking world with the title *Israel's Fateful Hour*. Endorsing by implication what I had said in my book about the need for Israel to face up to reality and negotiate with Arafat, Harkabi wrote this:

> What we need in Israel is not a united front behind a wrong policy (continuing Israeli occupation of Arab land seized in

1967) but searching self-criticism and a careful examination of our goals and means, so that we can differentiate between realistic vision and adventurist fantasy. We need clear, rational and, above all, long-term, comprehensive political thinking. Politicians frequently focus their gaze on the pebbles they may stumble on, ignoring the precipice. Some are brilliant in their analysis of the past weeks, but myopic in their perspective on what can happen in the coming months or years.

Jews in the West, particularly in the United States, should participate in this debate. They should not be squeamish and discouraged by the fear that the arguments they air may help their enemies and those of Israel. The choice facing them, as well as Israel, is not between good and bad,

> **Harkabi: "Jews in the West, particularly in the United States, should participate in this debate. They should not be squeamish and discouraged by the fear that the arguments they air may help their enemies and those of Israel."**

but between bad and worse. Criticizing Israeli policies may be harmfully divisive, but refraining from criticism and allowing Israel to maintain its wrong policy is incomparably worse. If the state of Israel comes to grief, God forbid, it will not be because of a lack of weaponry or money, but because of skewed political thinking and because Jews who understood the situation did not exert themselves to convince Israelis to change that thinking.

What is at stake is the survival of Israel and the status of Judaism. Israel will soon face its moment of truth. The crisis that faces the nation will be all-consuming. It will be bitter because many will have to acknowledge that they have been living in a world of fantasy; they will have to shed conceptions and beliefs they have held dear.[44]

And time was of the essence so far as Harkabi was concerned. Israel, he insisted, had to negotiate its way out of occupation while there was still a Palestinian leadership that was interested in compromise and could deliver. Harkabi understood the reality on the Palestinian side. It was, as I had said in my book, that Arafat would run out of credibility with his own people if Israel did not assist him to demonstrate to them that his policy of politics and compromise would get results.

On the subject of Arafat's PLO, Harkabi wrote this:

By describing the PLO as a basically terrorist organisation

we criminalize it and thus, unwittingly, criminalize the whole Palestinian community, which hails the PLO as its representative and leader. Such a stance is both politically and morally wrong.[5]

And Harkabi gave this warning:

Israel is the criterion according to which all Jews will tend to be judged. Israel as a Jewish state is an example of the Jewish character, which finds free and concentrated expression within it. Anti-Semitism has deep and historical roots. Nevertheless, any flaw in Israeli conduct, which initially is cited as anti-Israelism, is likely to be transformed into an empirical proof of the validity of anti-Semitism... It would be a tragic irony if the Jewish state, which was intended to solve the problem of anti-Semitism, was to become a factor in the rise of anti-Semitism. Israelis must be aware that the price of their misconduct is paid not only by them but also by Jews throughout the world. In the struggle against anti-Semitism, the front line begins in Israel.[6]

It would be a tragic irony if the Jewish state, which was intended to solve the problem of anti-Semitism, was to become a factor in the rise of anti-Semitism. Israelis must be aware that the price of their misconduct is paid not only by them but also by Jews throughout the world.

If a *goy* had written such words he (or she) would have been condemned by Zionism's zealots as the most rabid anti-Semite, and probably would not have gotten such thoughts published.

As we shall see, Harkabi was by no means the first of his faith to see Zionism as a factor in the rise of anti-Semitism.

The Hebrew edition of Harkabi's book and the debate it provoked led, as he intended, to some serious rethinking by leaders representing rational Israel—about half and perhaps more of the country's Jewish citizens. And that led in due course (better late than never, I thought at the time) to Prime Minister Yitzhak Rabin, pulled by Arafat and pushed from behind by Foreign Minister Peres, agreeing to recognise and negotiate with the PLO in what became known as the Oslo process. And thus it was, on the lawn of the White House on 13 September 1993, that Rabin accepted Arafat's outstretched hand. A watching world was stunned and amazed. I was in a BBC studio at Broadcasting House, and I was not the only one of the assembled pundits who struggled to hold back a tear of joy and hope.

Two years later Rabin paid for his conversion to reality with his life. He was assassinated by a Zionist fanatic who knew exactly what he was doing—killing the Oslo peace process. I was and still am convinced that if Rabin had been allowed to live he would have done his best to honour the

Oslo deal with Arafat. If he had succeeded there could have been peace on the basis of a two-state solution within five years or so as provided for by the Oslo Accords. And the countdown to Armageddon would have been stopped.

If that had happened, Arafat could have taken a place in history as the first among the peacemaking equals because the initiative for the Oslo process that led to the historic Israel-PLO breakthrough was his and his alone.

Rabin's place was taken by Peres but his prospect of winning Israel's next election and becoming prime minister in his own right, essential if the corpse of the Oslo peace process was to rise from the dead, was blown to pieces. As the election approached, Hamas suicide bombers struck (actually in response to an assassination Peres authorised which, as we shall see, was the biggest mistake of his life and a severe blow to Arafat's chances of containing the men of violence on his side). Over three days 59 Israelis were killed. Predictably Israel lurched to the hard right and in May that year, 1996, the Likud's Netanyahu defeated Peres and became prime minister. Netanyahu's mission was to halt and put into reverse the Arafat-Rabin peace process; to cancel as far as possible the gains the Palestinians had made on account of Arafat's policy of politics and compromise.

After Netanyahu's disastrous first term in office, a return to realism on the Israeli side was proclaimed by the Labour Party's next prime minister, Ehud Barak, a military man with not a lot of political skill. Late on his watch, and with President Clinton's assistance, another great Zionist myth was created. According to it, Barak offered Arafat "95 percent" of what he had been saying he wanted for peace, and Arafat rejected the offer because he was a terrorist, had never been a peacemaker, was committed to Israel's destruction, and thought he had more to gain in the short term from violence rather than negotiations.

That was what Zionists and their supporters everywhere wanted to hear. And it, the myth, was promoted and became the justification for everything Israel did after the Likud's Sharon defeated Barak and became prime minister.

It is not to their credit that so many American and European reporters who ought to have known better bought the myth; but buy it they did. Some, Americans in particular, were so committed to supporting the Zionist state right or wrong that peddling the myth was the most natural thing to do. But in other cases the buying of the myth was the result of lazy journalism. What happened when journalists were not lazy was illustrated by a remarkable article in the *New York Times* of 18 May 2002. The writer was Nicholas D. Kristof. Under the headline "Arafat and the myth of Camp David", his opening two paragraphs were the following.

> So does Yasser Arafat really want peace? In several columns I have sneered at the Palestinian leader and reiterated the common view that he had rejected very generous peace proposals proffered by former Prime

Minister Ehud Barak of Israel. That is a nearly universal understanding in the West, expressed by everybody from Henry Kissinger to the cocktail party set.

But, prompted by various readers, I've been investigating more closely and interviewing key players. This is what I found...

Kristof's conclusion was that "the common view in the West that Arafat flatly rejected a reasonable peace deal, and that it is thus pointless to attempt a reasonable strategy of negotiation (with Arafat), is a myth."

On the day Rabin shook hands with Arafat, Sharon vowed that he would destroy the Oslo peace process. When he became prime minister after Barak and Clinton's mishandling of the peace process, Sharon set about demonstrating that he was a man of his word. On the Israeli side reality was in the grave with Rabin.

And Arafat's credibility with the majority of his people was plunging. For more than two decades he had been telling them that his policy of politics and compromise would get results—a small Palestinian state with Arab East Jerusalem its capital. And that, it seemed, was nonsense.

As Sharon's attempt to break the will of the Palestinians to insist on more than crumbs from Zionism's table unfolded, I found myself returning again and again to page 220 of Harkabi's uniquely informed, prophetic and seminal book. "Israelis must be aware that the price of their misconduct is paid not only by them but also by Jews throughout the world. In the struggle against anti-Semitism, the frontline begins in Israel."

What Harkabi had feared could happen was happening. Israel's "misconduct" was awakening the sleeping giant of anti-Semitism. Predictably, hardcore Zionists—in America especially—insisted that the almost universal criticism of Israel's behaviour was itself the product of anti-Semitism. That was the usual Zionist propaganda nonsense and, as ever, an attempt to silence criticism of Israel; but there was something that could not be denied. The possibility of a new and virulent wave of anti-Semitism being provoked by Israel's behaviour at some point in a foreseeable future was a real one.

And I found myself wondering why it was that the Jews of the world, all but a very tiny minority of them, and many of whom are not political Zionists, were failing to respond to Harkabi's call for them to become involved in catastrophe prevention, by exerting themselves to convince Israel to change its thinking and its ways.

Why, why, why were they failing to respond?

The answer, I believed, was in my shorthand phrase—the Jewish predicament. The key to understanding the nature of it is in a short, uncluttered sentence in the Preface of Brenner's book. "Zionism thrives on the fears that Jews have of another holocaust."

Though I am a Gentile, I have been engaging with Jews for nearly 40 years; and on the basis of this experience I know that Brenner is right.

Deep down almost every Jew (including my accountant who has been one of my best friends for 40 years) does live with the fear that there could be, one day, another great turning against Jews. This is one half of the Jewish predicament.

The other half is the suppressed awareness that the Zionist state, because of its arrogance of power, could become, I think already has become, "a factor in the rise of anti-Semitism."

When you put the two halves of the predicament together, you have a logic, unspeakable by almost all Jews in public, that goes something like this: "We Jews of the world know we ought to be speaking out and exerting our influence to cause Israel to change its policies, but we dare not. Why not? Because there might come a day when we will need Israel as our refuge of last resort. For that reason we cannot even think of saying or doing anything that might give comfort to Israel's enemies and put our ultimate insurance policy at risk."

Zionism thrives on the fears that Jews have of another holocaust. For most Jews of the world, Israel's primary yet unspoken *raison d'etre* is their need for a refuge of last resort—just in case...

Now to the political significance of the Jewish predicament.

For many years I believed that America held the key to peace in the Middle East. Only an American President supported by enough members of Congress had the clout to oblige Israel to be serious about making peace. (That is, peace on terms almost all Palestinians could accept even though it would satisfy only their minimum demands and needs for justice). But my research for this book led me to quite a different conclusion in two parts.

The first was that from the moment in 1919 when President Woodrow Wilson suffered a stroke, and with the main exception of the eight years of President Eisenhower's two terms, America was incapable of being even-handed in the Middle East because its democracy is for sale to lobby groups representing vested interests of all kinds, of which the Zionist lobby is one of the most powerful. This is part of the depressing truth invited by the record of what actually happened, progressively, after President Wilson tried and failed to prevent the doing of a terrible injustice to the Arabs of Palestine.

To those readers who may think I am preparing the ground to blame the Zionist lobby in America for the fact that the Middle East is a complete catastrophe waiting for its time to happen, I say—not so. Hear me out.

It is the case that at critical moments the Zionist lobby was, and is, more the maker of U.S policy for resolving (or not) the conflict in and over Palestine than American Presidents and their administrations. But that is not my main point. It is that American politicians, including their Presidents, always had a choice. They did not have to do the bidding of the Zionist lobby. They chose to do it to serve their own short-term interests.

Put another way, I do not blame the Zionist lobby for exercising its awesome influence. The Zionists were and are only playing the Game of

Nations, ruthlessly to be sure, by The System's own rules. I blame most of all an American decision-making process which, because of the way election campaigns are funded and conducted, was, and still is, so open to abuse and manipulation by powerful vested interests as to be in some very important respects undemocratic.

During lecture and debating tours across America, I found myself saying on public platforms that the Zionist lobby had hi-jacked what passes for democracy; but I always added that it could not have happened without the complicity of America's pork-barrel politicians, Democrats especially.

For those unfamiliar with the term "pork-barrel" it was explained by the late Alistair Cooke in a BBC *Letter From America* on 26 December 2003. The term was derived, he said, from "a practice common in the South in the years before the Civil War." Slave owners would put out salt pork in big barrels at a certain time of an announced day and "the slaves would rush to the barrels to grab what they could." The pork was both a reward for the slaves and an inducement to make them more content than they otherwise might have been to do the master's bidding.

With the passage of time "pork" became the word used to describe the something that an elected politician did for his constituents to guarantee they would continue to vote for him. In general terms, the "something" is a sum of money which an elected politician persuades the House Appropriations Commitee to make available for a constituency project. But in the Arab-Israeli context of American politics, pork as in pork-barrel has a quite specific meaning. In this context, it's the politician's promise to vote for Israel right or wrong in exchange for campaign funds and votes.

In 1917 Britain played the Zionist card for reasons of empire. In America it was due to considerations of domestic politics that allowed the Zionist tail to wag the American dog—on President Truman's watch especially. For eight years after that President Eisenhower sought to contain Zionism and its child; but, with the main exceptions of Kennedy and Carter, he was followed by presidents who, in addition to their fear of offending the Zionist lobby, saw merit in doing what Britain had done—using Zionism as a means to an end. In Britain's case it was to maintain an empire. In America's case it was to create one.

The Jews of the world have most of the influence needed to persuade Israel to change course before it is too late for us all. No US president is ever going to confront the Zionist lobby unless he knows that a majority of Jewish Americans wish him to do so,

The second part of my conclusion was that the Jews of the world have most of the influence needed to persuade Israel to change course before it is, finally, too late for us all. And there are two ways in which this influence could be exercised. One would be for them to press arguments of their own on Israel, behind closed doors if necessary. The other would be for Jewish Americans to let the president know that

they wished him to use the leverage he has to require Israel to be serious about peace on terms almost all Palestinians and most other Arabs and Muslims everywhere could accept. In my analysis, which I know is shared by some leading Israeli and other Jewish critics of Zionism, it is, in fact, Jewish Americans who hold the master key to peace or not in the Middle East. Why? Because the bottomline reality in America is this... No president is ever going to confront the Zionist lobby unless and until he knows that a clear and evident majority of Jewish Americans wish him to do so, in order to best protect the best interests of all Americans.

A uniquely informed perspective on the significance of the influence of Jewish Americans was given by William Fulbright. In an address to Westminster College in Fulton, Missouri, on 2 November 1974, the (by then) ex-Senator and former chairman of the Senate Foreign Relations Committee, said this (emphasis added): *"Israel's supporters in the U.S., by underwriting intransigence, are encouraging Israel on a course which must lead toward her destruction—and just possibly ours, too."* [7]

The previous year Senator Fulbright had made himself Public Enemy Number One in Zionism's eyes by daring to say in public, during an appearance on CBS's *Face The Nation*, that Israel and its uncritical friends in America controlled the U.S. Senate and consequently controlled U.S. policy for the Middle East. Subsequently he said he saw little hope that Capitol Hill would effectively challenge the Israeli lobby. It was, he said, "suicide for politicians to oppose them."[8]

And that brings me to what it was, really, that motivated me to research and write this book. In fact I was motivated, I can even say driven, by both a concern and a fear.

My concern is that peace-making and catastrophe prevention will remain an impossibility unless and until there is, on the part of all involved and concerned, an open, honest acknowledgment of how and why the Arab-Israeli conflict was created and sustained. This requires all concerned to acknowledge the difference between Zionist mythology and historical fact. One aim of this book is to show the difference. Some will say history is academic. "What's done is done. We have to move on (with the peacemaking) from where we are today." That is an expression much favoured and over-used by disingenuous American and European politicians. It is because such an attitude has prevailed—one that ignores objective history—that still today there is not enough real understanding, in America especially, of why the Arab and Muslim masses are so angry and why, more to the point, the whole Arab and wider Muslim world is outraged, with their deep humiliation and despair waiting for its time to explode

My fear is that as things stand and are going, in the world not just the Middle East, there will be another great turning against Jews, triggered by overflowing resentment of Israel's arrogance of power and its conse-quences. (If Harkabi as quoted above had not raised this possibility, I would not have dared as a Gentile to go public with my own fear).

It is my hope that this book (all three volumes of it and perhaps a

fourth) will contribute in two ways to preventing that from happening. On one level I hope this book will enable non-Jewish readers to understand the profound difference between the Jews and Judaism on the one hand and Zionism and its zealots on the other.

On another level I hope this book will encourage the Jews of the world to debate, among themselves if they insist, why they, Jewish Americans especially, should respond at this late hour to Harkabi's call for them to exert themselves to convince Israel to change its thinking and its ways.

I am aware that much of this book could cause pain and possibly distress to very many Jews, so I want to take space in this Prologue to say that I do, in fact, work my way towards an uplifting conclusion, one that I hope will be a source of comfort, hope and inspiration for Jewish readers. In the Epilogue this *goy* dares to suggest that the Jews, because of their unique experience of suffering, are still uniquely placed to be a Light Unto Nations.

What I have tried to write above all is a book that is comprehensive enough—i.e. contains a sufficient amount of background information and global context—to enable non-expert readers, so-called "ordinary folk" especially, to make sense of what is happening in the Middle East and why, by seeing how all the pieces of the most complex jig-saw puzzle fit together.

Because real understanding is impossible without reference to some of the major events of the 20th century, the context includes: two World Wars; the revolution in Russia that ended a thousand years of monarchy and brought the Communists to power; and the superpower rivalry that followed, including the obscenity of the arms race (obscene because it gobbled up the money and other resources including brainpower that, in a more civilised and sane world, would have been committed to fighting and winning the only war that matters—the war against global poverty in all of its manifestations).

In my experience one way to keep focused on the main issues raised by the telling of a very dramatic, exciting but complicated story is to have in mind one key question, and to go on asking it as the events unfold. The key question in my mind as I researched and wrote this book was:

Did two events—Imperial Britain's decision in 1917 to give Zionism a spurious degree of legitimacy and the obscenity of the Nazi holocaust—make it inevitable that the story of Zionism's colonial enterprise would have only an apocalyptic ending?

Did two events—Imperial Britain's decision in 1917 to give Zionism a spurious degree of legitimacy and the obscenity of the Nazi holocaust— make it inevitable that the story of Zionism's colonial enterprise would have only an apocalyptic ending?

When I reviewed the final draft of my manuscript for this book, I took some comfort in the fact that I had performed in accordance with the first rule of journalism. It states that if the reporter offends both or all parties to a dispute or conflict, he (or she) is probably on the right track. I set out, not to give offence for the hell of it, but to participate in seeking the resolution of this dreadful conflict, for the well being of all

concerned. Nonetheless, this book will offend not only Zionists everywhere and their standard bearers in the mainstream media, but also many in the political Establishments of just about the whole world, the Western and so-called democratic world especially but also the Arab world. (It's impossible to tell the truth about Zionism without also telling the truth about the impotence of the Arab regimes). But I do believe this book should not give lasting offence to any who really want a just and sustainable peace because my real purpose, contrary to what sometimes might appear to be the case, is not to blame but to explain.

For Jewish readers especially I want to quote the most honest statement ever made to me by an Israeli.

He is the Israeli I most respect and admire. When I talked about him in the major capitals of the world to diplomats with the prime responsibility for crisis managing the Middle East, I said that if I was putting together a world government with 20 portfolios, he would have several of them, on account of his experience, his intellect, his wisdom and his humanity. In private conversations with me he did not display even a hint of the insufferable self-righteousness that is the hallmark of Zionism. He is without arrogance. For about two decades he was the head of research at the Directorate of Military Intelligence. Then, in 1973, he was called upon to become DMI, with a brief to make sure there could never again be an intelligence failure of the kind that had occurred in the countdown to the Yom Kippur war. He was, in short, the man to whom the government of Israel turned for salvation in the aftermath of what it perceived at the time, wrongly, to be a real threat to the Zionist state's existence. His name is Gazit. Shlomo Gazit. Major General (now retired) Shlomo Gazit. I met him while I was shuttling to and fro between Peres and Arafat. In our little conspiracy for peace, Shlomo was one of the chosen few advising Peres.

Over coffee one morning I took a deep breath and said to Shlomo: "I've come to the conclusion that it's all a myth. Israel's existence has never ever been in danger."

Through a sad smile he replied, "The trouble with us Israelis is that we've become the victims of our own propaganda."

Shlomo Gazit: "The trouble with us Israelis is that we've become the victims of our own propaganda."

If this book assists Jews everywhere to come to terms with that truth and its implications, I shall be—forgive the cliché—all the way over the moon. Because that would make real peace possible.

On reflection I decided that the cause of understanding might be well served if I reveal Golda's last private message to me. It was in the form of a confession. With poetic license I could call it a deathbed confession. And it has its place in Chapter One.

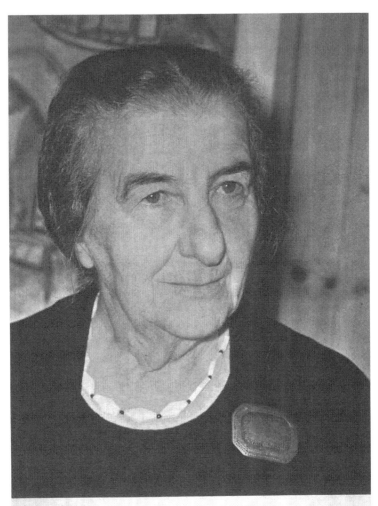

GOLDA MEIR גולדה מאיר

ראש הממשלה

*To a good friend
Alan Hart,
Golda Meir*

1

A VOICE FROM THE GRAVE

When Golda Meir died at 4.30 p.m. on Friday 8 December 1978, she was three years older than the 20th century. She had been one of the movers of the wheels of history for the best part of six decades.

Within minutes of hearing the news on the radio I booked a flight to Israel. On this occasion I went as a private citizen representing nobody but myself, with a simple wish to pay my last respects to a Jewish friend as she was lowered into her grave.

On arrival a telephone call to Lou Kaddar guaranteed that I would receive the necessary security clearance to attend the burial at the national cemetery on Jerusalem's Mount Herzl.

Lou was a warm, witty, wonderful Jewish lady of French origin. She had been Golda's assistant, most trusted confidant and best friend for more years than either of them cared to remember. When Golda was prime minister, Lou handled the men in her cabinets according to need. Sometimes as equals. Sometimes as children.

Golda was to be buried in a plot next to her predecessor as prime minister, the wise but much maligned Levi Eshkol. (As we shall see, Eshkol had not wanted to take his country to war in 1967, which was why he was maligned by those then called "hawks" in Israel).

The final farewell to Golda on Mount Herzl was going to be brief. Golda herself had seen to that. When she was very much alive she had deposited a sealed letter with the administrator of the Labour party, with the instruction that it should not be opened until she was dead. In the letter Golda said she wanted no eulogies at her graveside. When later she informed some of her senior Labour party colleagues of the contents of the sealed letter, she said, "When you're dead, people often say the opposite of what they mean about you." In life she could not bear the thought of somebody like Begin adding to his own prestige by basking at her graveside in the light of her achievements. When she died Begin's government considered her request and decided to respect her wishes.

It was, in fact, in my *Panorama* profile of her that Golda had put her nation on notice that she wanted no fuss when she died. Early in our

friendship Golda told me she had no intention, ever, of writing a book about her life, in part because she had never kept a diary. She had been too busy for that. I said there had to be a record of some sort in her own words because she had played a role in shaping the history of the world. My last question to Golda for my profile was about how she wanted to be remembered. She replied that she didn't want any streets or buildings named after her, and she didn't want any eulogies at her funeral. Then, after a pause, she said she had just one wish: "To live only as long as my mind is sound."[1]

Her fear was not of death but life as a cabbage.

In truth there was no need for eulogies. For Israelis of her own generation Golda's record of achievement spoke for itself.

The sobriquet "Mother Israel" was appropriate on account of her achievement in the months before the birth of Israel. Without what Golda achieved on a fund-raising mission to America, the Zionist state-in-the-making would not have acquired the weapons to give its leadership the confidence to declare their independence and trigger a war with the Arabs; and the Zionist enterprise might well have been doomed to failure.

On 29 November 1947, the consequence of Britain wanting to give up and get out of Palestine in the face of an escalating confrontation between its indigenous Arab inhabitants and incoming Zionist settlers, and a Zionist campaign of terror against the occupying British as well as the indigenous Arabs, the General Assembly of the United Nations voted to partition Palestine. There was to be one state for the Arabs and one for the Jews. The Arabs rejected partition but, as we shall see in Chapter Ten, the UN vote was rigged and the partition decision could not be implemented. So far as the UN was concerned as the body representing the will of the organised international community, the question of what to do about Palestine was still without an answer. But the British occupation of Palestine was going to end at midnight on 14th May 1948, whatever the situation at the UN and on the ground in the Holy Land. The mess the British had created would have to be cleared up by the UN (the successor of the ill-fated League of Nations), if it could be cleared up.

As soon as the British were gone, the Jewish Agency, the Zionist government-in-waiting, was intending to declare the coming into being of the Zionist state. The problem was that the Jewish Agency's official underground army—the Haganah ostensibly for defence and the Palmach for attack—lacked the equipment and the ammunition to fight and win the war its unilateral declaration of independence would provoke.

The Jewish Agency's treasurer, Eliezer Kaplan, made a presentation to the Agency's Executive Committee, the Cabinet-in-waiting. Kaplan estimated they needed a minimum of $25 million U.S. dollars to equip the Haganah and the Palmach for war with the Arabs. The most urgent need was for tanks and planes. The only place where serious money could be raised was America. But Kaplan had just returned from there. His news could hardly have been more gloomy. American Jews, he pointed out, had been "giving and giving since the beginning of the Hitler era". Because of

that and the fact that wartime prosperity had come to an end in America, there was not so much money around. As a consequence there were limits to what they could expect to raise from America's Jews. He estimated that perhaps $5 million, certainly not more than $7 million, could be raised in America. And that was not nearly enough to guarantee the survival of their state when they declared it.

David Ben-Gurion, the leader of the Jewish Agency and prime minister in-waiting, was an irascible character at the best of times. As Kaplan was sitting down, Ben-Gurion leapt to his feet. "I'll leave at once for the United States." Raising money was obviously the most immediate and most essential job. As leader he had to be the one to undertake the mission. Only he was likely to be successful. He did not say so but that was his view.

Golda at the time was the acting head of the Agency's Political Department. She spoke her mind. When she was recalling the moment, she told me that even she herself was surprised by the words that came out of her mouth. "Let me go instead," she heard herself saying. "Nobody can take your place here. What you can do here, I can't do. But what you can do in the States, I can do."

None too politely Ben-Gurion rejected Golda's suggestion. But she was not going to take "No" for an answer.

"Why don't we let the Executive vote on it?" Golda said.

With some reluctance Ben-Gurion agreed and the Executive voted for Golda to go.

"But at once," Ben-Gurion said. "You must go immediately."

She was driven to the airport in the spring frock she had put on for the Executive meeting and without a coat for the bitter winter that would greet her on arrival in New York. Her only luggage was in her handbag. It contained a ten-dollar bill and her comfort—her cigarettes. She smoked up to three packets a day.

Only when she was in the air did she allow herself to think about the consequences of failure. She was terrified by the thought that she might have bitten off more than she could chew. What if Kaplan was right in his assessment that America's Jews would come up with not more than $7 million or less?

Golda was no stranger to America. She was born Goldie Mabovitch, the daughter of a carpenter, in Kiev, in the Ukraine. In 1906, when she was eight, the Mabovitch family emigrated to America and took up residence in Milwaukee.

She received her very first lesson in American politics and how it really worked on a visit to the home of Joseph Kennedy. He was bouncing his first-born son on his knee. Suddenly he lifted the boy into the air like a trophy. Then, sure that he had the complete attention of his audience, he said, according to what Golda told me, "It might take 50 million dollars, but this boy, my boy, will one day be the President of these United States of America and live in the White House."[2] (As it happened Joe Kennedy's first son did not make it. He was killed in action in World War II. But the second

son, John Fitzgerald, did go all the way to the White House where he lived for a thousand days before his assassination).

The first great test of Golda's ability as a major fundraiser came in Chicago on 21 January 1948, at a meeting of the General Assembly of the Council of Jewish Federations and Welfare Funds. All the delegates were professional fundraisers. They controlled the Jewish fundraising machinery across America. Because of Golda's speed there had been no time to prepare the way for her. She learned about the meeting only after her arrival in America. Her first task was to persuade its organisers to let her address the gathering. Palestine was not on the agenda and most of the delegates had never heard of Golda Mabovitch. She was, so to speak, an unknown, cold calling. When she rose to speak she was aware that most of the elderly fundraisers in her audience were not supporters of the Zionist cause. Some of her friends in New York had advised her not to address this particular gathering because she might find herself in confrontation with those who opposed Zionism.

When she did address them it was, as she always preferred, without notes and briefly. "You must believe me", she said, "when I tell you that I have not come to the United States solely to prevent seven hundred thousand Jews from being wiped off the face of the earth. During these last years the Jewish people have lost six million of their kind, and it would be presumptuous indeed of us (the Zionists in Palestine) to remind the Jews of the world that seven hundred thousand Jews (in Palestine) are in danger. That is not the question. If, however, the seven hundred thousand Jews survive, then the Jews of the world will survive with them." [3]

The essence of political Zionism: a Jewish state in Palestine had to be created and assisted to survive because it would be the ultimate insurance policy for all Jews everywhere.

It was the very essence of political Zionism; the unstated but clear implication being that a Jewish state in Palestine had to be created and assisted to survive because it would be the ultimate insurance policy for all Jews everywhere.

Then, in her gritty, no-nonsense way she told them the Jewish community in Palestine needed between $25 and $30 million dollars within the next two or three weeks if it was to establish itself. "In a few months", she told her audience, "a Jewish state will exist. We shall fight for its birth. That is natural. We shall pay for it with our blood. That is normal. The best among us will fall, that is certain. But what is equally certain is that our morale will not waver no matter how numerous the invaders be." [4]

Perhaps in anticipation of a challenge from those who did not support political Zionism she said she was not asking America's Jews to decide whether or not the Jews of Palestine should fight. That was a decision only the Jews of Palestine could take and had already taken. Whatever happened on the battlefield, the Jews of Palestine would not be raising the white flag. There was, however, one thing the Jews of America could

decide—whether the Jews of Palestine won or lost the coming war. "That's the decision American Jews can make and it has to be made quickly, within hours, within days."

Powerful stuff but she was not quite finished. "And I beg you, don't be too late. Don't be sorry three months from now for what you failed to do today. The time is now."[5]

Complete silence. For a terrifying moment she thought she had failed.

And then the place erupted. They applauded. They wept. And they pledged money in greater amounts than ever before. Recalling her triumph Golda said to me, "Some delegates even took out bank loans to cover their pledges."[6] She said it as though she was still amazed and in a way that implied, "Not even I would have expected Jews to do that—but they did."[7]

In six weeks she raised more than $50 million dollars, an amount equivalent to three times the entire oil revenues of Saudi Arabia for 1947. When she returned to Palestine, Ben-Gurion found the right words in private to sum up her achievement. "Some day when history will be written, it will be said there was a Jewish woman who got the money which made the state possible."[8]

The amount of money Golda raised determined much more than the outcome of the first Arab–Israeli war. It enabled the Zionist State to become the military superpower of the region in a matter of months and to believe, as a consequence, that it could solve all of its problems with the Arabs, especially the Palestinians, by military means. Without a state of their own the Jews had a moral compass; but many of those who became Israelis threw their compass away. In that sense the amount of money Golda raised had a most corrupting effect.

Golda's achievement was more than remarkable because she was, actually, bluffing. When she told them the decision to fight the Arabs had already been taken, she was telling the truth. What she did not say was that decision would have to be reviewed if the money to allow Israel to fight and win a war was not forthcoming.

On the world stage prior to Eshkol's death Golda made her mark as Israel's first ambassador to the Soviet Union and then as her country's foreign minister. She had taken on that job in 1956 and retired from it a decade later at the age of 67. Everybody, especially Golda herself, assumed that the grandmother and old-age pensioner had come to the end of her working life.

If that had been the end of the story of her public life and service to her country, this Middle East correspondent would not have known her.

When Abba Eban succeeded Golda as foreign minister and she went into retirement, I was a 24 year-old reporter covering for ITN mainly wars and conflicts of all kinds wherever they were happening in the world. I had reported from Israel on the countdown to the Six Days War and I was the first foreign correspondent to reach the banks of the Suez Canal with the advancing Israelis.

Though I say so myself, my relationship on the human level with

Golda Meir after she became Israel's prime minister in 1969 at the age of 71 was very special, so special that it was a source of annoyance to some of her male ministers.

On one celebrated occasion when I was chatting with her alone in Jerusalem she kept her entire cabinet waiting for more than 25 minutes, kicking their heels in the outer office while she allowed our conversation to run on. Out of pure mischief Lou had refused to tell the ministers who was inside with their PM. When I said goodbye to Golda and entered her outer office, the ministers were standing around in small groups, talking. The talking stopped when I appeared and I could see irritation written on some of their faces. Then the whispering started. It was hushed by Lou.

"Alan", she called in her commanding voice, "they're talking about you... Do you want to know what they're saying?"[9] *Lou's impeccable English was delivered with only a hint of a French accent unless she was exasperated or very tired.*

"Why not," I said.

By this time Lou was standing by my side as though ready to protect me. "They are asking what is so special about this *goy*." She really stressed the word *g-o-y* as presumably they had. "They are puzzled about what their prime minister sees in you and why she gives you so much of her time." Then Lou rattled off a few sentences in Hebrew. She was obviously amused and no doubt thought she was being amusing. But only some of the ministers were smiling when she stopped.

She turned to face me with a really big sparkle in her eyes. "Do you want to know what I said to them?"

She was going to tell me, anyway.

"I told them Golda likes you because you're the only man who treats her as a woman. None of them do."

Thereafter I was known in cabinet circles as Golda's "boyfriend". Dayan gave me that nickname. It was his way of sending me up. I got on quite well with him but he was a very difficult man to know. Even Golda herself was later to describe him as "the most complicated man", with "faults like his virtues that were not small ones"; and "who doesn't work easily with people and is used to getting his own way".[10] I had the strong impression that Dayan was not enthusiastic about any *goy* having a special relationship with Israel's prime minister. Deep down, and because of the Nazi holocaust, there was a part of most Israelis of Golda's generation (and, probably, most Jews everywhere of the same generation) that would never be completely comfortable with any *goy*. And some Israeli leaders, Begin and Shamir to name two, were definitely *anti-goy*.

The key to my special relationship with Golda was the three dozen roses I sent to her with my calling card every time I arrived in Israel. The sending of the roses started as a gesture that was my response to a moment of revelation when Golda was chosen to be prime minister. The gesture became a tradition which I maintained until her death.

The moment of revelation came shortly after noon on Friday 7 March 1969. Prime Minister Eshkol was dead. The Central Committee of the

ruling Labour Party was meeting to choose his successor. When informal consultations indicated that the Central Committee was split beyond repair on the matter of which man should succeed Eshkol, Golda had allowed her name to go forward as a compromise candidate.

It was a foregone conclusion that when the Central Committee met to make the decision Golda would be chosen to succeed Eshkol. For that reason most foreign television news teams in Israel at the time decided to give the meeting of the Central Committee a miss. There was not going to be a political fight and, anyway, it was not a visual story. That being so there was no need for foreign television reporters and their film crews to sit through several hours of political babble in Hebrew. The news story for the world— GOLDA MEIR TO BE ISRAEL'S NEXT PRIME MINISTER—could be illustrated with library footage of her and, at most, film of her leaving the meeting after the debate and the vote.

My journalistic assessment was different. I believed the event about to take place in the Labour Party's headquarters would produce a great television news story—provided it was filmed in the right way.

About 440 members of the Central Committee were entitled to attend, debate and vote. Nearly a quarter of them did not bother to put in an appearance. I presumed the absentees were unchangeably opposed to Golda's nomination but did not want to make a public show of saying so.

Golda sat in the main body of the assembled delegates, some distance from the stage on which the platform party was conducting the business of the meeting. Dayan was sitting next to her. That was quite interesting because he had been in the camp of those opposed to her becoming prime minister. I presumed he was sitting next to her as a way of indicating that he would be loyal to her. I told my cameraman that when eventually the voting took place and the result was announced, I didn't want the camera focused on the stage and whoever was making the announcement. In that moment I wanted the camera zoomed in on a tight head-and-shoulders close-up of Golda. The rest was of no consequence.

I could not follow the debate because, apart from "Hello", "Goodbye" and "Fuck you Nasser", I didn't understand a word of Hebrew. So I spent nearly two hours studying faces. It was the first time I had seen Golda in the flesh. And the more I studied her, the more I became amazed at what was happening.

Here, on the one hand, was this young, virile, arrogant, aggressive state which, not two years ago, had set a new world record for the speed at which a major war could be fought and won. There, on the other hand, not ten paces from where I was standing in the aisle, was this old woman. As old as my own grandmother and, if the appearance matched the reality, as frail as my grandmother. Golda was truly the stuff of which real legends are made, even by Israeli standards; but she was old, surely too old to take on the burden of being the state's prime minister. It was not fair, I thought, for them to ask her to do so. Not fair? Why not? I was aware of two reasons.

In her personal life she had already sacrificed so much for her country. Her career had destroyed her marriage. Her husband had wanted

more of her time than she felt she could give him because of the strength of her commitment to political work. Her relations with her children had also been damaged by the same commitment. Now she had grandchildren. Let her, at least, enjoy them to the full.

I was also aware—most Israelis were not—that Golda was dying of cancer. She was putting up one hell of a fight against the "Big C" but she was still dying. It was reasonable to suppose that the extra burden of worry Golda would be taking on as prime minister would reduce the time she had left.

It wasn't fair.

The votes when the result of the ballot was declared from the stage were 287 for Golda with 45 abstentions.

Our ITN camera was running in tight close-up as I had instructed and it faithfully recorded, with the microphone taking in the applause, what I was seeing for myself. As her victory was announced Golda closed her eyes and, with sagging shoulders, buried her face in her hands. Not too much imagination was required to believe that she was listening to a voice inside her that was saying, "No. It can't be. I can't do it. I don't want it."

Reporters often make reference to the weight of the burden of responsibility on the shoulders of prime ministers and executive presidents.

For the first time in my life I had seen that weight descending and, more to the point, how crushing it could be. It was the transfer to Golda of that weight that had caused her shoulders to buckle. I was moved close to tears and I felt sorry for her.

On my way into the Dan Hotel I asked Albert, the duty concierge, to order three dozen roses. "Something special", I whispered, "for Golda."

When I had typed and recorded my commentary for the film report, I wrote by hand a short note to Golda to go with the flowers.

Naturally I offered my congratulations, but my main purpose was to tell her of the thoughts I had entertained as I watched the burden of responsibility settling on her shoulders; and how moved the *goy* had been.

I was not confident (for security reasons) that my roses would get as far as Golda. But early in the evening I was called from the bar to the telephone at the reception desk. The gravel voice at the other end of the line said, "I want to thank you for the roses and the thoughts that came with them."[11] (Subsequently, Golda told me that she had ordered her security people to treat my roses with respect. She meant and said that she preferred to receive them in good condition, not with their petals stripped by hands looking for explosive materials or a bugging device).

In the years that Golda was Prime Minister and I remained a cog in the wheel of institutional journalism, there was only one occasion when my special relationship failed to secure me the first foreign interview with her at a moment of high drama.

At two o'clock in the afternoon of Saturday 6 October 1973, the Day of Atonement, Yom Kippur (the holiest day in the Jewish calendar, a day of prayer and fasting), Egyptian and Syrian forces launched a surprise attack

on Israeli forces in occupation of Arab land Israel had captured in the 1967 war. With three main exceptions—Egypt's President Sadat and his "good friend" Henry Kissinger, and Syria's President Assad—just about the whole world believed that Israel really was fighting for its survival.

The BBC had permanent news teams in Israel and reinforcements were sent within minutes of the first confirmed report of the Arab attack. I arrived on the second day of the fighting and my prime task was to secure the first foreign interview, world exclusive, with Golda. I discovered that she and her senior ministers were in an open-ended crisis session in the kitchen of her very modest Tel Aviv home. The kitchen was the only room in the house big enough to accommodate them all.

I did my usual thing—ordered three dozen roses and had them sent to Golda at home. In the circumstances as they were it was, I knew, a puny and pathetic gesture. I felt almost foolish. But I was determined that tradition would be maintained. Two hours later, and much to my surprise, Lou telephoned. Only her brevity indicated there was a crisis. "Alan, Golda thanks you for the roses as ever. She may or may not be able to talk with you this evening. Bye."

I put my *Panorama* camera crew on alert.

While I waited for the call that might or might not come, I learned that Israel was in urgent need of supplies from America—tanks, anti-tank missiles and fighter planes especially. President Nixon had already been asked to provide an emergency airlift to Israel.

At about half past ten in the evening Golda telephoned me. "Alan, this is the one time I can't give you the first interview. I've got to give the first one to the Americans. I need to apply some pressure." She paused, uncertain, I thought, about whether she should tell me more. Then she confirmed what I had heard about Israel's request to America for an emergency airlift of supplies.

"I understand," I said. "My roses against American tanks and planes—it's no contest."

She chuckled. Then she said, "As a matter of fact I need to go to Washington to talk with Nixon face-to-face. I've asked Simcha to get me an appointment. I told him I am prepared to make the trip for just one hour with the President." (Simcha Dinitz was Israel's Ambassador in Washington. He was a man I knew well and liked. He had previously been Golda's press secretary).

"Is Nixon giving you a hard time?" I heard myself asking.

Golda smiled aloud. "Nixon's not the problem. Nixon I can handle." Pause. When she spoke again there was no doubting the contempt in her voice. "The problem is Kissinger. He's sitting at Nixon's elbow telling the President to make us sweat."

Some years later Kissinger wrote that when he received Golda's request from Dinitz, he rejected it "out of hand and without checking with Nixon."

An intriguing question readers might like to keep in the back of their minds is this: *In the face of the surprise attack by Egyptian and Syrian*

forces, and when almost the whole world believed that Israel was fighting for its survival, why was Kissinger advising Nixon that he should not be in a hurry to supply the tanks and planes Israel was requesting, and that the President should, as Golda had put it, make the Israelis "sweat"?

My empathy with Golda on the human level did not turn me into a sycophant to protect the relationship. There was never an occasion on camera when I pulled my punches and refrained from asking her leading and challenging questions. And in private the nature of our relationship enabled me to say whatever I wanted. There was only one private occasion when I thought my frankness might bring our relationship to an end.

In the course of one of the long interviews for the *Panorama* profile I stopped the camera to allow us to have a cigarette. We both smoked 60 a day. Like Golda I had no time for small talk. As we puffed away I turned her attention to the subject of Israel's continuing occupation of the West Bank. I said, "You know, Mrs. Meir, if Israel remains in occupation, there will come a day when many journalists, including me, will write and speak about the tramp of Jewish jackboots on Arab soil."

For Jews there are only Nazi jackboots.

Golda froze with a hand on her heart as though to stem the blood where I had stabbed her. She seemed to be far away in the distant, unspeakable past. Eventually she held my eyes with her own. She was shocked and bewildered. Then, in a small, quiet voice not much above a whisper, she said, "You, Alan... Even you can say such a thing."

I said, "Yes, prime minister. And I mean it."

That exchange did put a chill into the atmosphere between us for the remainder of the time I spent with her that day, but it did not do lasting damage to the strength of our friendship on the human level. The next time we met the customary warmth was much in evidence. (It was, in fact, some time after that exchange that she inscribed the photograph "To a good friend, Alan Hart.")

When I withdrew from institutional television to try to do something useful with my life, I asked Lou to make me a promise. To call me when Golda's end was near. When I got the call, no matter where I was or whatever I was doing, I would go to Israel for a last conversation with Golda before the cancer claimed her.

It was to be nearly five years before Lou had need to deliver on her promise to me. The call came on a glorious summer morning when I was hammering my typewriter at home. I was so far away in my mind that it took me some time to realise the telephone was ringing. The fact that it was Lou could mean only one thing. She went straight to the point. "I'm sorry to tell you Golda's end is near. She might have only two or three weeks left. If you want to come, come now."

The wonderful thing about friendship, I mean the ability of one human individual to empathise with another, is that it's not diminished by distance and time. You can go years without seeing or even talking to a good friend and, when eventually you reconnect, you pick up from where you left off as though it was yesterday. That's the way my last meeting with Golda

was. (I took a friend with me. I had told him that if Golda did not object he could sit in on our conversation. The friend was my Jewish accountant. It was my way of thanking him for his many years of friendship and service. I also thought it would be good to have a witness. Golda did not object and when the conversation was over, she allowed me to take a photograph of the two of them, my friend's arm around her shoulder. It was, he said, "the proudest moment of my life." And today that photograph has pride of place in his London home).

I had not in fact talked with Golda since our telephone conversation on the second evening of the Yom Kippur war, when she told me she was seeking a face-to-face meeting with President Nixon.

I knew the Golda Meir I would meet for the last time was an old lady in torment for a reason that had nothing to do with her cancer and the nearness of death. In *My Life* she had said, "I will never again be the person I was before the Yom Kippur war"[12] (Given that Golda had had no intention of writing a book, how did *My Life* come to be written? The morning after the BBC transmitted my *Panorama* profile of her, publisher George Weidenfeld boarded a plane at London's Heathrow bound for Tel Aviv. Golda told me, "He arrived with a contract for my life story in one hand and a cheque in the other." Initially Golda told George that she didn't want to write a book, partly because she had not kept a diary and partly because she did not have the time. Eventually George prevailed upon her to work with a ghost writer he would provide. It was not an experience Golda enjoyed).

Despite the fact that Israel achieved a stunning and comprehensive military victory, and that its forces could have gone on to capture Cairo and Damascus, the main consequence of that war for Israel, the loss of 2,500 Israeli lives, was the cause of Golda's torment and the main reason for her surprise resignation as prime minister on 11 April 1974.

For non-Jewish readers who may not appreciate the impact on the Israeli psyche of the loss of 2,500 lives, the following might be helpful. In proportional terms of losses to population, Israel's losses in a few weeks were equivalent to three or more times America's losses in the Vietnam War over seven years.

Mother Israel believed that if she had listened to the warnings of her own heart, and followed her own gut instincts, many of those Israeli lives would not have been lost. She believed, in short, that she had failed her nation.

Was she right to blame herself for the scale of Israel's losses?

I think not. If there was someone in Israel's political, military and intelligence establishments who was not at all to blame or was least to blame, that someone was Golda. But I could understand why she blamed herself.

On Friday 5 October, the day before Egyptian and Syrian forces launched their surprise attack, Golda was right and all the men in her Cabinet, and the brilliant generals in the highest levels of Israel's military and intelligence establishments, were wrong.

Of all the information that poured into the prime minister's office

on that Friday there was one little fragment that meant more to Golda than all the other pieces put together. Soviet military advisers in Syria were packing and leaving with their families in a hurry. "Why the haste?" Golda asked herself. "What do those Russian families know that we don't know?"

All of Mother Israel's instincts, her intuition, told her it could mean only one thing. Syria was about to attack. And Golda knew, as all first-year students of the Arab–Israeli conflict ought to have known, that Syria's President Assad would not dream of attacking alone. If Syria was about to attack, Egypt was about to attack.

As a precaution, and even though she was well aware of the economic cost, and even though it was the eve of Yom Kippur, Golda wanted to order a full-scale mobilisation and call up the reserves. But all the men in her cabinet, including Defence Minister Dayan, and the best and brightest minds in the country's military and intelligence establishments, told her not to worry. They were on top of the situation, they said, and they would get sufficient warning of any Arab attack. What they meant and had no need to say was that in the most unlikely event of failure by their own intelligence people and systems, they would still get adequate warning of an Arab attack from the Americans—from their even more superior intelligence gathering apparatus. At the time nobody in Israel, absolutely nobody, had considered the possibility that somebody in America might be wanting an arrogant, expansionist and uncompromising Israel to be taught a little lesson by Sadat.

When the war was over Golda believed, and surely she was right to believe, that if she had ordered a full-scale mobilisation, some and perhaps many of the 2,500 would not have had to sacrifice their lives. It is also conceivable that such a precautionary move by Israel would have caused Egypt's President Sadat to change his mind about attacking. (Kissinger would have been disappointed but that is a story for later).

In *My Life* Golda said: "That Friday morning I should have listened to the warnings of my own heart and ordered a call-up. For me that fact cannot and never will be erased, and there can be no consolation in anything that anyone else has to say or in all the commonsense rationalisations with which my colleagues have tried to comfort me. It doesn't matter what logic dictated. It matters only that I, who was so accustomed to making decisions, and who did make them throughout the war, failed to make that one decision. It isn't a question of feeling guilty. I, too, can rationalise and tell myself that in the face of such total certainty on the part of our military intelligence, and the almost equally total acceptance of its evaluations on the part of our foremost military men, it would have been unreasonable of me to have insisted on a call-up. But I know that I should have done so, and I shall live with that terrible knowledge for the rest of my life."[13]

To the nation in her resignation statement Golda said: "I have come to the end of the road. It is beyond my strength to continue carrying the burden." To her cabinet colleagues she said: "This time my decision is final. I beg you not to try to persuade me to change my mind for any reason at all. It will not help."

In *My Life* Golda also said: "What those days (of the Yom Kippur war)

were like for me I shall not even try to describe." When I talked with her for the last time she gave me, without any prompting, a very vivid description of what those days were like. For her.

At the start of our conversation, which lasted nearly five hours, she described what was undoubtedly her worst moment of the war and probably her whole life. On Sunday 7 October, the second day but the first morning of the war—when Egyptian forces in strength were overwhelming Israel's lightly defended positions along the East bank of the Suez Canal—Dayan, in Golda's kitchen, made a pragmatic proposal. To save the lives of those frontline Israeli soldiers who were still holding out but who undoubtedly would be killed within hours if not minutes, Israel should "surrender" those positions and withdraw some 25 kilometres or so to establish a new first line of defence.

To me Golda said: "I told Moshe there was no such word as surrender in Hebrew; but I knew he was right. I got up from the kitchen table and went into that little room there (she pointed to the toilet). And I vomited."[14]

The highlight for me of Golda's account of the fighting was the moment she stopped the countdown to World War III and a possible nuclear holocaust; but that story has its rightful place in the pages to come.

It was Golda who introduced the subject of Secretary of State Kissinger, the most famous and the most powerful Jewish American of the time. She told me that when he arrived and they were alone together, he said this, very quietly: "Mrs. Meir, do you mind if I give you some advice..." Long pause. "Now that this airlift is underway, you must use it as the opportunity to take everything possible from Nixon—every tank, every plane, every bomb because the day may come when he will not any more be willing to supply in the manner to which you have become accustomed. The pressures from the Arabs are such that he can longer resist them."[15]

Golda did not tell me what she said to Kissinger in reply. To me she said, "If he expected me to be surprised by his news, he must have been disappointed. Of course I was not surprised by what he said."[16]

And she knew that I understood why she was not surprised.

In private conversations over the years Golda and Moshe Dayan were only two of a number of Israel's leaders who told me they had taken it as read, from the moment of the birth of their state, that there could come a time when it would be required by America and the West as a whole to become the sacrificial lamb on the altar of political expediency. In private, Dayan was the most pessimistic of them all. Not too long after the 1967 war he told me he was convinced that a day would come when the West concluded that Israel was dispensable. And that, he said, was the real reason why Israel had to be and remain the military superpower of the region.

Whenever an American President was confronted by the need to make a critical decision about what to do in the Middle East, he asked himself only one question: "Who am I most afraid of?"

The truth as I came to know it from my own American sources could

be boiled down to this: Whenever an American President was confronted by the need to make a critical decision about what to do in the Middle East, he asked himself only one question: "Who am I most afraid of?" The longer form of the same question was: "Who is the biggest threat to the interests of my party and my own re-election prospects—Israel and its powerful lobby in these United States or the Arabs?"

When Kissinger said what he said to Golda, he was speaking against the background of not only the Yom Kippur war which was raging, but the first great oil price rise explosion that came with it. In effect Kissinger was telling Golda that perhaps the time was approaching when an American president would conclude that he should be more frightened of the consequences of offending the oil-exporting Arabs than he was of the consequences of provoking the wrath of Israel and the Zionist lobby in America.

I asked Golda how much she had trusted Kissinger. She was well aware that I was not a member of his fan club. She gave me two answers.

The first was mainly in the form of a gesture. She raised her non-smoking hand high and formed the shape of a right angle, almost, by making the gap between her thumb and index finger as wide as it could possibly be. Then, slowly, very slowly, she closed the gap until finger and thumb were just about touching. "That much," she said.

The second answer was in the form of a short story. When Kissinger visited Israel it was his practice to slap Israeli cabinet ministers on the back and call them by their first names. They responded, as he obviously intended them to respond, by calling him Henry. "But not me," Golda said. "I always called him Mr. Secretary of State or Dr. Kissinger. And I insisted that he called me either Mrs. Meir or Madame Prime Minister." Pause. "If you're on first name terms with such a man he will screw you." That was wisdom of a kind most Arab leaders lacked. Especially Sadat. And he got screwed. Perhaps such wisdom is only a mother's thing.

Though Begin was leading for Israel when it happened, Golda was among Israel's VIPs who lined up to welcome President Sadat and shake his hand when he made his historic visit to Israel on 20 November 1977. When Golda and I talked for the last time, Israel's separate peace with Egypt was a *fait accompli*. I asked her what, really, she thought about it.

She replied: "It would not have happened if I had been prime minister. I would not have exchanged even a few grains of Sinai sand for a separate peace with Egypt."

If Golda had said that in public at the time of the separate peacemaking, she would have been dismissed by many in the West—politicians, leader writers and other commentators—as a stubborn old war horse and yesterday's woman. Some might even have said she had lost her marbles. But events were to prove that Golda was right. Again. The main effect of the separate peace with Egypt was to give Begin's Israel unlimited freedom to impose its will on the Arabs by force and, by so doing, jeopardise the prospects for a comprehensive peace, a peace most Arabs, by 1973,

wanted on terms which any rational Israeli government and people would have accepted with relief.

As I watched Begin and his ministers leaving the cemetery, I felt the gentle touch of a hand on my arm. It was Lou. "Do you want to come back to the apartment for a drink?"

I asked who else would be there.

"Nobody else," Lou replied. "Just the two of us. There is something I must tell you."

We drove the short distance in sombre silence but once inside the apartment Lou's mood changed, so much so that I was surprised by her apparent cheerfulness. "It's not a time to be sad," she said. "Golda had a great life and, to tell you the complete truth, it was a much longer life than she expected to have."

I gave Lou a "tell me more" look.

"It's no longer a secret that she was diagnosed with cancer 17 years ago," Lou added. (Israel's newspapers had revealed that fact with the announcement of Golda's death). "But still a secret is that when she was diagnosed all those years ago, she was given only three months to live."

We agreed that Golda's survival for so long was a tribute to her iron will and evidence that a strong mind can sometimes keep even cancer at bay.

Eventually I said to Lou, "What is it that you must tell me?"

She took time to collect her thoughts.

Eventually she said: "Do you remember the TV interview in which Golda told you there was no such thing as a Palestinian and that the Palestinians did not exist?"

"My dear Lou," I replied, "not only do I remember, the whole world remembers and will never forget!"

I was not the only reporter to whom Golda made such a statement, but because what she said to me was on camera, from her own lips, it had had a far wider and greater impact than quotations attributed to her in newspapers.

Golda was not alone in her view that the Palestinians did not exist. Her statement represented Zionism's official line on the matter; a line that was accepted and repeated parrot-like by Israel's unquestioning supporters everywhere.

What she had actually said on camera was: "There is no such thing as a Palestinian. It was not as though there was a Palestinian people and we came and threw them out and took their country away from them. They did not exist."[17]

Lou continued. "Golda told me to give you a message, but she made me promise I would not deliver it until she was dead." Pause. *"She told me to tell you that as soon as those words left her mouth, she knew they were the silliest damn thing she ever said!"* [18]

The significance of that message from the grave was almost impossible to exaggerate.

On a personal level I took it to mean that Golda wanted me to know

that she was not actually as deluded as I might have imagined her to be on account of her denial, while she lived, of the existence of the Palestinians as a people with rights and an irrefutable claim for justice.

Put another way, she was acknowledging the difference between, on the one hand, Israel's propaganda—the myth Zionism had created to fool the world and comfort itself—and on the other hand, what she knew to be true. In effect and posthumously Mother Israel was admitting that the creation of the Zionist state had required the doing of an injustice to the Palestinians, and that Israel was living a lie.

The problem for Golda's generation with the truth—the actual existence of the Palestinians—was that it raised fundamental questions about the legality and morality of the Zionist enterprise (her life's work) and the legitimacy of Israel's existence.

On reflection, and because of her last message to me, I am inclined to the view that Mother Israel went to her grave troubled by the injustice done to the Palestinians in the name of Zionism. She would not have been able to escape the logic of reality and the question it begged. *If the Palestinians did not exist—no problem. But if really they did exist— "What have we done?"*

The Golda Meir I knew would have asked herself that question when it was obvious—as it was before her death—that the regeneration of Palestinian nationalism was as much a *fait accompli* as the existence of her state.

As it happened the truth was too uncomfortable for Mother Israel to confront while she lived. That was to be a task for her children. The implication of her last message to me was that she wanted them to confront it, by asking themselves what they must do to right the wrong done in Zionism's name to the Palestinians. (Some of my secular, anti-Zionist Jewish friends have said that I have been much too kind to Golda. She was, they insisted, "an unchangeable gut-Zionist zealot." They could be right and I could be wrong; but I think I knew Golda more intimately than they did and I'll stick with my own interpretation).

2

BRITAIN PLAYS THE ZIONIST CARD— EVENTUALLY

In the minds of Zionism's founders a Jewish state in Palestine was to be the answer to the age-old curse of anti-Semitism, which, at the time of Zionism's birth in 1897, was mainly a phenomenon of European cultures. For many centuries previously Eastern Europe and mainly the Russian Empire of the Tsars had been the heartland of world Jewry. For most Jews in this heartland life was one of abject poverty and they were required to live in ghettos—designated and restricted areas where they could be watched and controlled. And more easily persecuted. But the ghetto was not just a physical thing. It was a mental thing. A Jewish mindset. A coping mechanism.

According to Zionism, it was only in a state of their own that Jews could be guaranteed security and freedom from persecution. In effect Zionism said: "Jews cannot afford, ever, to trust the Gentiles. Without a state of our own, we Jews are doomed to extinction." Zionism was therefore about separating Jews and Gentiles and, in essence, it was a *philosophy of doom*.

> In effect Zionism said: "Jews cannot afford, ever, to trust the Gentiles." In essence it was a philosophy of doom.

Before Zionism there was a Jewish *philosophy of hope*. It had been given concrete expression by the coming into being of the Haskala (Enlightenment) movement of the 18th century. The Haskala solution to the problem of anti-Semitism—the persecution of the Jews in their Eastern European heartland, was emigration and assimilation (the opposite of separation) in Western secular culture. This, the Haskala movement reasoned, was most likely to be the best form of protection for Jews. The giant of anti-Semitism would never die, but in the West it might well be encouraged to remain asleep if Jews contributed to Western societies and demonstrated their loyalty to the states of which they became citizens. In other words, if Jews made the effort, they would in time be accepted and permitted to lead fulfilling and secure lives in the Western nations of which they became citizens.

The nature of the challenge for Jews who took the Haskala route

to salvation was clear. They had to cast off their ghetto mentality and all the practices, habits and attitudes which went with it. To become acceptable as Jewish Englishmen, Jewish Frenchmen, Jewish Americans and so on, they had to make themselves—apart from their religion which was a private matter—indistinguishable to the limits of the possible from all other Englishmen, Frenchmen, Americans and so on. If they did not, they would stand out as being less than normal Englishmen, Frenchmen, Americans and so on. In that event stereotyping could well lead to anti-Semitism being given new life in the West, especially when the governments or peoples of the host nations needed somebody to blame.

Simply stated, the Haskala route to salvation required migrating Jews to invest hope in the belief that they would not be persecuted in the West if they demonstrated willingness and an ability to assimilate: if, in other words, they proved that they had escaped from both the physical ghetto and the ghetto of the mind. For people whose entire history had been one of persecution that was never going to be easy. Those seeking a new life in England, for example, did not need reminding that Jews in England had been slaughtered and that, after the killing, the surviving Jews had been expelled from the country in their entirety—by Edward I in 1290.

The proof that most Jews did and do still prefer the vision of hope is in the simple fact that today, and despite the Nazi Holocaust that gave Zionism the appearance of being right, the majority of the world's Jews do not live, by choice, in the Zionist state of Israel. (If it continues to be unwilling to make peace on terms the Palestinians can accept, my prediction is that a significant number of rational Israeli Jews—they form about half the

The majority of the world's Jews do not live—by choice—in the Zionist state of Israel.

present Jewish population of Greater Israel—will take their leave of the state. And what a final irony in the story of Zionism that would be. Exodus II, but out of Israel. As I write to slightly revise and update this book for its American edition, there is evidence that the number of Israeli Jews who are abandoning the Zionist state is becoming more than a trickle, with some of the best and the brightest being the most eager to seek a new life in America, Canada and Europe).

Almost all of the Jews who took the Haskala route to salvation and settled in Western Europe and North America, including some who became prominent in public life, were not merely without enthusiasm for Zionism, they became strongly anti-Zionist. As we shall see, Zionism would not have secured enough Jewish support to succeed with its Palestine project but for the Nazi Holocaust.

The founding father of Zionism was Theodore Herzl, a Hungarian-born Jew who worked as a journalist and playwright in Vienna, the capital of the Austro-Hungarian Empire. He convened the first Congress of the World Zionist Organisation (WZO) at Basel in Switzerland in 1897. When it ended the public statement of Zionism's mission was declared to be the striving "to create for the Jewish people a home in Palestine secured by

public law." But what Herzl wrote in his diary on 3 September, the day of the publication of Zionism's official mission statement, was a much more explicit expression of purpose. In part the diary entry for that day read: "Were I to sum up the Basel Congress in a word—which I shall guard against pronouncing publicly—it would be this: At Basle I founded the Jewish state."[1]

The entry for 3 September continued: "Perhaps in five years, and certainly in 50, everyone will know it ... At Basel, then, I created this abstraction which, as such, is invisible to the vast majority of people."[2]

Because of the implications of the Zionist enterprise for all concerned—including world Jewry and Judaism itself—it was appropriate that Zionism's first World Congress took place in a gambling casino.

In the year before the first Zionist Congress Herzl had written and published *Der Judenstaat, (The Jewish State)*. It had opened with these words: "The Jews who will it shall have a state of their own." But with the coming into being of political Zionism as a movement with institutions to make it happen, Herzl was among the first to appreciate the need for dropping the word state from all public policy statements and, in effect, telling a tactical lie about real intentions.

Herzl's diaries were not made public until 1960 when they were published in book form, *Completed Diaries*. As we shall see in Chapter Six, there were entries in them which prove he was aware from the beginning that the Arabs of Palestine would have to be dispossessed of their land and their rights if Zionism was to prevail.

The Zionist claim to Palestine, a claim made long before Hitler's arrival on the world stage and the Nazi holocaust, was based on the "historical connection" of the Jews to that land. The first formal presentation of the claim was made in a WZO memorandum to the Paris Peace Conference at the end of World War I. It called upon the victorious Allied Powers "to recognise the historic title of the Jewish people to Palestine and the right of the Jews to reconstitute in Palestine their National Home." What, actually, was the "historical connection" which, according to Zionism, gave the Jews of the world "historic title" to Palestine? It is possible to answer that question with one sentence. The first Jewish occupation of Palestine was only an episode, a relatively short one at that, in the long history of an Arab land that was constantly occupied by foreign powers, of which the ancient Hebrews were only one of many.

But though it is an accurate and honest summary, the one sentence is not enough to do justice to either the intensity of the spiritual attachment of Jews to Palestine or the flame of anger that burns in every Arab heart. *This flame is there and burning ever more brightly because of Zionism's use and abuse of the spiritual attachment of the Jews to Palestine to achieve its political objective by terrorism and institutional military means.*

In the Western world the Arab–Israeli conflict is perceived as a struggle between two peoples with an equal claim to the same land. As we shall now see, the notion of there being two equal claims to the same land does not bear serious examination.

The earliest known inhabitants of Palestine were the Canaanites. They gave the country its first name—"the land of Canaan" as in the Bible. The Canaanites were the inhabitants of the land in 3000 BC, some 1,800 years before the first Hebrew occupation. The Canaanites had an advanced civilisation for their time and lived in cities. They founded Jerusalem which was to become the capital of Palestine. Although they were of one race with a common civilisation and the same language, Arabic, the Canaanites did not possess a unified political structure. Canaan was divided into city states which were ruled by princes or kings.

The notion of there being two equal claims to the same land does not bear serious examination.

In about 1730 BC Hebrew tribes from Chaldea (modern Southern Iraq) migrated to Canaan but they did not establish themselves. They passed through Canaan and ended up in Egypt where they lived under the rule of the Pharaohs for several centuries.

In about 1200 BC there were two penetrations of Canaan, one by the Hebrews, the other by the Philistines. The Hebrew penetration took place over about 200 years and did not lead to the displacement of the original inhabitants. The Hebrews (the Israelites to be) settled in mainly unoccupied regions. Throughout this lengthy settling in period they did not have a kingdom or a central government. They lived as tribes, 12, and were ruled by Judges.

Initially the Philistines occupied the southern coast of Canaan and the maritime plain to a point north of Japho (Jaffa). They were known as the "People of the Sea". It is believed they came from Illyria, having passed through Crete on their way to Canaan. (Illyria was the northwestern part of the Balkan Peninsula, which, from about the 10th century BC, was inhabited by an Indo-European people). The Philistines gave the land of Canaan its new name, "Philistia", from which Palestine was derived. The ambition of the Philistines was to conquer all of Palestine and they were constantly at war with the Hebrews.

By about 1020 BC the Hebrews realised that if they continued to operate on a tribal basis, they would not be able to withstand the mounting attacks of the Philistines. If they were not to be defeated the Hebrews needed to be co-ordinated. Out of that realisation came the appointment of Saul as the first King of Israel. In reality Saul was a king more in title than substance. His capital at Globeah was a simple, rustic fortress. (There was not a "dom" to put on the end of king). Saul's main responsibility was to co-ordinate the military actions of the Israelite tribes.

Saul was a tragic hero. He was mentally unstable if not actually mad and, at a point, he openly declared his intention to slay David, the young harp player who would succeed him and establish the first real Jewish kingdom in Palestine. Under Saul's leadership the Israelites were never strong enough to deliver a knockout blow to the Philistines, but they did prevent the Philistines from dominating all of Palestine.

David became king in about 1000 BC when Saul was killed in battle with the Philistines at Mount Gilboa. David did much more than co-ordinate the military actions of the Israelite tribes. He united them under his rule. His first capital was at Hebron, to the south of Jerusalem. In probably 1006 BC he captured Jerusalem from the Jebusites, a Canaanite subgroup. David ruled from there until his death in 972 BC. His son, Solomon, ruled for forty years and built the Jewish Temple.

After Solomon's death in 932 BC the Israelite tribes revolted and the kingdom established by David, which never encompassed all of Palestine, split into the Kingdom of Israel in the north and the Kingdom of Judah in the south. The two Jewish kingdoms were continually at odds with each other and at war with their neighbours. Disaster was beckoning.

In 721 BC the Kingdom of Israel was destroyed by the Assyrians and its people were carried into oblivion. The Kingdom of Israel was extinct and on the territory where it had been there were four Assyrian provinces.

The Kingdom of Judah survived for a while but it was a precarious existence. Its capital, Jerusalem, was frequently besieged, captured and sacked. For long periods Judah paid tribute to Assyria, Egypt and Babylon. It became a vassal state. In 705 BC, when it failed to pay the tribute, the Assyrians occupied Judah. They gave most of its territory to the Philistines, leaving the king of Judah only his capital, Jerusalem. In 587 BC the Babylonians destroyed Jerusalem, including the Jewish Temple, and carried the Jews into captivity.

A vivid impression of what that meant was given by Georges Friedmann in *The End of the Jewish People*. The twelve tribes were deported to Babylonia, mainly, and also to the Caucasus and Armenia "and disappeared; and with them the Jewish people in the plenitude of their existence as a simultaneously ethnic, national and religious community also disappeared forever."[3]

The events of 587 BC marked the end of institutional Jewish rule in Palestine until Israel's second coming in 1948, more than twenty-five centuries later. But it was not the end of a Jewish presence in Palestine. In 538 BC the Babylonians lost Palestine to the Persians and they allowed Jews to return.

Two centuries later, in 332 BC, Alexander the Great took Palestine from the Persians. The Greeks had the country for a century and a half but, before their time was up, they were confronted by a Jewish revolt led by the Maccabees. They were a priestly family of Jews who took the lead in challenging laws that made the practice of Judaism impossible. After the Selucid (Greek puppet) ruler desecrated the Temple and rededicated it to Zeus, the Jews resorted to guerrilla warfare, led first by Mattathias Maccabee and then by his son, Judas. In 164 BC Judas liberated Jerusalem and had the Temple reconsecrated; an event which Jews celebrate in the festival of Hanukka.

But Maccabean independence in Jerusalem and some other parts of Palestine did not last long. In 124 BC Jerusalem was besieged by Antiochus Sidetes, the King of Syria. The siege was raised only after the payment of a tribute.

Then, in 63 BC, the Romans captured Palestine and it became, as Judea, a province of the Roman Empire. The Romans put an end to the rule of the Maccabees.

It was during the Roman occupation that the carpenter's son who became the Christ of Christianty was born. From that time, Bethlehem where Mary was said to have delivered him, Nazareth and Galilee where he lived, and Jerusalem where he was crucified, became Christianity's holiest places, and Palestine became the Holy Land of Christendom.

The Jews revolted against the Romans in AD 66 to 70 and again in AD 132 to 135. During the first revolt Titus destroyed Jerusalem including the Temple. In the second (Bar Kochba) revolt most Jews still in Palestine were killed or dispersed to the far corners of the Roman Empire. In 135 AD Hadrian built a new city of Jerusalem, which he named Aelia Capitolina, and none of the very few Jews who remained in Palestine were allowed to live in it.

From the above it can be seen that the life span of the one united Jewish nation of David and Solomon was not more than seventy years; and, as Dr. Julian Morgenstern pointed out in *As a Mighty Stream*, there were only two brief simultaneous periods of life in each of the two separate Jewish kingdoms, neither lasting more than fifty years, when there was any indication of Jewish national strength and glory.

The life span of the one united Jewish nation of David and Solomon was not more than seventy years.

There are two particular statements which put Zionism's claim to Palestine into its true historical context.

One was in the text of the report of the King-Crane Commission appointed in 1919 by President Wilson to consult the Arabs of Palestine. "The initial claim, often submitted by Zionist representatives, that they have a right to Palestine based on an occupation of two thousand years ago, can hardly be seriously considered."[4]

The other was made by Lord Sydenham in the House of Lords during a debate on Palestine in 1922. He said: "Palestine is not the original home of the Jews. It was acquired by them after conquest, and they have never occupied the whole of it, which they now openly demand. They have no more valid claim to Palestine than the descendants of the ancient Romans have on this country."[5]

Any objective review of the real history of the Jews must take account of the fact that, when the Zionists were making their claim to Palestine on the basis of "historical connection", very few of the Jews of the world outside Palestine, and not more than about 10,000 of them in Palestine, were the descendants of the ancient Hebrews who occupied and, as Israelites, ruled much of Palestine for a brief period.

Put another way, of the total number of Jews in the world outside Palestine, only a few were of Palestinian origin: the vast majority were the descendants of Jews who were Jews by conversion to Judaism in the many

lands of which they were citizens, conversions which took place long after the first Jewish presence in Palestine was all but extinguished. In short few if any incoming Zionist Jews were descendants of the original Israelites; most had no genealogical/historical connection to the land.

Few incoming Zionist Jews were descendants of the original Israelites; most had no genealogical/historical connection to the land.

So far as I am aware, the best short explanation of this fact of Jewish history was given by Joseph Reinach, a French politician of Jewish origin. In 1919 for *Journal des Debats* he wrote the following:

> The Jews of Palestinian origin constitute an insignificant minority. Like Christians and Muslims, the Jews have engaged with great zeal in the conversion of people to their faith. Before the Christian era the Jews had converted to the monotheistic religion of Moses other Semites, Greeks, Egyptians and Romans in large numbers. Later, Jewish proselytism was not less active in Asia, in the whole of North Africa, in Italy, in Spain and in Gaul. Converted Romans and Gauls no doubt predominated in the Jewish communities mentioned in the chronicles of Gregoire de Tours. There were many converted Iberians among the Jews who were expelled from Spain by Ferdinand the Catholic and who spread to Italy, France, the East and Smyrna. The great majority of Russian, Polish and Galician Jews (the provider, in time, of what might be called political Zionism's hardcore) descend from the Khazars, a Tartar people of Southern Russia who were converted in a body to Judaism at the time of Charlemagne.[6]

In *What Price Israel?*, first published in 1953, Lilienthal gave historical substance to the fact that the lineal ancestors of Eastern and Western European Jewry were the 8th century Khazar converts to Judaism. He also noted that "this is being kept

The lineal ancestors of Eastern and Western European Jewry were the 8th century Khazar converts to Judaism.

a dark secret because it tends to vitiate the principle prop of the Zionist claim to Israel."[7]

As Lilienthal himself susequently stated in *The Zionist Connection II: What Price Israel?* first published in 1978, the historical truth to which he had drawn attention did not become "widely known" until the publication in 1976 of a book by Arthur Koestler, the bestselling author of *Darkness At Noon, Promise and Fulfillment* and *The Roots of Coincidence*.[8] Koestler's 1976 bestseller was titled *The Thirteenth Tribe: The Khazar Empire and Its*

Heritage.[9] Lilienthal commented that Koestler had "dropped a bombshell by proving that today's Jews were, for the most part, descendants of the Khazars who converted to Judaism seven centuries after the destruction of Jerusalem in 70 A.D. and the dispersion of the small original Judaic Palestine population by Roman Emperor Vespasian and his son Titus."[10]

After the publication of Koestler's book, and taking account of it as well as his own previous research, Lilienthal offered this background perspective:

> The Khazars, a semi-nomadic Turko-Finnish people who settled in what is now southern Russia between the Volga and the Don, spread to the shores of the Black, Caspian and Azov seas. Jews who had been banished from Constantinople by Byzantine ruler Leo III found a home among the pagan Khazars and then, in competition with Muslim and Christian missionaries, won Khagan (King) Bulan, the ruler of Khazaria, over to the Judaic faith around 740 A.D. Some details of these events are contained in letters exchanged between Khagan Joseph of Khazaria and R. Hasdai Ibn Shaprut of Cordova, doctor and quasi Foreign Minister to Sultan Abd al-Rahman, the Caliph of Spain."[11]

Lilienthal noted that this correspondence, circa 936–950 AD, which had been verified, was first published in 1577 "to prove that Jews still had a country of their own—namely, the Kingdom of Khazaria.[12]

Encyclopaedia Britannica's account of the conversion of the Khazars to Judaism has the Khazar King saying to those who were seeking to convert him, "Your intentions are pleasing to the Creator, but your works are not."[13]

Lilienthal went on:

> When Khazaria fell to the Mongols in the 13th century, its population of 'Jewish'-convert Khazars fled northwest to become the progenitors of Ashkenazim (Russian/German/Baltic/Polish) Jewry. These Khazar Jews greatly outnumbered racially Jewish Jews who had reached Europe by other routes and at other periods of history. Therefore, the great majority of Eastern European Jews were not Semitic Jews at all, and as most Western European Jews came from East Europe, most of them are also not Semitic Jews... *This nullifies Zionism's strongest claim to Palestine/Israel*.[14]

In the years that have passed since Lilienthal published his own findings as quoted above, new facts have emerged which, as Shomlo Sand has put it, "face any honest historian with fundamental questions." Those words of his were in an article he wrote for *Le Monde diplomatique* in September 2008. At about the same time, Sand, who is Professor of History at Tel Aviv University, made history of his own with the publication in Hebrew by Resling, Tel Aviv, of his book *Matai ve`ech humtza ha`am hayehudi?* (*When and How Was the Jewish People Invented*?) In it he argues that the idea of a Jewish nation is a myth invented little more than a century ago. Before the invention Jews thought of themselves only as Jews because they shared a common religion. At the turn of the 20th century, Zionist Jews challenged this idea and started creating a national history by inventing the idea that Jews existed as a people separate from their religion.

The idea of a Jewish nation is a myth invented little more than a century ago. After 1960, Zionist historiography ceased to acknowledge, then erased, the complex origins of the Jewish people.

Sand also endorses in depth the view that most of today's Jews have no historical connection to the land called Israel. In his article for *Le Monde diplomatique*, he wrote that until about 1960 the complex origins of the Jewish people were more or less reluctantly acknowledged by Zionist historiography. He went on:

But thereafter they were marginalised and finally erased from public memory. After 1960, Zionist historiography ceased to acknowledge, then erased the complex origins of the Jewish people The Israeli forces who seized Jerusalem in 1967 believed themselves to the direct descendents of the mythic kingdom of David rather than—God forbid—of Berber warriors of Khazar horsemen. The Jews claimed to constitute a specific ethnic group that had returned to Jerusalem, its capital, from 2,000 years of exile and wandering. This monolithic, linear edifice is supposed to be supported by biology as well as history. Since the 1970s, supposedly scientific research, carried out in Israel, has desperately striven to demonstrate that Jews throughout the world are closely genetically related. Research into the origins of populations now constitutes a legitimate and popular field in molecular biology and the male Y chromosome has been accorded honoured status in the frenzied search for the unique origin of the 'chosen people'. The problem is that this *historical fantasy has come to underpin the politics of identity of the state of Israel.*" [emphasis added]

And why is that a bad thing? Sand said: "By validating an essen-

tialist, ethnocentric definition of Judasim it encourages a segration that separates Jews from non-Jews—whether Arabs, Russian immigrants or foreign workers." And that, he adds, is why 60 years on from its foundation, Israel refuses to accept that it should exist for the sake of all of its citizens.

As we shall see, the significance of the facts of Jewish history is impossible to exaggerate in the context of the wrong done to the indigenous Arabs of Palestine by Zionism. It explains among other things why critics of Zionism in the House of Lords and elsewhere used adjectives such as "extraneous" and "alien" to describe those Jews entering Palestine to serve Zionism's cause.

There is no certainty about the number of Jews who were living in Palestine at the time of the first Zionist Congress. The estimates vary from 20,000 to about 40,000, but the lower figure is generally reckoned to be the more accurate one. Some of them, probably about 10,000. were the descendants of the few who stayed in Palestine through everything, living as religious communities mainly in Tiberias and Safed but also Hebron and Jerusalem, waiting for the Messiah to come. Their presence was a continuous one and their connection to the land of Palestine was real. They were Palestinians. The rest (of the 20,000 to 40,000) were the descendants of those Jews who entered Palestine over many centuries, mainly during the "Expulsions" of the first half of the second millennium—1000 to 1500 AD.

During this period the giant of anti-Semitism was wide awake and rampaging through many lands. Jews were killed in, and expelled from, England, Wales, France, Spain, Portugal, Germany, Austria, Hungary, Sicily, Lithuania and the Crimea. They sought sanctuary in three main areas— Poland, Italy and the Turkish Empire. At the time of the first Zionist Congress the most recent arrivals in Palestine, then a part of the Turkish Empire, were those of the second half of the 19th century. They settled in communities founded by Sir Moses Montefiore and funded by Lord Rothschild. On his first visit in 1837 Montefiore put the total number of Jews in Palestine at 9,000.

Like many alien Jews who played a leadership role in the creation of the Zionist state, Ben-Gurion, the founding father, was a Polish Jew. The son of a lawyer, he was born David Green in the small factory town of Plonsk about 38 miles from Warsaw. He was later to write that he arrived in Palestine in 1906 as a Russian tourist on a three months visa "and simply overstayed".[15] His own first experience of Jerusalem provides revealing and amusing insight about one consequence of the fact that all but the small number of Jews who stayed in Palestine through everything were from many different lands, ethnic groups and cultures. He found Jerusalem to be a "Tower of Babel", with Jews "speaking to each other in 40 different languages, half of them unable to communicate with the other half."[16]

The number of Palestine's Arabs at the time of the first Zionist Congress was about 500,000. In other words, at the time of Zionism's secret commitment to the creation of a Jewish state in Palestine, the Arabs were the overwhelming majority of the inhabitants of that land.

It is also a fact that the minority Jewish community of Palestine was strongly opposed to the Zionist enterprise. Prior to the birth of Zionism, the Jews in Palestine were there for religious reasons. They quickly grasped the implication of Zionism—that it would make them as well as incoming Zionist Jews the enemies of the Arab majority. Zionism was thus seen by the religious Jews of Palestine as a threat to their continued well-being. The religious Jews of Palestine also believed that what the Zionists were proposing was morally wrong.

The minority Jewish community of Palestine was strongly opposed to the Zionist enterprise.

How did the Arabs of Palestine see things in the earliest days of Zionism? As Lilienthal noted, the majority Arab population of the time "failed to recognise the European Jewish émigrés as a threat until it was too late." This was largely because the Arabs "looked then upon the Jews in past historic terms as nothing more than a small, docile minority thriving in the region under the special protection of Muslim Arab rulers, protection traditionally provided to non-believers by the Koranic right of El Dimha with the payment of tax."

The two most powerful Jewish organisations in Britain (the Board of Deputies of British Jews and the Anglo-Jewish Association), and many American Jews did sympathise with the cultural aspects of Zionism, and did support the idea of a Jewish community in the Holy Land that would be secure in the enjoyment of civil and religious liberty, and which "would receive equal political rights with the rest of the population and reasonable facilities for immigration." But they were opposed to any recognition of Zionism on a political basis. They objected to "recognition of Jews as a homeless nationality and to the investment of Jewish settlers in Palestine with certain special rights in excess of those enjoyed by the rest of the population."[17]

In the pre-holocaust period one of the most prominent of Britain's anti-Zionist Jews was none other than Edwin Samuel Montagu, Secretary of State for India and the only Jew in the British cabinet. He insisted that Zionism was a "mischievous political creed" and that there was no such thing as a "Jewish nation". The Jews of England, like Jews elsewhere, were a religious community not a nation. He himself, he said, was a "Jewish Englishman".[18]

Montagu and his fellow anti-Zionists fought against the establishment of a Jewish state. They maintained that it would have the effect of "stamping Jews as strangers" in the lands in which they had settled and would undermine their hard won position as citizens and nationals of those lands.[19] With prophetic vision anti-Zionist Jews maintained that the idea of a Jewish state was all the more inadmissible "because Jews are and will probably long remain a minority of the population of Palestine, and because it might involve them in the bitterest of feuds with their neighbours of other races and religions."

The founding fathers of Zionism had some serious problems to overcome. If their ambition was to be fulfilled, there had to be a transfer of Jews to Palestine. But for that to happen on a significant scale, Zionism needed the recognition that only big power support could convey. Without the recognition of a major power, Zionism would be without credibility. And without credibility it would not attract enough Jews to make the Palestine project a viable one. (The story of the remarkable effort Montagu made from inside the cabinet to persuade his government colleagues that Britain should not support Zionism has its place in Chapter Four).

If Zionist ambitions were to be fulfilled, there had to be a transfer of Jews to Palestine.

Zionism's recruiting propaganda was based on a lie, a lie which was to become a truth of necessity in the minds of many of those Jews who, after they were traumatised by the Nazi holocaust, became Israelis. Still today there are Israelis who tell the lie as truth when they are seeking to justify or explain what happened. The lie was in the recruiting slogan which proclaimed that Zionism was concerned with "A land without people for a people without land."

When the lie was told for the first time there were hundreds of Arab settlements in Palestine. And Haifa, Gaza, Jaffa, Nablus, Acre, Jericho, Ramle, Hebron and Nazareth were flourishing towns. And Jerusalem was a flourishing city. As many a traveller had noted, the hills of Palestine were painstakingly terraced and irrigation ditches criss-crossed the most fertile parts of the land. The products of the citrus orchards and the olive groves were known throughout the world. Cottage industries of all kinds were much in evidence. Yes, Palestine was underdeveloped, but so was all of the Arab world, as was most of the whole world. Yes, Palestine was not free. It was a feudal system with Palestinian landowners exploiting their own people and cheerfully collaborating with their masters by conquest of the time— the rulers of the Turkish (Ottoman) Empire. This major Muslim power had controlled south-eastern Europe, the Middle East and North Africa since the 16th century. Under the Turks, Palestine was a part of Greater Syria which also included present day Lebanon. But uninhabited, uncultivated and uncivilised Palestine was not. Except in Zionist mythology. When time and events exposed as a nonsense the notion that Palestine was an "empty land", the Zionists were ready with another piece of mythology. There were Arabs in Palestine but they were late arrivals. They came with the Muslim Arab conquest in the 7th century AD. The meaning

When the "empty land" notion was disproved, the Zionists then claimed Arabs were "late arrivals".

implicit if not always openly stated in Zionist propaganda was that since the first Israelites were in Palestine nearly two thousand years before the Muslim Arab conquest of it, the Zionist claim to Palestine was far, far superior to that of the Arabs. To those who did not know history it was and would

remain a plausible story. To those who knew history it was another big lie.

As Henry Cattan pointed out in his acclaimed book, *Palestine and International Law*, "Arab" is a generic term which includes all the peoples who live in the Middle East whose mother tongue is Arabic, regardless of their religion. Today there are Muslim Arabs, Christian Arabs and Israeli Arabs. The Arabs, originally pagan, have lived in the Middle East, including the land of Canaan which became Palestine, since the dawn of history. Prior to the Muslim conquest of Palestine in 637 AD, most of its indigenous Arab population were Christian Arabs. As a consequence of the Muslim conquest, most Palestinian Christian Arabs were converted to Islam and became Muslim Arabs. It was the religion, Islam, that came with Muslim Arab conquest, not the Palestinians. "The Muslim Arab conquest of Palestine did not involve any mass immigration of the Arabs of the Arabian Peninsula into Palestine or any colonisation of that country. In fact, the number of invaders was very small and they were assimilated by the indigenous population."[20]

The Zionists were not successful in their initial search for big power support for their political ambitions. Herzl turned first to the Turks as the "owners" by conquest of Palestine at the time. The deal Herzl proposed to the Sultan of Turkey, Abdul Hamid, took account of the condition of the Turkish Empire. It was in the process of disintegration, "decomposing" as some said. The British had been occupying parts of it, Egypt and Sudan, since the early 1880s.

When they met, Abdul Hamid told Herzl he was willing to receive Jewish immigrants in all his provinces with the exception of Palestine, provided they became Ottoman subjects, accepted military service and settled "in a disbursed manner, five families here and five families there."[21]

But Herzl wanted nothing less than an autonomous Jewish Palestine within the Turkish Empire; and he had gone to the meeting confident that he could make Abdul Hamid a good enough offer to get what he wanted. The offer was that the WZO would take up the Turkish Empire's foreign debts. Whether Herzl had cleared this with Jewish bankers or was simply assuming they would deliver is not known to me. In response to the offer Abdul Hamid said: "I cannot agree to vivisection... my people fought for this land and fertilised it with their blood... let the Jews keep their millions."[22]

Herzl concluded that he needed a major European power to pressure the Sultan on Zionism's behalf. He believed that Kaiser Wilhelm's Germany (first choice) and Tsar Nicholas's Russia (second choice) were his best bets. If one of them could persuade Turkey to grant Zionism even a small part of Palestine for starters, the Zionists would be able to claim, Herzl reckoned, that their aspirations had been recognised and their enterprise legitimised. The question was—what could Zionism offer that would motivate either Germany or Russia to put pressure on the Sultan?

The founding father of Zionism understood in principle how the real world worked. International politics was a game, The Game of Nations. As they played it, the big, powerful nations were not at all concerned with doing what was right for its own sake. Their only purpose was to advance

their interests. There was no moral code. Only interests. If small, weak nations and, even more so, nationalist movements such as Zionism (and later Arafat's PLO) wanted the support of a major foreign power, they had to be able to do one of two things—serve the interests of the big power or pose a credible threat to them.

Herzl's answer to the question of what Zionism could offer the Kaiser's Germany or the Tsar's Russia for their support was, to say the least, a very pragmatic one.

The Kaiser and the Tsar were symbols of an Old Order that was reaching the end of its sell-by date because it was opposed to inevitable change; and those two leaders had one thing in common. Both wanted to be rid of sections of their Jewish communities. And for the same reason. Their Jewish intellectuals and workers were in the vanguard of the ever-growing revolutionary (Social Democratic) movement that was pressing for equal rights and a fair deal for all citizens—a New Order.

Herzl's strategy was to put Zionism at the service of either the Kaiser or the Tsar as an anti-revolutionary taskforce. As a consequence of having its headquarters in Berlin, the WZO was well connected to the Kaiser's regime. Herzl was aware that the Kaiser himself saw merit in Zionism as a solution to his Jewish problem. Behind closed doors the Kaiser had expressed the view that if the Zionists had a state of their own in Palestine, Germany's "Social Democratic elements" (the Kaiser's euphemism for "my troublesome Jewish citizens") would "stream into it."

> **Herzl's strategy was to put Zionism at the service of either the Kaiser or the Tsar as an anti-revolutionary taskforce.**

In fact that was wishful thinking on the Kaiser's part. The reality was that Germany's Jews wanted to stay put. They did not see their future in Palestine. Life for Jews in Germany at the time was far from ideal but it was not so bad either. The Kaiser had frozen Jews totally out of the officer class and the foreign office, and sanctioned severe discrimination against them throughout the civil service; but he permitted them complete economic freedom. In that environment Germany's wealthy Jews were content and the discontented Jewish students and workers were committed to struggle to improve their lot in Germany.

- Germany was the first base of the Jewish family with a name which became synonymous with immense wealth and the power that comes with it—the Rothschilds. According to Paul Vallely, writing about the Rothschilds in *The Independent* on 16 April 2004, banking industry insiders of today count the fortune of the Rothschilds "not in billions but in trillions."

- The founding father of the world's largest and secretive private banking dynasty was Amshel Mayer Rothschild. He was the son of an itinerant money lender and goldsmith who settled in the

Jewish ghetto in Frankfurt in 1744. Amschel Mayer (1773–1855) specialised "not just in clever accounting practices but also kept secret books and subterranean vaults that he ensured were never the privy of auditor, lawyer or taxman." What he founded in the 1790s was "a business that grew from the humble beginning of selling rare coins to becoming the prime money lender to greedy and spendthrift governments across Europe." The Rothschilds loan-funded the military adventures (wars) of governments and frequently financed both sides.

- Amschel Mayer built on his own success by sending four of his five sons to different European capitals to take advantage of the rise of capitalism and the growth of international trade. Nathan was despatched to London, James to Paris, Saloman to Vienna and Carl to Naples. Their private banks made huge sums from buying and selling government bonds (government debt instruments with fixed interest rates), and they invested in the railways and all aspects of the industrial revolution. The Rothschilds "got a cut of everything" and it gave them "a new kind of power". How much power is indicated by the following quotation attributed to Nathan by Vallely: *"I care not what puppet is placed upon the throne of England to rule the Empire on which the sun never sets. The man who controls Britain's money supply controls the British Empire, and I control the British money supply."* (Emphasis added). At a point Nathan rescued the Bank of England after a run on gold caused the collapse of 145 banks.

When Herzl met with the Kaiser he asked him to intervene personally with the Sultan to secure his agreement to the formation in Palestine of a chartered company under German protection. It was to be the Zionist acorn from which the oak tree would grow. From his diary we know that Herzl played what he thought was his trump card with the Kaiser. "I explained that we were taking the Jews away from the revolutionary parties."[23]

The Kaiser himself was so anxious to get rid of his revolutionary Jews that he seriously thought about pressing the Sultan on Zionism's behalf. But his diplomats were totally opposed to such a move. They were cultivating the Sultan and they knew he would never agree to such a scheme. They also knew that Germany's Jews would never leave their homeland voluntarily. Eventually the Kaiser said "No" to Herzl.

Herzl's approach to Russia suggests that his grasp on reality was not strong.

As told by Brenner, Herzl met with the murderous Vyacheslav von Plevhe, the Tsar's Minister of the Interior. Plevhe had just organised the first pogrom in 20 years. At Kishenev in Bessarabia at Easter, 45 Jews were slaughtered and more than a thousand were injured. After that even most Russian Zionists were opposed to Herzl's meeting with Plevhe. But

the Zionist leader still went ahead with it. What took place at the meeting was later revealed by Chaim Zhitlovsky, then a leading Jewish figure in the Russian Social Revolutionary Party. According to Zhitlovsky, this is what Herzl told him:

> I have just come from Plevhe. I have this positive, binding promise that in 15 years, at the maximum, he will effectuate for us a charter for Palestine. But this is tied to one condition—the Jewish revolutionaries shall cease their struggle against the Russian government. If in 15 years from the time of the agreement Plevhe does not effectuate the charter, they become free again to do what they consider necessary.[24]

On the basis of the deal he had done with Plevhe, Herzl was asking Zhitlovsky to use his influence to stop Russia's revolutionary Jews from pressing their efforts to improve their lot in Russia.

Zhitlovsky was furious and scornfully rejected Herzl's proposition. Zhitlovsky knew the Tsar had not the slightest influence with the Turks who saw him as their enemy. The idea that Tsarist Russia could do for Herzl what the Kaiser's Germany had refused to do was plain silly. From that perspective alone Herzl's strategy was pointless and humiliating. But even if that had not been the case, there was no way, Zhitlovsky told Herzl, that Jewish revolutionaries would call off their struggle for elementary human rights in their Russian homeland in return for a vague promise of a Zionist state in Palestine in the distant future.

Zhitlovky's subsequent judgement of Zionism's founding father was sharp and perceptive and, in a word, withering. Herzl was, the Russian Jewish revolutionary leader said, "too loyal" to the ruling (corrupt and repressive) authorities to be interested in the revolutionaries and involving them in his calculations. Herzl had not made the journey to argue for better treatment of Russia's Jews and "to awaken compassion for us in Plevhe's heart." Herzl had travelled to Russia, Zhitlovsky said, as a politician who was concerned only with "interests", not with his Jewish people and their actual real needs and sentiments. "Herzl's politics is built on pure diplomacy, which seriously believes that the political history of humanity is made by a few people, a few leaders, and that what they arrange among themselves becomes the content of political history."[25]

Unable to get either the Kaiser's Germany or the Tsar's Russia to persuade Turkey to give him what he wanted in Palestine, Herzl became anxious and was prepared to do anything to get the support of a major foreign power. Without it Zionism had no credibility and was going nowhere. In some despair Herzl himself was prepared to accept a British proposal that the Zionists should settle in part of what is today Kenya (then a part of the East Africa segment of the British Empire), and develop a home there as the substitute for Palestine.

Though it is usually dismissed by historians with a sentence and a smile, this bizarre idea, born in the minds of leading figures of the ruling British Conservative Party, had both a serious purpose and a powerful history.

For centuries (as previously noted) the Russian empire of the Tsars had been the heartland of world Jewry. It had started to become something less than that after Oliver Cromwell reopened the doors of England to Jews in the 17th century and they began to make for England (and other Western nations) from all over Eastern Europe.

It was the re-opening of England's doors to Jews that gave the Haskala movement both its inspiration and its impetus. A few of the Jews who decided that assimilation in England was their best and safest bet were quite wealthy, but most were peddlers, many so poor and destitute that they were little more than beggars. With time and effort on their part in a more enlightened England they were accepted by the host community, and began to acquire rights and freedoms they had never previously enjoyed: and in the process of becoming "Jewish Englishmen", they started to feel secure. Then something happened to make them fear that their well-being and security was once again at risk; and that their loyalty to the Britain of which they were citizens might not be enough to protect them from a new upsurge of anti-Semitism.

Between 1881 and 1915 about three million Jews left Russia in search of a better life in Western Europe and America. It was the biggest mass migration in history. Russian Jews were leaving their homeland in such vast numbers because of poverty and persecution including pogroms. (Golda Mabovitch was among those who went to America).

Those who sought sanctuary and assimilation in England arrived in boats with excrement running down their sides. So appalling was their condition that these new Jewish immigrants smelled and looked like what they were described as being, even by some of England's assimilated Jews, "the refuse of Eastern Europe." Adding to the perception of the host community that they were the most undesirable of aliens was the fact that none of these new Jewish immigrants spoke a word of English. Their common language was Yiddish, a corrupted form of the speech of the ancient Hebrews, mixed with Russian, Polish and the many other native languages of the homeland they had abandoned. Among them was Michael Marks, a peddler who traded from a tray around his neck and went on to found Marks & Spencer.

By the dawn of the 20th century, with the exodus of Jews from Russia apparently unending, senior figures in Britain's Conservative Establishment were of the view that England could not and should not take any more Jews—all the more so if Russia's impoverished Jews were bringing revolutionary thoughts with them. England, it was argued, mainly in private, was reaching the limits of her economic capacity to absorb Jews. Underlying this view was the fear that when the number of Jews in England

reached and passed "saturation point," the non-Jewish majority would turn against all the Jews in its midst.

In the hearts and minds of the earlier Jewish immigrants, those for whom assimilation in their new homeland, England, had been, on the whole, a rewarding and comforting experience, the alarm bells were ringing. They feared that the growing presence of their impoverished co-religionists from the East would spark anti-Semitism which would engulf them and put at risk their own hard won status, rights and freedoms. So great was their fear that Britain's assimilated Jews put pressure on the newly-arrived immigrants to return to the Russia they had left because of poverty and persecution. At a point the Chief Rabbi of England appealed to Russia's Jews to stay at home and not even to think about coming to England.

Fearing anti-Semitism, Britain's assimilated Jews put pressure on the newly-arrived immigrants to return to Russia.

In 1902 the British parliament started to debate an Aliens Exclusion Bill. Though it was not stated openly, its main purpose was to put Britain off limits to Russia's Jews. Herzl came to London to make a representation on behalf of the Zionists. He argued that parliament should not pass the Bill and that, instead of it, the British government should support Zionism.

From his diaries we also know of a private conversation Herzl had with Lord (Lionel) Rothschild. In the course of it Herzl said that he, Herzl, "would incidentally be one of those wicked persons to whom English Jews might well erect a monument because I saved them from an influx of East European Jews, and also perhaps from anti-Semitism."[26]

Herzl was obviously confident that the British would offer him something.

What they did offer him in due course, but as a substitute for Palestine, was the Highlands of East Africa in the Kenya of today. Britain's Prime Minister of the time was Arthur James Balfour, who was to become the first of Israel's three Godfathers (the second was Adolf Hitler and the third was President Truman). From the perspective of the British government, a Zionist colony in East Africa would serve the strategic interests of empire rather well; but the immediate virtue of the proposal was that it offered the best available way of preventing by diversion more Jews from entering Britain—if Herzl accepted the proposition and could sell it to his Zionist leadership colleagues.

Herzl, who was not religious, did accept the Kenya Highlands but was overruled by his leadership colleagues. For them it was Palestine or nothing. When subsequently Herzl indicated his willingness to accept other bits of Britain's empire as a substitute for Palestine, his leadership colleagues said they would resign if he did.

According to Brenner's detailed and intimate research, it was only Herzl's premature death in 1904 that prevented the internal collapse of the Zionist movement. Herzl's immediate successor was David Wolffsohn, but it was the man who was to lead the WZO after him, and who was fated

to become Israel's first president, who did the deal with Britain that gave Zionism enough of what it needed to be able to assert that its ludicrous claim on Palestine was legitimate.

That man was Dr. Chaim Weizmann, a brilliant scientist whose speciality was developing explosive substances for bigger and better bangs on battlefields; and who would prove that he had few if any equals in the art of diplomacy—putting the best possible gloss on everything often to the point of making wrong appear to be right.

Of Russian origin Weizmann was active in the Zionist movement from its birth. He went to university in Berlin and Geneva, and in 1904 he moved to London to take a faculty post in chemistry at the University of Manchester. Then, during World War I, he was asked to direct a special laboratory the British government had established to improve the production of artillery shells.

From the moment of his arrival in London, Weizmann had set about the task of developing contacts with the British Establishment at the highest levels, and with Balfour in particular. Weizmann was more aware than most of Balfour's anti-Semitism. As was subsequently to be revealed by the publication of some of Weizmann's private letters, he had a particularly interesting conversation with Balfour on 12 December 1914. According to Weizmann, Balfour unburdened himself. "He told me how he once had a long talk with Cosima Wagner (the composer's wife) at Bayreuth and that he shared many of her anti-Semitic 'postulates'".[27]

Weizmann obviously saw Balfour's anti-Semitism as the magic carpet on which he could make Zionism fly. As the foreign minister in Britain's wartime coalition government, Balfour, obviously, was going to be very supportive of the Zionist enterprise as the best way to prevent more Jews—impoverished, persecuted and potentially if not actually revolutionary Jews—from entering Britain.

Britain's support for Zionism's political ambitions in Palestine was made public on 2 November 1917. It was in the form of a short letter from Foreign Minister Balfour to Baron Lionel de Rothschild. Weizmann and his associates—not British Foreign Office mandarins—had done most of the drafting. Balfour's main contribution was his signature. The actual text of what came to be called the Balfour Declaration was a mere 67 words, but they were more than enough to start the Armageddon clock ticking.

The complete text of Balfour's letter was as follows (emphasis added):

Dear Lord Rothschild,

I have much pleasure in conveying to you on behalf of His Majesty's Government the following declaration of sympathy with Jewish Zionist aspirations, which has been submitted to and approved by the Cabinet. His Majesty's Government view with favour the establishment in Palestine

of a national home for the Jewish people and will use their best endeavours to facilitate the achievement of this object, *it being clearly understood that nothing shall be done which may prejudice the civil and religious rights of existing non-Jewish communities in Palestine*, or the rights and political status enjoyed by Jews in any other country.

I should be grateful if you would bring this declaration to the knowledge of the Zionist Federation.

Yours sincerely,
Arthur James Balfour

One of the things that made the Balfour Declaration such an astonishing document and commitment was that Britain had no right of any kind to give Palestine away, in whole or in part, to anybody.

As Cattan noted:

The British government, as author of the Balfour Declaration, possessed no sovereignty or dominion in Palestine enabling it to make a valid promise of any rights, whatever their nature and extent, in favour of the Jews of the world. It is immaterial whether these rights were meant to be territorial, political or cultural. On the date that the Balfour Declaration was made, Palestine formed part of Turkey, and neither its territory nor its people were under the jurisdiction of the British Government. The Declaration was void on the basis of the principle that a donor cannot give away what does not belong to him.[28]

In 1957 an article in the American Bar Association Journal by Sol M. Linowitz (who was to become an adviser to and a negotiator for President Carter) noted that Britain had had no sovereign rights over Palestine, no proprietary interest, and no authority to dispose of the land. It added: "The most significant and incontrovertible fact is, however, that by itself the (Balfour) Declaration was legally impotent."[29]

The most astonishing thing about the wording of the Balfour Declaration was the way it concealed from public view a reality which, if it had been widely known, would have invited the conclusion that the document was bound to be the harbinger of catastrophe.

The Balfour Declaration had no legal authority to dispose of Palestine, and obfuscated the fact that its existing population was overwhelmingly Arab—a clear harbinger of future strife.

The concealed reality was the make-up of the population of Palestine. At the moment of the Balfour

Declaration the Arabs of Palestine numbered about 670,000 and constituted 93 percent of the population. Jews then in Palestine numbered about 60,000 and constituted 7 percent of the population. There could not have been a more obvious indicator of strife and catastrophe to come if Zionism had its way. (And one does not need the benefit of hindsight to say so).

Equally telling was that those responsible for drafting the Balfour Declaration had been unable to bring themselves to acknowledge the existence of the Arabs of Palestine as a people. The term "Arab" or "Arabs" did not appear in the Balfour Declaration. It reduced the 93 percent Arab majority to "existing non-Jewish communities". That was an expression, a formula, which could only have been invented to serve a hidden agenda.

The implication, which has its context in Chapter Four, is that the British government of the day, which had previously committed itself to independence for the Arabs including the Palestinians, was in such need of the Zionists and their influence that it was not prepared to overrule them, at least to the extent of insisting that the Arabs be recognised in the Balfour Declaration as Arabs and the majority community in Palestine.

The Zionists needed the Balfour Declaration to conceal the demographic reality of Palestine in order to dispossess the Arabs of Palestine without troubling the conscience of Jews everywhere.

Why would the Zionists have wanted such an important document to conceal the demographic reality and truth? Short answer: To make it easier for them, as they set about realising their territorial and political ambitions, to suppress and dispossess the Arabs of Palestine without troubling the conscience of the majority of Jews everywhere, especially those in Western Europe and North America.

In fact the first Zionist draft of the letter to which Balfour eventually put his signature had envisaged recognition by the British government of the whole of Palestine as "the national home of the Jewish people". The first Zionist draft was also without safeguard for the rights of the majority Arab population. It was only at the insistence of anti-Zionist British Jews, and Montagu in particular, that the final text of the letter as signed by Balfour included a safeguard for the rights of the "existing non-Jewish communities" in Palestine.

For their part Zionist leaders were not concerned with what was legally or morally right. Or wrong. What they wanted, and what they got, was a document which allowed them to assert that Zionism's claim to Palestine had been recognised by a major power and that, as a consequence, the Zionist enterprise was a legitimate one.

Why did Britain decide to play the Zionist card in 1917?

Before coming to grips with the answer we must look at why Britain, previously, had played the Arab card; and at how, having played it, Britain then betrayed the Arabs, the Arabs of Palestine most of all.

The context in which Britain played both cards was the upheaval and slaughter of World War I.

3

BRITAIN BETRAYS THE ARABS

For World War I Britain and the Allies (including Tsarist Russia and, eventually, America) mobilised about 42,000,000 men and lost, killed in action, about 5,000,000. Germany and the Axis powers (including Turkey) mobilised about 23,000,000 and lost, killed in action, about 3,400,000. Slaughter does not seem to be an adequate word. The total number of wounded combatants on both sides was about 21,000,000.

All that need concern us by way of essential background is imperial Britain's war aims. Fundamentally Britain went to war to protect and expand its empire. The British Establishment (political and military leaders, Whitehall mandarins, leading industrialists, their bankers and media barons) believed that maintaining the British Empire was the key to ensuring Britain's economic prosperity at a time when Britain's industrial supremacy was increasingly being challenged—by Germany especially, but also America.

By 1914 Germany had established military predominance in Europe. One British war aim was to destroy Germany's navy.

Britain's initial strategic concern with regard to the Middle East (and India) was to keep its *entente* with Russia going. If that broke down there was the danger of a renewed Russian threat to British interests in the Middle East (and India). Later in the war there was also the matter of trying to prevent the victory of communism in Russia.

So far as the Arab part of the decomposing Turkish Empire was concerned, Britain's intention was to take as much of it as she could get. In competition with her ally, France.

With World War I underway the first British promise of support in return for services to be rendered went to the Arabs, not the Zionists. The Arabs were to make the mistake of trusting the British.

With World War I underway the first British promise of support in return for services to be rendered went to the Arabs, not the Zionists. And they, the Arabs, were to make the mistake of trusting the British.

At the time Arab leaders were preoccupied with the task of trying to secure their independence from the Turks.

For Britain's purposes the most influential Arab leader was Hussein, the Sharif of Mecca (the custodian of Islam's Holy Places). He was the leader of the Hashemites—descendants of the prophet Muhammad, the founder of Islam. Hussein's domain was the Arabian peninsula—the Arab world east of the Suez Canal, a large part of which was to become Saudi Arabia. The chunk of it that Hussein regarded as his own was the Hedjaz, the western region that bordered the Red Sea and contained the Holy Cities of Mecca and Medina. Hussein's mission—he declared himself king of the Hedjaz in 1916—was to make emerging Arab nationalism a potent enough force to secure independence from the Turks.

On 31 October 1914, six days before Britain declared war on Turkey, Hussein received a message from Lord Kitchener, Britain's Secretary of State for War. He understood that victory over both the Germans and the Turks would be most unlikely unless the Arabs could be persuaded to join the war on the side of the Allies. The essence of Kitchener's message to Hussein was a pledge of British support for Arab independence if the Arabs revolted against the Turks and entered the war on the side of Britain and the Allies.

Hussein was willing in principle to strike such a bargain with the British but in practice he was very cautious. Arab nationalists did want to be free of Turkish rule but under it they had enjoyed, and were still enjoying, a measure of self-government. They did not want to exchange one type of colonial rule for British or other Western European domination. On its own Kitchener's pledge was not enough for Hussein. He wanted the British to make a specific commitment to outright independence for the Arabs.

To give himself the time and space to negotiate such a commitment from the British, and also to strengthen his negotiating hand, Hussein went through the motions of joining the Turks in the jihad (Holy War) the Sultan had proclaimed against Britain and her allies.

On 23 May 1915, in what came to be known as the Damascus Protocol, Arab leaders stated the terms on which, under Hussein's leadership, they were prepared to unleash a revolt against their Turkish masters and enter the war on the side of the Allies. They wanted a specific British commitment to the independence of all Arab land east of the Suez Canal with the exception of Aden. They also offered Britain a bonus. In the areas liberated, Britain would enjoy economic and trade preference. And the independent Arabs would have a defence alliance with Britain.

The British were very worried about the effect of the Sultan's jihad. They needed to have the Arabs fighting on their side but they did not want to give the specific commitment the Damascus Protocol had requested.

There followed a protracted correspondence between Hussein and, for Britain, General Sir Harry McMahon, the British High Commissioner in Egypt. Eight letters and nearly a year later Hussein was satisfied that he had secured from Britain a specific and irrefutable commitment to Arab independence.

In the years to come the Zionists would claim, supported for a while by the British, that the letters which formed the basis of Britain's

commitment to Arab independence had excluded Palestine. But, as we shall see in Chapter Seven, the eventual publication of all the relevant documents proved that Palestine was unmistakably included in the McMahon independence promise. The British were always economical with the truth and deception was the essence of Zionist diplomacy.

The Arabs honoured their part of the bargain. Their revolt against the Turks started on 5 June 1916. But it would not have happened if the Arabs had been aware of the secret discussions which were going on, even as they were committing themselves to fighting for the Allies, between the Allies (Britain, France, Italy and Russia) to determine how the spoils of the Turkish Empire were to be divided among themselves after victory.

After his Declaration that Britain viewed with favour the establishment in Palestine of a national home for the Jewish people, Balfour sent an alarmed Hussein a message: "His Majesty's Government confirms previous pledges respecting the recognition of the independence of the Arab countries."[1]

But the Arabs were still not inclined to trust British intentions. Seven Arab leaders then living in exile in Cairo requested Britain to state frankly her policy with respect to the future of the Arabs. On 16 June 1918, Britain responded with a "Declaration to the Seven". It confirmed the previous pledges of the Hussein-McMahon correspondence and gave an additional assurance that the wishes of the "population" would be respected. The Zionists had asserted that the Balfour Declaration superseded and by implication invalidated Britain's previous promises to the Arabs. That was not so and was made clear, apparently, by the "Declaration to the Seven".

Hussein was also given further comfort by Commander D.G. Hogarth, a British archaeologist. He was sent to Jeddah on behalf of the British government to meet with Hussein and **Hussein was willing to** reassure him that as far as Palestine was **"welcome Jews in all** concerned "we are determined that no people **Arab lands" but would** shall be subjected to another"; and that while **not accept a Jewish** Jewish immigration was to be permitted, it **state.** would be allowed "only insofar as compatible with the freedom of the existing population, both economic and political."[2] According to Hogarth's own account, Hussein said he was willing to "welcome Jews in all Arab lands" but would not accept a Jewish state.[3]

The greatest war in all of recorded history to that point came to an end with victory for the Allies at eleven o'clock on 11 November 1918 when the cease-fire was sounded. The Armistice had been signed at five o'clock that same morning. But the peace had still to be made. Making it was to be the business of the Paris Peace Conference. It opened in January 1919 and was attended by leaders including America's President Wilson and other senior representatives from twenty-seven states. The defeated belligerents were not to be admitted to the Conference. The terms of the peace were to be imposed on them by the victorious Allies and embodied in a sheaf of treaties. The most important of them was the Treaty of Versailles

which was signed on 28 June 1919. This was the treaty between the Allied and Associated Powers (with the exception of America, for reasons to be explained later) and Germany. Complementary treaties were also concluded with Austria, Bulgaria and Hungary. But peace was not finally concluded with the Turks until 24 July 1923; and before then many strange things were to happen, some with regard to the fate of the Arabs in general and Palestine and the Palestinians in particular.

How significant was the Arab contribution to the Allied victory?

By throwing in their lot with the Allies in return for the promise of independence the Arabs changed the balance of power in the Middle East. Arab participation in the war enabled the British to withstand the German effort to take Aden and blockade the Red Sea and the Indian Ocean, Britain's main artery of Empire.

The Arabs also drew off considerable Turkish forces that were directed against Britain's advance on Palestine. The commander of that advance, General Murray, noted that there were more Turkish troops fighting the Arabs than were engaged with his men.

It was to be many years before the official assessment of the value of the Arab contribution to the Allied war effort was considered by the British to be fit for public consumption. The official assessment was that made behind closed doors at a secret meeting of the Supreme Council of the Allied Powers in Paris on 20 March 1919. At that meeting General Allenby, Commander-in-Chief of the Expeditionary Force which wrested Palestine, Syria and Lebanon from the Turks, declared that Arab assistance had been "invaluable". The same meeting was told by Britain's Prime Minister, Lloyd-George, that on the basis of McMahon's letters to Hussein, "the latter had put all his resources into the field, which helped us most materially to win the victory."[4]

And those were judgements endorsed by the defeated Turks. When Hussein called upon all Arabs to join the revolt, Jamal Pasha, the commander of the Turkish forces, was obliged, as he later admitted, "to send forces against Hussein which should have been defeating the British on the Canal and capturing Cairo."[5]

The terror unleashed on the Arabs by the Turks told its own story about how valuable the Arab contribution to the Allied war effort was. As part of a frenzied effort to crush the Arab revolt, the Turks dragged Arab leaders in Damascus from their homes and hanged them in public squares. Food was denied to the people in Palestine and Lebanon and Arab patriots everywhere, not only those fighting for Britain and the Allies, paid with their lives.

With the prolonged haggling that was called the Peace Conference still underway, and with the hopes of their innocence high, Arab nationalist leaders set about the task of preparing for the independence Britain had promised. As a priority they organised the election of the General National Syrian Congress.

This, when it convened in Damascus on 2 July 1919, with representatives from all over Syria as it then was including Palestine, was effectively the first Arab parliament. The delegates favoured a new United

Syria with a constitutional monarchy under Hussein's first son, Faysal. In territorial terms the new United Syria was to be the Syria of today including the Golan Heights occupied and taken by Israel in the 1967 war; plus Lebanon of today; plus Jordan of today including the West Bank occupied by Israel in the 1967 war; plus Israel as it was inside the borders as they were on the eve of the 1967 war.

The delegates declared their opposition to further Jewish immigration but said that "our fellow Jewish citizens shall continue to enjoy the rights and bear the responsibilities which are ours in common." (That was in accord with the thinking of anti-Zionist Jews).

That first Arab parliament also expressed its preference for having America, not Britain, as the power mandated by the League of Nations to give political, economic and technical assistance to the new United Syria. Britain was to enjoy the status of "friend" and no assistance was required from France. (The French were trusted even less than the British). When they were expressing their preference for America as the overseeing and protecting Big Brother, one Arab delegate spoke for most when he said: "We may look to President Wilson and the liberal American nation, which is known for its sincere and generous sympathy for the aspirations of weak nations." (The story of why the Arabs had so much faith in President Wilson and the America of his time has its place in Chapter Seven.)

But it was all of no consequence.

While the Arab nationalists were meeting in Damascus and proclaiming the independence they had been promised, Britain and France were concluding their secret discussions to carve up the old pre-war Greater Syria for themselves! And they were determined to delay telling the truth about what they had decided until the time was strategically and politically right.

The way in which the spoils of the Ottoman Empire were to be shared among the European victors was made public on 5 May 1920 in San Remo. The news then and there was that the new United Syria the Arabs had proclaimed was not to be. Syria was to be partitioned, divided into three spheres of big power influence. France was to have the Mandates for ruling a separate Lebanon and a separate Syria minus Palestine. Britain was to have the Mandate to rule Palestine. (Britain was also to have Iraq). To the Mandate for Palestine there was to be attached a rider that would require Britain to apply the Balfour Declaration there.

The people of Palestine, the overwhelming majority of them Arabs, were not even consulted as Britain and France connived to carve up Greater Syria for themselves.

The carve-up announced at San Remo was a repudiation of Britain's promises to Hussein and also Britain's Declaration To The Seven. The stark, shocking truth was that the wishes of the people of Palestine, the overwhelming majority of them Arabs, had been ignored. They were not even consulted by Britain or France. But that is only a part of the story of the British betrayal of the Palestinians. As we

shall see in Chapter Seven, President Wilson sent his own Commission to Palestine to consult the Arabs, but the report of its findings was suppressed for a critical amount of time at the insistence of Britain-and-Zionism.

In his famous book, *The Seven Pillars of Wisdom*, (which he had to publish himself and which very nearly bankrupted him), T.E. Lawrence, the British Liaison Officer with the Arab fighting forces, acknowledged that the Arabs had been betrayed, and that they had revolted against the Turks "on false premises". He added, "If I had been an honourable adviser, I would have sent my men (his Arabs) home and not let them risk their lives for such stuff."[6]

Hussein was so bitter that not even Lawrence could persuade him to sign the Hedjaz-British Friendship Treaty that Lawrence took to Jeddah for signature in July 1921. Rejecting the Friendship Treaty was a tough decision for Hussein because it promised him money as well as military support. Without both he was, as we shall see, doomed.

It was to be twenty years before there was anything like an honest official explanation—actually more of a hint—of why Britain decided to play the Zionist card in 1917 despite its promise to the Arabs.

4

WHY BRITAIN PLAYED THE ZIONIST CARD

In July 1937, speaking in the House of Commons about why the Balfour Declaration was issued, Winston Churchill (then excluded from office and campaigning for the Hitler threat to be taken seriously) said this:

> It is a delusion to suppose this was a mere act of crusading enthusiasm or quixotic philanthropy. On the contrary, it was a measure taken... in due need of the war with the object of promoting the general victory of the Allies, for which we expected and received valued and important assistance.[1]

In other words, *Britain had needed the Zionists and their influence and had been prepared to pay the price they asked for it.*

Where was it that Britain wanted the Zionists to use their influence? In *The American Zionist* of October 1953 a former President of the Zionist Organisation of America, Rabbi Emanuel Neumann, put it this way: "Britain, hard pressed in the struggle with Germany, was anxious to gain the whole-hearted support of the Jewish people; in Russia on the one hand and in America on the other. The non-Jewish world regarded the Jews as a power to reckon with and even exaggerated Jewish influence in unity. Britain's need of Jewish support furnished Zionist diplomacy the element of strength and bargaining power which it required to back its moral appeal."[2]

The "valued and important assistance" the Zionists were expected to provide was not in the Middle East, but in Russia and America.

What was the "valued and important assistance" the Zionists were expected to provide in Russia and America?

There has never been, and probably never will be, an official answer to that question. Writers and other interested parties have to work it out for themselves. Such a task would be impossible without an understanding of the British and Allied position in the war when the Balfour Declaration was issued and, most important of all, in the months leading up to it—the

months in which the Zionists were bargaining with the anti-Semitic British foreign secretary and his representatives.

Neumann's phrase "hard pressed" to describe Britain's situation in the war was a considerable understatement.

In the spring of 1917 Allied fortunes in the war were at their lowest. Defeat rather than victory was in prospect. The much respected British historian whose work helped to inform my schoolboy learning days, J.A.R. Marnott, put it this way: "The Allied position was unspeakably grave". For Britain "literally everything depended on her sailors and ships."[3]

In February the Germans had intensified the war by resorting to "unrestricted" submarine warfare—the sinking without warning of anything afloat. This included unarmed merchant vessels and hospital ships and, also, the vessels of neutral nations, America being the first and foremost of them at the time. The all-out German submarine offensive was terribly effective. The loss of British ships and lives became so great that the strain on the British was perilously close to breaking point. On the basis of British losses, the Germans believed that Britain would have to surrender by 1 August at the latest. For its part the British Admiralty had calculated that unless the German submarine peril could be countered, surrender could not be postponed beyond November. (I remind myself and readers as necessary that the date of the issuing of the Balfour Declaration was 2 November).

The British faced defeat by November, 1917. The Balfour Declaration was issued 2 November, 1917.

As we shall see in Chapter Seven, the British and the French brought the disaster of unrestricted German submarine warfare upon themselves, and prolonged the conflict, because they rejected President Wilson's mediation. But in the months leading up to the Balfour Declaration it was not only what was happening at sea and on the Western land front that suggested Britain and her allies were facing the prospect of defeat. There was alarm in London and elsewhere about the prospect of losing Russia as an ally in the war.

The developing situation in revolutionary Russia was very complicated and, at the time, it must have been difficult for diplomats to read.

In 1914 Imperial Russia had mobilised rapidly and greatly assisted the Allies in the early months of the war. (The German army could have crushed either France or Russia alone, but not both together). In 1916 Russian forces won a series of victories against the Turks and raised British hopes that Russia would be able to provide effective assistance to the Allied cause in Mesopotamia (broadly the Iraq of today). But Russia's troops were ill equipped, lacking both guns and munitions and, in the lower ranks, the motivation to fight and die for a repressive regime which cared nothing for its masses and their poverty. Russian efforts in the field became paralysed by gross maladministration and, probably, some treachery.

Simply stated, the imperial Russian edifice on which the British were

relying was rotten to the core; and it collapsed on 12 March 1917. Three days later Tsar Nicholas, a pathetic figure, abdicated. He would have been content if, to keep him in power, Russian troops had fired on his people. They were fed up with standing in food lines and were demonstrating about the breakdown of everything. When it became clear that Russian troops were not going to fire on their own people—there were mutinies against orders to do so in some barracks, and when still the Tsar refused to dismiss his exceptionally incompetent and unpopular administration and appoint a "government of public confidence", the end of a thousand years of monarchy in Russia was at hand. Tsar Nicholas, his wife and their children were imprisoned and subsequently murdered.

The collapse of the Old Order in Russia constituted the first revolution and was regarded in Western Europe as the revolution of the "moderates". When a Provisional Government took power the British asked themselves two questions.

The first was: Would the Provisional Government have the will to keep Russia in the war, even at the cost of suppressing opposition to it if necessary?

The second question was: Would the Provisional Government have the ability to contain and then defeat the emerging anti-capitalist or communist forces, in order to prevent a second revolution and the creation of a communist Russia? (The most significant of the emerging anti-capitalist or communist movements was that of the Bolsheviks).

Because the British were staring down the barrel at defeat they felt they could not afford to let events in revolutionary Russia take their own course. They needed to have a way of influencing them.

Cue the Zionists.

As we have seen, Herzl was content to prop up the Old Order (repressive and rotten to the core) in Russia by consenting to Plevhe's wish to use Zionism as an anti-revolutionary taskforce. And that was precisely what Weizmann offered Britain, and subsequently at the Paris Peace Conference all the victorious capitalist powers—Zionism as an anti-revolutionary, actually anti-communist, taskforce.

Weizmann offered Zionism to all the victorious Western powers as an anti-communist taskforce.

Because of their experience of poverty and persecution including pogroms in the Russian empire of the Tsars, many Russian Jews had become radicalised and active participants in the struggle for change. (It was, in fact, Jewish workers who formed Russia's first mass socialist organisation, the General Jewish Workers League or Bund) They had played a major role in mobilising the masses in the years leading up to the collapse of monarchy. Unlike the three million of their co-religionists who abandoned their Russian homeland between 1881 and 1915, they were fired by noble ideals of a better and more just society in Russia. They were, in short, in the vanguard of those who favoured going all the way to real revolution and the

establishment of a communist system and terminating Russia's participation in the war. From the British perspective... If the Jews of Russia who were committed to real revolution could be persuaded to change their minds—break with or distance themselves from the anti-capitalist or communist forces, or be confronted if they refused—the prospects for keeping Russia in the war and the communists out of power would be much improved.

In that context enormous significance was attached to the fact that one of the two most important and influential leaders of the real Russian revolution in-the-making was Jewish.

His real name was Lev Davidovich Bronstein. He was born in the village of Yanokova in the Ukraine on 26 October 1879. His father, David, was a farmer who had settled in the steppe region. His mother, Anna, was middle class and well educated.

At the age of eight Davidovich Bronstein was sent to school in Odessa. For the next eight years he lived there with the family of his mother's nephew, a liberal intellectual. The young Bronstein demonstrated intellectual brilliance and remarkable literary and linguistic gifts.

In 1896 Bronstein moved to Nikolayev to complete his schooling. There he was drawn into an underground Socialist circle and introduced to Marxism. After a brief spell at the University of Odessa he returned to Nikolayev to help organise the underground South Russian Workers' Union. Then, in January 1898, Bronstein was arrested for revolutionary activity. His punishment was exile to Siberia. Four years later he escaped on a forged passport bearing the name he was to keep as his revolutionary pseudonym. The name? Leon Trotsky. With that name the Jewish Bronstein was to become, in the perception of British policymakers, the biggest potential threat to the continuation of empire and the economic benefits Britain derived from it.

After his escape, Bronstein, now Trotsky, went to London. There he joined a group of Russian Social Democrats working with Vladimir Ulyanov, the founder of the Bolshevik Party, and who, as Lenin, would become the first leader of communist Russia. Their main project at the time was production of the revolutionary newspaper *Iskra* (*The Spark*). Because of his intellectual brilliance and his remarkable abilities as a speaker, writer and organiser, Trotsky quickly assumed a leading role.

At the Second Congress of the Russian Social-Democratic Workers' Party, held in Brussels and London in 1903, Trotsky sided with the Menshevik faction which advocated a democratic approach to Socialism. That put Trotsky, in principle, in opposition to Lenin and his Bolsheviks. Effectively Trotsky was (then) rejecting Lenin's dictatorial methods and the Bolshevik concept of immediate revolution and taking power by all and any means.

With the outbreak of revolutionary disturbances there in 1905, Trotsky returned to Russia. He became the leading spokesman of the St. Petersburg Soviet (Council) of Workers' Deputies when it organised a revolutionary strike movement and other measures against the Tsarist government. For that he was arrested, tried and exiled to Siberia. Again. And again he escaped. This time he settled in Vienna and supported himself

as a war correspondent. (He covered the Balkan wars of 1912–13). He continued to be very active in Russian Social-Democratic émigré circles as a celebrated but isolated figure on the left-wing of the Menshevik faction. And he engaged in polemical exchanges with Lenin and the Bolsheviks over organisational matters and tactical questions.

At the outbreak of World War I, Trotsky joined the majority of Russian Social Democrats in condemning the war and refusing to support the war effort of the Tsarist regime. He moved to Switzerland and then to France where he helped to edit a Russian anti-war journal. That led to his expulsion from France and he moved to Spain. In turn he was expelled from there and in January 1917 he arrived in New York.

It was from neutral America that Trotsky hailed the revolution of the "moderates". But so far as he and Lenin were concerned it was unfinished business, and both called for the overthrow of the Provisional Government by the workers. Anti-capitalist or communist leaders saw the Provisional Government for what it really was—something close to a British puppet regime.

Trotsky then decided it was time for him to return to Russia to play a leadership role in the unfolding events. The British authorities and their agents everywhere put great effort into trying to prevent both Trotsky and Lenin from returning to their homeland. At the time of the first revolution the Bolshevik Party was very small with fewer than 30,000 members. And it was disoriented. Most of its leaders, not only Lenin, were in exile abroad or imprisoned in Siberia. A smallish, leaderless revolutionary movement was not so much of a threat. Or so the British assumed.

In retrospect there is a respectable case for saying that even though the British failed to prevent Trotsky and Lenin returning to Russia to organise, the anti-capitalists or communists would still not have triumphed—i.e. Russia might not have gone communist, if Britain with Zionism's assistance had not had sufficient influence and clout to induce the Provisional Government to keep Russia in the war against the will and protests of Russia's impoverished and angry masses. It was the Provisional Government's continuing pro-war policy and popular opposition to it that gave the Bolsheviks the opportunity they needed to win support and generate momentum.

At one level British and Zionist influence on the Provisional Government was exercised through its War Minister, Aleksandr Kerensky. In July he was induced to halt the revolutionary momentum with a crackdown on the Bolshevik leadership in particular and the communists in general. Lenin managed to avoid arrest and went into hiding in Finland. Trotsky was jailed. After that Kerensky became prime minister and his liberal Provisional Government swung to the right. But not, apparently, far enough to the right for the British.

At the time he was jailed, Trotsky was not a Bolshevik because of his opposition to Lenin's dictatorial ways. But in jail he became a Bolshevik and was elected to membership of the Bolshevik Central Committee. When he was released from prison in September, and with Lenin still in hiding, the Jewish Trotsky became the principal leader of the Bolshevik Party in

its preparations to take power.

Trotsky owed his freedom to Kerensky's fear that the British were plotting with conservative forces of the Old Order to have him replaced by his chief of staff, General Lavr Kornilov. By releasing Trotsky and relaxing the ban on the Bolsheviks, Kerensky was placing an each way bet for his own survival. By this time the political situation in Russia was extremely complicated with nobody but the Bolsheviks knowing who could be trusted.

The second revolution came as something of an anti-climax. On the afternoon of 25 October, in one of the most impassioned speeches of his life, Trotsky proclaimed the overthrow of the Provisional Government and introduced Lenin in public as the first leader of what was to become the Soviet Union.

The coming to power of Lenin and his Bolsheviks effectively marked the end of Russia's participation in World War I; but at the time Britain was still so desperate that it was not prepared to accept the *fait accompli*—the Bolshevik victory.

Britain and her remaining allies, including by now America, were so alarmed that they resorted to direct military intervention in Russia's affairs. The opportunity for intervention came when Lenin's Russia was torn by civil war, brought about, at least in part, by Zionism's agents. The Allies took the side of the anti-communist Russians, the "Whites", against Lenin's "Reds". The "Whites" were led by officers of the old Russian army. How far the British and the French might have pushed on with their intervention if President Wilson had not insisted on the escalation being stopped is a good question. The civil war ended with victory for Lenin's "Reds"; and that was due in no small part to Trotsky's success, then as war minister, in building a new Red Army out of the shambles of the old Russian army.

The policy difference between Trotsky and Lenin's successor Stalin, was very great. Initially Stalin wanted only to create "socialism in one country" as an impregnable stronghold against counter-revolution. Trotsky wanted the Soviet Union to become the communist base for world revolution. That had been his idea from the beginning; and that was why, in 1917, the British were more frightened of Trotsky and what he represented than they were of Lenin. After the first revolution, and prior to the issuing of the Balfour Declaration, British thinking was something like this: If there was a second revolution and if, after it, Trotsky's ideas prevailed, a communist Russia would become the engine of anti-capitalism and would inspire and support revolutions by the workers throughout the capitalist West and, no doubt, the colonies of the British Empire. Trotsky and his Jewish revolutionaries had to be stopped.

It was the realisation by Weizmann and his Zionist leadership colleagues of how much the British feared Trotsky and what he represented that gave them their bargaining power with Britain in the "in Russia" context of Neumann's statement.

So far as I am aware there is no record of what was said by the Zionists when they propositioned the British for the Balfour Declaration, but in the light of comments subsequently made by Churchill on the significance

of events in revolutionary Russia, it is not difficult to imagine what Weizmann might well have said to Balfour, or somebody with the foreign secretary's ear.

On 8 February 1920 Churchill, then Secretary of State for War, wrote an article for the *Illustrated Sunday Herald*. It was headlined "ZIONISM VERSUS BOLSHEVISM". In it Churchill told his readers about Trotsky and "his schemes of a worldwide communistic state under Jewish domination." Churchill then noted "the fury with which Trotsky has attacked the Zionists generally and Dr. Weizmann in particular." But, Churchill declared, Trotsky's scheme was being "directly thwarted and hindered by this new ideal (Zionism)." Churchill's conclusion was the following: "The struggle which is now beginning between the Zionist and Bolshevik Jews is little less than a struggle for the soul of the Jewish people."[4]

Churchill': "The struggle which is now beginning between the Zionist and Bolshevik Jews is little less than a struggle for the soul of the Jewish people."

When Weizmann informed the British that he was ready to put Zionism to work for them in Russia, probably very soon after the collapse of the monarchy, I think it is reasonable to speculate that he said something like this: "We understand and sympathise with your fears about what is happening in Russia. To the extent that some of our Jewish people there are a cause of the problem, we Zionists can assist you to overcome it. Use us."

History in the shape of Zhitlovksky's scornful rejection of Herzl's willingness to allow Zionism to be used as an anti-revolutionary taskforce should have warned Weizmann and his WZO leadership colleagues how difficult their "in Russia" mission was going to be.

Churchill's graphic description of the struggle invites a question about the exact nature of Zionism's in-Russia strategy. Was it premised, at least initially, on the hope that Zionists could persuade those Russian Jews who supported Trotsky to turn away from the path of revolution? Or were Weizmann and his leadership colleagues committed from the beginning to setting Jew against Jew in Russia, in order to reduce the prospects of victory for communism?

I am not aware that such a question has ever been asked and I cheerfully confess that I don't know the answer to it. But whatever the truth, one thing seems to me to be clear.

Weizmann and his Zionist leadership colleagues realized the British fear of Trotsky and Communism gave them bargaining power with Britain.

For Zionism to have had even a chance of influencing events in Russia in Britain's favour, it had to be able to assure Russia's Jews that Zionism was in a position to give them a better future in Palestine than that on offer in Russia from Trotsky and the Bolsheviks if their revolution succeeded. But Zionist words alone were not going to be convincing enough. What the Zionists had to have, in order to be taken seriously by Russia's Jews, in order to be of service to Britain, was a declaration of Britain's support for Zionism's ambitions in Palestine.

It may have been that Weizmann gave the British a short history lesson in order to underline Zionism's need for a public declaration of Britain's support. If he did, he might have drawn attention to Zhitlovksy's comment to Herzl that Jewish revolutionaries were not about to call off their struggle for elementary human rights in Russia in return for "a vague promise" of a better life in Palestine. (I can almost hear Weizmann saying to the British: "We've got to be able to demonstrate that Britain is serious in its support for us. A vague promise won't do.")

Zhitlovky's fundamental criticism of Herzl was that he did not give a damn about Russia's Jews and their real needs in Russia, and was only intending to use them to serve Zionism's political ambitions. Was Weizmann any different from Herzl in that respect? I think not. The British were using Zionism and Zionism was using Russia's Jews. It was a matter of political expediency, politics without principles, all down the line. Weizmann was saying to the British what Herzl had said to the Kaiser, "We're taking Jews away from the revolutionary parties."

There is nothing in any record to suggest that Weizmann and his Zionist leadership colleagues never allowed themselves to be troubled by thoughts about the price Russia's Jews might pay in the future, if communism triumphed, for Zionism's collusion with Britain and her capitalist allies. It must have been obvious to anybody who thought about it at the time that, in the event of a communist victory, all of Russia's Jews, because of the anti-revolutionary and anti-communist activities of some, would be regarded by the Soviet authorities as potential subversives and would suffer accordingly. One can only wonder about how much better the life of Russia's Jews might have been after the coming into being of the Soviet Union if Zionism had not meddled Russia's internal affairs. If that meddling had not happened, Jews in the Soviet Union may not have had such a tough time as they did have in the decades that followed.

Zionist leaders never allowed themselves to be troubled by thoughts about the price Russia's Jews might pay in the future for collusion with Britain.

As it happened Zionist influence on events in Russia changed not a lot—one might say the situation there was too far gone for the Zionists to have had anything but a marginal impact; but that is not the point. It is that at the time Weizmann was propositioning the British, they had good reason to hope and believe that the Zionists could and would deliver something of value. But in the "in Russia" context I agree with Neumann. The British did exaggerate Zionism's influence.

But perhaps it was not in Russia that the Zionists performed their most valuable service for Britain.

There were some people close to the action who believed that the issuing of the Balfour Declaration was also a "thank you" to the Zionists for mobilising America's Jews to play a critical and perhaps decisive role in bringing America into the war. Among those who thought so was Lawrence. When the U.S. State Department sent Professor William E. Yale to the

Middle East to gather information about "the Arab situation", Lawrence was one of those who briefed him. According to Yale, Lawrence said: "Britain is supporting the Zionists for the help it is thought they could be to us in Russia and because they brought America into the war."[5] (I return to this subject in Chapter Seven, which includes the story of America's entry into the war and how President Wilson tried to prevent the doing of an injustice to the Arabs of Palestine).

T.E. Lawrence: "Britain is supporting the Zionists ...because they brought America into the war."

There was also a particular strategic consideration which played a part in motivating Britain to issue the Balfour Declaration. It was the need to protect the Suez Canal, which was vital for the maintenance of "the spinal chord" of the British Empire. In his book *Trial and Error*, Weizmann recalled a conversation he had on the subject of the Canal with Lord Robert Cecil, Britain's assistant secretary of state for foreign affairs. The Zionist leader said he stressed to Cecil the point that a "Jewish Palestine would be a safeguard to England, in particular in respect to the Suez Canal."[6]

But Weizmann's suggestions that Zionism should be used as an instrument to help preserve and protect the British Empire were not confined to private conversations. In his book he also recalled an important public announcement he had made on the subject:

> We can reasonably say that should Palestine fall within the British sphere of influence, and should Britain encourage Jewish settlement there, as a British dependency, we could have in twenty to thirty years a million Jews out there, perhaps more: they would develop the country, bring back civilisation to it and form a very effective guard for the Suez Canal."[7]

I do not mean to suggest that Britain would have refrained from using Zionism for its own ends if the Zionists had not asked Britain to use them. The British had their own logic. With the fire of Arab nationalism burning, and with Arab leaders learning to play the Game of Nations (or so it seemed), they, the Arabs, could not be relied upon to put Britain's interests first when it came to protecting the Canal, especially with Egypt on its way to independence (and given, also, that the French were not to be trusted). In any future crisis with Britain the Arabs might even threaten to close the Canal as a bargaining chip. That, surely, was what the British would do if they were the Arabs and the need arose. So the best way to guarantee that interests with regard to the Canal would always be put first was to have, as close to it as possible, a protective Zionist base; a Zionist presence which, because of the Balfour Declaration, would obligate the Zionists to do whatever had to be done to protect the Canal for Britain. (Forty years later when the Zionist state went to war with Egypt, it was at the request of Britain and France for the purpose of giving them the pretext to intervene, to take back the Suez Canal from Egypt and remove President Nasser from power.)

There was also a wild card in the pack of Britain's considerations in 1917. This was a report that Germany was considering a Balfour-type Declaration to win over Zionism and its influence on matters political and financial. It is not difficult to imagine that this report caused alarm in the highest levels of the British government. Was the report true—were the Germans really thinking about offering the Zionists a deal? Or did Zionist negotiators invent that story to put pressure on the British? Those are questions without answers. They, the answers, went to graves with men.

And now a most intriguing question.

How much was "The Anti-Semitism of the Present Government" (Lloyd-George's wartime coalition government) a motivating factor in the issuing of the Balfour Declaration, the playing of the Zionist card?

The quotation in the paragraph above was the title of a memorandum marked SECRET written by Montagu—the only Jewish Englishman in the cabinet and Secretary of State for India—and distributed by him to his cabinet colleagues.[8] (Montagu also had jurisdiction over British Colonial interests in the Near and Middle East as well as India).

This amazing document was dated 23 August 1917—i.e. when Montagu the passionate anti-Zionist was leading the fight against the creation of a Jewish state and, at the particular moment, was insisting that any declaration Balfour might make had to contain safeguards for the rights of the Arabs in Palestine.

As it happened, Montagu's memorandum was not de-classified, not considered to be fit for public consumption, until 1970. Put another way, it was suppressed for more than half a century. (Truth was—as it always has been and no doubt always will be—a most worrying thing for politicians; and all the more so when it's to do with the politics of the creation of the State of Israel).

Edwin Samuel Montagu was a Jewish Englishman by birth, in London in 1879. He entered Parliament as a Liberal in 1906 and became secretary to Herbert Asquith who was prime minister from 1908 to 1916. As parliamentary undersecretary to the India Office between 1910 and 1914, Montagu had the job of explaining Indian matters to the House of Commons. After the outbreak of World War I he served in a number of minor government posts and entered the cabinet as Chancellor of the Duchy of Lancaster in 1915. As financial secretary to the Treasurer he helped to popularise the first war loans and set up voluntary war-savings organisations. He was appointed Secretary of State for India in 1917, when the government had decided to play the Zionist card and the discussion was only about the wording of the Balfour Declaration.

As Lilienthal put it, Montagu "deeply resented the efforts of Zionist nationalists to persuade unwitting co-religionists that they were an ethnic racial group, one of superior stock entitled to rule over Palestine."[9]

This most remarkable Jewish Englishman feared that endorsement by the government of Zionism's Palestine project could endanger the hard-won status of Jews as an integrated religious community enjoying

equal rights, privileges and obligations in Western countries in which they lived. In plain language Montagu's gut fear in its English context was that English people who succeeded only with great effort in suppressing their anti-Semitism would say out loud: "We really don't want you Jews here. Now you don't need to be here. Go to your home in Palestine."

In conversation with Prime Minister Lloyd-George, Montagu said he had striven all his life "to escape from the ghetto" to which he now faced possible relegation as a result of the contemplated British policy lurch in Zionism's favour.

Under the heading The Anti-Semitism of the Present Government, the text of Montagu's memorandum as slightly shortened by me was as follows (emphasis added):

> I have chosen the above title for this memorandum not in any hostile sense, not by any means as quarrelling with an anti-Semitic view, which may be held by my colleagues, not with a desire to deny that anti-Semitism can be held by rational men, not even with a view to suggesting that the Government is deliberately anti-Semitic, but I wish to place on record my view that *the policy of His Majesty's Government is anti-Semitic in result and will prove a rallying ground for anti-Semites in every country of the world.*

The war has indeed justified patriotism as the prime motive of political thought. It is in this atmosphere that the Government proposes to endorse the formation of a new nation with a new home in Palestine. This nation will presumably be formed of Jewish Russians, Jewish Englishmen, Jewish Romanians, Jewish Bulgarians and Jewish citizens of all nations...

Montagu feared that endorsement by the government of Zionism's Palestine project could endanger the hard-won status of Jews as an integrated religious community in Western countries.

Zionism has always seemed to me to be a mischievous political creed, untenable by any patriotic citizen of the United Kingdom. If a Jewish Englishman sets his eyes on the Mount of Olives and longs for the day when he will shake British soil from his shoes and go back to agricultural pursuits in Palestine, he has always seemed to me to have acknowledged aims inconsistent with British citizenship and to have admitted that he is unfit for a share in public life in Great Britain or to be treated as an Englishman. [By obvious implication Montagu was saying that Zionism ought to be "untenable" for any Jewish citizen of any nation—i.e. not just the Jewish citizens of England.]

I have always understood that those who indulge in this creed (Zionism) were largely motivated by the restrictions upon them and refusal of liberty to Jews in Russia. But at the very time when these Jews have been acknowledged as Jewish Russians and given all liberties, [the Provisional Government of Russia had decided to treat its Jews better to stem the exodus in general and the brain drain in particular], *it seems to me to be inconceivable that Zionism should be officially recognised by the British Government, and that Mr. Balfour should be authorised to say that Palestine was to be reconstituted as the 'national home of the Jewish people.'* I do not know what this involves, but I assume it means that Mohammedans and Christians are to make way for the Jews, and that Jews should be put in all positions of preference and should be peculiarly associated with Palestine in the same way that England is with the English or France with the French, that Turks and other Mohammedans in Palestine will be regarded as foreigners...

I assert there is not a Jewish nation. The members of my family, for instance, who have been in this country for generations, have no sort or kind of community of view or of desire with any Jewish family in any other country beyond the fact that they profess to a greater or lesser degree the same religion. It is no more true to say that a Jewish Englishman and a Jewish Moor are of the same nation than it is to say that a Christian Englishman and a Christian Frenchman are of the same nation—of the same race...

Montagu: "I assert there is not a Jewish nation... It is no more true to say that a Jewish Englishman and a Jewish Moor are of the same nation than it is to say that a Christian Englishman and a Christian Frenchman are of the same nation".

I certainly do not dissent from the view, commonly held, as I have always understood by the Jews before Zionism was invented, that to bring the Jews back to form a nation in the country from which they were dispersed would require Divine leadership. I have never heard it suggested, even by their most fervent admirers, that either Mr. Balfour or Lord Rothschild would prove to be the Messiah...

I claim that the lives that British Jews have led, that the aims that they have had before them, that the part they have played in our public life and our public institutions,

have entitled them to be regarded not as British Jews, but as Jewish Britons. *I would willingly disenfranchise every Zionist. I would almost be tempted to proscribe the Zionist organisation as illegal and against the national interest....*

I deny that Palestine is today associated with the Jews. [Montagu's own emphasis.] It is quite true that Palestine plays a large part in Jewish history, but so it does in modern Mohammedan history, and, after the time of the Jews, surely it plays a larger part than any other country in Christian history. The Temple may have been in Palestine, but so was the Sermon on the Mount and the Crucifixion. I would not deny to Jews in Palestine equal rights to colonisation with those who profess other religions, but a religious test of citizenship seems to me to be only admitted by those who take a bigoted and narrow view of one particular epoch of the history of Palestine, and claim for the Jews a position to which they are not entitled...

I am not in the least surprised that the non-Jews of England may welcome this policy (of recognising Zionism and endorsing its ambition). I have always recognised the unpopularity, much greater than some people think, of my community. We have obtained a far greater share of this country's goods and opportunities than we are numerically entitled to. We reach, on the whole, maturity earlier, and therefore with people of our own age we compete unfairly. Many of us have been exclusive in our friendships and intolerant in our attitude and I can easily understand that many a non-Jew in England wants to get rid of us...

I would say to Lord Rothschild that the Government should be prepared to do everything in their power to obtain for Jews in Palestine complete liberty of settlement and life on an equality with the inhabitants of that country who profess other religious beliefs. I would ask that the Government should go no further.

By definition "Jews in Palestine" meant only those who were there up to the time Montagu wrote the memorandum, which was more than two months before the text of the Balfour Declaration was finally agreed and issued. By asking his cabinet colleagues to go "no further" than giving a commitment to liberty and equality for those Jews then in Palestine and only those Jews, Montagu was effectively saying: "Don't do it. Don't give Zionism the recognition and the endorsement it seeks because, if you do, you'll be creating the mechanism for fuelling instead of extinguishing the embers of the fire of anti-Semitism."

When all is said there are two statements that can be made without fear of contradiction.

The first, as Churchill indicated, is that Britain gave the Zionists the Balfour Declaration because it was perceived to be in Britain's self-interest to do so at the time—no matter the consequences would be down the years for the Arabs, the Jews, the British themselves and the whole world.

The second is that the Zionists were "the greatest war profiteers". Who said that? None other than Weizmann himself, as quoted in Paul Goodman's 1945 book, *Tribute on His Seventieth Birthday*.[10]

There remains an intriguing and provocative question.

Did Britain enter into a conspiracy with the Zionists, I mean was Britain secretly committed to the creation of a Jewish state with all that implied—the doing of a terrible injustice to the Palestinians: or was Britain only committed, as the Balfour Declaration said, to the establishment in Palestine of a Jewish national home, something less than a state?

There is a hook on which it is possible to hang an argument that the anti-Semitic Balfour (if not necessarily the whole of the British cabinet minus Montagu) did conspire with the Zionists. The hook is what Balfour himself said in a memorandum on 11 August 1919 which was prepared for the Paris Peace Conference:

> In Palestine we do not propose even to go through the form of consulting the wishes of the present inhabitants of the country... The four great powers are committed to Zionism. And Zionism, be it right or wrong, good or bad, is rooted in age long traditions, in present needs, in future hopes, of far profounder import than the desires prejudices of the 700,000 Arabs who now inhabit that ancient land.[11]

Balfour: "The four great powers are committed to Zionism. And Zionism, be it right or wrong, good or bad, is rooted in age long traditions in present needs, in future hopes, of far profounder import than the desires prejudices of the 700,000 Arabs who now inhabit that ancient land."

In the language of today that could be translated to mean: "In the Middle East we are going to bank on the Zionists not the Arabs as the protectors of Britain's interests. It follows that we will support and assist the Zionists to achieve their objectives. Though we cannot say so, and will always deny it, we are for a Jewish state and the Palestinians can get stuffed".

5

AHAD HA-AM AND
THE FALSE MESSIAH

If Britain intended the Balfour Declaration to mean what it said, its only significance for Jews was as summed up by Ahad Ha-am, the pre-eminent Jewish scholar, philosopher, moralist and humanist of his time, 1856 to 1927.

In Ahad Ha-am's considered opinion the Balfour Declaration made possible only the establishment of an international spiritual centre of Judaism; a centre of study and learning for spiritual purification and to which all Jews would look with affection.

The prospect of such a national home for Jews in Palestine, by definition one without political sovereignty, was welcomed by Ahad Ha-am because he was a spiritual Zionist. For him the distinction between spiritual and political Zionism (Jewish nationalism) was all important. He was the conscience of the former and the principal architect of criticism of the latter. But the moral force he represented, a moral force rooted in Judaism, was to be extinguished by the uncompromising attitudes and ruthless nature of the political Zionists and the dreadful event that played into their hands —the Nazi holocaust.

The historical significance of Ahad Ha-am is not merely the fact that he warned political Zionism's founding fathers that the creation of a Jewish state in Palestine would require its creators and defenders to abandon moral principles and, as a consequence, put the integrity of Judaism at risk. The point is that he warned them before they proclaimed the coming into being of their movement and issued their dishonest mission statement.

Ahad Ha-Am's credentials were such that wiser men than Zionism's founding fathers might have heeded his warnings. If they had done so, the Arabs of Palestine would not have been dispossessed of their land and their rights, and there would not have been an Arab-Israeli conflict.

So who was Ahad Ha-am and on what basis did he conclude that political Zionism's colonial enterprise was morally wrong and should not be attempted?

As I noted in the Prologue, Ahad Ha-am was a pen name. Its literal meaning was "One of the people." The man who signed his articles in that way, and who was well known to Zionism's founding fathers and also to

Weizmann (who was one of his students), was Asher Zevi Ginsberg.

He was born into the Jewish community of a small town near Kiev in the Ukraine of today. If he had obeyed the instructions of his father, Yeshayahu, he would have grown up to be a small-minded man, probably a bigot, and his name would not have been known even to Jews beyond the boundaries of part of his Russian homeland.

For a Russian Jew of his time and class Yeshayahu Ginsberg was an exception to the rule in that he was not poor during the years in which he sought to mould his son's life. For some years Yeshayahu had farmed the estate near Berdichev of a member of the Russian nobility. When Asher was 12, Yeshayahu leased the estate and the Ginsberg family took up residence there to live, apparently, in the style of the Russian gentry. And that might have been the reason why, subsequently, Asher chose to write under the pen-name of Ahad Ha-am, to indicate that whatever people might suppose about him because of the apparent style of his early life, he was an ordinary man.

Material comfort did not tempt Yeshayahu to become anything less than a Jew of totally unbending religious orthodoxy. And he had only one ambition for his son. Asher would become, had to become, a great rabbinical scholar. (Yeshayahu would have been well aware that the respect accorded to him when his son achieved such a status would be priceless). And to that end the pious father did everything in his power to bring up the son in accordance and compliance with strict—the most strict—religious orthodoxy. As a consequence Asher was required to shun wordly matters and affairs. When he was recognised as an illui, a young man of superior intellectual gifts and a master of Talmudic learning, Yeshayahu must have been mightily pleased and supremely confident that his ambition for his son would be achieved. And all the more so when the son accepted the bride of the father's choice in an arranged marriage.

David Vital, the author of *The Origins of Zionism*, was of the view that by the time he was 30 and had broken free from what he regarded as a provincial prison, Asher was embittered by a sense of wasted and lost years and, in particular, the denial of the formal secular education which he had craved. That may have been so but, because of Asher's somewhat subversive human spirit, the years were not nearly as wasted as they might have been. In defiance of his father's wishes, Asher had found various ways, by subterfuge, to study Russian and the major Western languages, along with the literature including the philosophy of each. Locke and Hume were among Asher Ginsberg's favourite Western philosophers.

Thus it was that when Asher Zevi Ginsberg entered the real world, with a passion for public affairs in general and the affairs of Jewry in particular, he had a good, basic understanding of how it worked and why things were as they were. Most critical of all, and because his father's regime of religious tyranny had required him to make judgements unaided and virtually uninfluenced by others around him, he had an uncommon and great ability to think for himself. And that, so to speak, was his own tradition; and he was to maintain it for the rest of his life. The basis for all

the judgements he was to make about political Zionism was mainly his own highly developed sense of what was morally right and wrong.

From the moment he started to speak and write about Jewish policy matters, he was committed to exposing what he regarded as the "muddle-mindedness" and "self-deception" of political Zionism's founding fathers. He believed their many shortcomings had to be exposed both as a matter of principle and as a necessary preliminary to charting any kind of course in matters of public policy.

Zhitlovsky, as we have seen, thought Herzl was guilty of self-deception for believing that the Tsar had any influence with the Sultan of Turkey. Asher Ginsberg believed that Herzl was guilty of self-deception for even thinking (before he sought the intercession of first the Tsar and then the Kaiser) that the Sultan could be bribed into giving political Zionism what it wanted in Palestine. Asher Ginsberg did not dispute that backsheesh (bribe money) had a great power in Turkey and that even the greatest men there were unable to resist it. But for complete understanding, he insisted, you had to take into account the religion of the great men and their concern for the authority of their government. When you did that, you could see that they were fierce patriots who were absolutely opposed to the settlement of Jews in Palestine. And that meant, Asher Ginsberg also insisted, that the more Jews settled in Palestine, the greater the opposition of the Turks would be.

Apart from his intellectual brilliance and his absolute insistence on all Jews behaving in accordance with the moral principles of Judaism, Asher Ginsberg had knowledge that made him a greater authority on the subject of Palestine than all of the founding fathers of political Zionism put together. Unlike them, he had bothered to go to Palestine to see for himself what the situation on the ground was, and what the practical possibilities for Jewish development in that land were. He was subsequently to tell associates in Russia that no one who had not been to Palestine and seen matters for himself should have responsibility for policymaking with regard to Jewish aspirations in Palestine.

Asher Ginsberg made his first visit to Palestine in 1891, six years before the coming into being of the WZO. On his return to Russia after three months of seeing for himself, he was disillusioned and bitter on account of "the wrong way" of Jewish immigrants. He was also deeply depressed. In his first devastating summary of what he had seen, he wrote, as Ahad Ha-am, that his intention was to reveal a bit of the truth—the bit which was "the ugliest."

On the basis of what he observed with his own eyes, he believed there were two main obstacles to further Jewish settlement in Palestine.

The first was that there was very little cultivatable land which was not already in use. What was cultivated could not be purchased from the Arabs. What could be purchased was either totally infertile or would have to be cleared at immense cost in labour and money. (As it happened that did not turn out to be an obstacle because the money and the labour were provided).

The second obstacle was the existence of the Arabs. The Jews

abroad, Ahad Ha-am wrote, thought little of the Arabs and supposed them to be incapable of understanding what went on around them. For thinking so the Jews abroad were "in error".

It was, however, the "quality" and the behaviour of the early Zionist settlers that troubled Asher Ginsberg most. The more he saw of them in action, the more he came to the conclusion that they were the wrong people drawn in for the wrong reasons. They were, in his opinion, totally unsuited to agricultural development and, more generally, they were ill-prepared, ill trained or not trained at all. They were also full of mistaken and irrelevant ideas, ill-informed, ill-directed and ill-behaved.

In one of his articles Asher Ginsberg (as Ahad Ha-am) warned that Jewish settlers should under no circumstances arouse the wrath of the natives. Later he wrote:

> Yet what do our brethren do in Palestine? Just the very opposite! Serfs they were in the lands of the diaspora and suddenly they find themselves in unrestricted freedom and this change has awaked in them an inclination to despotism. They treat the Arabs with hostility and cruelty, deprive them of their rights, offend them without cause and even boast of these deeds; and nobody among us opposes this despicable and dangerous inclination.[1]

When Jewish settlers implemented the WZO's policy of boycotting Arab labour, Ahad Ha-am was outraged; and he gave expression to his despair in this way:

> Apart from the political danger, I can't put up with the idea that our brethren are morally capable of behaving in such a way to humans of another people, and unwittingly this thought comes to my mind: if it is so now, what will be our relation to the others if in truth we shall achieve at the end of times power in Eretz Israel?[2]

He added:"If this be the messiah, I do not wish to see his coming."

Ahad Ha'am's message could not have been more clear. Political Zionism was a false messiah.

Another legendary spiritual Zionist who spoke against political Zionism was Dr. Judah Magnes, the founder and first president of the Hebrew University in Jerusalem. He warned time and time again that by establishing a political dominion in Palestine against the wishes and without the consent of the Arabs "we shall be sewing the seed of an eternal hatred of such dimensions that Jews will not be able to live in this part of the world for centuries to come." And that, Magnes said to political Zionists, "is something you had better try to avoid."[3]

He went on:

We seem to have thought of everything—except the Arabs. We have issued this and that publication and done other commendable things. But as to a consistent, clearly worked-out, realistic, generous policy of political, social, economic, educational co-operation with the Arabs—the time has never seemed to be propitious.

But the time has come for the Jews to take into account the Arab factor as the most important facing us. If we have a just cause, so do they. If promises were made to us, so were they to the Arabs. If we love the land and have a historical connection with it, so too the Arabs. Even more realistic than the ugly realities of imperialism is the fact that the Arabs live here and in this part of the world, and will probably live here long after the collapse of one imperialism and the rise of another If we wish to live in this living space, we must live with the Arabs."

On the basis of all the evidence Asher Ginsberg concluded that Palestine could not provide a full-scale solution to the material problems of the Jewish people—their poverty and their insecurity. If realism was to prevail, the most that should be attempted in Palestine was the creation of an international spiritual centre for Judaism.

He defined it as being a model workshop for the regeneration of the Jewish people. Out of it, by example and teaching, a new and healthy influence would radiate. This, Asher Ginsberg believed, would reflect the essential nature of Judaism, was what was needed and, most important of all, was what could be done in Palestine. Nothing else could or should be attempted or even thought about. It was the case, he acknowledged, that some would find what he was saying disheartening because it offered no answer to the great question of the material condition of the Jewish masses. What was to be done to guarantee their security and give hope for an end to their poverty? The blunt truth was, he insisted, that means other than settlement in Palestine would have to be found to solve those problems. And those Zionists who still insisted that Palestine was the answer to the Jewish problem were guilty of not only deceiving others but, worse still, deceiving themselves.

But even if such a modest mission—the creation in Palestine of an international spiritual centre for Judaism—was to be accomplished, Asher Ginsberg believed it would only be as the result of a cautious and well-planned approach. He defined this as being one that, in terms of Jewish settlers, would provide quality, not quantity, and appeal to their highest motives, not their lowest. And that was not all. If it was to reflect the essential nature of Judaism, a new Jewish yishuv (area of settlement) in Palestine, whatever its size, would have to be frugal and orderly, hardworking and socially cohesive. In short it would have to be created by dedicated and, above

all, virtuous men and women, virtually to the exclusion of lesser beings.

Conclusion? Asher Ginsberg believed that if something other than a centre for the spiritual regeneration of the Jews were to be created in Palestine it would not be worth having, and might very well create a new Jewish problem.

Asher Ginsberg had the vision to realise, as Harkabi would many years later, that the Jews of the world would be judged in part, perhaps in the final analysis in large part, by what a small number of Jews did in Palestine in their name. If the false Messiah came and had his way, all Jews and Judaism itself would pay a terrible price. It was because the stakes were so high for Jews everywhere that Asher Ginsberg, Ahad Ha-am in print, believed that Jewish policy with regard to Palestine should be the concern of the entire Jewish people, and should not be determined by the muddle-mindedness and deception of a few in the name of all.

And he told Weizmann that the Balfour Declaration was not the green light for a Jewish state. The WZO, he added, had painted conditions in Palestine "in false colours" and had promised what they could not hope to deliver. (Eventually, of course, the Zionists did deliver, but in a way that would have made Asher Ginsberg fear even more for the future of Jewry and Judaism).

According to Walter Laqueur in *A History of Zionism*, Ahad Ha-am regarded Herzl as "little more than confidence trickster."

Zionism's criticism of Ahad Ha-am in his time seems to me to boil down to this. What he had to say was not only difficult for "real" Jews to grasp (real Jews were the impoverished, persecuted masses), it also offered no solution to their problems; and that being so, it was not relevant to their real needs and, consequently, was not what they wanted to hear. I think it's reasonable to assume that Zionism probably did its best to limit the circulation of Ahad Ha-Am's messages.

Uncomfortable though it may be for many and perhaps most Jews today, the truth is that Ahad Ha-am had the full moral authority of Judaism on his side when he denounced the Zionist intention (and so political Zionism itself) to create a Jewish state on Arab land. Because I am a Gentile and no expert on Judaism, I did not myself become aware of this truth until I read Harkabi's book. Under the heading of Judaism and Zionism, Harkabi wrote this:

> Zionism's attachment to the Land of Israel is rooted in the Jewish religion; but Judaism itself is not Zionist, and Jews throughout the generations have not been Zionists even if year by year they uttered the fervent hope 'Next year in Jerusalem!' or the admonition that 'Living in Eretz Israel is of equal weight to all the other commandments.' In doing so they were expressing their longings and desires—their grand design [the abstract will]—and not their policy [the practical will]. Of course there was a handful who

did emigrate to the Land of Israel but their intention in most cases was to die there rather than to build a Jewish independent state.

Zionism is not an ideal; it is the realisation of an intention, a political programme. One has to distinguish between a wish and an intention. An intention depends on some practical beginning. For example, to say 'would so and so were dead' is to express a wish, not necessarily an intention to murder. A wish becomes an intention by means of taking a decision and implementing it by some action that leads toward its realisation; in our example, obtaining a weapon. Zionist historiography has thus erred in describing the Jews as always having been Zionist, for the distinction between love of Zion and Zionism as a political programme is essential to a proper understanding of Jewish history. Zionism was born when the messianic wish, embodied in the ideal or grand design of the ingathering became a political intention embodied in an organisation to settle Jews on the land.

From the time of the Bar Kochba Revolt (132 to 135 BC) until the rise of Zionism, the central political idea of Judaism was expressed by the three Talmudic 'oaths' that God required. They can be paraphrased as follows: there would be no mass movement of the Jews from the lands of the diaspora to the land of Israel, no rebellion against the nations of the world, and no excessive oppression of the Jewish People by Gentiles. This was an important Jewish doctrine, even though it did not arouse much discussion, since in the historic circumstances of the times it seemed obvious almost to the point of banality. The core of this idea is passivity—avoiding political action while patiently waiting for the Messiah to come, without attempting to precipitate His coming, which was strictly forbidden.

Thus Zionism was proscribed. Modern religious Zionism attempted to reinterpret and blunt the force of the oaths. It claimed, for example, that the oaths were a sort of package deal: because the nations of the world had not upheld their part of the bargain as expressed in the third oath, Jews may now immigrate collectively to their homeland. Such an interpretation makes Zionism merely conditional: were it not for the Gentiles' ignoring the oath not to oppress the Jews, the Jews would have to refrain from migrating en masse to Eretz Israel. [We might note that the anti-Zionist Satmar Hasidim (sect of Jews) exploit the oaths to

castigate Zionism and interpret them as a package deal in precisely the opposite sense: it was the Jews' violation of the oaths—by pursuing the Zionist enterprise—that led to the Holocaust.][4]

The oaths, Harkabi wrote, can be understood as "a decision to prevent any initiative that would undermine the Jewish way of life as it developed in the diaspora." He added: "Jewish Orthodox circles, afraid of changes that would undermine this way of life, were strongly opposed to Zionism. They suspected that the realisation of Zionism would create a new and difficult challenge for Judaism."[5] (In 2008, the title of a book written by a very dear Jewish friend of mine gave expression to the new and difficult challenge for Judaism that had been created by Zionism. As mentioned in the Preface to this volume of mine, he is Dr. Hajo Meyer, an Aushchwitz survivor. The title of his book, it bears repeating, is *An Ethical Tradition Betrayed, The End of Judaism*).

Amazing though it may seem to be in retrospect—amazing given the refusal today of all but a minority of Jewish Americans to criticise Zionism and its child openly—it was, in fact, in America that Jewish opposition to Zionism as mentioned by Harkabi was most strongly expressed in public.

The ink on Zionism's dishonest mission statement was hardly dry when the Central Conference of American Rabbis adopted a resolution disapproving of any attempt to establish a Jewish state. The resolution said: "Zion was a precious possession of the past... as such it is a holy memory, but it is not our hope of the future. America is our Zion."[6] (Substituting England for America, Montagu was saying the same thing 20 years later in his secret memorandum to his cabinet colleagues. And that was also the position of Germany's Jews before the Nazi holocaust).

The community in whose name the rabbis were speaking was that of the earliest Jewish settlers in America. The product of the first two waves of Jewish immigration, they were mainly Sephardic (Spanish and Portuguese) and German Jews. These early Jewish settlers—the first Jewish Americans —had no concern for group rights and were totally opposed to the idea of emancipated Jews living a segregated cultural existence. They just wanted to be Americans and, allowing for the fact that their religion was Judaism (a private matter), indistinguishable to the limits of the possible from all other Americans. This, as the Haskala philosophy maintained, was most likely to be the best possible guarantee of no further persecution. The first Jewish Americans were, one might say, anti-ghetto. They had not escaped from countries in which Jews were un-free and persecuted and had to live in ghettoes only to create new ghettoes in the Land of the Free.

In 1904, in an edition of the *American Israelite*, the following stark statement was made: "There is not one solitary prominent native Jewish American who is an advocate of Zionism."[7]

If the views and values (and wisdom) of the earliest Jewish Americans had prevailed, Zionism would not have gotten even a toehold in the U.S.

A question that gets a complete answer later in these pages is this: How and why was it that a majority of Jewish Americans became committed to Zionism, right or wrong?

The first part of the answer (the second part being, as we shall see, the Nazi Holocaust and Zionism's ruthless and brilliant exploitation of it) is that everything was changed by demographic dynamite.

As noted in Chapter Two, between 1881 and 1915 about three million Jews abandoned their homelands in the Russia of the Tsars. More than two-and-a-half million of them found their way to the U.S. This was the third wave of Jewish immigration into America. Many of these new immigrants (including Golda Mabovitch) settled in the larger eastern cities. And they were "inclined to Zionism".

Why, was explained by Lilienthal with touching insight that only a Jew can have. The challenge for the Gentiles is to understand:

> They had not only lived (in the homelands they had abandoned) as a separate nationality, but had voted as Jews for other Jews to represent them in governments. They mostly had spoken a language other than their environments, and had lived in a mental ghetto to balance the physical ghetto around them. The Jews from these countries had been a nation within a nation so that, when they came to the U.S. as emancipated persons, the nation complex came with them.[8]

The Jews who abandoned their homelands had been a nation within a nation so that, when they came to the U.S. as emancipated persons, the nation complex came with them.

And that made many of them susceptible to Zionism's nationalist propaganda; not in most cases to the extent of wanting to go themselves to Palestine to create a Jewish "home" there (Golda Mabovitch was one of those who did), but to the extent of empathising with Zionism's nationalist ambitions.

Prior to the arrival of the great third wave of Jewish immigrants, the institutional link between the small community of religious Jews in Palestine and Jewish Americans (and assimilated Western Jews generally) was the Jewish Agency. It was essentially a philanthropic-minded body, the vehicle used by the great Jewish families of the Western world—those, Lilienthal wrote, "whose Judaic traditions made philanthropy the crowning justification of their wealth" and who "totally rejected political Zionism"[9]—to make contributions to the welfare and betterment of the religious Jews in Palestine.

After the arrival of the great third wave of Jewish immigrants, the anti-Zionist Jewish Agency was transformed, slowly but surely, into a pro-Zionist institution. Some of its anti-Zionists were outvoted by Zionists. Some did not want the hassle of confrontation and simply surrendered their

seats to fervent Zionists. And others were neutralised and became merely "non-Zionists". In addition, new Jewish American organisations were set up to advance the cause of Zionism.

After the arrival of the great third wave of Jewish immigrants, the anti-Zionist Jewish Agency was transformed, slowly but surely, into a pro-Zionist institution.

By the time of the Balfour Declaration what might be called the masses of American Jewry were on their way to becoming Zionised. But the great Jewish American families as described by Lilienthal, and other prominent but not so wealthy Jewish Americans, did not give up their opposition to Zionism without a fight. Not for a while.

In December 1917, for example, Chief Judge Irving Lehman, brother of New York Governor Herbert H. Lehman, made the following most explicit statement in a speech at the Menorah Society Dinner:

> I cannot recognise that the Jews as such constitute a nation in any sense in which that word is recognised in political science, or that a national basis is a possible concept for modern Judaism. We Jews in America, bound to the Jews of other lands by our common faith, constituting our common heritage, cannot as American citizens feel any bond to them as members of a nation, for nationally we are Americans and Americans only, and in political and civic matters we cannot recognise any other ties. We must therefore look for the maintenance of Judaism to those spiritual concepts which constitute Judaism.[10]

(I think it is reasonable to suppose that the writings of Ahad Ha-am were at or near the top of the Chief Judge's reading list).

That Lehman statement of December 1917 was philosophically in tune with Montagu's thinking as expressed in his secret memorandum to his British cabinet colleagues in August of the same year. Taken together the two statements demonstrate that many of the most prominent and thoughtful of the assimilated Jews of America and Britain (and actually all of Western Europe) were united in their belief that political Zionism was a false messiah.

It is true that the main motivation for their anti-Zionism was self-interest, driven by the gut fear that the benefits of successful assimilation into Western secular culture, and the protection against persecution the Haskala way provided, could be endangered by Zionism's Palestine project, but they were also aware of the implications for the integrity of Judaism itself of the founding of a Jewish state on a massive injustice to the Arabs of Palestine. Lehman's view that Jews had to look for the maintenance of Judaism not to Zionism but to "those spiritual concepts which constitute Judaism" was another echo of Montagu's thinking (and also, of course, that

of Ahad Ha-Am). Montagu was depressed about the state of Judaism and believed that without a "deep sense of righteousness" there was little left to Judaism. More to the point, he was aware that Zionism, if it was successful, would make a mockery of the spiritual concepts which constituted Judaism and, very probably, given time, would destroy the little that was left of it.

In the pre-holocaust period the most graphic public expression of what most if not all wealthy and wise Jewish Americans really thought about Zionism was that of Henry Morgenthau Senior. In his autobiography, *All in a Lifetime*, published in 1921, this former American Ambassador to Turkey defined Zionism as follows:

> Zionism is the most stupendous fallacy in Jewish history. It is wrong in principle and impossible of realisation; it is unsound in its economics, fanatical in its politics and sterile in its spiritual ideas. I speak as a Jew.[11]

Lilienthal's view was that prominent Jewish Americans such as Morgenthau Senior, Julius Rosenwald and Felix Warburg would not have permitted "all the Hitlers in the world to change their basic philosophy."[12]

Prominent Jewish Americans such as Morgenthau Senior, Julius Rosenwald and Felix Warburg would not have permitted "all the Hitlers in the world to change their basic philosophy".

As we shall see, Morgenthau Senior was one of 30 prominent Jewish Americans who signed a petition to President Wilson as part of their efforts to strengthen his resolve to prevent Britain-and-Zionism determining his agenda for the Middle East and the doing of a terrible injustice to the Palestinians.

As I write I find myself asking this question: How many Jewish Americans who became Zionised had any idea of even the possibility that a Zionist *fait accompli* in Palestine might one day pose a threat to the well-being of Jews everywhere and to the moral integrity of Judaism itself? The answer to that question is unknowable. My guess is that probably not more than a handful of them had sufficient information to understand just how much might be at stake if Zionism was allowed to have its way.

A related question invited by the next chapter is: How different might the future have been if more than a small number of Jews everywhere, and Jewish Americans especially, had been aware of what the honest Zionists were writing and saying about what actually would have to be done in Palestine if a Jewish state was to be created there?

6

THE HONEST ZIONISTS

In June 1922, Winston Churchill, then Secretary of State for the Colonies, issued a White Paper that seemed to suggest the British government shared Ahad Ha-am's interpretation of the meaning of the Balfour Declaration for Jews.

In one part, however, the White Paper added insult to Arab injury. "It is not as has been represented by the Arab delegation that during this war His Majesty's Government gave an undertaking that an independent national government should be at once established in Palestine."[1] That statement was literally true but somewhat disingenuous in all the circumstances. To those with suspicious minds it indicated that when Britain had obtained the League of Nation's endorsement of its Mandate to rule Palestine, the British were intending to stay in Palestine as the rulers for quite some time and by force if necessary.

That aside, Churchill's White Paper was a disappointing document for Zionism. One passage explicitly rubbished a statement Weizmann had made during the Paris Peace Conference. In a reference to it the White Paper said: "Unauthorised statements have been made to the effect that the purpose in view is to create a wholly Jewish Palestine. Phrases have been used such as 'Palestine is to become as Jewish as England is English.' (That was Weizmann's statement). His Majesty's Government regard any such expectation as impracticable and have no such aim in view. Nor have they at any time contemplated... the disappearance or the subordination of the Arabic population, language or culture in Palestine. They would draw attention to the fact that the terms of the (Balfour) Declaration referred to do not contemplate that Palestine as a whole should be converted into a Jewish National Home, but that such a Home should be founded in Palestine."[2]

In a statement to the House of Commons, Churchill said: "At the same time as this pledge was made to the Zionists, an equally important promise was made to the Arab inhabitants in Palestine—that their civil and religious rights would be effectively safeguarded, and that they should not be turned out to make room for newcomers."[3]

Churchill also assured a deputation of Arabs that a Jewish national home did "not mean a Jewish government to dominate Arabs." He added, "We cannot tolerate the expropriation of one set of people by another."[4]

The White Paper also said: "It is contemplated that the status of all citizens of Palestine in the eyes of the law shall be Palestinian, and it has never been intended that they or any section of them should possess any other juridical status."[5]

Despite the various assurances to them, the Arabs, all Arabs, remained deeply suspicious of Britain's real intentions. And not without reason. On the subject of Jewish immigration the White Paper said the Jewish community in Palestine should be allowed to grow. There was the caveat that the rate of increase in the numbers of new Jewish immigrants should "not exceed whatever may be the economic capacity of the country at the time to absorb new arrivals."[6] But that did not allay Arab alarm.

Weizmann also was far from happy. He had confessed to his WZO leadership colleagues that the final wording of the Balfour Declaration represented a "painful recession", this because there was nothing in the final text to so much as hint at the prospect of the Jewish national home being allowed to become, one day, with Britain's blessing, a Jewish state. But because of its commitment to continuing Jewish immigration, the 1922 White Paper was not completely without comfort for the Zionists.

Ahad Ha'am said that Zionism's leaders ought to have told their people that the Balfour Declaration had not opened the way to a Jewish state.

Weizmann's public position was that Zionism's political work was far from finished. He was later to write: "The Balfour Declaration and the San Remo decision were the beginning of a new era in the political struggle, and the Zionist organisation was our instrument of political action."[7]

There were, it is usually said, two streams of Jewish nationalism under the one Zionist banner. One stream, the *mainstream*, was that founded by Herzl and now led by Weizmann.

The other, the so-called *revisionist current,* was that founded and led by Vladimir Jabotinsky, the mentor of Menachem Begin. In the sound-bite terminology of the present day, the mainstream Zionists could have been called the moderates and the revisionist Zionists the extremists.

In reality, and as we shall see in a moment, there was only one thing that made the revisionists different from the mainstream.

From its beginning in 1897 mainstream Zionism had lied about its true purpose and the implications of it for two main reasons.

One was the need to avoid provoking too much Arab hostility too soon. After the Balfour Declaration, Weizmann himself led a campaign to try to dispel Arab suspicion of Zionism's real intentions. He said that Arab fears about being ousted from their present position indicated "either a fundamental misconception of Zionist aims or the malicious activities of our common enemies."[8] Weizmann even visited Hussein's son Faysal in his camp near Aqaba to give the Arab leader assurance that Zionism was "not working for

From its beginning in 1897 mainstream Zionism had lied to deceive both Arabs and Jews about its true purpose and the implications of it.

the establishment of a Jewish government in Palestine."[9]

The other and more important reason for mainstream Zionism's tactical lie was to do with the need to mislead and deceive Jews, in Western Europe and North America especially, about Zionism's real intentions.

If from the beginning the Zionists had publicly declared that their real intention was to create a Jewish state in Arab Palestine, they might well have failed to sustain enough momentum in the pre-holocaust period to keep their cause alive. Most if not all the Jews who had taken the Haskala route to security and settled in Western Europe and North America were not remotely interested in the idea of uprooting themselves again and resettling anywhere, not even in Palestine. And most, if they had been aware of Zionism's true intention and the implications of it, would have said something like the following to themselves: "We Jews, because of our history of persecution, are the very last people on earth who ought to become the persecutors of others. What the political Zionists are proposing is immoral. We want no part of it."

As we have seen, the relatively few influential Western Jews who were aware of Zionism's true intention, and who had thought through for themselves the terrifying implication of it, were initially opposed to there being a Balfour Declaration. They, Montagu especially, feared that whatever it might say, and however much their inputs to the final version might limit Zionism's ambitions, Zionists would still make use of it to give spurious legitimacy to their unstated state enterprise.

When the possibility of a Balfour Declaration became a real one, and while discussions about what it should say went on, Nahum Sokolow led the Zionist campaign to persuade the most influential anti-Zionist Jews that their fears about Zionism's intentions were misplaced, and that they should drop, or at least remain silent about, their opposition to a Balfour Declaration. Sokolow, who was later to enjoy a spell as President of the WZO, was Weizmann's closest collaborator in negotiating the Balfour Declaration. He removed or diluted enough of the doubts of troubled Jewish community leaders to guarantee there would be no unmanageable Jewish opposition to the Declaration; and he did it by lying to them. Pretending that political Zionism was the sinned against party, he told his listeners: "It has been said and is still obstinately being repeated by anti-Zionists again and again, that Zionism aims at the creation of an independent Jewish state. But that is wholly fallacious. The Jewish state was never a part of the Zionist programme."[10]

In the closed Jewish circle in which he was operating, Sokolow felt himself free to indicate that he was prepared to make life difficult for anti-Zionist Jewish leaders who sought to block the issuing of a Balfour Declaration. The truth was that no wealthy and influential Jews, not even the most ardent anti-Zionists, wanted to give Sokolow the opportunity to accuse them, falsely but effectively, of being against a British declaration that would approve the development in Palestine of the sort of Jewish community Ahad Ha-am envisaged.

When Weizmann got down to writing his own book, he was unable to resist the temptation to hint at how he, Sokolow and other Zionist leaders,

most of them Eastern European in origin, had exploited non-Zionist wealthy Jews of the West in their political and fundraising activities. Weizmann wrote: "Those wealthy Jews who could not wholly divorce themselves from the feeling of responsibility toward their people, but at the same time could not identify themselves with the hopes of the masses, were prepared to give with a sort of left-handed generosity, on condition that their right hand did not know what their left hand was doing. To them the university-to-be in Jerusalem was philanthropy, which did not compromise them; to us it was nationalist renaissance. They would give—with disclaimers; we would accept —with reservations."[11]

The train of thought which leads to the conclusion that Zionism would not have generated a sustainable momentum but for the Nazi holocaust has its starting point in a comment Weizmann made some months before the Balfour Declaration. In April 1917, he said: "The Jews could work (in Palestine) for one or two generations under British protection endeavouring to develop the land as far as possible and counting upon a time when a just tribunal would give them the rest of Palestine to which they have an historical claim."[12]

If that statement reflected Weizmann's private as well as his public thinking, he was naïve and unrealistic. The implied expectation was that as Jewish immigration continued, and diaspora philanthropy funded the development of more and more Jewish communities, there would come a time when Imperial Britain would do Zionism's dirty work—by requiring the Palestinians either to submit to Jewish rule or seek a new life elsewhere in the Arab world. Britain, even perfidious Britain, was never going to do that. (Even if doing so had been Balfour's personal policy preference and an idea with which the British Labour party would flirt).

After the Balfour Declaration and Churchill's 1922 White Paper it was the so-called revisionist Zionists, the honest Zionists, who supplied what was necessary for the fulfilment of Zionism's ambition and the execution of the crime it necessitated.

Jabotinsky saw the Balfour Declaration as providing "a corner of Palestine, a canton." And he asked mainstream Zionism a question: "How can we promise to be satisfied with it?" His own answer was: "We cannot be satisfied... Never... Should we swear to you that we were satisfied, it would be a lie."[13]

A Russian Jew, born in Odessa in 1880, Vladimir Jabotinsky was the founding father of Israel's army. In the beginning it was an underground military organisation formed and led initially by Jabotinsky himself—the Haganah. (The official name of the IDF, Israel Defence Forces, is Tzva Haganah le-Yisra'el. In due course the Haganah would give its allegiance to mainstream Zionism in the shape of Ben-Gurion's in-Palestine Jewish Agency).

Jabotinsky: "We cannot be satisfied... Never... Should we swear to you that we were satisfied, it would be a lie."

Like Herzl, Jabotinsky first came to prominence as a journalist, a career he embarked upon in 1898 as a foreign correspondent for a number of Odessa newspapers. He reported from Berne in Switzerland and then Rome where he studied law. By 1901 his popularity on account of his writing was such that he was recalled to Odessa to become an editorial writer. And it was back in Russia that he obtained his law degree. With his pen he was more than successful. His published works included a novel, Russian translations of Poe and Dante and, eventually, an autobiography.

Early in World War I Jabotinsky was convinced that the decomposing Ottoman Empire was doomed and that Britain would end up with Palestine. He believed that if Zionism could demonstrate its usefulness to Britain in the fighting against the Turks, Britain would reward Zionism by allowing it to colonise Palestine—to create a Jewish state that would be committed to serving the cause of an expanded British Empire. As Abba Achier, one of Jabotinsky's top men in Palestine put it, the Zionists would assist the British to expand their empire "even further than intended by the British themselves."[14]

With another Zionist leader, Joseph Trumpeldor, Jabotinsky petitioned the British government to allow him to form and lead Jewish military units to fight with British army. When the British said "No thanks", Jabotinsky was not put off. He was still determined to demonstrate Zionism's usefulness to the British in action against the Turks. He organised Jewish mule drivers— "the Zion Mule Corps"—to act as ammunition carriers for the British. Later in the war, when Britain did allow the formation of three Jewish battalions, Jabotinsky enlisted and quickly became a lieutenant.

In Hebrew Haganah means defence. When Jabotinsky brought the Haganah into being in 1920, its declared purpose was to defend newly established Zionist settlements. The British army was responsible for that task and Britain-in-Palestine was not prepared to tolerate private armies. The Haganah was outlawed and Jabotinsky was sentenced to 15 years imprisonment with hard labour. But that provoked an outcry and he was quickly reprieved.

Jabotinsky had been developing his own ideas about Zionism for more than two decades. In his analysis the source of Jewish suffering was not merely anti-Semitism but the diaspora (dispersion) itself. The suffering of the Jews could not be relieved until their statelessness was ended. He seems to have assumed that most if not all the Jews in the world would wish to live in a state of their own. The size it had to be in order to accommodate them all or most of them was therefore a major factor in the equation. The Zionist state Jabotinsky favoured was one that would occupy the whole of Palestine on both sides of the river Jordan, with a Jewish army efficient enough to take and keep more Arab land if necessary.

It was Jabotinsky who wrote with brilliant and brutal frankness *The Iron Wall*, the bible of so-called revisionist Zionism and, actually, the main inspirational text for all Jewish nationalists who became Israelis, including those who would not have considered themselves to be revisionists. I am quoting immediately below nine paragraphs from *The Iron Wall* because to

understand Jabotinsky's mindset is to understand how Israel became the arrogant, aggressive and oppressive state it is today (emphasis added):

> There can be no discussion of voluntary reconciliation between the Arabs, not now and not in the foreseeable future. All well-meaning people, with the exception of those blind from birth, understood long ago the complete impossibility of arriving at a voluntary agreement with the Arabs of Palestine for **the transformation of Palestine from an Arab country to a country with a Jewish majority.**
>
> Any native people view their country as their national home, of which they will be the complete masters. They will never voluntarily allow a new master. So it is for the Arabs. **Compromisers among us try to convince us that the Arabs are some kind of fools who can be tricked with hidden formulations of our basic goals. I flatly refuse to accept this view of the Palestinian Arabs.**
>
> They have the precise psychology that we have. They look upon Palestine with the same instinctive love and true fervour that any Aztec looked upon his Mexico or any Sioux upon his prairie. Each people will struggle against colonizers until the last spark of hope that they can avoid the dangers of colonization and conquest is extinguished. The Palestinians will struggle in this way until there is hardly a spark of hope.

Jabotinsky: "Each people will struggle against colonizers until the last spark of hope that they can avoid the dangers of colonization and conquest is extinguished. The Palestinians will struggle in this way until there is hardly a spark of hope."

> It matters not what kind of words we use to explain our colonization. Colonization has its own integral and inescapable meaning understood by every Jew and every Arab. Colonization has only one goal. This is in the nature of things. To change that nature is impossible. It has been necessary to carry on colonization against the will of the Palestinian Arabs and the same condition exists now.
>
> Even an agreement with non-Palestinians (other Arabs) represents the same kind of fantasy. In order for Arab nationalists of Baghdad and Mecca and Damascus to agree to pay so serious a price they would have to refuse

to maintain the Arab character of Palestine.

We cannot give any compensation for Palestine, neither to the Palestinians nor to other Arabs. Therefore, a voluntary agreement is inconceivable. **All colonization, even the most restricted, must continue in defiance of the will of the native population. Therefore, it can continue and develop only under the shield of force which comprises an Iron Wall which the local population can never break through. This is our Arab policy. To formulate it any other way would be hypocrisy.**

Whether through the Balfour Declaration or the Mandate, external force is a necessity for establishing in the country conditions of rule and defence **through which the local population, regardless of what it wishes, will be deprived of the possibility of impeding our colonization, administratively or physically. Force must play its role—with strength and without indulgence.** In this, there are no meaningful differences between our militarists and our vegetarians. One prefers an Iron Wall of Jewish bayonets; the other an Iron Wall of English bayonets.

If you wish to colonize a land in which people are already living, you must provide a garrison for that land, or find some rich man or benefactor who will provide a garrison on your behalf. Or else? Or else, give up your colonization, **for without an armed force which will render physically impossible any attempt to destroy or prevent this colonization, colonization is impossible—not difficult, not dangerous but IMPOSSIBLE! Zionism is a colonizing adventure and therefore it stands or it falls by the question of armed force.** It is important to speak Hebrew but, unfortunately, it is even more important to be able to shoot—or else I am through with playing at colonization.

To the hackneyed reproach that this point of view is unethical, I answer—absolutely untrue. This is our ethic. There is no other ethic. As long as there is the faintest spark of hope for the Arabs to impede us, they will not sell these hopes—not for any sweet words nor for any tasty morsel, because this (the Palestinians) is not a rabble but a people, a living people. And no people makes such enormous concessions on such fateful

**questions, except when there is no hope left, until we
have removed every opening visible in the Iron Wall.** [15]

That, a decade before the Nazis came to power in Germany, was the ideology of what was called revisionist Zionism. Its Big Idea was the application of brute force in order to give the Arabs, when they had been dispossessed of their land, no hope of getting it back. There was to be no consideration of what was morally right or wrong. Compromise was entirely ruled out. It was a "them or us" strategy.

To revise means to examine and correct, to make a new, improved version. The use of the noun revisionist as an adjective to describe the honest current of Zionism has (or could have) a particular implication—that Jabotinsky alone was responsible for turning Zionism into a monster that devoured Palestinian land and rights. In theory there is a case for dumping on Jabotinsky all the blame for what Israel became; but, in fact, it would be a case with big holes in it.

As far back as 1895, two years before he convened the first Zionist Congress in Basle, Herzl, the founding father of mainstream Zionism, committed to his diary his own private thoughts on what would have to be done about the Arab natives of Palestine if Zionism was to achieve its objective of creating a Jewish state. He wrote:

> We shall have to spirit the penniless population across the border by procuring employment for it in the transit countries while denying it any employment in our own country... Both the process of expropriation (of Arab land) and the removal of the poor must be carried out discreetly and circumspectly. [16]

Over the years Herzl's original thinking was developed by honest Zionists in Palestine. Joseph Weitz was the head of the Jewish Agency's Colonisation Department. In 1940 he wrote a secret memorandum headed *A Solution to the (Jewish) Refugee Problem*. It said: "Between ourselves it must be clear that there is no room for both peoples together in this country. We shall not achieve our goal if the Arabs are in this country. There is no other way than to transfer the Arabs from here to neighbouring countries—all of them. Not one village, not one tribe, should be left." [17]

The Jewish Agency's Colonisation Department: "We shall not achieve our goal if the Arabs are in this country... Not one village, not one tribe, should be left."

By 1976 the fact that there were places in Israel where the Palestinian Arabs were either outnumbering Jews or soon would outnumber Jews was the cause of another secret memorandum. This one, submitted to Prime Minister Rabin, was written by Israel Koening, the Northern District Commissioner of the Ministry of the Interior, who had called the

Palestinians in the Galilee "a cancer in the state's body". In Lilienthal's account the Koening Memorandum proposed "to redress the drastic situation by giving the Arabs no more than 20 percent of the available jobs; by changing the selection system to reduce the number of Arab students in the universities and encouraging the channelling of these students into technical professions, physical and natural sciences and thus to leave them with less time for dabbling in nationalism—also to make trips for students easier while making the return and employment more difficult, which is to encourage their emigration." In Ralph Schoenman's account in *The Hidden History of Zionism*, the Koening Memorandum included this: "We must use terror, assassination, intimidation, land confiscation and the cutting of all social services to rid the Galilee of its Arab population."[18]

The Koening Memorandum: "We must use terror, assassination, intimidation, land confiscation and the cutting of all social services..."

As for Jabotinsky's Iron Wall policy, there would be no greater advocate of it than Raphael Eytan. The day was coming when, as the IDF's chief of staff, he would say: "We declare openly that the Arabs have no right to settle on even one centimetre of Eretz Israel... Force is all they do or ever will understand. We shall use the ultimate force until the Palestinians come crawling to us an all fours."[19] And the day was also coming when, before the Knesset's Foreign Affairs and Defence Committee, Eytan would say this: "When we have settled the land, all the Arabs will be able to do will be to scurry around like drugged cockroaches in a bottle."[20]

The only difference between mainstream and revisionist Zionists, the so-called moderates and extremists, was that the latter were always prepared to do whatever was necessary—in defiance of the moral teachings of Judaism and international law—to advance Zionism's cause. The former hoped that the dirty work would be done by Britain. The real division was between truly effective and not-so-effective Zionists.

Eytan: "When we have settled the land, all the Arabs will be able to do will be to scurry around like drugged cockroaches in a bottle."

It might be an error to describe Herzl as the founding father of mainstream or so-called moderate Zionism. The truth might be that Herzl was the founder of the Zionist way proclaimed and executed by Jabotinsky and his heirs and successors; and that their revisionism was necessary only because Weizmann as president of the WZO was, as well as being naïve in some respects, ambivalent about actually doing whatever was necessary to bring a Jewish state into existence; ambivalent because, perhaps, the doing of a terrible injustice to the Arabs troubled his conscience.

Sometimes.

When Jabotinsky wrote *The Iron Wall* he was fully aware that it would be years before the Zionists were capable of taking on and beating

the Arabs in battle. Jews were good at bargaining and banking, but fighters they were not. Not yet.

In 1935, on board a ship taking him to America for a visit, Jabotinsky was recognised by a Jewish communist journalist, Robert Gessner. He asked Jabotinsky if he would consent to an interview that would be published in *New Masses*. Jabotinsky agreed with enthusiasm. In the course of the interview he said it was his intention to speak about revisionism very frankly in America. To Gessner and for publication he said: "Revisionism is naïve, brutal and primitive. It is savage. You go out into the street and pick any man—a Chinaman—and ask him what he wants and he will say 100 percent of everything. That's us. We want a Jewish Empire."[21]

There is a case for saying that, after the Balfour Declaration and before Britain obtained from the League of Nations endorsement of its Mandate for Palestine, President Wilson might have been able to prevent the doing of a terrible injustice to the Palestinians if he had not suffered a stroke.

> **Jabotinsky: "Revisionism is naïve, brutal and primitive. It is savage. You go out into the street and pick any man—a Chinaman—and ask him what he wants and he will say 100 percent of everything. That's us. We want a Jewish Empire."**

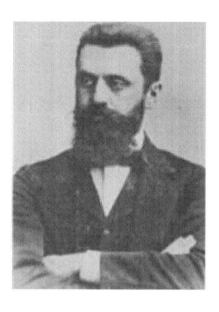

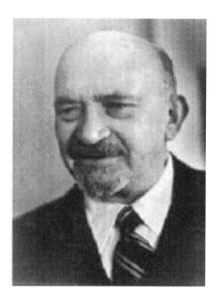

Theodore Herzl
Political Zionism's Founding Father

Chaim Weizmann
Political Zionism's Master Diplomat

Ahad Ha-am
Conscience of Spiritual Zionism,
Scourge of Political Zionism

David Ben Gurion
The Zionist's state's founding
father and first Prime Minister

Arthur Balfour
*British Godfather of the
Zionist State, modern Israel*

Edwin Samuel Montagu
*"Jewish Englishman", British Cabinet
Minister who opposed a state for Jews*

Vladimir Jabotinsky
Founding Father of Zionist militarism

President Woodrow Wilson
*Couldn't stop Britain and Zionism
sewing the seeds of catastrophe*

President Franklin D Roosevelt
Troubled by Zionism and not in
favour of a Jewish State

King Ibn Saud
Saudi Arabia founder who warned the
US about making enemies of the Arabs

Bernard Mannes Baruch
Jewish American advisor to Presidents
with great influence for Zionism

King Abdullah of Jordan
Annexed part of Palestine to
prevent Israel taking it

7

AMERICA RETREATS FROM THE MORAL HIGH GROUND

The Arabs did have reason to put their trust in America's good intentions as they were represented and presented by President Wilson,and to believe he would see to it that Britain honoured its promise to them.

Woodrow Wilson was a man of many abilities who wanted to use the power of the presidency to change the world for the better, and who really believed that doing so was a mission possible.

It can also be said that few if any American presidents before or since were as highly qualified as Woodrow Wilson for public service - to the world as well as the Land of the Free. He was a political scientist and historian by training but his thinking was the product of his heart as well as his mind. He received his Ph.D. after advanced studies in government and history at Johns Hopkins University. After serving the Princetown faculty as professor of jurisprudence and political economy, he was chosen to be the president of that most prestigious university. Unlike so many academics he was able to communicate his ideas vertically. I mean that he could talk down his highest ideas for understanding by those on lower intellectual levels. His academic lectures, like all of his public addresses and published writings, were characterised by what others described as "clarity of presentation and brilliance of phrasing."[1] He also had broad cultural interests. To those who worked sympathetically with him and under him he displayed "a magnetic personality." He was genial, humorous and considerate. From his sympathetic subordinates he received admiration and affection.

But what made President Wilson a chief most worthy of being hailed was something much more than the extent and the quality of his vision about how the world ought to be—if it was to be managed for the benefit of the whole of mankind and not just the few in the most wealthy and powerful nations. He believed, really believed, that the President should be the leader and not the follower of public opinion.

Before the Europeans went to war, the guiding principles of the foreign policy President Wilson wanted to pursue were these: a refusal to

exert America's material power against weaker nations; a belief that the rights and interests of small nations should be respected; and the view that peoples then dominated by the big European powers should be set on the road to self-determination.

The foreign policy principles President Wilson wanted to pursue: refusal to exert America's material power against weaker nations; respect for the rights and interests of small nations; and self-determination for peoples then dominated by the big European powers.

But President Wilson failed, not for the want of trying, to deliver on his principles.

Because of that failure America would become with time the leading supporter of Israel right or wrong; a fact of international life that allowed the Zionist state to behave without regard for international law and, along the way, to pursue, with an arrogance to match its overwhelming military might, expansionist policies which heaped humiliation after humiliation upon all Arabs and the entire Muslim world. The phenomenon of anti-Americanism has its origins in America's retreat from the moral high ground in 1919.

Whether the retreat would have happened if President Wilson had not suffered a stroke at a critical moment is a good question.

The story this chapter tells is how neutral America was forced into war after President Wilson's mediation to bring it to an early end had been accepted by Germany and rejected by Britain and France; and how, then, America ended up going along with British policy for the Middle East—a policy President Wilson did not favour because it was in opposition to his deeply held principles and his ideas for creating a New World Order out of the ruins of the Old.

America proclaimed its neutrality on 4 August 1914, the same day as Britain declared war on Germany.

With Europe on the road to madness (as in non-nuclear Mutually Assured Destruction), Americans were doggedly united in their wish not to be involved in Europe's war unless American rights were violated.

Two weeks after the formal proclamation of neutrality, President Wilson made a direct appeal to his people. He asked them to remain neutral in thought as well as behaviour. His most passionate desire was to bring the war in Europe to the earliest possible end through his personal and secret mediation. For that purpose he was determined to be seen by each and all of the warring parties in Europe as a truly impartial mediator.

His initial offers to mediate were rejected by both Britain and France and by Germany.

Then, early in 1916, President Wilson sent Colonel Edward M. House to Europe to try to persuade Britain and France to be serious about giving his secret mediation a fair chance. Wilson had reason to believe that he could persuade Germany to do so. House was authorised to tell the British Foreign Secretary, Sir Edward Grey, that the President, "on hearing from Britain and France that the moment was opportune", would propose

a conference to end the war.[2] In the hope that he was making Britain and France an offer of mediation they could not refuse, Wilson authorised House to say that if the Allies accepted his proposal and Germany refused it, the United States "would probably enter the war against Germany."

On 22 February 1916, the outcome of the secret discussions in London was the House-Grey Memorandum. It stated that America might enter the war if Germany rejected Wilson's mediation, but it also said Britain was reserving her right "to initiate American mediation."

President Wilson could not have been pleased. Effectively he had been rebuffed by the British. Thereafter he pressed Grey to initiate American mediation because he knew that German Chancellor Theobald von Bethmann Hollweg (hereafter Bethmann) was in favour of it. Britain and France continued to say "No" to Wilson's mediation but Chancellor Bethmann said "Yes".

In Germany from the summer of 1916 Chancellor Bethmann advocated a negotiated peace despite the fact that his own militarists were pressing him to allow them to escalate the war, by resorting (actually returning) to unrestricted submarine warfare. Bethmann was aware that if any neutral American vessel was attacked and American lives were lost, President Wilson would probably be obliged to declare war on Germany and join the Allied camp. Bethmann did not want to provoke that. (Germany's militarists had resorted to all-out submarine warfare at a very early point in the conflict, but Bethmann under pressure from Wilson had persuaded them to call it off).

Bethmann was then informed that he would have to be patient because President Wilson had to take time out of his mediation effort to get reelected. With great difficulty the German Chancellor succeeded in postponing a decision to return to unrestricted submarine warfare.

Wilson was re-elected on 7 November but he let a month pass without doing anything to press upon the British his case for mediation. In that month Bethmann lost patience with Wilson. He did so because he came under irresistible pressure from his militarists. To delay further the unleashing of the unrestricted submarine warfare they wanted, Bethmann had to do a deal with them. It was that instead of waiting for President Wilson to act, Germany would announce its own peace proposals and, if the Allies rejected them, the German submarine fleet would be given unlimited freedom without further discussion.

On 12 December Germany announced the terms of its own peace offer. They were so unfavourable to Britain and France that they were bound to be rejected. They were. Unfortunately, Bethmann had played the last card in his struggle to keep his own militarists in check.

President Wilson was in despair. On 18 December he invited both belligerent camps to state their war aims and the terms on which they were prepared to end the conflict. This, Wilson hoped, would be, at last, the prelude to negotiations for peace. The Allies were annoyed by Wilson's initiative and offered terms too sweeping for the Germans to accept. The Germans suspected collusion between President Wilson and the Allies

but still agreed in principle to the opening of negotiations, while keeping their own unacceptable offer of 12 December on the table as a bargaining chip. But no further progress was made and that initiative was dead by the middle of January 1917.

There was collusion between neutral America and Britain but it had taken place behind the President's back. The British had been secretly encouraged by President Wilson's Secretary of State, Robert Lansing, to put forward terms that would guarantee Germany's rejection of the President's mediation.

President Wilson, real leader that he was, responded with what amounted to a pre-emptive policy strike against those in his own camp who were playing games with Britain and, in the President's view, had compromised the neutrality he valued so highly.

Wilson's pre-emptive strike, on 22 January 1917, was in the form of a remarkable address to Congress. In it President Wilson made a dramatic appeal, this time not only for negotiations to end the great European war then taking its remorseless course and terrible toll, but for negotiations to end the fighting on terms that would lead to a just and lasting peace. It was not a speech any politician who happened to be President could have made. It was the speech of a real, towering statesman, a true giant among men.

The essence of the message was the need for "peace without victory."[3] What did that mean?

President Wilson said that if the eventual victors of World War I imposed harsh and humiliating terms on the vanquished, the inevitable consequence would be, at some point, World War II. If negotiations to end the first one were to lead to an enduring peace, it followed that they should not result in settlement terms that violated the rights of either side. In other words: If the British and their Allies were to win and then rubbed German noses in the excrement of their defeat, the predictable consequence would be another great conflict. (And vice versa if the Germans won). Thus the need for "peace without victory." It was not just a clear vision, it was a most prophetic warning.

With that Wilsonian message there was a proposal for the creation of a world body to be called the League of Nations. It was to be the vehicle through which the governments of nations, led by the "major forces", would co-operate to maintain peace and "make the world safe for democracy". Wilson believed that the League of Nations was essential and needed to be created as a matter of urgency, as part of the peace-making process that would take place in Paris as soon as the fighting could be stopped. Lansing wanted the creation of the League of Nations to be postponed: and when the moment came he was opposed to the idea of President Wilson attending the Paris Peace Conference. When the President ignored his Secretary of State's advice and insisted on leading the American delegation to the Paris Peace Conference himself, the two men were on a collision course. Unfortunately Woodrow Wilson was not adept at dealing with those he did not like or trust and those who opposed him.

My reading of events in perspective is that knowledge of Lansing's collusion with Britain and Zionism made President Wilson aware that if he did not remain in complete control of his agenda and if he did not secure the widest possible public sympathy for his vision of a New World Order, it would be sabotaged by powerful American vested interests in collusion with Britain-and-Zionism.

In that context President Wilson, with his 22 January address to Congress, was going over the heads of his own and other political and military Establishments—the governing elites of the Old Western Order— and was appealing directly to the people of the world for support for his vision of a New World Order. By doing so he was hoping to generate sufficient popular momentum to prevent the implementation of his vision being sabotaged.

In its section on the History of the United States, *Encyclopaedia Britannica* puts it this way: "In one of the most ambitious rhetorical efforts in modern history, President Wilson attempted to rally the people of the world in a movement for a peace settlement that would remove the causes of future wars and establish the machinery to maintain peace." In my view President Wilson was looking upon his pre-emptive strike on 22 January 1917 as an insurance policy.

Worthy of note here to complete the background understanding is the fact that Woodrow Wilson's early training—that which made him more qualified for public service than probably any other President before or since—had included detailed study of the American decision-making process in action. As an undergraduate he had written and published a skilful and critical analysis of the committee system of the U.S. Congress. His clear, precise and scholarly doctoral dissertation, published in 1885, had the title, "Congressional Government". As a result of his studies Wilson was completely aware that the Congressional committee system was open to abuse by powerful lobbies whose prime concern was not the public interest. A man as informed as Woodrow Wilson about how The System really worked did not need experience in the highest office to tell him that the power of the presidency had limits other than those imposed by constitutional checks and balances; and that there were ways short of assassination to stop a president doing what he believed to be right. (There would come a time when some distinguished Americans would acknowledge that the U.S. has "the best democracy money can buy". In President Wilson's day the extent to which America's version of democracy would be for sale, to Zionism especially, was probably not foreseeable. My point for now is only that President Wilson was informed and wise enough to know that he needed an insurance policy).

The Wilson address of 22 January did, in fact, elicit a confidential response from Britain expressing a readiness to accept the president's mediation. Whether Britain was serious or was only playing a game to reduce Wilson's irritation is not known to me. But it was too late. Germany had passed the point of no return. Its submarines had already been let off the leash to do their unlimited worst and were heading for their first targets. They struck on 1 February (1917).

President Wilson responded by breaking off diplomatic relations with Germany, but he was still determined to keep America out of the war. He announced that he would accept unrestricted submarine warfare against belligerent merchant ships and would act only if American vessels were sunk. In early March he put arms on American ships in the hope that this would deter German submarine attacks on them. On 18 March three American merchant ships were sunk. On 6 April America declared war on Germany and joined the Allies.

When the German submarines were let off the leash it was no secret that America was unprepared and ill-equipped to go to war in Europe, and that the mobilisation of America's industrial, financial and manpower resources would take time to organise. That being so, Germany's militarists had concluded that America would not be able to mobilise for war on a scale big enough and in time enough to change the balance of power, in the waters around the British Isles especially, before Britain would be obliged to surrender.

It was not, in fact, until the spring of 1918 that the American people and their economy were harnessed for total war. And that, everyone in America agreed, was a "near miracle" given how unprepared and ill-equipped the U.S. had been when it declared war.

As it happened the mobilisation in America took place in two distinct phases.

From the declaration of war until November 1917, Wilson's administration relied mainly on voluntary and co-operative efforts. That was phase one or what might be called the pre-Balfour Declaration phase.

In phase two, from December, the government moved with fierce determination to establish complete control over every important aspect of economic life. The railways were nationalised; a war industries board established ironclad controls over industry; food and fuel were strictly rationed; an emergency corporation began construction of a vast merchant fleet; and a war labour board used coercive measures to prevent strikes. And, in the Land of the Free, opposition to the war was sternly suppressed, first by the Espionage Act of 1917, then by the even more severe Sedition Act of 1918. It's reasonable to suppose that President Wilson became more and more alarmed on account of the repressive legislation being enacted in the name of suppressing dissent and opposition to the war. He was in politics to extend the freedom of citizens, not to place limits on the amount of it they already had.

America's military contribution to the winning of the war was small compared to that of the other main Allies, but it was decisive in one respect and helpful in another. The U.S. Navy provided the ships that assisted Britain to overcome the German submarine threat. On the western front the main impact of the infusion of American ground forces—up to 1,200,000 by September 1918—was a psychological one. The escalating number of American forces had the effect of speeding up the breaking down of the German army's morale and will to fight on; and the consequence of that

was Germany's surrender a year earlier than Allied military commanders had anticipated.

Given Churchill's admission that Britain expected and received valued and important assistance from the Zionists in return for giving them the Balfour Declaration, the following (picking up from where I left the subject in Chapter Four) is a necessary question. In the "in America" scenario of Neumann's statement, what assistance were the Zionists expected by Britain to provide, and what assistance did they actually provide?

There are some clues.

By 1 April 1917, when the German submarine threat was at its greatest and the British Admiralty was entertaining the prospect of surrender, the Allies had exhausted their means of paying for essential supplies from America. Without huge loans Britain would not have been able to sustain the war. My guess is that the Zionists were expected to use their influence to see to it that Britain got the loan funding and other credits it needed. (And which Britain is still today repaying).

Could Lawrence have been right when he said the Zionists were rewarded for "bringing America into the war"?

The issue was, apparently, clear-cut. If German submarines attacked and sank neutral American vessels, the U.S. would declare war. As it happened, there was a delay of three weeks minus one day between the sinking of the three American vessels and the U.S. declaration of war. Why the delay? Short answer—America's almost total unpreparedness for war.

Before he could declare war, President Wilson had to be certain that he could mobilise the vast financial and industrial resources necessary to provide the U.S. with the munitions—not just ammunition and guns, but tanks and other armoured vehicles of all kinds, aircraft of all kinds and ships of all kinds. Establishing whether or not such vast financial and industrial resources could actually be mobilised and harnessed, against the clock and on a sustainable basis, was not something that could happen overnight. And putting everything together, if it could be done, was a job for only the most remarkable man. He needed to be wealthy in his own right (wealth being the measure of personal success needed to impress others), extremely well connected to financial and industrial America, and to be, in addition, a deal-maker, motivator and organiser second to none.

That man, the one most responsible for the "near miracle" of America's mobilisation for war against the clock, was Bernard Mannes Baruch. He was a Jewish American gentleman who would be described in retrospect and with remarkable brevity by the *Encyclopaedia Britannica* as a "financier known as an adviser to U.S presidents." The *Britannica* noted that the designation "elder statesman" was applied to Baruch "more often than to any other American."

So who, really, was Baruch? What was the stuff of which his behind-closed-doors legend was made?

After graduating from the College of the City of New York in 1889, Baruch started his working life as an office boy in a linen business. Then

he became fascinated by Wall Street. He worked in several brokerage houses on it and, over the years, amassed a fortune as a stock market speculator. In 1916 he was appointed by President Wilson to the Advisory Commission of the Council of National Defence. On the face of it a curious appointment. What relevance to National Defence was experience in the linen industry and success as a stock market speculator? Subsequently he became chairman of the War Industries Board and in that capacity he was, so to speak, Mr. Mobilisation. (In 1919 he was also a member of the Supreme Economic Council at the Paris Peace Conference and served as a personal adviser to President Wilson on the terms of the peace. Nearly two decades later it was Baruch, as reported by Walter Lippman, who coined the phrase Cold War).

In retrospect there is a case for saying that Baruch was, in effect, one of the two trump cards in Zionism's hand when it was negotiating with the British for the Balfour Declaration, (the other being its influence in revolutionary Russia).

Given that Britain "expected" important assistance from Zionism, there must have been a moment when the British said to the Zionists, "What can you do for us that will influence the situation in America?" At the time the question was asked the British would have been completely aware that the U.S., without an extraordinary effort to mobilise its financial and industrial resources for war, was in no state to assist Britain and its allies.

My speculation is that the Zionists replied to the effect that they had people in positions of influence—they may or may not have named Baruch—who could see to it that America performed as required.

Another possible explanation for the delay between the sinking of the three American merchant vessels and the U.S. declaration of war is that the clamour in America for war was not spontaneously overwhelming and had to be worked up. It could have been that the Zionists, assisted by their influential and unquestioning supporters in the media, were expected by Britain to play, and did play, an important role in the creation of a pro-war atmosphere that left a reluctant President Wilson with no choice.

There is no way of knowing precisely what Lawrence really meant when he said the Zionists were rewarded for "bringing America into the war." If he meant that the U.S. might not have been able to mobilise in time enough to assist Britain in her darkest hours without the influence and efforts of American Jewry as organised by the Zionists, I think he might have been right.

My research for this book led me to the conclusion that Bernard Mannes Baruch was, quietly, the single most influential Jewish American of his time—1870 to 1965. (The story of his influence continues in Chapter Twelve—Forrestal's "Suicide").

From the moment President Wilson was committed to war he displayed outstanding qualities of leadership on that front, too. But he continued to enlarge and explain his vision for peace as the war progressed.

He constantly stressed that, so far as America was concerned,

the war was "a crusade on behalf of freedom."[4] What he had in mind, as he frequently indicated, was not just the overthrow of the German government and the liberation of the German nation, but the freedom of peoples under foreign rule throughout the huge area of conflict and by implication everywhere. Not a message the imperial British (or the French) wanted to hear.

President Wilson became deeply frustrated by the refusal of Britain and France to join him in issuing a common statement of war aims. On 8 January 1918, unable to contain his frustrations any longer, he decided to go—philosophically, politically, strategically and morally—for broke. On that day he delivered to Congress the most breathtaking of his pre-emptive policy strikes. This one in the form of an address on his Fourteen Points. They were his definitive statement to the people of America and the world of what he believed to be the essential basis of a just and lasting peace.

In point (1), which was about "the renunciation of secret diplomacy", President Wilson was as good as reading the riot act to imperial Britain and France. How so?

He had been much influenced by the British radical tradition of the 19th century. Throughout it, British radicals had criticised secret diplomacy and called for a foreign policy based on morality rather than expediency, and on general ethical principles rather than short-term calculations about the balance of power. President Wilson shared the view of those who believed that old style secret diplomacy was the maker of sinister secret international agreements which committed their countries to war without the knowledge of their citizens. Thus, when he unveiled his Fourteen Points, President Wilson stressed the need for "open covenants of peace openly arrived at, after which there shall be no private international understandings of any kind, but diplomacy shall proceed always frankly and in the public view."[5]

President Wilson's hope was that the League of Nations, when it came into being as envisaged in point (14), would oversee a new system of international relations in which diplomatic bargains and secret military agreements would be abolished, and international relations would be conducted by consensus before the eyes of the public and under their control. If that had happened, Zionism could not have triumphed.

For governments one of the good things about secret diplomacy was that their diplomats could make agreements and promises of all kinds which could be broken at will. The need, President Wilson was saying, was for a new style of open diplomacy that would leave no scope for disputes about what had been agreed, which in turn would mean that violators of agreements could be punished. (One of the small things Trotsky did as foreign minister, and which caused big embarrassment for Britain and France, was to order the publication of the secret treaties entered into by the Tsar's regime with Britain and France).

For the Arabs the comfort and inspiration was in point (12). Included in it was the statement that those then under Turkish rule (the Arabs fighting on the side of the Allies) should be assured of an "absolutely unmolested opportunity of self government."[6] By definition though unstated that was "unmolested" by Britain-and-Zionism.

Then, on 4 July 1918, America's own Independence Day, in a speech at Mount Vernon, Wilson said that one of America's primary aims when it entered the war was: "The settlement of every question whether of territory, sovereignty, of economic arrangement or of political relationship, upon the basis of free acceptance of that settlement by the people immediately concerned, and not upon the basis of a material interest or advantage of any other nation or people which may desire a different settlement for the sake of its own exterior influence or mastery."[7]

The soaring idealism of Wilson's Fourteen Points was regarded by many as the signal that America had taken the moral high ground.

That statement of magnificent and soaring idealism was regarded by many, not just the Arabs, as the signal that America had taken the moral high ground and was intending to use its power and influence on the world stage from that lofty position.

But even as President Wilson was unveiling his Fourteen Points and following up with the Mount Vernon speech, Britain was in the process of doing in secret its deal with France (over the carve-up of the Turkish empire), which would make a nonsense of the President's principles.

With the passage of time and the release of classified documents, it is possible to work out when and how things went wrong for President Wilson in the Middle East.

At the start of the Paris Peace Conference President Wilson's own first priority was the creation of the League of Nations as the world body to manage the peace and see to it that there would be no more major wars. He achieved an early triumph at the conference in winning acceptance of the principle that a League of Nations should be created, and that its Covenant would be an integral part of the peace treaties. But to get British support for the creation of the world body, President Wilson had to concede that Britain would not be prohibited from pursuing its interests in the Middle East, in part for the purpose of honouring its commitment to Zionism.

On the face of it President Wilson ought not to have made such a concession to Britain-and-Zionism because it was against the spirit of the fundamental principles of his Fourteen Points and his Mount Vernon speech. If his policy was to be consistent with them, the right of the "liberated people" of Palestine to self-determination could not be compromised by the imposition on them of the alien thing called Zionism. (At the time the Arabs were, of course, the overwhelming majority of the "liberated people" of Palestine and most of the minority Jewish community, by definition Palestinians too, were not supporters of Zionism).

The assumption has to be that President Wilson made the concession to Britain in the belief that he could prevent the doing of an injustice to the Arab majority in Palestine provided the League of Nations was established with America fully engaged in its business. On that basis he could have told himself that though he appeared to be giving in to Britain-and-Zionism, thereby making a nonsense of his own principles for

the sake of getting the League of Nations up and running, he would not be doing so in practice. In other words, the problem of Britain's commitment to Zionism, a commitment the President knew that Britain had had no right to make and was without legal standing, was manageable—provided, it bears repeating, that America had an appropriate say in determining and implementing the policies of the League of Nations.

In March, while the haggling at the Peace Conference was continuing, there were the first public signs (for the few who knew how to read them) of the struggle that was underway to determine who would have most influence on President Wilson—anti-Zionist Jewish Americans or Zionism's American supporters and their British allies.

The Peace Conference initiated a struggle to determine who would have most influence on President Wilson—anti-Zionist Jewish Americans or Zionism's American supporters and their British allies.

On the third day of the previous month, with Weizmann leading their delegation, the Zionists had formally presented their petition to the Peace Conference. Britain had guaranteed them their moment. The Zionist petition called on the victorious Allied Powers to recognise the "historic title" of the Jews of the world to Palestine. (It was then that Weizmann made his statement that "Palestine is to become as Jewish as England is English.") In effect the Zionists were asking each and all of the victorious powers to endorse the Balfour Declaration and for it to be implemented without further undue delay, in accordance with a programme the Zionists would draw up for unrestricted Jewish immigration to Palestine. For public consumption Zionism's official line (and lie) was still that it was seeking something less than an independent Jewish state.

Then, on 5 March, the *New York Times* revealed that 30 of the most prominent and outstanding Jewish Americans had signed a petition to President Wilson. It had been presented to him on their behalf—he also signed it—by San Francisco's Congressman Julius Kahn.

Though the term was not used, it was a fiercely anti-Zionist petition. Those who signed it included Cleveland's E.M. Baker, President of the Stock Exchange; Simon W. Rosendale, former Attorney General of New York; Adolph S. Ochs, publisher of the *New York Times*; and Henry Morgenthau Senior, former Ambassador to Turkey.

These petitioners and their associates feared that Zionism's presentation to the Peace Conference of its claim of "historic title" to Palestine might lead to a U.S. commitment to the Zionist cause. A fear that was to be reinforced by Balfour's memorandum stating that the major powers were committed to Zionism "right or wrong".

In their petition the anti-Zionist Jewish Americans warned against any U.S. commitment "now or in the future to Jewish territorial sovereignty in Palestine." Such a demand, the anti-Zionists said, "not only misrepresented the trend of the history of the Jews who ceased to be a nation 2,000 years

ago, but involves the limitation and possible annulment of the larger claim of Jews for full citizenship and human rights in all lands in which those human rights are not yet secure."[8]

Here again (echoing Montagu) was an expression of the gut fear that was the prime motivation of Jewish anti-Zionism. If a Jewish state did come into being in Palestine (or anywhere else for that matter), its very existence might provoke anti-Semitism everywhere else—i.e. by giving the non-Jewish majority peoples of the lands in which the Jews who had taken the Haskala route to salvation had settled the opportunity to say to the Jews among them: "We really didn't want you here. We don't want you to remain here. Now you've got no reason to stay here. Go to your state."

The indication of the gut fear was the repudiation in the petition of "every suspicion of double allegiance which is necessarily implied in, and cannot by any logic be removed from, the establishment of a sovereign state for Jews in Palestine."[9]

I do not mean to suggest that self-interest was the only motivation of those prominent Jewish Americans and Jewish Englishmen and others who openly opposed Zionism. I mean only to say that self-interest born of the gut fear was a prime motivation. The most prominent and the most informed anti-Zionist Jews were also deeply concerned by their knowledge that a Jewish state in Palestine could only be constructed on an injustice to the Arabs and was bound to be the source of great conflict between Arabs and Jews.

The anti-Zionist petition to President Wilson also contained this statement:

> It is not true that Palestine is the national home of the Jewish people, and of no other people... To subject Jews to the possible recurrence of such bitter and sanguinary conflicts, which would be inevitable, would be a crime against the triumph of their whole past history and against the lofty and world-embracing visions of their great prophets and leaders... Whether the Jews be regarded as a 'race' or as a religion, it is contrary to democratic principles for which the World War was waged to found a nation on either or both of these bases.[10]

In effect the prominent anti-Zionist, Jewish Americans were saying to their President: "If you really believe in the principles you have proclaimed to be the guiding lights of your policy for changing the world for the better, there's no way you can give Zionism the commitment it is demanding. If you are serious, and we think you are, you must tell the Zionists to go to hell."

Doing so was, actually, President Wilson's own personal and private inclination. And Zionism's leaders knew that.

President Wilson took the anti-Zionist petition to Paris with the intention of making the best possible use of it.

The response of Zionism's leaders was in the form of another newspaper story. According to it, President Wilson had "expressed his personal approval" of Zionism's claim that the Jews of the world had "historic title" to Palestine and, furthermore, the President had been "persuaded" that the Allied nations, "with the fullest concurrence of the American government", should "lay the foundation of a Jewish Commonwealth in Palestine."[11]

To those who understood the terminology, Commonwealth implied government. If the report was an accurate representation of President Wilson's real position, he had made not only a complete nonsense of his own principles with regard to self-determination for liberated peoples (in this case the liberated people of Palestine), he had committed himself to the creation of a Jewish state.

In fact it did not matter whether the report was true or false. If the President did not publicly deny the pro-Zionist policy that had been attributed to him, the Zionists could assert without challenge that he had come down on their side.

In the light of subsequent events it is reasonable to assume that the Zionists had calculated that it would be difficult and probably impossible for President Wilson to deny the report, because to do so might create problems with Britain which could endanger the President's priority—getting the League of Nations up and running.

Some of the Peace Commissioners in Paris were so amazed by President Wilson's apparent reversal that they doubted the authenticity of the report; and through Secretary of State Lansing—Wilson had returned to Washington—they asked the President to make a statement about his real position on Palestine. Was it or was it not consistent with his Fourteen Points and his Mount Vernon speech? Was the report suggesting that he had changed his position, at least with regard to Palestine, authentic or not?

On 16 April President Wilson issued the following statement to the Peace Commissioners—a document that was not made public for 55 years.

> Of course I did not use any of the words quoted in the enclosed, and they do not indeed purport to be my words. But I did in substance say what is quoted, though the expression foundation of a Jewish Commonwealth goes a little further than my idea at that time. All that I meant was to corroborate our expressed acquiescence in the position of the British government in regard to the future of Palestine.[12]

By using the word "acquiescence" President Wilson was as good as saying: "I did not want to support Britain's position but I had to do so because I needed British support for the creation of the League of Nations."

A clue to President Wilson's real but publicly unstated position on Zionism was in a remark he made to some of the Peace Commissioners in Paris on 22 May. He said he had never been able to see by what right Britain gave Palestine away to anyone. Since it was not anyone but the Zionists to whom Britain was intending to give at least a part of Palestine,

the President's meaning was not open to misinterpretation. The clear implication was that President Wilson did not believe the Zionist claim to Palestine deserved to be taken seriously; and would be the cause of big trouble if it was.

The conclusion invited by the President's carefully worded statement was that the report to which he had been required to make a response was a deliberate misrepresentation of his position, for the purpose of committing him, so far as the public perception was concerned, to an agenda for Palestine that was not his own.

As we shall see in Chapter Eight, there was to be opposition in Britain to the idea of incorporating the Balfour Declaration into the British Mandate for Palestine. My guess is that the Zionists saw this opposition coming and concluded that Britain might not implement the Balfour Declaration. And that, I believe, is why the Zionists and some of their supporters in the media conspired to produce the report that was intended to commit President Wilson and so America to their agenda. If the British were going to let them down, their cause would be a lost one if they could not assert that President Wilson supported it.

The gain the Zionists expected to make from having the freedom to assert that President Wilson was on their side (and by implication against the 30 prominent Jewish American petitioners who had urged him to say "No" to Zionism) had to do with numbers.

At the time even the Zionists themselves were not claiming to have the support of more than 150,000 Jewish Americans out of a total 3.5 million Jews in America. Which probably meant, at the time, that the prominent anti-Zionists who signed the petition to President Wilson were speaking for the overwhelming majority of Jewish Americans. But with the freedom to assert that President Wilson was in favour of their enterprise, the Zionists could be certain that the number of Jewish American recruits to their cause would grow. And growth in numbers meant political momentum. The more Jewish Americans endorsed Zionism, the greater Zionism's ability to influence the political process with votes and campaign funds would become.

The prominent anti-Zionists who signed the petition to President Wilson were speaking for the overwhelming majority of Jewish Americans.

Despite his expressed acquiescence in the position of the British government with regard to the future of Palestine, President Wilson was not reconciled to the idea of doing an injustice to the Arabs. And he did, in fact, take a major initiative that was designed to prevent injustice being done.

After his Mount Vernon speech, the Arabs proposed that the Allies send a commission of inquiry to ascertain the wishes of the people of Syria including Palestine (and also Iraq). President Wilson supported this suggestion but Britain said "No" (having previously promised the Arabs they would be consulted): and, with the assistance of a French "Non" to consulting the Arabs, the idea of an Allied commission died a quick and

unnatural death.

Then, after the attempt to manoeuvre him into becoming an unquestioning standard bearer for the Zionist cause, President Wilson decided to appoint and send an American commission of inquiry. My guess is that President Wilson was privately outraged by Balfour's memorandum which asserted that the victorious Allied Powers, not just Britain, were committed to Zionism "right or wrong".

The principals of the American commission were Dr. Henry C. King, President of Oberlin College and Charles R. Crane, an industrialist. The King-Crane Commission spent six weeks on location listening and taking evidence.

Then an astonishing thing happened.

The substance of the report of the Commission's findings was kept secret, suppressed, for more than two years—until Britain and France had got what they wanted from carving up the Turkish Empire. What they wanted and what they got in July 1922 was endorsement by the League of Nations of their Mandates to rule in place of the Turks.

When, late in December 1922, former President Wilson gave permission for the King-Crane Commission's report to be published, it was obvious why Britain-and-Zionism (and France) had opposed the idea of an Allied inquiry into what should happen in the Middle East if right was to be allowed to prevail over might. The report said:

> No British officer consulted by the Commissioners believed that the Zionist programme (of unlimited Jewish immigration to Palestine) could be carried out except by force of arms... only a greatly reduced Zionist programme should be attempted ... and then only very gradually initiated.[13]

King and Crane noted with remarkable frankness that they had been predisposed to Zionism at the start of their inquiry; but, they said, reality on the ground in Palestine had caused them to call for a serious modification of the Zionist programme of unlimited immigration. "The actual facts in Palestine coupled with the force of the general principles proclaimed by the Allies and accepted by the Syrians" had driven them to new recommendations.

Their main recommendation was that Syria should not be the subject of three or even two Mandates. There should be only one Mandate for it including Palestine, with Lebanon having autonomy within that framework. In short the King-Crane Commission report endorsed, before it was too late, the programme of the first Arab Parliament.

On the subject of the Balfour Declaration, King and Crane wrote this: "A national home is not equivalent to making Palestine into a Jewish state nor can the erection of such a Jewish state be accomplished without the gravest trespass upon the civil and religious rights of existing non-Jewish communities."

King and Crane also noted that, during their investigation, no

Jewish representative had ever attempted to conceal "the ultimate goal of completely dispossessing the non-Jewish inhabitants of Palestine by various forms of land purchases."

The anti-Zionist feeling of the Arab people of the liberated Turkish provinces was, King and Crane reported, "intense and not to be lightly flouted." Nine-tenths of the inhabitants were against the entire Zionist programme. "To subject the people so minded to unlimited Jewish immigration, and to steady financial and social pressure to surrender the land, would be a gross violation of the Wilsonian principle (of self-determination) and of the peoples' rights..."

King and Crane also found a way to indicate their considered view that America would be foolish to throw away or even put at risk the good will of the Arabs. They made their point by noting that the victorious colonial powers, Britain and France, were in "great disfavour" with the Arabs. That was on the one hand. On the other was that 60 per cent of the Arabs petitioned by the Commission had indicated that America was their first choice as the Mandatory power. Neither Britain nor France had been the first preference of more than 15 per cent of those petitioned. America, King and Crane wrote, had earned its popularity among the Arabs through her unselfish record untainted by territorial or imperialist ambitions, the philanthropic and educational institutions she had set up and her past record of good treatment of backward areas. America's decision to allow Cuba and the Philippines to move toward freedom were cited as examples.

The conclusion invited, it seems to me, is that the report of the King-Crane Commission was suppressed because of its recommendation that Jewish immigration to Palestine should be restricted, and to prevent informed and honest debate in America about the wisdom of supporting Zionism right or wrong. If such a debate had been allowed to happen the Middle East might not have been set on the road to catastrophe.

The King-Crane Commission Report was suppressed because of its recommendation that Jewish immigration to Palestine should be restricted, and to prevent informed and honest debate in America about the wisdom of supporting Zionism right or wrong.

How could the suppression of such an important document have happened on President Wilson's watch? The truth is simple and sad.

By September 1919 the stress and strain of the burden President Wilson was bearing for America and the world was beginning to take its toll on his health. In that month he undertook a punishing coast-to-coast programme of major speeches and interviews to try to sell to his own people the need for the Treaty of Versailles to be ratified by Congress. This treaty not only imposed the settlement terms on defeated Germany; it also included, was prefaced by, the Covenant of the League of Nations. America's political and military establishments were deeply divided about whether or not to ratify the treaty. Failure to ratify would mean that America would not become a

member of the League of Nations. So President Wilson had a big fight on his hands. And that's why he was campaigning across the country.

In Colorado on 25 September he was compelled to give up his tour. He returned to Washington in a state of complete exhaustion. Then, on 2 October, he suffered a thrombosis, a stroke, that impaired his control over the left side of his body.

During the weeks in which President Wilson was isolated from men and affairs, foreign policy was directed and a Cabinet meeting was conducted by Secretary of State Lansing. Behind closed doors Lansing expressed the view that the President, because of his illness, was not competent enough to tend to business. It was during this period that the decision to suppress the report of the King-Crane Commission was taken, no doubt in collusion with Britain-and-Zionism.

The suppression of the report was the green light for Britain and France to put the finishing touches to their plan to carve up the Syrian part of the Turkish empire for themselves, ("Up yours gentlemen", was effectively their message to King and Crane and President Wilson). It was also the green light for Britain to tell the Zionists, unchallenged about their real intentions in Palestine and the terrifying implications of them, not to worry about President Wilson's opposition to (or, at the very least, grave doubts about) their enterprise.

When President Wilson had regained something of his physical health and his mind was nervously active again, the first thing he did was to demand Lansing's resignation. It became effective on 13 February 1920. But the damage had been done. The President was now a prisoner of an agenda for the Middle East that was not his own. The San Remo announcement of the British and French *fait accompli* was less than three months away. The time for open and honest debate about Zionism and support for it right or wrong had been and gone—while President Wilson was incapacitated by his stroke.

The time for open and honest debate about Zionism and support for it right or wrong had been and gone—while President Wilson was incapacitated by his stroke. It was both the first and the last major initiative by prominent Jewish Americans to have Zionism stopped in its tracks.

It is only in retrospect that the true historical significance of the anti-Zionist petition to President Wilson can be fully appreciated. It was both the first and the last major initiative by prominent Jewish Americans to have Zionism—"the most stupendous fallacy in Jewish history"—stopped in its tracks.

After his own reflections on that matter and the absence of even significant Jewish American criticism of Israel's behaviour, Lilienthal, in 1978, wrote the following: "It is most unfortunate for everyone that the descendants of those who took an inspiring anti-nationalist (anti-Zionist) stand should today be found either in Zionist ranks or among the numerous fellow travellers, tongue-tied by fear to speak up."[14]

What happened to the moral principles? They were crushed in the emotional turmoil generated by the Nazi holocaust. And after that, silence on the part of almost all diaspora Jews was guaranteed by belief in the myth that poor little Israel lived each and every day of its life in danger of annihilation.

A cause of great sadness for me as events unfolded, especially after Begin came to power in Israel in 1977, was knowledge that some prominent Jewish Englishmen and Jewish Americans of advancing years, men I respected and admired, were being tortured by their recognition of the fact that they could and should have done more to prevent the Zionisation of their assimilated communities.

Diaspora Jews' silence was guaranteed by the fears generated by the holocaust, and belief in the myth that Israel lived each and every day of its life in danger of annihilation.

As it happened Woodrow Wilson got virtually nothing of the real substance of what he wanted for mankind. Congress did not give him the majority needed for ratification of the Treaty of Versailles.

The minor consequence was that America formally ended its involvement in World War I with separate peace treaties of its own initially with Austria, then Germany, then Hungary, and subsequently with Turkey and the new states of Eastern and Central Europe.

The major consequence was that America excluded itself from the League of Nations when it came into existence in January 1920 with its headquarters in Geneva. So far as the Middle East was concerned, that reduced the world body to being more or less a tool of British and French imperialism. The opposite of what President Wilson had intended.

The belief that Britain and France were intending to use the League of Nations as a cover to advance their colonial ambitions was one of the reasons why some in Congress voted against ratification of the Treaty of Versailles and thus to exclude America from the world body. Others did so for the opposite reason—because they objected to the way in which being a member of the world body would place limits on America's freedom to act in its own self-interest. The actual difference between these American opponents of the League of Nations and the British was not so great. Whereas some Americans in Congress were saying, in effect, "We don't wish to be part of a world body that will restrict our freedom to do what we want in the world", the British were saying, in effect, "Neither do we, but we are not intending to take our obligations to the League of Nations all that seriously and, anyway, we'll be calling the shots."

After his retirement from office Woodrow Wilson lived quietly in Washington D.C., refraining from political comments and avoiding political contacts, though he did, as we have seen, authorise the release of the suppressed King-Crane Commission report. I imagine he did so in the hope that it might play a part in causing his successors to do what was necessary to prevent Zionism getting completely out of control, in Congress as well

as Palestine.

The received wisdom about Woodrow Wilson's contribution to history is that reflected in *Encyclopaedia Britannica*. According to it the intensity of his idealistic fervour crippled his ability for effective compromise. "He was impatient of partisan opposition and there was much of the intolerant Calvinist in his refusal to temporise or deviate from the path which he believed himself appointed by providence to tread. His illusion that the nobility of ideals would suffice to obliterate the stubborn facts of political life took his international policy down the road to bankruptcy." He was a great leader "but lacked the political intuition and deftness... which might have strengthened his contribution to the peace conference and brought the United States into the League of Nations."

That is one verdict. Mine is different and in two parts and perhaps—how shall I put it?—more in accordance with what is known today about what actually happened.

The first is that President Wilson got screwed by Imperial Britain-and-Zionism and their allies in Congress and the media; with assistance as required from France. I also think he might not have been screwed, at least on the matter of Palestine, if he had not had a stroke.

The second is that he was too good a man for the politics of his era (and perhaps of any era). I think, as I said in the Prologue, that he was many, many years ahead of his time. I mean that, given the state of the world today, there is coming a time when the idealism he represented will be seen as pragmatism and the only alternative to a new dark age of totalitarianism. He was, in my judgement, rather like Asher Zevi Ginsberg, Ahad Ha-am in print—a prophet without sufficient honour in his own time.

With President Wilson's exit from the stage, America was once more in an isolationist mood. And that left Zionism free to fill the foreign policy-making vacuum in America. And Britain free to make a mess in Palestine.

8

BRITAIN ADMITS, TOO LATE, "WE WERE WRONG"

The justification for continuing the occupation of Palestine after conquest in World War I was that Britain was there by right of possession of a Mandate endorsed by the League of Nations. The Mandate gave the British enterprise the appearance of legality but it was not one that stood the test of examination, as debates in the House of Lords indicated and Cattan's judiciously argued book demonstrated. If the League of Nations had been much more than the tool of British and French imperialism, Britain would not have gotten the endorsement of a Mandate that was fatally flawed because it was legally invalid as well as being an instrument of injustice.

The Mandate system was an experiment. In essence the major powers who lost the war renounced their overseas possessions in favour of the victorious powers as approved by the League of Nations; but there was a general understanding that Mandates for the territories renounced were to be granted to the victorious powers not for the purposes of political aggrandisement or commercial exploitation—i.e. not for perpetuating colonialism, but in the spirit of *trusteeship*. The basic idea in principle was that the "backward peoples" of the renounced territories were not swapping one colonial master for another, but one colonial master for an enlightened and sympathetic Big Brother (officially the "Mandatory") who would guide and assist them to independence. In practice Britain looked upon its possession of the Mandate for Palestine as the means of extending and perpetuating its empire with Zionist assistance. In everything but name Palestine became a British colony when Britain's Mandate for the territory was endorsed by the Council of the League of Nations on 24 July 1922.

Palestine and International Law is widely regarded as a seminal work on its subject. In it Henry Cattan, a jurist of international repute, set down the several grounds on which Britain's Mandate for Palestine was invalid.

The first was that by incorporating the Balfour Declaration and therefore accepting the concept of the establishment of a Jewish national home in Palestine, "the Mandate violated the sovereignty of the people of

Palestine and their natural rights of independence and self-determination. Palestine was the national home of the Palestinians from time immemorial. The establishment of a national home there for an alien people was a violation of the legitimate and fundamental rights of the inhabitants. The League of Nations did not possess the power, any more than the British government did, to dispose of Palestine, or to grant to the Jews any political or territorial rights in that country. In so far as the Mandate purported to recognise any rights for alien Jews in Palestine, it was null and void."[1]

In Britain the House of Lords opposed the incorporation of the Balfour Declaration in the Mandate. On 21 June 1922 there was a debate in that House on a motion declaring the Mandate to be unacceptable in its present form—i.e. because it did incorporate the Balfour Declaration.

Speaking for the motion, Lord Islington said that in its existing form the Mandate directly violated the pledges made by His Majesty's Government to the people of Palestine. In the course of his prophetic speech he said the following:

> In fact, very many orthodox Jews, not only in Palestine but all over the world, view with the deepest misapprehension, not to say dislike, this principle of a Zionist home in Palestine... The scheme of Zionist Home seeks to make Zionist political predominance effective in Palestine by importing into the country extraneous and alien Jews from other parts of the world... This scheme of importing an alien race into the midst of a native local race is flying in the face of the whole of the tendencies of the age. It is an unnatural experiment... It is literally inviting subsequent catastrophe... The harm done by dumping down an alien population upon an Arab country— Arab all round in the hinterland—may never be remedied... What we have done, by concessions, not to the Jewish people but to a Zionist extreme section, is start a running sore in the East, and no one can tell how far that sore will extend.[2]

By this time Balfour had been elevated to the House of Lords and he replied to Lord Islington's criticism. It was possible, Lord Balfour conceded, that "Zionism may fail." But this was an adventure. "Are we never to have adventures? Are we never to try new experiments?" Then, with a mixture of calculated indifference and arrogance, Lord Balfour said: "I do not think I need dwell upon this imaginary wrong which the Jewish Home is going to inflict upon the local Arabs."[3]

Lord Islington had pointed out that the Mandate's provisions concerning the establishment of a Jewish national home were inconsistent with Article 22 of the Covenant of the League of Nations.

Cattan was to make the same point in his own way and with greater precision. "The second ground of invalidity of the Mandate is that it violated, in spirit and in letter, Article 22 of the Covenant of the League of Nations, under the authority of which it purported to be made."[4]

Article 22 was of supreme importance because it was the one that defined the basic objective of the Mandate system. It was to assure "the well-being and development" of the peoples inhabiting the Mandated territories; an objective described by Article 22 as forming "a sacred trust of civilisation."

Question: Was Britain's Mandate for Palestine conceived (by the British) for the well-being and development of the inhabitants of Palestine?

As Cattan said, the answer was in the provisions of the Mandate itself.

The Mandate sought the establishment in Palestine of a national home for another people, contrary to the rights and wishes of the Palestinians. It required the Mandatory (Britain) to place the country under such political, administrative and economic conditions as would secure the establishment of a Jewish national home. It required the Mandatory to facilitate Jewish immigration into Palestine. It provided that a foreign body known as the Zionist Organisation should be recognised as a public body for the purpose of advising and co-operating with the (British) Administration of Palestine in matters affecting the establishment of the Jewish national home. It is clear that although the Mandate system was conceived in the interest of the inhabitants of the Mandated territory, the Palestine Mandate was conceived in the interest of an alien people originating from outside Palestine, and ran counter to the basic concept of mandates.[5]

Although the Mandate system was conceived in the interest of the inhabitants of the Mandated territory, the Palestine Mandate was conceived in the interest of an alien people originating from outside Palestine, and ran counter to the basic concept of mandates.

In short, Britain's Mandate for Palestine was "nothing but a travesty of the Mandate system as conceived by the Covenant of the League of Nations."[6] Lord Islington described the Palestine Mandate as "a real distortion of the Mandatory system." He added: "When one sees its Article 22... that the well-being and development of such peoples should form a

sacred trust of civilisation, and when one takes that as the keynote of the Mandatory system, I think your Lordships will see that we are straying down a very far path when we are postponing self-government in Palestine until such time as the population is flooded with an alien race."[7]

When the motion declaring the Mandate in its present form to be unacceptable was put to a vote in the House of Lords, it was carried by 60 to 29.

In the House of Commons two weeks later the government succeeded in defeating a motion calling on it to submit the Mandate for approval by parliament.

And that was the basis on which the British government formally sought and obtained the approval of the Council of the League of Nations for the Mandate.

As it happened neither the Balfour Declaration nor the Mandate for Palestine were approved by the British parliament. A policy with catastrophe written all over it was never endorsed by the British people. In fact they, the people, had no knowledge worth having of what was happening and being done in their name. Open diplomacy of the kind President Wilson called for was intended to make governments accountable to their people before points of no return were passed. (One might say that the prospect of open diplomacy was destroyed by his stroke).

During the 26 years of its Mandate, Britain's main achievement was to set in motion three conflicts:

• One between the indigenous and betrayed Arabs of Palestine and the incoming (extraneous and alien) Zionist Jews;

• One between Palestinian nationalists and the forces of the occupying British; and

• One, eventually, between the Zionist Jews in Palestine and the British.

To reduce the prospect of a violent Arab challenge to its occupation of Palestine and its predominant influence in the region as a whole, Imperial Britain had need to mend its fences with the Hashemites, whose leader, Hussein of the Hedjaz, it had betrayed. The fence mending was to be in the form of reward for Hussein's two sons, Faysal and Abdullah. Faysal was to be imposed upon the people of Iraq as their king with the prime role of protecting Britain's oil interests in that country. Abdullah was to be given a part of Palestine to be called Transjordan and of which Abdullah would become king.

Under Turkish rule Palestine east of the River Jordan was part and parcel of the province of Syria and was known as the district of Al Balqa. It was this territory the British were to give to Abdullah in the expectation that he would become their man and would assist them to prevent Palestinian

nationalism becoming an uncontrollable force. Weizmann had hoped the British would give Transjordan to Zionism but he was to be disappointed. Britain needed friends to help it suppress the fire of Palestinian nationalism, not friends who would fan the flames.

A brief account of the repositioning of the Hashemites will enable readers to make some sense of Britain's Palestine policy as it unfolds in the pages to come.

After the defeat and expulsion of the Turks, Hussein became the absolute and undisputed ruler of his part of the vast territory that was to become (in 1927) the independent kingdom, Saudi Arabia. His hope was that he and his sons would end up controlling and ruling all of it. And perhaps more. Given that the Hashemites were descended from the Prophet and were the Guardians of Islam's Holy Places, it was not an unreasonable expectation on his part. But Hussein had a rival. Ibn Saud. For a while the British played their time-honoured game of supporting, funding and arming both sides in the struggle for power in the bulk of the Arabian peninsula, ready to dump the loser at the right time.

It was, in fact, action by France that triggered the repositioning of the Hashemites on the big power chessboard of the Arab world east of Suez.

In July 1920—two months after the San Remo announcement that France was to have the Mandates for Syria and Lebanon, and Britain the Mandate for Palestine—the French drove Faysal, Hussein's first son, out of Syria; thus bringing to an end the arrangement for independence the Arabs had proclaimed for themselves in accordance with the promises Britain had made to Hussein. (So the need for Britain to reposition Faysal in Iraq was great).

In response Abdullah, Hussein's second son, occupied what was to become Transjordan and threatened to attack the French in Syria. It's not difficult to imagine that some British policymakers allowed themselves to fantasise about how marvellous it would be if Abdullah was capable of driving the French out, but there was never a prospect of him succeeding.

Eight months later, in March 1921, the British said something like the following to Abdullah: "Never mind, old chap, stay here, play your cards right—help us to administer this territory and keep Palestinian nationalism under control—and we'll let you have this part of Palestine in due course." The official British announcement of the time was to the effect that, under the Mandate, Britain had agreed to the creation of an Arab government in Transjordan with Abdullah as its head.

At more or less the same time the British made Faysal the King of Iraq.

The sons of the father were in the process of being well rewarded, but because of the strategic and economic importance of the territory that was to become Saudi Arabia, there was still the need for Britain to have Hussein's goodwill. Without it Britain could be in serious trouble if he emerged with greater power than Ibn Saud.

The man most likely to secure Hussein's co-operation if not actually

his good will was Lawrence. On behalf of the British government he travelled to Jeddah in July for a meeting with Hussein. Lawrence was carrying the proposed Hedjaz-British Friendship Treaty. His mission was to persuade the king to sign it. Hussein badly needed the treaty because it promised him military support as well as money. During the Arab revolt Britain had paid him £25,000 a month.

Hussein refused to sign because the treaty required him to accept Britain's Mandate for Palestine and thus the creation of a Jewish homeland there. According to Robert Lacey's account in *The Kingdom* (an epic story of the creation and development of Saudi Arabia under the House of Saud), Lawrence at one point was very blunt with Hussein. "Palestine does not want you,"[8] Lawrence said. The "you" was the Hashemite dynasty. Lawrence obviously believed that Hussein's interest in Palestine was purely dynastic, and that his vision of the future was one in which the Hashemites would rule all of the Arab world east of Suez. Hussein replied, "All we are asking is that Britain keep her plighted words to the Arabs."[9]

By rejecting the treaty Hussein, who by then was showing signs of mental instability (apparently a genetic inheritance), sealed his fate. Without the money from Britain—officially "the subsidy"—he began to lose his ability to keep the tribes which had been loyal to him in order. And that made it easier for Ibn Saud, in due course, to conquer the Hedjaz and establish himself as the ruler of all the land that was to take his family's name—Saudi Arabia.

On 3 October 1924, Hussein abdicated and went into exile on Cyprus. It was a humiliating end for the Arab leader who had proclaimed the Arab Revolt to assist the British and their Allies in World War I.

For his part Abdullah was not slow to learn the lessons of his father's fate. If you wanted to advance your own interests, you had to serve the British interest.

In Transjordan Abdullah's first objective was to persuade the British to separate it from the rest of Mandated Palestine. He succeeded and by 1928 his Arab administration of Transjordan was virtually self-governing. It was the beginning of process which would see the emergence of Transjordan in 1946 as an independent state with Abdullah as its King and, so far as the British were concerned, their puppet, more or less.

Effectively Britain's message to Palestinian nationalists was: "Forget about Transjordan. This part of Mandated Palestine is no longer up for grabs." Without being consulted the Palestinians of Transjordan—still today the majority population of Jordan—were to be ruled by the Hashemites.

From the beginning the Arabs of Palestine rejected the Mandate because it could not do other than impair and prejudice their rights as the majority and original inhabitants of the territory. If they had been less than implacable in their opposition to unrestricted Jewish immigration under the Zionist banner, they would have been idiots and deserving of the fate that did overtake them. Jabotinsky had said as much when he wrote that no native people "will ever voluntarily allow a new master."

Initial Palestinian resistance to the Mandate took the form of non-cooperation with the occupying British; but as Britain allowed more and more Jews to enter Palestine in Zionism's name, non-cooperation turned to demonstrations, disturbances, strikes and finally rebellion.

In fact the first Palestinian riots under British rule took place quite some time before Britain had the Mandate. They were sparked by the arrival in 1919 and 1920 of more than 10,000 Jewish immigrants from Russia. Arranging for them to go to Palestine was one way of reducing the number of Jews who were committed to revolution in Russia!

As the Zionists set about acquiring more and more land in Mandated Palestine, (money buys as well as talks), sporadic Palestinian attacks on newly established Zionist settlements became a feature of life.

1929 saw the first big explosion of anti-Zionist Palestinian rage. On 23 August a mob of a thousand or more Palestinians attacked Jews in Jerusalem. Violence quickly erupted throughout Palestine and by nightfall on 26 August, 133 Jews had been killed and 339 wounded. In their efforts to protect the Jews and bring the violence to an end, British police shot and killed 110 Palestinians.

Without the British presence Zionism could not have entrenched itself in Palestine. On their own the Palestinians could have pushed the Zionists out. Between 1933, when Hitler came to power in Germany, and 1936, when the Palestinians rebelled, the number of Jews in Palestine almost doubled—from just over 200,000 to 400,000. Jewish immigration on this scale only served to reinforce the Palestinian and wider Arab conviction that Britain was secretly committed to the creation of a Jewish state in Palestine. (It was not, however, only to Britain that Zionism looked for support in its determination to fundamentally change the demographic facts of life in Palestine. For this purpose, and as we shall see in Chapter Nine, some Zionists actually collaborated with the Nazis).

Without the British presence Zionism could not have entrenched itself in Palestine. On their own, the Palestinians could have pushed the Zionists out.

A six-month strike in 1936 was the beginning of a full-scale rebellion by the Palestinians. It had two aims. One was to force Britain to stop Jewish immigration. The other was to oblige Britain to deliver on its promise of independence for Palestine.

Britain's first response was to appoint a Royal Commission (the Peel Commission) to consider the deteriorating situation in Palestine. It recommended the partitioning of Mandated Palestine into Arab and Jewish states.

The Palestinians rejected partition and then underlined their rejection by escalating a campaign to destroy trees and crops in newly established Zionist settlements. In the skirmishes 80 Zionist settlers were killed. It became obvious to even the British that partition was not a practical proposition.

Britain's next response was to declare war on the Palestinians.

In its attempt to crush the rebellion Britain had virtually to re-conquer the land. More and more British troops were committed to that effort. Many of the new roads built by the British after 1936 were for the purpose of facilitating the movement of British troops.

With martial law prevailing the British application of brute force included a twin-track strategy to rob Palestinian nationalism of its leaders. Up to 300 were detained and many were deported to the Seychelles. Of those who took their places as organisers and co-ordinators of resistance, not a few were assassinated by British intelligence agents who used as their cover an internal struggle for power between rival wings of the Palestinian nationalist movement. That enabled the British to claim that Arabs were killing Arabs. (It was a standard British tactic and one the Israelis were to copy and refine.)

But British might did not break the Palestinian will to resist the Mandate and prevent the implementation of the Balfour Declaration.

It was, however, the situation in Europe—Hitler on the rampage—that caused Britain to rethink its Palestine policy. By early 1939, pre-occupied with the task of appeasing Hitler in the hope of avoiding war with Nazi Germany, a British government led by Neville Chamberlain was ready to talk to the Arabs about what needed to be done to end the confrontation in Palestine.

The talking was done in London at the Anglo-Arab conference.

As a first priority the conference set up a committee, whose members included the Lord Chancellor, Vincent Caldecot, to examine the McMahon-Hussein Correspondence of 1915–1916. Among the other documents it studied, and which was made public for the first time at the conference, was Hogarth's message to Hussein.

The Lord Chancellor, probably privately appalled by the British duplicity he and the committee uncovered, admitted that "the Arab point of view proved to have greater force than had appeared heretofore."[10]

When the committee had completed its work, it unanimously reported on 11 March 1939 that "His Majesty's Government were not free to dispose of Palestine without regard for the wishes and interests of the inhabitants of Palestine... "[11] The committee's report went on to say that all British statements made to the Arabs during and after the war had to be taken into account in any attempt "to estimate the responsibilities which—upon any interpretation of the [McMahon-Hussein] Correspondence —His Majesty's Government have incurred towards those inhabitants as a result of the Correspondence."[12]

If there was a moment when, in effect, Britain repudiated Balfour's policy of support for Zionism right or wrong, the British government's acceptance of the committee's report was it.

Six weeks later, on 17 May 1939, (with the countdown to World War II unstoppable despite Chamberlain's hopes to the contrary), Colonial Secretary Malcolm MacDonald unveiled a White Paper setting out Britain's

new policy for Palestine; a policy the Zionists regarded as, and proclaimed to be, a betrayal of Britain's promise to them.

The White Paper set out its stall by pointing to the ambiguity of the expression "a national home for the Jewish people", and "the resulting uncertainty as to the objective of (Britain's) policy."[13] This uncertainty was the "fundamental cause of unrest (a euphemism for the Arab rebellion) and hostility between Arabs and Jews."

The White Paper went on: "His Majesty's Government believe that the framers of the Mandate in which the Balfour Declaration was embodied could not have intended that Palestine should be converted into a Jewish state against the will of the Arab population of the country. That Palestine was not to be converted into a Jewish state might be held to be implied in the passage from the Command Paper of 1922, which reads as follows…" The 1939 White Paper then quoted from Churchill's 1922 White Paper, both its assurances to the Arabs and its commitment to the founding in Palestine of a Jewish National Home.

Acknowledging that the 1922 White Paper had not removed Arab doubts about Britain's policy, the 1939 White Paper then said:

> His Majesty's Government therefore now declare unequivocally that it is not part of their policy that Palestine should become a Jewish state.

Then, in a most explicit way that left no scope for misunderstanding by anybody and no opportunity for misrepresentation by the Zionists, the 1939 White Paper spelled out what Britain's Palestine policy was to be from here on.

Britain's 1939 White Paper: The objective was an independent Palestinian state in 10 years, in which "Jews and Arabs would be as Palestinian as English and Scottish in Britain are British."

The objective was an independent Palestinian state within 10 years, in which "Arabs and Jews could share in such a way as to ensure that the essential interests of each are safeguarded." In such a Palestinian state it was envisioned that "Jews and Arabs would be as Palestinian as English and Scottish in Britain are British."

The establishment of the independent state was to be preceded by a transitional period throughout which His Majesty's Government would have ultimate responsibility. As soon as peace was sufficiently restored, steps would be taken to give Palestinians (Arabs and Jews) an increasing part in government with the object of placing Palestinians (Arabs and Jews) in charge of all the departments of government, with the assistance of British advisers and subject to the control of the High Commissioner. The Palestinian heads of departments (Arabs and Jews) would sit on the Executive Council which advised the High Commissioner, and Arab and

Jewish representatives would be invited to serve in proportion to their respective populations.

The process would be carried on whether or not Arabs and Jews availed themselves of the opportunity.

Five years from the restoration of peace an appropriate body representing Palestine and His Majesty's Government would be established to review the working of arrangements during the transitional period to that point and make recommendations regarding the constitution of an independent Palestine.

His Majesty's Government would do everything to create conditions enabling the independent state to come into being in 10 years, but if the circumstances required a postponement, His Majesty's Government would consult with the Palestinians (Arabs and Jews) and the League of Nations, as well as neighbouring Arab states, before deciding on a postponement.

(I think I should point out that Zionist and other Jewish leaders were consulted by the British government while it was rethinking its policy for Palestine. As well as the Anglo-Arab Conference there were tripartite talks in London involving the British government, the Arabs and the Jews—Zionists, non-Zionists and anti-Zionists).

As a concession to the Zionists, the 1939 White Paper also stated that Britain would permit a total of 75,000 more Jews to enter Palestine over the next five years, which would take the Jewish population of Palestine to approximately one-third of the whole.

This continuing Jewish immigration was to be at the rate of 10,000 a year for each of the five years. In the same period (taking the total to 75,000) an additional 25,000 Jews were to be allowed into Palestine as "a contribution" to the solution of the Jewish refugee problem then in the making as a consequence of the unleashing of anti-Semitism by the Nazis. (At the time of the unveiling of the MacDonald White Paper, the extermination of Jews in Europe was not underway; but by 1939, and in fact earlier, the violence against Jews in Germany was the clearest possible indication that the Jews of continental Europe were in extreme peril, and would most likely be, in very large numbers, in need of refuge).

After five years Britain was not intending to allow any more Jews to enter Palestine without the consent of the Arabs. Since it was predictable that the Arabs would not agree to further Jewish immigration, the 1939 White Paper was effectively announcing the end of it after five years.

The 1939 White Paper pledged that Britain would check the ever-increasing illegal immigration into Palestine.

In addition the 1939 White Paper pledged that Britain would check the ever-increasing illegal immigration into Palestine. It also announced that the High Commissioner would be given powers to regulate the sale and transfer of land.

The White Paper's explanation of Britain's policy options was as follows. His Majesty's Government did not read any previous British

policy statements as implying that it was required "for all time and in all circumstances to facilitate the immigration of Jews into Palestine subject only to consideration of the country's economic absorptive capacity." (That had to be a correct and true statement because of the pledge in the Balfour Declaration that nothing would be done to prejudice the rights of the "non-Jewish community.") "Nor do they find anything in the Mandate or in subsequent statements of policy to support the view that the establishment of a Jewish national home in Palestine cannot be effected unless immigration is allowed to continue indefinitely."

So, said the official explanation, the alternatives before His Majesty's Government had been:

either, (i) to seek to expand the Jewish national home indefinitely by immigration, against the strongly expressed will of the Arab people of the country;
or (ii) to permit further expansion of the Jewish national home by immigration only if the Arabs are prepared to acquiesce in it.

Therefore:

His Majesty's Government, after earnest consideration, and taking into account the extent to which the growth of the Jewish national home has been facilitated over the past 20 years, have decided that the time has come to adopt in principle the second of the alternatives referred to above.

Zionism rejected the White Paper and accused Britain of betraying the Jews. And it was pleased to note that when the House of Commons approved the White Paper and the new policy it represented, Churchill was among those who opposed it.

In Palestine itself Ben-Gurion's Jewish Agency, the government-in-waiting of the Zionist state-in-waiting, issued an immediate statement. It said:

The White Paper denies to the Jewish people the right to reconstitute its National Home in its ancestral land. It hands over the government of the country to the present Arab majority and places the Jewish community of Palestine at the mercy of that majority... It sets up a territorial ghetto for Jews in their own homeland. The Jewish people regard this breach of faith and as a surrender to Arab terrorism.[14]

As I write I find myself wondering if the authors of that statement stopped to consider how absurd it might appear to those who believed that handing the government of the country to the "Arab majority" was the natural, right and proper thing to do; all the more so because of the proposed

power-sharing safeguards for the Jewish minority.

From this point every act of legitimate Palestinian resistance to the Zionist enterprise would be defined by Zionism as terrorism. It was a definition that, in time, the Zionist state persuaded the governments of the Western world to accept, at least in their public statements. It did not matter to Zionists, then and still today, that all peoples have the right to use all means including violence to resist occupation.

Ben-Gurion himself declared "We will fight with the British against Hitler as if there were no White Paper; and fight the White Paper as if there were no war."[15]

In the Zionist mind the root cause of all the trouble in Palestine was Arab violence, an analysis for propaganda purposes which took no account of the fact the Arab violence was (then as now) the consequence of Zionist provocations—the violation of Arab rights that was implicit in the very nature of the Zionist enterprise, and the creation by the Zionists of facts on the ground.

> **From this point every act of legitimate Palestinian resistance to the Zionist enterprise would be defined by Zionism as terrorism, and not as a consequence of Zionist provocations. It was a definition that, in time, the Zionist state persuaded the governments of the Western world to accept.**

A different perspective on why, really, things had gone so badly wrong in Palestine was offered by Sir John Hope Simpson. He was the British expert sent to Palestine in 1930 to report on the serious disturbances of the previous year. His analysis, which did not find its way into public print until 1944, included this observation: "Had the Jewish authorities been content with the original object of settlement in Palestine—a Jewish life without oppression and persecution in accordance with Jewish customs—the national home would have presented no difficulty."[16]

In support of this view he pointed to the successful way in which new Jewish immigrants had settled in communities such as those founded by Sir Moses Montefiore and funded by Baron Rothschild. The point was, he said, that those Jewish immigrants had been determined to have a friendly relationship with their fellow Arab citizens and to be loyal citizens of Palestine.

"The unfortunate fact", Sir John Hope Simpson went on, "is that the Jewish immigration of today is not composed of Jews who, on religious grounds, wish to return to the land of Zion in order to lead a Jewish life without oppression and persecution in accordance with Jewish customs. Rather it is composed of Jews, largely devoid of religious conviction, animated by a spirit of political nationalism, and determined to secure domination in Palestine... No effort has been made to coalesce with the existing population. On the

> **"The Jewish immigration of today is ... composed of Jews, largely devoid of religious conviction, animated by a spirit of political nationalism, and determined to secure domination in Palestine."**

contrary, there is extreme divergence between the virile occidentalism of the immigrant and the conservative orientalism of the mass of the resident population."[17]

With the White Paper of 1939 Britain admitted it had been wrong to seek to dispose of even a part of Palestine without the consent of the Arabs. But it also has to be said that the British government of the day decided to try to right the wrong its predecessors had done only because it was terrified—of the prospect of the Arabs supporting Nazi Germany on the basis that the enemy of their enemy was their friend.

But it was too late.

By 1939 Zionism had established enough of a presence in Palestine, and sufficient lobbying power in America, to turn the dreadful thing about to happen, the Nazi holocaust, to its advantage.

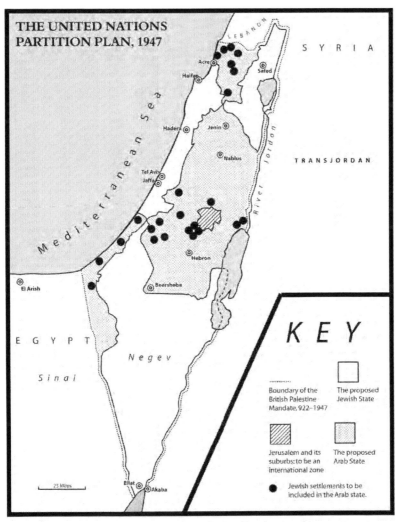

THE UNITED NATIONS
PARTITION PLAN, 1947

KEY

Boundary of the
British Palestine
Mandate, 922–1947

The proposed
Jewish State

Jerusalem and its
suburbs: to be an
international zone

The proposed
Arab State

Jewish settlements to be
included in the Arab state.

The UN partition plan proposed that 56.4 percent of Palestine should be given for a Jewish state to people (many of them recently arrived alien immigrants) who constituted 33 percent of the population and owned 5.67 percent of the land. It was a proposal for injustice on a massive scale.

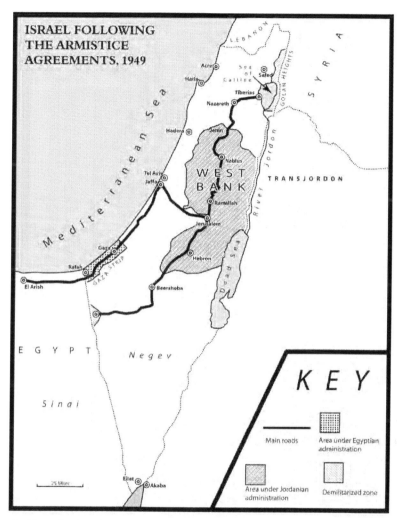

ISRAEL FOLLOWING
THE ARMISTICE
AGREEMENTS, 1949

LEBANON

SYRIA

Acre
Sea
of
Galilee
Safed
Haifa
GOLAN HEIGHTS
Tiberias
Nazareth

Hadera
Jenin

Nablus
Tel Aviv
WEST
Jaffa
BANK
TRANSJORDAN

River Jordan
Ramallah
Jerusalem

Gaza
Hebron
Dead Sea
Rafah
GAZA STRIP
El Arish
Beersheba

EGYPT
Negev

Sinai

KEY

Main roads
Area under Egyptian
administration

25 Miles
Eilat
Akaba
Area under Jordanian
administration
Demilitarized zone

As Ben-Gurion had hoped, war enabled the unilaterally-declared
state of Israel to take more land by fighting—more land than had
been allotted to it by the vitiated United Nations Partition Plan.

9

HOLOCAUST— JEWISH DEATH, ZIONIST LIFE

For any Jew there cannot be more spine-chilling words than those that were the names of the death camps in which the extermination of six million European Jews happened: *Belsen, Buchenwald, Dachau, Flossenberg, Grossrosen, Mittlebaudora, Sachsenhausen, Ravensbruck, Neuengamme* and *Stutthof* in Nazi Germany; *Vught* in Nazi-occupied Holland; *Mathhausen* in Nazi occupied Austria; *Theresienstadt* in Nazi-occupied Czechoslovakia; *Treblinka, Chelmno, Sobibor, Majdanek, Belzec* and *Aushchwitz* in Nazi-occupied Poland.

If the tide of war had not turned against Nazi Germany, all of Europe's Jews might well have been exterminated. A total of about 11 million. That was the number of Jews marked for slaughtering by General Reinhard Heydrich, the Head of Reich Security Central Office and the man entrusted by Hitler with the task of planning and implementing the "Final Solution" to the "Jewish problem".

The blueprint for the Final Solution was discussed and approved at a meeting of 15 top Nazis chaired by Heydrich. The date was 20 January 1942. The place was Wannsee, a picturesque suburb of Berlin. The meeting, arranged by Lt. Colonel Adolf Eichmann, took place in a magnificent mansion that had been the home of a German Jew. Heydrich informed the participants that he would live in it when the war was over.

Always in a hurry—he piloted himself from place to place—Heydrich was pressed for time and insisted on a working lunch. So the details of how they could actually exterminate up to 11 million Jews were discussed over the finest wine, the best food and the most expensive cigars.

Among the issues they discussed was why shooting Jews was not the answer. As one of the participants said, ordinary German soldiers would not have the stomach for it. Not on such a scale. And, anyway, it would take far too long. Shooting the Jews was simply not a practical proposition. There was also the problem of disposing of the bodies. The answer was in the application of the industrial process and science. The Jews would be gassed in purpose built chambers and their bodies burned in purpose built

ovens. By such methods Eichmann calculated they could make 60,000 Jews a day "disappear".

Heydrich did not live long enough to see his plan implemented. In the spring of the same year he was assassinated by two Czech resistance fighters and his place as managing director of the Final Solution was taken with enthusiasm by Eichmann. After the collapse and defeat of Nazi Germany he escaped to Argentina. There in 1960 Israeli agents caught up with him. They spirited him back to Israel where he was tried for war crimes and, at 11.58 p.m. on 31 May 1962, hanged.

There are anti-Semites who deny that the Nazi holocaust happened, either at all or on the scale it actually did. Holocaust denial is something I cannot get my Gentile mind around. It strikes me as evil on a par with the commissioning of the slaughter and the slaughtering itself.

In this book I do not use the term The Holocaust because the holocaust experience—being the victims of genocide—is not a uniquely Jewish one. In terms of the number of Jews slaughtered, and because of the planning and the systemic nature of the slaughtering, what happened in Nazi Europe was the single most terrible act of genocide in all of human history. But the Nazi holocaust was neither the first nor the last example of man's inhumanity to man on a scale that made use of the term genocide appropriate. (Since the end of World War II there have been to date 250 conflicts and 70 genocides)

At the core of Zionist mythology about what happened after Hitler came to power is the assertion, sometimes stated, always implied, that Zionism did what it did in Palestine because it had no choice—because the world refused to give sanctuary to European Jews who were fleeing from the Nazi terror and became refugees or displaced persons (DPs in the official jargon). That is far from the truth.

Zionist mythology asserts that Zionism did what it did in Palestine because the world refused to give sanctuary to European Jews fleeing from the Nazis. The truth is that a serious intention to rescue Jews and give them sanctuary in countries other than Palestine was sabotaged by Zionism.

Much closer to it, the truth, is that a serious intention to rescue Jews and give them sanctuary in countries other than Palestine was frustrated—I think sabotaged is not too strong a word—by Zionism. And there is no mystery about why.

Zionism's most zealous and uncompromising leaders saw the Nazi holocaust as the event that would give them the number of Jewish immigrants they needed to create and sustain their state. From 1939 Zionism's first objective was to cancel Britain's policy, declared in the White Paper of that year, of restricting and effectively ending after five years further Jewish immigration to Palestine. The orgy of Nazi anti-Semitism gave Zionism's zealots the battering ram they needed to achieve their objective.

As a matter of indisputable historical fact Zionism's Big Idea of

using Hitler's anti-Semitism for the purpose of creating a Jewish state in Palestine predates the Nazi holocaust.

It was Herzl who pointed the way. As he confided to his diary and may well have said to some of his close associates (emphasis added): *"Anti-Semitism is a propelling force which, like the wave of the future, will bring Jews into the promised land...*Anti-Semitism has grown and continues to grow—and so do I."[1] He also made this prediction: "The governments of all countries scourged by anti-Semitism will be keenly interested in assisting us to obtain the sovereignty we want."[2]

One strategy of Zionists in Palestine was to send *shliachim* (emissaries) to develop contacts with the up-and-coming totalitarian forces and parties of Europe, in particular Hitler's National Socialists and Mussolini's Fascists. The main function of the *shliachim* was to cultivate the totalitarian forces and parties and to find out what accommodations Zionism could make with them.

Brenner's book is an incredibly well-documented exposé of the full extent of Zionism's collaboration with both the Nazis and Italy's Fascists, and the tensions this collaboration led to within the WZ0 at the highest leadership level.

The main deal Zionism struck with the Nazis was enshrined in the infamous *Ha'avara* (Transfer) *Agreement.* In return for being allowed to send money and people to Palestine and having some Jewish property in Germany protected, Germany's Zionists agreed to take no part in, and actually to oppose, an international boycott of Nazi Germany's exports. In the world, and in America especially, many Zionist and other Jewish organisations wanted a boycott of Nazi Germany's exports, but it was eventually German Zionism's

The Ha'avara (Transfer) Agreement: In return for being allowed to send money and people to Palestine and having some Jewish property in Germany protected, Germany's Zionists agreed to take no part in, and actually to oppose, an international boycott of Nazi Germany's exports.

policy of collaborating with the Nazis that prevailed. German Zionism's institution was the ZVfD, *Zionistische Vereinigung fur Deutschland* (Zionist Federation of Germany).

As part of the same deal the ZVfD also agreed not to resist the Nazis.

Brenner is among those who believe it is possible that Hitler might not have achieved power if, at an early enough stage, the ZVfD had sided with those in Germany who opposed Hitler and all he stood for.

One of the most celebrated members of the *shliachim* cast was Enzo Sereni, a Zionist Jew of Italian origin. He was the emissary to Germany in 1931–32. As Brenner noted, Sereni was one of those who saw Hitler as a scourge driving Jewry toward Zionism. Sereni once told Max Ascoli, an Italian anti-Fascist activist, "Hitler's anti-Semitism might yet lead to the

salvation of the Jews."[3] Subsequently, to a Zionist Congress. Sereni said: "We have nothing to be ashamed of in the fact that we used the persecution of the Jews in Germany for the up-building of Palestine—that is how our sages and leaders of old taught us... to make use of the catastrophes of the Jewish population in the diaspora for up-building."[4]

Of even greater significance is a statement made by Ben-Gurion to a meeting of his Jewish Agency's Executive in Palestine on 17 December 1938. He was warning his leadership colleagues about something that could not be allowed to happen. He said this:

If Jews (of the diaspora) have to choose between refugees—saving Jews from concentration camps, and assisting a national museum in Palestine, mercy will have the upper hand and the whole energy of the people will be channelled into saving Jews from various countries.

Ben Gurion: "If we allow a separation between the refugee problem and the Palestine problem, we are risking the existence of Zionism."

(He meant that Jews would be rescued and given sanctuary in lands other than Palestine). Zionism will be struck off the agenda not only in world public opinion, in Britain and the United States, but elsewhere in Jewish public opinion. If we allow a separation between the refugee problem and the Palestine problem, we are risking the existence of Zionism.[5]

The principal architect of the first plan to rescue Europe's uprooted Jews was America's 32nd President, Franklin Delano Roosevelt or FDR as he was known. Some Americans regard him as the most effective and the greatest of all American presidents to date. He was certainly the longest serving president, the only one to be re-elected three times. He was in office from 1933 until he died of a massive cerebral haemorrhage during his fourth term in 1945.

Shortly before he entered the White House for the first time Roosevelt made this statement: "The presidency is... pre-eminently a place of moral leadership."[6]

When he became aware of the Jewish refugee problem, President Roosevelt, on purely humanitarian grounds, set his mind to work on devising a rescue plan. The scheme he favoured was "generous worldwide political asylum". He established that Canada, Australia and some South American countries might open their doors. And he believed that if good examples were set by other nations, the American Congress could be "educated to go back to our traditional position of asylum." The quotations in this paragraph are from a conversation the President had with his friend and confidant Morris Ernst, a Jewish American and New York Attorney.[7]

Going back to "our traditional position of asylum" meant changing the immigration laws passed in 1921–4 during what Brenner described as a

"wave of xenophobia" when anti-Semitism was quite widespread in America.[8]

Roosevelt knew that the key to his rescue plan was in London and he sent Ernst there to sound out the British and ask if they were prepared to take in 100,000 or even 200,000 of Europe's uprooted Jews. Ernst arrived in London during the second blitz (all night raids by German bombers). Partly on account of the pounding London and other parts of Britain were taking he was impressed by the British response. According to what Ernst himself told a Cincinnati audience in 1950, and as noted by Lilienthal, the following is part of the conversation Ernst had with President Roosevelt when he returned from London:

> ERNST: We are at home plate. This little island on a properly representative program of a World Immigration Budget will match the United States up to 150,000.

> ROOSEVELT: 150,000 to England—150,000 to match that in the United States—pick up 200,000 or 300,000 elsewhere and we can start with half a million of these oppressed people.

> A week later Ernst and his wife visited the President again.

> ROOSEVELT: Nothing doing on the [rescue] program. *We can't put it over because the dominant vocal Jewish leadership of America won't stand for it* (emphasis added).

> ERNST: It's impossible! Why?

> ROOSEVELT: They are right from their point of view. The Zionist movement knows that Palestine is, and will be for some time, a remittance society. They know they can raise vast sums for Palestine by saying to donors, "There is no other place for this poor Jew to go." But if there is a world political asylum... they cannot raise their money. Then people who do not want to give money will have an excuse to say, "What do you mean—there is no place they can go but Palestine? They are the preferred wards of the world.[9]

Ernst was shocked and, without mentioning what Roosevelt had said, he approached his influential Jewish friends to try to get their support for a worldwide program of rescue. As he described it himself in his own book, this was the response he got. "I was thrown out of parlours of friends of mine who very frankly said, 'Morris this is treason [*sic*]. You are undermining the Zionist movement.'"[10] He also said that he found, everywhere, "a deep, genuine, often fanatically emotional vested interest in putting over the Palestinian (Zionist) movement" in men "who are little concerned about

human blood if it is not their own."[11]

The obstacle Ernst and President Roosevelt had come up against was not only Zionism's insistence on having Europe's Jewish refugees directed to Palestine. There was also great fear on the part of America's assimilated and prospering Jews that another big influx of Jewish refugees, particularly impoverished, embittered and radical Jews of Eastern European origin, might put their own security and well-being at risk by provoking anti-Semitism in America. It was the American version of the same fear that Britain's assimilated Jews had had when three million of their co-religionists were abandoning Russia in the two decades prior to World War I. In 1938, because of the fear of provoking anti-Semitism in America, two bills proposed by Democratic congressmen to liberalise U.S. immigration laws were dropped.

Subsequently the guilt that many Jewish Americans felt for not doing enough to rescue Jews was the violin on which Zionism played to produce its sweetest background music.

With the start of World War II, Britain decided it had no option but to shelve its efforts to resolve the Palestine problem until the war was over. (I imagine British ministers and the civil service mandarins who advised them told each other they had better pray that the Arabs would show patience while Britain was engaged in the struggle against Hitler).

The guilt that many Jewish Americans felt for not doing enough to rescue Jews was the violin on which Zionism played its sweetest background music.

In America, neutral again until the Japanese attack on Pearl Harbour in December 1941, Zionists stepped up their pressure to get President Roosevelt's administration committed to supporting Zionism right or wrong, with an expanded set of demands for what it wanted in Palestine. For most of the period between the two world wars, and following President Wilson's exit from the stage, America had been in a more or less isolationist mood and, perhaps understandably, mainly preoccupied with domestic affairs—the inflation of the 1920's and the depression of the early 1930's. The consequence was a policy vacuum with regard to international affairs in general and the Middle East in particular. And so far as the Middle East was concerned, it was America's Zionists and their supporters (a steadily growing number of America's pork-barrel politicians in both the Senate and the House of Representatives) who filled the policy vacuum. Starting in June 1922, support for Zionism was voiced in resolutions submitted to successive congresses.

By 1922 or thereabouts, competition began between Democrats and Republicans to see who could promise the Zionists most in return for votes and election campaign funds.

By 1922, competition began between Democrats and Republicans to see who could promise the Zionists most in return for votes and election campaign funds.

After President Roosevelt had picked up the pieces from the Wall Street

crash and seen through his New Deal for Americans, the emerging Zionist lobby was learning how to co-ordinate its powerful muscles. America's leading Zionists were, however, very much aware that Roosevelt was a politician *par excellence*, and that manoeuvring him into becoming the standard bearer for their cause was not going to be an easy task.

President Roosevelt did, in fact, take a leaf out of President Wilson's book and sent his own man on a fact finding mission to the Middle East, to give him independent advice on how to respond to events there. (In Wilson's case it was, as we have seen, two men, King and Crane). Roosevelt's chosen man was Brigadier General Patrick J. Hurley, later Ambassador to China. Hurley was instructed to report directly and only to the White House.

From State Department documents that were declassified in 1964 we know what Hurley reported to his President and, more generally, what Roosevelt's private position on Zionism was. Hurley said there was mounting opposition throughout the Arab world to Zionism's insistence on increased Jewish immigration into Palestine and its concrete plans for expansionism. Hurley also noted that some "Palestinian Jews" were opposed to Zionism.

Early Zionist planning included commitment to a Jewish leadership for the whole Middle East in the fields of economic development and control.

Hurley's report to Roosevelt included this:

For its part the Zionist Organisation in Palestine has indicated its commitment to an enlarged program for:
a) A sovereign Jewish state which would embrace Palestine and probably Transjordan;
b) An eventual transfer of the Arab population from Palestine to Iraq;
c) Jewish leadership for the whole Middle East in the fields of economic development and control.[12]

From what was revealed by the documents declassified in 1964 we know that President Roosevelt's personal policy preference for a solution to the Palestine problem was "A trusteeship of the Holy Land with a Jew, a Christian and a Muslim as the three responsible trustees."[13] Though he never said so in public, and despite the fact that he gave Zionist leaders the impression that he did support their cause—he gave this impression to protect his party from the firepower of the Zionist lobby—Roosevelt was not in favour of a Jewish state. He regarded the Zionist enterprise as a threat to America's national interests. On that basis it is reasonable to assume that he was privately outraged by the substance of Hurley's report on Zionism's expanding ambitions.

Roosevelt regarded the Zionist enterprise as a threat to America's national interests.

Shortly after America entered the war, Roosevelt agreed in principle with Churchill (then prime minister) that they needed to say something which, they hoped, would lower the rising temperature of Arab anger; anger that was being generated by continuing Jewish immigration into Palestine and the fact that resolution of the Palestine problem was being delayed until the war was over. Churchill and Roosevelt feared that an explosion of Arab anger could jeopardise the Allied war effort. There were, in fact, many Arabs who were hoping that the enemy (Nazi Germany) of their enemy (Britain) would win the war. Roosevelt also wanted to make a statement which he hoped would be sufficient to persuade the Zionist lobby to call off its political bombardment of the White House while the war was in progress.

After lengthy consultations in London and Washington the text of a joint Anglo-American statement was prepared for release to the public. It assured both Arabs and Jews that though a resolution of the Palestine problem was being delayed until after the war, no decision about the future of Palestine would be reached without prior consultation with both. And it emphasised that "no changes brought about by force in the status of Palestine or the administration of the country would be permitted or acquiesced in."[14]

As a holding statement designed to underpin the British and American war effort, it was both reasonable and fair; *but it was not what Zionism wanted and it was not released.* Before it could be made public, the text was leaked to the Zionists and they arranged for the highest government officials to be flooded with protests.[15] And Roosevelt, for reasons of domestic politics, acquiesced in the suppression of the joint Anglo-American statement.

The real zealots in the American Zionist camp saw this as a sign of weakness on Roosevelt's part and determined to turn their heat on him up. By now they were enjoying and benefiting from the inspirational assistance of Ben-Gurion himself.

In his epic book, Israel, *A Personal History*, Ben-Gurion wrote:

America's entrance into the war left no room for doubt that after the war the United States rather than England would call the tune. In my capacity as Chairman of the Executive in Jerusalem, I travelled to the United States in 1940 and 1942 to enlist the support of American Jewry in the struggle to cancel out the White Paper and establish a Jewish state after the war.[16]

The extent to which organised American Jewry did rally to that cause was apparent when American Zionist organisations endorsed what became known as the Biltmore Program. In 1942 the first ever conference of the American Zionist Movement took place in New York's Biltmore Hotel. The conference approved the following program:

1. That the gates of Palestine be opened to Jewish immigration.

2. That the Jewish Agency be vested with control of immigration into Palestine and with the necessary authority for up-building the country, including the development of its unoccupied and uncultivated lands.

3. That Palestine (all of it) be established as a Jewish Commonwealth integrated into the structure of the new democratic world.[17]

As Ben-Gurion noted, the Biltmore Program "became the official platform of the WZO."[18] By this time Weizmann's influence on world Zionism was declining and Ben-Gurion's was increasing.

American Zionistm's 1942 Biltmore Program called for establishing all of Palestine as a Jewish Commonwealth to be integrated into the structure of the new democratic world.

One of the products of Zionism's awesome mobilising ability was the formation of what was called the American Palestine Committee (APC). It had a top-tier membership of hundreds including Cabinet members, politicians in both branches of Congress, governors, mayors, other elected officials and influential personalities from all walks of life. The task of APC people on behalf of Zionism was to exert pressure everywhere it counted, with special attention, in addition to Congress and the White House, to the media and advertising worlds. (In the newspaper world editorial lines can be determined, and content can be suppressed, by pressure from advertisers).

In December 1942 American Zionists fired what was effectively the first shot in their campaign to have Roosevelt do their bidding. It took the form of a joint statement signed by 63 Senators and 181 members of the House of Representatives. It called on the President "to restore the Jewish homeland." Most if not all of those who signed would have been aware that "homeland" was the euphemism for "state"; and some would have known, as Hurley had reported to Roosevelt, that the state the Zionists in Palestine had in mind was one that embraced all of Palestine and probably Transjordan, with provision for the Arabs of Palestine to be transferred to Iraq. The Senators and Representatives who signed the joint statement were effectively asking President Roosevelt to read the riot act to the Arabs on Zionism's behalf.

Instead of doing that President Roosevelt welcomed a State Department initiative to send a special emissary for talks with the leader of the Arab world, Saudi Arabia's founding father, King Abdul Aziz Ibn Saud, to find out if he had any suggestions that might form the basis for a settlement of the Palestine problem.

Saudi Arabia was the most important and influential Arab country; this on account of its role not only as the Guardian of Islam's Holy Places, but its oil and thus the money which enabled Saudi Arabia's rulers to buy off Arab troublemakers—states as well as groups.

The State Department's special emissary for the meeting with Ibn Saud was Colonel Harold B. Hoskins. Early in 1943 he had headed a mission to the Middle East and North Africa. It was decided that he was the best person to engage with Ibn Saud because of his intimate knowledge of

the region and the fact that he spoke Arabic fluently.

When Hoskins set out on his mission in August 1943 the State Department was fully informed—by its resident representative in Riyadh, James Moose—of Ibn Saud's position. He was, as Moose had reported, totally opposed to the creation of a Jewish state in Palestine and "vehemently opposed" to further Jewish immigration.

President Roosevelt's input to the Hoskins mission was the suggestion that Ibn Saud be asked to consider the proposition that he should meet with Weizmann.

Hoskins had conversations with the Saudi monarch every day for a week. In the course of them Ibn Saud rejected the idea of a meeting with Weizmann on the grounds that his position of leadership in the Arab world did not permit him "to speak for Palestine, much less deliver Palestine to the Jews."[19] But there was more to it. Ibn Saud told Hoskins that during the first year of the war Weizmann had "impugned his character and motives" by attempting to bribe him with an offer of £20 million (pounds sterling).[20] And still there was more. Ibn Saud had been told, he informed Hoskins, that Weizmann's promise of payment had been guaranteed by President Roosevelt himself. When this story was relayed to Roosevelt he was furious at the use of his name "as a guarantor of payment" when there was, he said, "no basis in fact for doing so."[21] (Was the politician *par excellence* telling the truth?)

Ibn Saud also showed Hoskins evidence of the floods of telegrams and congratulations he had received from Arabs and Muslims all over the world for his anti-Zionist stance. Hoskins concluded that the Saudi monarch "could never afford to support Jewish claims to Palestine."[22]

Because of Saudi Arabia's growing strategic significance, President Roosevelt was profoundly troubled by the strength of Ibn Saud's total opposition to the Zionist enterprise. So troubled that towards the end of 1943 he wrote a personal and private letter to the Saudi monarch. It gave him the assurances that were contained in the joint Anglo-American statement the President had shelved because of Zionist pressure. In fact Roosevelt sent similar personal and private letters to other Arab leaders. To this point America's Zionist leaders were not too dismayed by Roosevelt's refusal so far to commit himself to their cause. Why? 1944 was an election year and Zionism's leaders knew that during the election campaign many candidates running

In 1944, Jewish Americans were about three percent or less of the population and were contributing nearly 50 percent of campaign funds. Both Democrats and Republicans were running a pro-Zionist campaign.

for office, including their party leaders, would be at their most vulnerable so far as Zionist pressure was concerned. (By the 1970's it was reckoned that candidates running for the White House needed campaign funds in excess of $50 million, those running for the Senate about $15 million and those running for the House of Representatives about $10 million. At the

time official statistics showed that Jewish Americans were about three percent or less of the population and were contributing nearly 50 percent of campaign funds. The amounts needed in 1944 were, of course, smaller, but the political buying power of the Zionist lobby was and is a constant of American politics).

To create a pressure point early in the 1944 election campaign the Zionist lobby arranged for the Wright-Compton resolution to be introduced in Congress. It called for unrestricted Jewish immigration to Palestine and the establishment of a Jewish commonwealth there. The Wright-Compton resolution became the subject of lengthy hearings before the Foreign Affairs Committee and it took a letter from the Secretary of War, Henry L. Stimson, to get the hearings suspended and the resolution shelved. In his letter to Committee Chairman Sol Bloom asking for the resolution to be shelved, Stimson said the hearings were vastly complicating the Middle East picture, and that continuing with them "would be prejudicial to the successful prosecution of the war."[23]

Mid-campaign, the Zionists sought adoption of the Wright-Compton resolution calling for unrestricted Jewish immigration to Palestine and establishment of a Jewish commonwealth there.

The vastly complicating factor was the protests including riots that were rocking the Arab world as a consequence of the introduction of the Wright-Compton resolution and the hearings on it. The State Department was so alarmed that it sought and obtained President Roosevelt's approval to issue the suppressed Anglo-American statement. But before it could be issued, Roosevelt was obliged to receive two of American Zionism's most powerful and influential leaders—Rabbi Stephen Wise and Rabbi Abba Hillel Silver.

Rabbi Wise was polite and courteous, a gentleman who wrote "Dear Boss" letters to Roosevelt; and who had long been troubled by what Zionism was becoming and where it would take the Jews and Judaism. Rabbi Silver was a ranting extremist, a true zealot not open to compromise of any kind. It could have been said that Wise was Rabbi Nice and Silver was Rabbi Nasty. The question waiting for an answer was: Which of the two of them would emerge victorious from the internal struggle to determine how far American Zionism should go in compelling, effectively blackmailing, the government of the United States of America to support the creation of a Jewish state? At the State Department the hope was that Rabbi Nice would be able to stay in control of events in the American Zionist camp.

The two rabbis emerged from their meeting with Roosevelt to proclaim to the waiting media, and through it the world, that the President had affirmed his support for Zionism's position as in the Biltmore Program. In other words, President Roosevelt was for a Jewish state. Or so he was saying through Rabbis Wise and Silver. Apparently.

In the Arab world reports of President's Roosevelt's support for the Zionist position as stated by the rabbis added anger to anger and raised the possibility of serious anti-American and anti-British disturbances in the region.

What happened next was revealed by the documents declassified in 1964. With the President's agreement, the State Department resorted to behind closed-doors crisis management. It prepared and distributed for the use of American Chiefs of Mission in all Arab countries a "confidential interpretation" of the statements made by Rabbis Wise and Silver. Its purpose was to enable American Chiefs of Mission to tell Arab leaders in private that the President's real position was unchanged—i.e. that he stood by his earlier assurances to them. The implication conveyed to Arab leaders was that a Jewish state was out of the question unless they agreed to it. At leadership level in the Arab world the damage done by the statement of the two rabbis was contained. But that was not the case in America. The truth about President Roosevelt's real position had been conveyed to Arab leaders in private and remained a secret for many years. The only thing known to American public opinion in 1944 was that President Roosevelt supported the Zionist position—because Rabbis Wise and Silver had said so and the media had spread their statement and its pro-Zionist implications.

Americans believed President Roosevelt supported the Zionist position—because Rabbis Wise and Silver had said so and the media had spread their statement and its pro-Zionist implications.

For the American election of 1944 both the major parties—Roosevelt's Democrats and Governor Thomas E. Dewey's Republicans—had a pro-Zionist plank in their campaign platforms. The Democrats' campaign pledge was support for "a free and democratic Jewish commonwealth" in Palestine. The Republican campaign propaganda had referred only to "a free and democratic commonwealth"; but New York's Governor Dewey, running against Roosevelt, and pressed by Rabbi Silver, subsequently made it clear that the commonwealth was to be a Jewish one.

Thus, in complete ignorance of what the Palestine problem was all about, the people of America were offered a choice between pro-Zionism and pro-Zionism. And this at a time when their President of the moment, and the man who was to be their President again, was privately of the view that, whatever else it might be, Zionism was not in America's longer term best interests.

With the election won President Roosevelt moved quickly to try to prevent Zionism's mouthpieces in Congress making the situation in the Middle East more dangerous than it already was. He asked his Secretary of State, Edward R. Stettinus, to tell Rabbi Wise and congressional leaders that the introduction of pro-Zionist resolutions in Congress was not desirable. That plea fell on deaf ears and pro-Zionist resolutions were introduced. It finally took a personal appearance by Stettinus before the Senate Foreign Relations Committee to defeat proposed pro-Zionist legislation. Behind the scenes Roosevelt played his own part by telling key senators and Rabbi Wise that pro-Zionist resolutions could lead to bloodshed between Jews and Arabs.

On 9 January 1945, at the start of his fourth and unprecedented term as president, Roosevelt received some honest advice from James Landis. He was the State Department's Director of Economic Operations and a former Dean of the Harvard Law School. He was admired by some and despised by others because he was a liberal. His advice, actually a warning, was that any presidential action with regard to Palestine that did not go to the root of the matter "was not likely to advance very far" and that, for this reason, "it might be well for the President to avoid the issue entirely unless he was prepared to make some far-reaching proposals."[24]

The essence of Landis's advice to the President was revealed in the documents declassified in 1964:

> A vacillating policy with reference to Zionism as in the past 20 years has proved to be the equivalent of no policy... The approach to the problem must start from the insistence that the objective of the Jewish commonwealth or the Jewish state as distinguished from the Jewish national home must be given up. The political objective implicit in the Jewish state idea will never be accepted by the Arab nations... But given an adequate conception of the Jewish national home, together with the political limitations that must be placed on that conception, it should be possible to sell that to the Jews and Arabs as well.

> Of course, the one great stumbling block is the question of immigration. That question at present possesses a significance that it should not possess because of its relationship to the political as distinguished from the economic future of Palestine. In other words, if the extent of immigration can be related to the economic absorptive capacity of Palestine rather than to the political issue of the Jewish minority or majority, there is hope for striking an acceptable compromise even on the immigration question with the Arabs. This is particularly true now, for I believe the economic absorptive capacity of Palestine has been grossly exaggerated.[25]

While he studied that advice President Roosevelt was preparing for a summit with Churchill and Stalin. The world's Big Three were to meet in Yalta in early February mainly for the purpose of discussing how to divide post-war Europe into agreed spheres of East-West influence; but they were also scheduled to discuss all outstanding problems including Palestine. And it was known that after the Yalta summit Roosevelt and Churchill were to have separate meetings with King Ibn Saud.

For the first time in Roosevelt's long presidency the zealots in Zionism's leadership were seriously worried. As Lilienthal noted, they were

not fooled by Roosevelt. They knew that whatever he said for the purpose of preventing the Zionist lobby being mobilised against his party, he was not a supporter of the Zionist enterprise. Rabbi Neumann would later write that Roosevelt had "little time and thought" for the Zionist cause; and that, Neumann added, was why Zionism's leaders in America had concentrated their pressure on those they could influence in both parties in both houses of Congress.[26] The main purpose of the introduction of various pro-Zionist resolutions in Congress, plus the work the Zionists put into getting both main parties committed to Zionism in their 1944 election manifestos, had been to create a political environment in which Roosevelt would not be free to support a settlement of the Palestine problem that denied Zionism a state.

The pro-Zionist resolutions in Congress and Zionist support in both US parties' 1944 election manifestos aimed to create a political climate in which the anti-Zionist Roosevelt would not be free to deny Zionism a state.

But on the eve of the Yalta summit Zionist zealots entertained the fear that President Roosevelt, under pressure from the State Department, might agree to a settlement of the Palestine problem that would put an end to Zionism's ambitions.

Zionism viewed the State Department as being rabidly pro-Arab. True or false? First and foremost the State Department was what it was supposed to be—pro-America, which meant putting the American interest first. In that context the senior professionals in the State Department regarded the Zionist enterprise as a threat to American interests. Not an amazing position given that the whole Arab and Muslim world was opposed to the creation of a Jewish state in Palestine. In that context the State Department was effectively anti-Zionist.

While President Roosevelt was making his final preparations for Yalta, the Zionists subjected the State Department and the White House to immense and intense lobby pressure. Its main purpose was to remind the President that his party had committed itself to Zionism and to demand unrestricted Jewish immigration to Palestine.

Senior professionals in the State Department regarded the Zionist enterprise as a threat to American interests.

As it happened Palestine was not discussed by the Big Three at Yalta. The subject of what to do about Palestine was left, at Roosevelt's request, for the discussions he and then Churchill were to have with Ibn Saud. (Stalin was happy to oblige because he had not yet made up his own mind about how to play the situation in Palestine for his own purposes. If the Americans ended up backing the Zionists, he would have the option of backing the Arabs. Perhaps).

Roosevelt's meeting with the Saudi monarch took place on board the *U.S.S. Quincy* on the Great Bitter Lake in the Eastern Mediterranean.

Ibn Saud summarised the Arab case and explained to Roosevelt why it was that continued Jewish immigration and the purchase of land constituted a "grave threat" to the Arabs. After the meeting Roosevelt told his staff that he had learned more about the Arab-Jewish situation from Ibn Saud in five minutes than he had understood all his life. He also said he had been "deeply impressed by the intensity of the Arab feeling with regard to Palestine."[27]

In response to Ibn Saud's summary of the Arab case, President Roosevelt said he wished to assure His Majesty that he would "do nothing to assist the Jews against the Arabs" and would make "no move hostile to the Arab people."[28]

The implication of what Roosevelt went on to say is that Ibn Saud expressed some doubts about what the President's assurances were worth given the influence of the Zionist lobby in American politics and its ability to have pro-Zionist resolutions introduced in Congress. Roosevelt explained to the leader of the Arab world that it was impossible to prevent resolutions and speeches in Congress, but that, he said, was not the point. It was that the assurances he had given to His Majesty "concern my own future policy as Chief Executive of the United States Government."[29]

Though there is nothing in the available record to support it (so far as I am aware), the evidence of events is that Roosevelt sought and obtained from Ibn Saud, in return for the presidential assurance, a promise that whatever it might say in public, Saudi Arabia would never use the oil weapon to put pressure on the U.S. (As we shall see, the evidence of events is also that at least one of Ibn Saud's sons, Foreign Minister and King-to-be Feisal, thought that his father should not have given any such promise).

At the time of the meeting and after it, media reports asserted that President Roosevelt had urged the Saudi monarch to agree that more Jews should be admitted to Palestine. Roosevelt made no such pitch. But he did mention a possibility he knew Churchill was going to raise when he met with Ibn Saud—that some of the uprooted Jews of Nazi-ravaged Europe might be resettled in Libya. When Ibn Saud objected on the grounds that it would be unfair to the Muslims of North Africa, the two leaders agreed that the Jewish refugees would best be resettled "in the lands from which they were driven" and mainly Poland.

It is evident from the record that Roosevelt handled the Saudi monarch with great care and courtesy. Churchill's approach a week later could not have been more different. Was it a pre-planned "good cop" (Roosevelt) "bad cop" (Churchill) routine? I think not. Churchill was by nature arrogant and a bully. He was also strongly pro-Zionist and something of a racist, especially with regard to the Arabs. He had once described them as "eaters of camel dung".

According to what Ibn Saud later told William Eddy, America's Chief of Mission in Saudi Arabia, Churchill arrived "confidently wielding a big stick."[30] That was a reference to the fact that Churchill began his meeting with the Saudi monarch by telling him that he probably would not have been King, or remained King, without Britain's support. Churchill was

more right than wrong. Ibn Saud had founded his country and his dynasty by the sword. Without British support, guns and money, Ibn Saud might not have been able to see off the competing tribes including the Hashemites.

Ibn Saud was smart enough to acknowledge (instead of disputing for reasons of face) the truth of what Churchill had said. It was the case, he replied, that British support for 20 years had enabled "my reign to be stable and fend off potential enemies on my frontiers."[31] But now he was the King, and the leader of the Arab world, he wanted from Churchill an assurance that Jewish immigration to Palestine would be stopped.

Churchill refused to give such an assurance, but he did say he would "not drive the Arabs out of Palestine or deprive them of their means of livelihood there."[32] How generous of him.

The previous year the National Executive Committee of the British Labour Party, then in Zionism's pocket and on the brink of taking power from Churchill, had called for the Arabs to be transferred out of Palestine. In its report to the party's 1944 annual conference, the National Executive Committee had said, "Let the Arabs be encouraged to move out as the Jews move in."[33] The report was officially adopted by the annual conference. As Michael Adams and Christopher Mayhew noted in *Publish It Not—The Middle East Cover-Up*, the British Labour Party "is probably the only political party in the world to have openly advocated that the Palestinians should be exiled from their homeland to make way for the future Israelis."[34]

Even the pro-Zionist and to a degree anti-Arab Churchill was not prepared to go that far. (I believe that Churchill's pro-Zionist preference was not due to with any great affection for Jews or sympathy with the Zionist cause for its own sake. I believe Churchill was pro-Zionism only because he saw it as a force to assist with the maintenance of the British Empire.)

In essence Churchill was telling Ibn Saud that he owed the British a debt of gratitude and that Britain was now requiring repayment of that debt. What Britain wanted by way of repayment was Arab moderation and a realistic compromise with Zionism.

That made Ibn Saud angry. He later told Eddy that what Churchill had demanded of him was not gratitude or even help. "He was requiring me to wipe out my honour and destroy my soul."[35]

Ibn Saud told Churchill that he would not make a compromise with Zionism and "in the preposterous event that I was willing to do so, it would not be a favour to Britain since the promotion of Zionism from any quarter must indubitably bring bloodshed and widespread disorder in the Arab lands with certainly no benefit to Britain or anyone else."[36]

Ibn Saud told Churchill that he would not make a compromise with Zionism and "in the preposterous event that I was willing to do so, it would not be a favour to Britain".

After that, according to what Ibn Saud told Eddy, "Churchill laid down his big stick." The Saudi monarch then said to Churchill: "You British and your allies will be making the wrong

choice between a friendly and peaceful Arab world and a struggle to the death between Arabs and Jews if unreasonable immigration of Jews to Palestine is renewed. In any case the formula must be arrived at by and with Arab consent."[37]

Those words seem to me to be profoundly significant. They almost demand the conclusion that there *were* circumstances in which Ibn Saud as leader of the Arab world was prepared to compromise to the extent of allowing more Jews to enter Palestine. But the right circumstances would be created only if Roosevelt and Churchill took the advice offered by Landis (and others) and told the Zionists that the idea of a Jewish state in Palestine had to be dropped. I think Ibn Saud was signalling that, in such circumstances, the Arabs, provided they were consulted on "the formula", would be prepared to acquiesce in the establishment of a Jewish national home in Palestine—the national home of the Balfour Declaration as envisaged by Ahad Ha-am.

Unfortunately the first thing President Roosevelt did when he got back to Washington after his meeting with Ibn Saud was to authorise Rabbi Wise to say that he, the President, was still in favour of unrestricted Jewish immigration to Palestine and the creation there of a Jewish state!

Again the media's reporting of President Roosevelt's position as stated by Rabbi Wise and other leading Zionists led to anger and protests, and confusion at leadership level, in the Arab world. And again the State Department had to resort to behind-closed-doors crisis management. This time America's Chiefs of Mission in the Arab world were instructed to tell Arab leaders in private not to panic and to appreciate that, for reasons of domestic politics, the President had to play games with the Zionists.

By now the most senior and responsible officials in the State Department were greatly alarmed by what Landis had correctly described as their country's "vacillating policy with reference to Zionism"; and they began to press for a definitive Palestine policy that would "give full consideration to U.S. long-term interests."

On 10 March President Roosevelt received letters simultaneously from King Ibn Saud and other Arab leaders. The letters were detailed presentations of the Arab case—the historical, legal, political and moral basis of Arab rights to and claim on Palestine. Also signalled was the willingness of the Arabs to fight if necessary to defend their position in Palestine.

Shortly after President Roosevelt had read the Arab letters, the State Department warned him of how dangerous the situation was becoming. A position paper written by Wallace Murray, the Director of the office of Near Eastern Affairs in the State Department, said this: "The President's continued support of Zionism may thus lead to actual bloodshed in the Near East and even endanger the security of our immensely valuable oil concession in Saudi Arabia."[38]

But bloodshed and possible disruption to the flow of oil were not the State Department's only concerns. At the time the Soviet Union was opposed (said it was opposed) to the creation of a Jewish state. With that in

mind Murray also advised that it would not be wise to attempt a settlement of the Palestine problem without the full agreement of the Soviet Union. He added: "The continued endorsement by the President of Zionist objectives could throw the entire Arab world into the arms of the Soviet Union."[39] In his letters of reply to Ibn Saud and the other Arab leaders, President Roosevelt repeated in writing more or less what he said to the Saudi monarch face-to-face, that no decision would be taken with respect to the basic Palestine situation without full consultation with both Arabs and Jews, and that he would "take no action as Chief of the Executive Branch which might prove hostile to the Arab people."[40]

Roosevelt's letters were dated 5 April 1945. They were not transmitted until 10 April. Two days later he was dead.

The question that has to be asked about President Franklin Delano Roosevelt with regard to Palestine is—what on earth was his game-plan?

Palestine did not become a significant item on President Roosevelt's agenda until America entered World War II. What explains thereafter his double-speak? Why did he say one thing in private to the leaders of the Arab world, which represented his real position, and another thing, the opposite, to the Zionists, knowing that through the media they would proclaim what they represented him as saying to the people of America and the world?

Why did Roosevelt say one thing in private to the leaders of the Arab world, which represented his real position, and the opposite to the Zionists, knowing that through the media they would proclaim it to the people of America and the world?

I think there is only one answer that makes any sense.

Up to the moment of his death Roosevelt was not prepared to say "No" to the idea of a Jewish state; and the reason why can be summarised as follows.

Prior to the 1944 election he was unwilling to do so on account of domestic political considerations—his concerns about the damage in terms of campaign funds and votes the Zionist lobby could do to his party's election prospects if it, and he himself, did not give at least the impression of support for Zionism's objectives in Palestine. For reasons of political expediency he did actually sign, on demand, a public letter endorsing his party's pro-Zionist election platform.

After the 1944 election, and because of the public sympathy for Jews as the full horror of the Nazi holocaust emerged and began to sink in and move public opinion, *the time for confronting Zionism was simply not right.* Not right emotionally and so not right politically. In the dreadful shadow of the Nazi holocaust, saying "No" to a Jewish state would have required a battle in Congress, with the most powerful media voices on Zionism's side, that no President could have won.

But tied though his hands (and feet) were, I am in no doubt that President Roosevelt did have a game-plan with regard to Palestine.

Roosevelt died on the 82nd day of what would otherwise have been four more years in the White House. That would have been time enough, probably, for the emotional impact of the Nazi holocaust to become less of an exploitable factor in American politics. I mean exploitable by Zionism's zealots and their unquestioning supporters in Congress and the mainstream media.

On that basis let us speculate for a moment or two about what might have happened if Roosevelt, opposed as he was to the creation of a Jewish state in the face of Arab opposition, had had four more years.

When he signed his letters to Ibn Saud and the other Arab leaders, Roosevelt had already decided (rather like President Wilson before him in similar international circumstances) that he would personally lead America's delegation to a hugely important international conference. It was scheduled to open in San Francisco on 25 April, two weeks after Roosevelt's death as it turned out.

The purpose of the San Francisco Conference, to be attended by 46 nations, was to draft a Charter for the founding of the United Nations —the world body to replace the discredited League of Nations. (It was, in fact, doomed from the beginning by America's refusal to join, and then by Imperial Britain's domination of it, initially to get a Mandate to give its continuing occupation of Palestine, and its intended implementation of the Balfour Declaration, the appearance of legitimacy. Later the League of Nations was discredited by its failure to prevent Japanese expansion in Manchuria and China; by Italy's conquest of Ethiopia; and, the last nail in its coffin, Hitler's repudiation of the Treaty of Versailles. Early in the course of World War II the League of Nations was so discredited that it ceased to function. But Woodrow Wilson's idealism did not die with it. World War II only confirmed the need for leaders to give substance to his vision with regard to the creation of a global institution).

At the Yalta summit, Roosevelt, Churchill and Stalin had settled their differences about setting up the UN. Its Charter was signed and came into force on 24 October 1945. And the new world body came formally into being the following year. While it was convening elsewhere, in London and then Switzerland, John D. Rockefeller Jr. donated $8.5 million dollars for its headquarters site in New York.

If Roosevelt had lived to serve his full fourth term as President, he would have had four years minus 82 days to make good and proper use of the UN as the institution for settling not only the Palestine problem but his Palestine problem—the influence of the Zionist lobby.

Roosevelt believed that the UN, reflecting the will of the international community at the time, would not resolve the Palestine issue by endorsing Zionism's demand for the creation of a Jewish state.

Roosevelt believed, as indeed did everyone who was informed on the issue, that a resolution of the Palestine problem by the UN, representing the will of the organised international community at the time, would not be one that endorsed Zionism's preposterous demand for the creation of a Jewish

state—assuming only that all the member states were allowed to vote freely.

On that basis, probably not before he was nearing the end of his final term in office, and assuming the UN went for a settlement of the Palestine problem that did not give Zionism a state, President Roosevelt, politician *par excellence* that he was, could have said to the people of America something like this:

> At such a critical but promising moment in the history of mankind, the United States of America cannot afford to be out of step with, and effectively challenging the authority of, the United Nations. We, too, must abide by its decisions, all the more so if it is our wish to give the world the moral leadership it so desperately needs.

He could also have pointed out that, as a consequence of resolving the Palestine problem with the agreement of the Arabs, there would be in Palestine not a Jewish state—that was impossible—but a home for Jews as envisaged by the Balfour Declaration and Ahad Ha-am.

Could it be that President Roosevelt, if he had lived, would have played his final hand in such a way?

The evidence in the record made public in 1964 suggests that the answer is very probably yes. In addition there are two summary reasons why I am in no doubt about it.

The first is that President Roosevelt did not believe in the idea of a Jewish state. (And that probably explains why he was called an "anti-Semite" —a false and wicked charge in my view—by Ben Hecht in his autobiography, *Child of the Century*). Roosevelt was fully aware, and not just because of the State Department's line, that the Zionist enterprise was not in America's longer term and best interests.

The second, or so I believe, is that Roosevelt meant what he said when he described the Presidency as being "pre-eminently a place of moral leadership". FDR could and did play the game of politics (double-talking and double-dealing) as well as any and better than most. That was how he kept the Zionists at bay on his watch. He played them at their own game! He might not have had such a grand vision as Woodrow Wilson about how the world ought to be; and to that extent he was less of an idealist and less naïve than Woodrow Wilson. But fundamentally Presidents Wilson and Roosevelt were the same—good human beings who wanted to do what was right for the right reasons.

But I am more than content to leave the last word on the subject of President Roosevelt and Israel to one of Amercian Zionism's most influential sons, David K. Niles, another voice from the grave. In 1974, Dr. Stephen D. Isaacs of *The Washington Post* had published (by Doubleday in New York) a book described as "A vast storehouse of information on a touchy subject which is poorly understood by Jews and their enemies." The book's title was *Jews and American Politics*. On page 244, Isaacs wrote this (emphasis

added): "The late David K. Niles, a Jew who was an aide to Roosevelt and, later, to Truman, made the point that, *had Roosevelt lived, Israel probably would not have become a state.*" (The critical role Niles played in the determination of American policy has its place in the pages to come.)

President Roosevelt's untimely death set the stage for the mother and father of political struggles in America. At issue was one very simple but profoundly important question: Who would determine U.S. policy for Palestine—an American President and his administration acting to serve and best protect the American interest, or the Zionist lobby?

When the struggle started Roosevelt's successor, Harry S. Truman, was the man in the middle, caught in the crossfire of the opposing forces.

The truth about this struggle only started to emerge in the 1970's with the release into the public domain of de-classified State Department documents and Truman papers. Some vested interests had not wanted some of the information to be de-classified. And still today discussion about what actually happened behind closed doors is not welcomed. Why not?

Because the documented truth raises seriously embarrassing and disturbing questions not only about how Israel and the Arab–Israeli conflict were created, but also about how America is governed and, in particular, the quality of its democracy.

Even today, discussion about what actually happened behind closed doors is not welcomed because the documented truth raises disturbing questions not only about how Israel and the Arab–Israeli conflict were created, but also about how America is governed and, in particular, the quality of its democracy.

As the President of the United States of America and the leader of the so-called Free World, Truman was an enormously powerful man. If he was more powerful than Stalin, and surely he was, Truman was the most powerful man in the world. The single most dramatic symbol of his power was his decision to authorise the dropping of atomic bombs on Hiroshima and Nagasaki; this to bring World War II to an end in a way that, according to the official version, would save the lives of up to 500,000 American ground troops. That was the projected number of Americans who might be killed in action if the defeated Japanese army honoured its promise to fight to the last man rather than surrender.

But thanks to Adolf Hitler, Zionism had its own awesome weapon—the Nazi holocaust as a political and emotional blackmail card. The Zionists had played it with skill to prevent President Roosevelt, up to the time of his death, denying them the prospect of victory in Palestine.

The question waiting for an answer after his untimely death was—how would the Zionists play this card on Truman's watch and what impact on him would playing it have?

The first shot in the political struggle to determine which of two forces would command President Truman's support—the State Department or Zionism—was fired by Secretary of State Stettinus.

On the sixth day of the Truman presidency Stettinus sent the new man in the White House a private and confidential letter. Apart from the deteriorating situation in Palestine and rising tension throughout the Middle East, there were several related reasons for the Secretary of State's urgency.

One was to do with fact that in his 82 days as Roosevelt's Vice President, Truman had met with Roosevelt only twice. When he took the presidential oath of office a month short of his 61st birthday, Truman therefore had no understanding worth having of either the complexities and dangers of the Palestine problem, or how the Roosevelt administration had been intending to deal with it. (Missouri's Senator Truman had not been President Roosevelt's own choice of running mate for the 1944 election).

Another reason for Stettinus's urgency was to do with the perception, widely held, that Truman was "far too small for the job."

That reputation did, in fact, stay with him for all of his nearly two terms as America's 33rd President, but after his retirement many Americans saw him in a much more favourable light. Many agreed with what Truman himself once said—that he had "done his damndest."

From the Arab point of view that was true in the profanatory sense.

There is good reason to believe that Truman had not wanted to be Vice President let alone President.

In *The Forrestal Diaries,* Forrestal recorded Senator Truman as having said to him, on 4 July 1944, "that he was being urged to accept the nomination for Vice President but that he proposed to resist", because he was "happy in the Senate and felt that he was able to exercise (there) as much influence in Government as he wished."[41]

James Forrestal was the man who reorganised America's armed forces and became the first U.S. Secretary of Defence. In Chapter Twelve of this book he gets the attention he deserves because he was one of the two truly great men of principle in Truman's first administration who tried and failed to persuade the President to put America's interests first so far as decision making about Palestine was concerned. The other was the legendary General George C. Marshall, the U.S. Army's Chief of Staff during World War II, described by Churchill as "the organiser of victory"; and who was Secretary of State when Truman eventually surrendered to Zionism. But it was Forrestal, as we shall see, who tried to do the one thing necessary to prevent Zionism calling America's foreign policy shots in the Middle East.

If Senator Truman's words to Forrestal represented his real thinking, they suggest that the man himself had serious doubts about whether he was big enough for the job at this most critical time in the history of mankind. (A name from Truman's past to remember is that of Eddie Jacobson. He was a non-Zionist Jew who served with Truman in World War I and became his partner in a Kansas City haberdashery store. As we shall see, Eddie, when his friend Harry was the President of the United States of America, would do something of the utmost importance for Zionism, something that was critical to Zionism's success and which Zionism, incredibly influential though it was, could not do for itself).

Truman took the oath of office in the cabinet room of the White House at 6.45 p.m. on 12 April 1945, half an hour after Mrs. Roosevelt had given him the news of her husband's death. While he was being sworn in, Truman failed to raise his right hand when he was repeating the oath with his left hand on the Bible. Chief Justice Harlan F. Stone intervened to tell Truman that he should raise his right hand to give the occasion dignity and firmness.

The new president had what the English call a short fuse and Americans describe as a "low boiling point." He also had an inoffensive cockiness; but this apparent confidence in himself masked what others recognised as insecurity; and this caused some who were going to have to work with him to fear that President Truman would be very susceptible to Zionist lobby pressure.

Secretary of State Stettinus knew what the Zionists were thinking as the torch passed from Roosevelt to Truman. As Rabbi Neumann would later confess, the Zionists were confident that "the going would be much easier with Truman in the White House."[42] Truman, Rabbi Neumann would later write, "was a far less complex personality than his illustrious predecessor —less adroit and sophisticated, simpler and more straight forward. He accepted the Zionist line reluctantly and under pressure at first, but having accepted it, he followed through honestly and firmly. In the end he found himself in direct conflict with Britain's Bevin. He did not shrink from the encounter, but, supported by popular opinion, he stuck to his guns and forced the State Department to acquiesce in his pro-Zionist policy."[43] But as we shall see, Truman's commitment under pressure to Zionism was not nearly as firm as Rabbi Neumann suggested.

The position at the time Stettinus was writing his letter can be summed up like this: Zionism's zealots were confident they could do on Truman's watch what they did not do and could not have done on Roosevelt's watch—oblige the President of the United States of America to call the policy shots in their favour. About Truman's illustrious predecessor, Rabbi Neumann wrote: "To cross him, to offend him, to alienate his affection was to court disaster for the Zionist cause."[44]

The private and confidential Stettinus letter delivered to Truman on his sixth day as President said this:

> It is very likely that efforts will be made by some of the Zionist leaders to obtain from you at an early date some commitments in favour of the Zionist program, which is pressing for unlimited Jewish immigration into Palestine and the establishment there of a Jewish state. As you are aware, the government and people of the United States have every sympathy for the persecuted Jews of Europe and are doing all in their power to relieve their suffering. The question of Palestine is, however, a highly complex one and involves questions which go far beyond the plight

of the Jews in Europe... There is continual tenseness in the situation in the Near East, largely as a result of the Palestine question, and as we have interests in the area which are vital to the United States, we feel that this whole subject is one that should be handled with the greatest care and with a view to the long-range interests of the country.[45]

Secretary of State Stettinus to Truman: Palestine involves questions which go far beyond the plight of the Jews in Europe and should be handled with a view to the long-range interests of the U.S.

Two weeks later Acting Secretary of State Grew followed up with a lengthy memorandum. (Stettinus had played a key role in the founding of the UN and had gone on to be the first U.S. delegate to the world body.) Grew's memorandum briefed Truman in detail on the history of the relations between President Roosevelt and Arab leaders. Particular attention was drawn to Roosevelt's assurances to Ibn Saud about prior consultation with the Arabs as well as the Jews and, most important, Roosevelt's eyeball-to-eyeball pledge to the Saudi monarch, confirmed in writing, that he would "make no move hostile to the Arab people and would not assist the Jews against the Arabs."

President Truman's first action on Palestine was to reply to a letter sent to President Roosevelt by King Abdullah. It had gone unanswered because of Roosevelt's death. (Abullah's message had arrived later than those sent by other Arab leaders, as did one from Egypt's Prime Minister, Mahmoud Nokrashy). Truman's reply to Abdullah said: "I am glad to renew to you the assurances which you have which you have previously received to the effect that it is the view of this government that no decision shall be taken regarding the basic situation in Palestine without full consultation with both Arabs and Jews."[46] This promise was also repeated by Truman in writing to Nokrashy.

Zionism had its own eyes and ears in the White House. By far the most important of them belonged to the previously mentioned David K. Niles. After the 1940 election, weighed down by his war responsibilities, Roosevelt had taken Niles into his inner circle as an Executive Assistant to the President for minority affairs. When Truman succeeded Roosevelt he gave Niles the Palestine problem to handle. Niles had a "passion for anonymity" (his own words) and was once described in a newspaper (*The Saturday Evening Post*) as "Mr. Truman's Mystery Man".

President Truman's private confirmation in writing that he would stand by Roosevelt's assurances to the Arabs provoked renewed and more intense Zionist lobby pressure on him and a threat to the State Department— that unless a forthright position was taken on Palestine, one by definition that would give Zionism all it was demanding, the "moderate" leadership of organised American Jewry would be replaced by a less accommodating and more extreme one. The meaning was that the uncompromising and

fanatical Rabbi Silver would assume the leadership and the moderate and conciliatory Rabbi Wise and Dr. Nahum Goldman would be sidelined.

The threat of a more extremist leadership was a convenient cover for the fact that all was far from well in Zionism's leadership ranks. By this time Wise and Goldmann were disillusioned with what the WZO had become; and Zionism's zealots saw possible danger in the two of them continuing to play leading roles in the politics of presenting and pushing Zionism's demands.

Rabbi Wise, for years the leader of organised American Jewry, had wanted Zionism to take the lead in organising an international boycott of Nazi Germany's exports; and he had gone along with the *Ha'avara Agreement* policy of collaborating with the Nazis only to avoid a damaging and probably disastrous split in Zionist ranks. But his real disillusion with the WZO had its origins further back in time. At a conference in 1934 he attacked the in-Palestine Zionists for insisting that the creation of a Jewish state should

The World Zionist Organization leadership itself was conflicted over the primacy of Eretz Israel over the needs of the majority of the world's Jews.

have "primacy over all other factors in the equation in all circumstances."[47] He acknowledged that Palestine should have primacy, but he said, "*that primacy ceases when it comes into conflict with a higher moral law,*" (emphasis added).[48]

As Brenner commented, Rabbi Wise had "identified the rot in the WZO". The rot being that the WZO's Zionism was without morality and "saw the land of Eretz Israel as being more important than the condition and needs of the majority of the Jews of the world".[49]

By the time Truman became President, Rabbi Wise was alarmed because it was clear that Ben-Gurion and his in-Palestine Zionists were setting the pace and that the WZO was blindly following their lead. I imagine Rabbi Wise was also deeply troubled by the fact that there were now in existence Zionist terrorist organisations committed to driving both the British and the Arabs out of Palestine by violence.

For his part Nahum Goldmann (who served as a President of the WZO) was disgusted by Zionism's collaboration with the Nazis and the WZO's policy of not even trying to resist Hitler. In his book, *Autobiography*, a contrite and remorseful Goldmann told of his own shameless role during the Hitler epoch.

Czech Foreign Minister Benes was shouting. "Don't you understand that by reacting with nothing but half-hearted gestures, by failing to arouse world public opinion and take vigorous actions against the Germans, the Jews are endangering their future and their human rights all over the world?"

He described a dramatic meeting he had with Edvard Benes, the Czech Foreign Minister. Benes was condemning the WZO's abject failure to resist the Nazis. The Czech Foreign Minister, Goldmann wrote long after the events, was shouting. "Don't

you understand that by reacting with nothing but half-hearted gestures, by failing to arouse world public opinion and take vigorous actions against the Germans, the Jews are endangering their future and their human rights all over the world?"[50]

Goldmann added (emphasis added): "I knew Benes was right... In this context success (the creation of a Jewish state in Palestine) was irrelevant. *What matters in a situation of this sort is a people's moral stance, its readiness to fight back instead of helplessly allowing itself to be massacred.*"[51]

On 16 June Assistant Secretary of State Grew warned Truman that he was about to be subjected to even more intense Zionist lobby pressure. At the time Truman was preparing for his Potsdam meeting with Churchill and Stalin, set for 16 July to 2 August. Grew advised Truman that when the Zionists turned up their heat on him before he set off for Potsdam, he should receive their materials with thanks; tell them that their views would be given careful consideration; and "reiterate that the matter of settlement (of the Palestine problem) would eventually come before the United Nations Organisation."[52]

It was President Roosevelt's intention to have the Palestine problem solved by the UN as the agency representing the will of the organised international community. Grew could not possibly have said such a thing to Truman if he was not speaking from a Roosevelt policy script.

Ben-Gurion himself was brought in to add to the pressure America's Zionists were piling on the State Department. At a meeting with senior officials in the Department on 27 June, Ben-Gurion insisted that the Jews had to be allowed to get on with creating their state "without interference from outside elements."[53] That was Ben-Gurion's way of saying Zionism objected to the fact that Truman was continuing with the Roosevelt policy of assuring the Arabs, all Arab leaders who mattered so far as the U.S. was concerned, that they would be consulted about the future of an Arab land. In the course of that conversation with State Department officials Ben-Gurion also said the Jews in Palestine would fight if necessary; and he let slip that he and his colleagues were confident they could deal with the Arabs if it came to war. He said he knew the Arabs well and predicted they would "not really put up any kind of fight."[54] On that, as we shall see, Ben-Gurion was proved to be more right than wrong.

The main point of Ben-Gurion's contribution to the discussion was that the lifting of Britain's restrictions on Jewish immigration to Palestine would not solve the problem of anti-Semitism. The only answer to that problem was "the immediate establishment of a Jewish state."[55] Ben-Gurion was aware that, if the member states were allowed to vote freely, there would not be majority support at the UN for the creation of Jewish state.

President Truman was not yet submissive enough to support the idea of a Jewish state but, under pressure, he was prepared to push Britain on the matter of Jewish refugees—those European Jews who had survived the Nazi holocaust but who had been uprooted and were homeless, festering in camps. When he met Churchill in Potsdam, Truman handed

him a memorandum that said the U.S. was interested in Britain "finding it possible without delay to take steps to lift the restrictions of the White Paper on Jewish immigration to Palestine."[56] At a press conference after the Potsdam summit, Truman said the American view was that as many Jews as possible should be allowed to enter Palestine; but it was a matter "that would have to be worked out diplomatically with the British and the Arabs"; and it would have to be "on a peaceful basis as we have no desire to send half a million Americans to keep the peace in Palestine."[57]

Truman also asked Churchill to send him his views on a settlement of the Palestine problem.

While they waited for Britain's views and the answer to Truman's request for the lifting of restrictions on Jewish immigration, top officials at the State Department prepared a detailed position paper that discussed four possible options for a solution to the Palestine problem. They were:

(1) An independent Jewish "commonwealth"—the term the Zionists were still using in public and which everybody knew meant state.

(2) An independent Arab state.

(3) Partition under UN trusteeship.

(4) A proposed trusteeship agreement to be reached by Britain, the U.S. and the Soviet Union, and if possible France, under which Palestine would be given special status as an international territory with Britain the administering authority.

The writer of the position paper was Loy Henderson, the Director of the State Department's Office of Near Eastern and African Affairs. He ruled out the first option on the grounds that it was a violation of the wishes of a large majority of the local inhabitants, and would "jeopardise American economic interests including our oil interests in Saudi Arabia and other Arab countries."[58] Henderson predicted the probability of an Arab oil embargo. (When it happened 28 years later it shook the global economy to its foundations and was a huge setback for the development prospects of the poorest nations containing the majority of the human inhabitants of Planet Earth.)

Option (4) was the one favoured by Henderson and recommended to the new Secretary of State, James Byrnes. When Henderson came down in favour of option (4) he acknowledged that it would be opposed by both the Arabs and the Jews but, he thought, "with less intensity than any of the other alternatives."

Senior State Department people who argued against the creation of a Jewish state on the grounds that it was not in America's longer-term interests became targets of a Zionist campaign of character assassination.

Like all senior State Department people who argued against the creation of a Jewish state on the grounds that it was not in America's longer-term interests, Henderson, and Henderson especially, became the target of a Zionist campaign of character assassination.

It was not to Truman's credit that, when it suited him to do so for reasons of domestic politics—appeasing the Zionist lobby—he sometimes said, or allowed others to say for him, that State Department people were "disloyal" to him.

Many years after the events Henderson wrote the following in a letter to Lilienthal: "More criticism has been aimed at me for what I did during my three years as Director of NEA than what I did in all my other years of service [nearly 40]. I can take criticism for bad judgement, for poor performance and for inadequacy. But attacks on my motives, charges of disloyalty and lack of honour leave scars that are slow to heal."[59] (The same could have been said by other senior State Department officials including, after Stettinus, three successive Secretaries of State, and America's first Defence Secretary, who each did their professional and patriotic duty by trying to put the American national interest first and arguing against the creation of a Jewish state in the face of Arab opposition).

At about the time Henderson was putting together the State Department's options paper, the American and British governments were presented with the first official figures of the total number of displaced persons—those made refugees by Hitler's rampage in Europe. They showed that the refugees were from many lands, mainly Austria, Germany, Poland, Hungary, Rumania and the Baltic countries; and of many faiths. In numbers the three main groups, assembled in refugee camps, were: Jews—226,000; Protestants—100,000; and Catholics—500,000.

On 31 August President Truman sent a top-secret communication to Britain's new Prime Minister, Clement Attlee. (His Labour Party had beaten the Conservatives by a huge margin and Churchill was gone—respected by many for his inspirational wartime leadership, but wanted by few for the task of rebuilding Britain and preparing the country to take its place in what many hoped would be a new and better world).

Truman's letter informed Attlee that the issuance by Britain of 100,000 certificates of immigration to Palestine would help to alleviate the Jewish refugee problem.

The Truman letter was so secret that it was handed to Attlee in person by Secretary of State Byrnes. Truman feared that if his request to Britain became public, the Zionists, led by Ben-Gurion's in-Palestine lot, would attack him and accuse him of manoeuvring to solve the refugee problem as a prelude to killing the idea of a Jewish state.

Somehow a copy of Truman's top-secret communication found its way into the hands of a former Iowa Senator, Guy Gillette. As an officer of the American League for a Free (Jewish) Palestine, he was one of Zionism's most devoted servants in the U.S. And he fed the story of Truman's request to Attlee to the media. And then, politically speaking, all hell broke loose.

The Zionists protested because they did fear it might be the opening move in a strategy to deny them their state. In Britain Truman was attacked for his "generosity at the expense of the Arabs". And Arab leaders angrily complained that Truman was dishonouring the promises, first made by President Roosevelt, then repeated by Truman himself, to consult with them.

My reading of events in perspective is that if Truman's letter could have been kept secret, it might well have been possible for Britain to persuade the Arab leaders who mattered most to accept another 100,000 Jewish immigrants on the basis that that was it—no more Jewish immigrants and no Jewish state. And that, I believe, is what Ben-Gurion feared would happen. It was because he had anticipated the possibility of the politics going against him that, on 27 June, he had gone to the State Department to tell the Americans to their faces that immigration would not solve the problem of anti-Semitism and that only the immediate creation of a Jewish state would.

There was then a most bizarre episode. The story was put about, President Truman did not deny it, that a search of the late President Roosevelt's papers had failed to discover any record of a pledge made by him to Ibn Saud about prior consultations with the Arabs! Ibn Saud himself was so disgusted by this propaganda lie that he cabled Truman saying that if the President was not prepared to reveal the truth, he, Ibn Saud, would publish the memorandum of his meeting with President Roosevelt on board the USS *Quincy* and the correspondence between himself and Roosevelt. And eventually that's what he did.

Question: Who of the White House insiders was best placed to leak President Truman's top-secret request to Attlee and also had a powerful enough motive for doing so? The most likely answer, I believe, is Niles. I suspect it was also Niles who put about the story that a search of Roosevelt's papers had not produced evidence of any promises to the Arabs. His position and his access was such that he would have been believed, especially by Zionism's unquestioning supporters in the media. It might have been that Niles did actually conduct a search for evidence of Roosevelt's promises and did not find any because it had been put beyond his reach.

Because of the emotions generated by the Nazi holocaust and the way those emotions were being exploited by Zionism, in America especially, the Palestine problem was becoming almost too dangerous politically for Truman and Attlee to handle.

Because of the emotions generated by the Nazi holocaust and the way those emotions were being exploited by Zionism, in America especially, the Palestine problem was becoming almost too dangerous politically for Truman and Attlee to handle.

The experience of the Gillette affair taught Attlee that, on the super sensitive subject of the Jewish refugees and what to do about Palestine, Truman's White House was too insecure for a British prime minister to put things in writing under his own signature. Thus it was, on 29 October, that Attlee's eventual reply to Truman's request for 100,000 immigration certificates was in the form of a memorandum written by Britain's Ambassador in Washington, Lord Halifax, to Secretary of State Byrnes. It was handed in person to Byrnes by Halifax but the real substance of what Britain wanted to say was reserved for the one-to-one conversation between the two men.

The memorandum itself called for the urgent establishment of a joint Anglo-American Committee of Inquiry to examine the question of Jewish immigration. In conversation Halifax insisted, as instructed, that the Committee should explore the possibilities of Jewish emigration to countries "other than Palestine." [60] The British view, Halifax said, was that the Jewish refugees "should be enabled to play their active part in building up the life of the countries from which they came."[61] Halifax also conveyed the British impression that if the Jewish refugees themselves were consulted, most of them would express a preference for going not to Palestine but returning to the homelands from which they came or starting a new life in America. (This British input was to have a profound effect on President Truman's thinking and cause him, just before Christmas of 1945, to take a bold initiative).

The British sought Jewish emigration possibilities other than Palestine, contending most Jewish refugees would have preferred to return to the homelands from which they came or to start a new life in America.

Halifax also told Byrnes that "the Zionists are using every possible form of intimidation to stop Jews from leaving Palestine to go back to Europe and play their part in its reconstruction." (It is a fact that before the Nazi holocaust quite a number of new Jewish arrivals in Palestine were horrified by the discovery that it was not the empty land of Zionism's recruiting propaganda. And, morally outraged by what Zionism was proposing to do, they turned around and went back to Europe and America).

It was, however, the timing of what Britain wanted to happen next that most concerned the Attlee government. The need for Truman's agreement to set up the proposed Anglo-American Committee was desperately urgent because of the worsening situation on the ground in Palestine. Not only was the fighting between the Arabs and the Jews escalating, the two main Zionist terrorist organisations were launched on their campaign of violence to drive the occupying British and the Arabs out of Palestine.

Lord Halifax emphasised the need for urgency. Secretary of State Byrnes was in sympathy with all that Halifax said but was totally honest in his assessment of what could be expected of his President at the time they were speaking. Byrnes pointed to the nearness of elections in New York City and did not need to tell Halifax they were elections in which Jewish votes were far more important than Jewish campaign money.

An explanation of the importance of the Jewish vote in general was provided by Lilienthal in his epic work *The Zionist Connection II*. He opened his chapter headed "Whose Congress: Thwarting the National Interest" as follows:

> The reason for the remarkable political success achieved by the Jewish connection and the Zionist connectors lies deep in the American political system. Our system of

representative government has been profoundly affected by the growing influence and affluence of minority pressure groups, whose strength invariably increases as presidential elections approach, making it virtually impossible to formulate foreign policy in the American national interest. And the Electoral College system has greatly fortified the position of the national lobbies established by ethnic, religious and other pressure groups, the Jewish-Zionist Israel lobby in particular.

An added tower of strength to the Jewish connection has been the Jewish location: 76 percent of American Jewry is concentrated in 16 cities of six states—New York, California, Pennsylvania, Illinois, Ohio and Florida—with 181 electoral votes. It takes only 270 electoral votes to elect the next President of the U.S. Our Chief Executive is chosen by a plurality of the Electoral College votes, not of the popular vote. Under this system the votes of a state go as a unit to the candidate winning a plurality of voters, which endows a well-organised lobby with a powerful bargaining position.

For example, in the presidential election of 1884, in the State of New York, Democratic candidate Grover Cleveland received 563,015 popular votes while his Republican rival, James G. Blaine received 562,011 votes. With a bare 1,004 plurality Cleveland received all of New York's electoral votes, resulting in his election. A change of 503 votes would have shifted the election to Blaine. This explains why the politicians have been mesmerised by fear of the "Jewish vote" and by those who claim they can deliver the "swing vote" in a hotly contested state.

The will of the majority has often been frustrated. Three Presidents—John Quincy Adams in 1824, Rutherford B. Hayes in 1876 and Benjamin Harrison in 1888—were elected with fewer popular votes than their leading opponents. [In a note Lilienthal added that, in all, 12 presidents had been elected with an actual minority of the popular votes. The last edition of his book was published in 1982. In an up-to-date edition he might well have noted that at least one president, George W. Bush, secured The White House only because the Florida vote, if not others, was rigged.] But it is the Cleveland 1884 election that is the classic example, under the prevailing system, of how a minority group such as the Zionists possesses a potent bargaining strength by pandering the votes of a block.

The inordinate Israelist influence over The White House, the Congress and other elected officials, stems principally from the ability to pander to the alleged 'Jewish vote' as well as fill the campaign coffers of both parties with timely contributions on a national as well as a local level, while taking full advantage of the anachronistic system by which American Presidents are elected.

None of the many powerful political lobbies in Washington is better entrenched than the meticulously organised brokers of the "Jewish vote".

The individual Jew, who might not go along with the Zionist ideology or Jewish nationalism, is too cowardly to speak up and take the usurpers of his voice to task, and so the peddling of his vote goes forward. Hence the happy alliance dating back to World War I, between the supine American politicians and the Zionists, who have controlled the Congress in its near 100 percent pro-Israel stance.

The inordinate Israelist influence over The White House, the Congress and other elected officials, stems principally from the ability to pander to the alleged 'Jewish vote' as well as fill the campaign coffers of both parties with timely contributions on a national as well as a local level, while taking full advantage of the anachronistic system by which American Presidents are elected.

As reported by Halifax, Byrnes said, "I know it [the decision Truman had to make in response to Attlee's suggestion] has a lot to do with that election." [62]

Reading between the lines it is obvious that Byrnes was saying to Halifax something like: "If you press me before the New York election to get the President to approve your Prime Minister's proposal for the setting up of an Anglo-American Committee, he will say no." The alternative for the present, Byrnes told Halifax, was that "nothing would be done."[63] Byrnes also told Halifax that he himself was being subjected to intensive Zionist lobby pressure.

By not pressing Truman until the New York election was over, the Attlee government got not only his approval for the setting up of an Anglo-American Committee of Inquiry; it also got, eventually, after a lot of hassle, terms of reference for the inquiry that were less than disastrous from the British point of view.

It was to be called the Anglo-American Committee of Inquiry on Palestine. The formal announcement that there would be such an inquiry was made simultaneously on 13 November, in London by Foreign Minister Ernest Bevin, who was to be falsely accused by some Zionists of being anti-Semitic, and in Washington by Truman himself. Between then and 10 December when

the names of the Committee's members and their terms of reference were announced, the Arabs piled on political pressure of their own.

By this time the Arab League was in being as the institution representing the Arab states. Initially there were seven member states. Through U.S. Chiefs of Mission in those states the Arab League sent the State Department a strong memorandum. It drew attention to the fact that in Palestine over the preceding 20 years the proportion of Jews to Arabs had increased from one-in-ten to one-in-two. And it went on to say that President Truman's call for 100,000 more Jews to be allowed to enter Palestine was a violation of American (and British) government pledges that no decisions would be taken on Jewish immigration or the settling of the Palestine problem as a whole "without full consultation and agreement with the Arab states."

And that raised a big and difficult question that could no longer be avoided. Did previous American assurances of full consultation mean what the Arabs assumed it to mean—*consultation and agreement?*

In Saudi Arabia, Prince Feisal, Ibn Saud's second son in the line of succession and the kingdom's foreign minister, wanted an answer to that question and he asked America's Chief of Mission, William Eddy, to call on him. In his cabled report of the conversation to Secretary of State Byrnes, Eddy said that when asked the question by Feisal he had replied that "consultation would be meaningless if the results were predetermined, but that my personal understanding is that it (consultation) assures full consideration of Arab opinion and local conditions."[64]

It was not the answer Feisal wanted or needed to hear. Consultation so defined implied that the Americans could listen to the Arabs and then tell them to go to hell.

Feisal then gave Eddy a warning which the American diplomat included word for word in his cable to Byrnes.

> I assure you that the British are telling us officially that they favour the Arab case against Zionism, but that they are being pushed by you into pro-Zionist moves. *The very real admiration and respect which all Arabs hold for America is rapidly evaporating and may soon disappear altogether, along with our many mutual interests and co-operation.* We Arabs would rather starve or die in battle than see our lands and people devoured by the Zionists, as you would do if we were giving them one of your states for a nation. Do not think we would yield to Zionism in the hope of survival or property elsewhere. If it develops that the USA and the British will aid the Zionists against our will and to our destruction, we shall fight Zionism to the last man. In the meantime, don't forget that the British are blaming this initiative [for the 100,000 additional Jewish immigrants] on the Americans."[65]

Feisal's warning enabled the State Department to persuade President Truman to change his mind about the terms of reference for the Anglo-American Committee of Inquiry On Palestine. As Lord Halifax had indicated in his conversation with Secretary of State Byrnes, the British wanted the Committee to be free to recommend Jewish emigration to countries "other than Palestine". Out of fear of provoking Zionism's wrath, and probably on the advice of Niles, Truman had been resisting that.

The extent to which Truman did adjust his position was evident when the terms of reference were announced simultaneously in London and Washington on 10 December. The six American and six British members of the Committee were empowered "to examine political, economic and social conditions in Palestine as they bear upon the problem of Jewish immigration and settlement therein", and to examine the position of European Jews in terms of estimating the "possible migration to Palestine or elsewhere outside of Europe."[66]

Zionism's response to the announcement was immediate and also simultaneous in London and New York. The Anglo-American Committee of Inquiry On Palestine was a "fresh betrayal" to which Zionists "would never submit".[67] And there were Zionist riots in Tel Aviv.

On 22 December 1945, when the Committee was preparing to begin its work, President Truman took a major initiative. He directed the Secretaries of State and War and all appropriate federal authorities to speed up in every possible way the granting of visas to "facilitate full immigration to the United States under existing quota laws."

Truman ordered the speed up in every possible way of granting of visas to "facilitate full immigration to the United States under existing quota laws."

Every possible way included making use of the quotas that had not been taken up in the war years because of the need to keep out enemy agents and potential subversives of all kinds. In 1942 only 10 per cent of the quotas were used; in 1943 only 7 per cent; in 1944 only 6 per cent; and in 1945 only 7 per cent. If the unused quotas could be brought into use in the immediate aftermath of the war—in the lengthening shadow of the Nazi holocaust, it was possible that up to 400,000 refugees could be given visas for a new life in the USA as American citizens. That was nearly twice the number of Jewish refugees festering in the camps of liberated Europe. As Halifax had told Byrnes, very many of them would have opted for a new life in America rather than Palestine if they had been given the choice.

Truman's initiative could have permitted up to 400,000 refugees to be given visas for a new life in the USA as American citizens— nearly twice the number of Jewish refugees festering in the camps of liberated Europe—and solved the Jewish refugee problem.

Such a solution to the Jewish refugee problem, if it had been implemented, would have destroyed Zionism's most powerful weapon of

the time—the Nazi holocaust as a political and emotional blackmail card. At the very least Zionism would have been put into a position in which it did not have the influence needed to determine America's foreign policy agenda for Palestine.

Nobody seems to know, and probably nobody will ever say if they do know, from where the initiative came. Was it Truman's alone, or was it really a State Department initiative that Truman endorsed and agreed to take forward?

From a practical point of view there was a problem. Use of the unused quotas of the war years to make up these numbers required legislation in Congress. The truth is that for nearly two critical years the Zionist lobby succeeded in preventing the necessary legislation being introduced into Congress. (The story of what happened when Congressman William G. Stratton did introduce the necessary legislation has its place later in this chapter).

Use of the unused quotas of the war years to make up these numbers required legislation in Congress. For nearly two critical years the Zionist lobby succeeded in preventing the necessary legislation being introduced into Congress.

There was to come a time when one of President Truman's Secretaries of State, Dean Rusk, would say that there were "two Harry Trumans".[68] I think there were three.

One was the Truman who was inclined to the State Department's view (under successive Secretaries of State) that the creation of a Jewish State in the teeth of Arab opposition was not in America's longer-term interests and, most likely, would be a disaster for all concerned.

Another was the Truman who, as the leader of his party, felt the need to do whatever had to be done to protect his party's election prospects from being damaged by the Zionist lobby if it turned nasty, even when doing so meant allowing Zionism to determine America's agenda for the Middle East.

Another was Truman the human being who, like most Americans, and as Rusk said, had been "deeply shocked by the full exposure of the frightful atrocities of the Hitler regime."[69] It is reasonable to assume that this Truman's understanding of the history of anti-Semitism and the persecution of the Jews was greatly assisted by the man who was, probably, his best friend in the whole world—his former haberdashery partner in Kansas, the non-Zionist Jew, Eddie Jacobson. The quality of their friendship was such that Harry's White House doors were always open to Eddie. (During the Truman presidency Eddie passed through them for private conversations with his friend on not less than 24 occasions, and there were numerous telephone conversations between the two men). I imagine that it was this Truman—not president or calculating party leader—who took the visa initiative. My guess is that he did not even think about the damage it could do to Zionism. I think this Harry Truman just wanted to do whatever he could to bring an end, as quickly as possible, to the suffering of the Jewish refugees in Europe. And

I think he wanted to do it out of the brotherly love he had for his old friend Eddie, and on account of the understanding his friendship with Eddie had given him about the agony and the ecstasy of being Jewish.

From here on the three Trumans were at war with each other as events unfolded.

The six British and six American members of the Anglo-American Committee of Inquiry on Palestine began their work in early January 1946. When the Committee's unanimous report[70] was made public simultaneously in London and Washington on 30 April 1946, the proverbial excrement hit the fan in great dollops, mostly great Zionist dollops.

The Anglo-American Committee on Palestine said "No" to the creation of either a Jewish state or an Arab state.

Though one of the Committee's ten recommendations said "Yes" to the immediate issuance of entrance certificates into Palestine for 100,000 Jews "who had been the victims of Nazi and Fascist persecution", another said "No" to the creation of a Jewish state.

As a package the Committee's recommendations also fell far short of what the Arabs of Palestine wanted, and not just on account of the insistence that they accept another 100,000 Jewish immigrants. There was also a "No" to an exclusive Arab state.

In the light of what was to happen—in the days, weeks, months and years to come—the report containing the Committee's recommendations is worth a closer look.

The first recommendation was concerned with "The European Problem". Under this heading the report said:

> We have to report that such information as we have received about countries other than Palestine gave no hope of substantial assistance to finding homes for Jews wishing or impelled to leave Europe.

> But Palestine alone cannot meet the emigration needs of the Jewish victims of Nazi and Fascist persecution. The whole world shares responsibility for them and indeed for the settlement of all Displaced Persons.

> We therefore recommend that our governments together, and in association with other countries, should endeavour immediately to find new homes for all such Displaced Persons, irrespective of creed or nationality, whose ties with their former communities have been irreparably broken. Though emigration will solve the problems of some victims of persecution, the overwhelming majority, including a considerable number of Jews, will continue to live in

Europe. We recommend therefore that our governments endeavour to secure that immediate effect is given to the provision of the United Nations Charter calling for universal respect for, and observation of, fundamental freedoms for all without distinction as to race, sex, language or religion.

In retrospect an intriguing question is in order. At the time they were writing their report did the Committee members know that Zionism, through its mouthpieces in Congress, was intent on blocking the introduction of legislation to give substance to President Truman's wish to open America's doors by use of the unused visa quotas? If they did know of Truman's initiative, it would have been best practice for the Committee to cite it as an example of what could be done. And that might have made it far more difficult for Zionism to block the legislation to make it happen.

The second recommendation was for the immediate issue of certificates for the admission into Palestine of 100,000 Jews, with "actual immigration pushed forward as rapidly as conditions will permit."

The third recommendation was concerned with "Principles of Government" in Palestine. Under this heading the report said:

No Arab, no Jewish state: in order to dispose once and for all of the exclusive claims of Jews and Arabs to Palestine we recommend it as essential that a clear statement of the following principles be made:
(1) That Jew shall not dominate Arab and Arab shall not dominate Jew in Palestine.
(2) That Palestine shall be neither a Jewish nor an Arab state.
(3) That the form of government ultimately to be established shall, under international guarantees, fully protect and preserve the interests in the Holy Land of Christendom and of the Muslim and Jewish faiths.
Thus Palestine must ultimately become a state which guards the rights and interests of Muslims, Jews and Christians alike; and accords to the inhabitants, as a whole, the fullest measure of self-government, consistent with the three paramount principles set forth above.

This section of the report also included the observation that because it was a Holy Land sacred to Christians, Jews and Muslims alike, "Palestine is not, and can never become, a land which any race or religion can justly claim as its very own."

Under the same heading three members of the Committee who were later to become pro-Zionist and advocates for Jewish statehood expressed this view as their own: "While the Jews have an historic connection with the country, they embody but a minority of the population... Palestine is not

and never can be a purely Jewish land. It lies at the crossroads of the Arab world, its Arab population, descended from the long-time inhabitants of the area, rightly looks upon Palestine as their homeland."

On the subject of how Palestine should be governed for the foreseeable future, the Committee said, in its fourth recommendation, the following:

> We have reached the conclusion that hostility between Jews and Arabs and, in particular, the determination of each to achieve domination, if necessary by violence, make it almost certain that now and for some time to come any attempt to establish either an independent Palestinian state or independent Palestinian states could result in civil strife as might threaten the peace of the world.

> We therefore recommend that until this hostility disappears, the government of Palestine is continued as at present under Mandate pending the execution of a trusteeship agreement under the United Nations.

The idea was that Britain, unless another nation was mad enough to want the job, would remain the administering power as the UN's Trustee. The Committee acknowledged this would mean a very heavy burden for the British, but the burden, it said, would be lightened if the difficulties were appreciated and the Trustee had the support of other members of the United Nations.

The most obvious implication for the longer term of the Committee's report was that if and when hostility "disappeared", an independent Palestine would have a single power-sharing government to serve the well-being of the inhabitants "as a whole", with the rights of the minority Jews guaranteed by the UN. Another possible implication was that a single state of Palestine might have a federal government, with members elected by separate Arab and Jewish regions or cantons. The only things ruled out were Palestine as a Jewish or Arab state. *On any reading of the report as a whole, it was "No" to the Zionist enterprise.*

My own view is that the Committee, no doubt in the name of political expediency, was misrepresenting the situation when it spoke of the "determination of each to achieve domination, if necessary by violence..." *The Zionists in Palestine were seeking to dominate the Arabs. The Arabs were merely trying to avoid being dominated.*

It was in the section of the report concerned with "Future Immigration Policy" (presenting and explaining its sixth recommendation) that the Committee made clear what its own stance was—one of pure pragmatism. The Committee was not concerned with what might be right or wrong when judged in the light of past events and even international law; it was concerned only with what was possible given the situation as it was. The Committee's

pragmatism (and, I think, its wisdom) was indicated in this passage:

> In Palestine there is a Jewish National Home created by the consequences of the Balfour Declaration. Some may think the Declaration was wrong and should not have been made; some that it was a conception on a grand scale and that effect can be given to one of the most daring and significant colonization plans in history. Controversy as to which view is right is fruitless. The National Home is there. Its roots are deep in the soil of Palestine. It cannot be argued out of existence; neither can the achievements of the Jewish pioneers.

Pragmatism was insisting that even if wrong had been done to the Arabs of Palestine by Britain's issuing of the Balfour Declaration and the consequences of it—too bad. It was a wrong that could not be righted. It was too late.

On the subject of future Jewish immigration into Palestine the Committee's sixth recommendation was this:

> We recommend that, pending the early reference to the United Nations and the execution of a trusteeship agreement, the Mandatory [Britain] should administer Palestine according to the Mandate which declares with regard to immigration that the Administration of Palestine, while ensuring that the rights and positions of other sections of the population are not prejudiced, shall facilitate Jewish immigration under suitable conditions.

In its statements about how further Jewish immigration into Palestine should be facilitated if the rights of the Arabs were not to be further prejudiced, the Committee delivered a few words the Arabs did not want to hear and many words the Zionists did not want to hear.

The following three paragraphs from the Committee's report take us to the very heart of the matter, and they help to explain why the Arabs had good cause to be aggrieved by what happened next and throughout the years to come; and is still happening.

> The well-being of all the people of Palestine, be they Jews, Arabs or neither, must be the governing consideration. We reject the view that there shall be no further Jewish immigration into Palestine without Arab acquiescence, a view which would result in the Arab dominating the Jew. We also reject the insistent Jewish [actually Zionist] demand that forced Jewish immigration must proceed apace in order to produce as quickly as possible a Jewish majority

and a Jewish state. The wellbeing of the Jews must not be subordinated to that of the Arabs; nor that of the Arabs to the Jews. The well-being of both, the economic situation of Palestine as a whole, the degree of execution for further development, all have to be carefully considered in deciding the number of immigrants for any particular period.

Palestine is a land sacred to three Faiths and must not become the land of any one of them to the exclusion of the others, and Jewish immigration for the development of the National Home must not become a policy of discrimination against other immigrants. Any person, therefore, who desires and is qualified under applicable laws to enter Palestine must not be refused admission or subjected to discrimination on the ground that he is not a Jew. All provisions respecting immigration must be drawn, executed and applied with that principle always firmly in mind.

Further, while we recognise that *any Jew who entered Palestine in accordance with the law* [Committee's own emphasis] is there of right, we expressly disapprove of the policy taken in some Jewish quarters that Palestine has in some way been ceded or granted as their state to the Jews of the world, that every Jew everywhere is, merely because he is a Jew, a citizen of Palestine, and therefore can enter Palestine as of right without regard to conditions imposed by the Government upon entry, and that therefore there cannot be illegal immigration of Jews into Palestine. We declare and affirm that any immigrant Jew who enters Palestine contrary to its laws [at the time British law administered by Britain] is an illegal immigrant.

The Committee expressly disapproved of the policy that Palestine had in some way been ceded or granted as their state to the Jews of the world, that every Jew everywhere is, merely because he is a Jew, a citizen of Palestine.

There could not have been a more explicit condemnation of the strategy Zionism was pursuing in the shadow of the Nazi holocaust to achieve its ends. And it was the strategy that was to become Israel's policy. *In the years to come the Arabs driven out of their homeland would have no right of return, while citizens of any country in the world had [and still have] an absolute and unquestionable right to go and live in Israel provided they were Jewish.*

On the subject of "The Need for Peace" the Committee, in its 10th and last recommendation, said this:

We recommend that if this report is adopted, it should be made clear beyond all doubt to both Jews and Arabs, that any attempt from either side by threats of violence, by terrorism, or by the organisation or use of illegal armies to prevent its execution, will be resolutely suppressed.

Furthermore, we express the view that the Jewish Agency should at once resume active co-operation with the Mandatory in the suppression of terrorism and of illegal immigration, and in the maintenance of law and order throughout Palestine, which is essential for the good of all, including the new immigrants.

An objective reading of the Committee's entire report invited two conclusions.

The first was that the fairness principle had been stretched to favour Jews because of the exceptional and emotionally charged circumstances of the time. On the subject of the "hostility between Jews and Arabs" in Palestine, the Committee could have noted (and in my view should have noted) that in pre-Zionist times, and as even Ben-Gurion had admitted to the State Department, the minority of Jews in Palestine had lived "in amity" with the majority Arabs; and that it was only political Zionism that turned Jews in Palestine into enemies so far as the Arabs were concerned.

The second was that the Committee was right, in the name of pragmatism, to say that the consequences to this point of Britain's implementation of the Balfour Declaration could not be undone. And that being so, the solution had to be one that was less than fair to the Arabs. But it was a solution that could prevent a massive and cruel injustice being done to the Arabs of Palestine.

The Anglo-American Committee's report on the way forward in the best interests of all concerned—Arabs, Jews everywhere, Britain, the U.S., the whole world—was, in American terminology, D.O.A. *Dead On Arrival.*

Unfortunately the Anglo-American Committee's report on the way forward in the best interests of all concerned—Arabs, Jews everywhere, Britain, the U.S., the whole world—was, in American terminology, D.O.A. *Dead On Arrival.*

Zionism's reaction to it was predictable. While it was willing in principle to endorse just one of the report's ten recommendations—the one calling for the immediate issuance of 100,000 entrance certificates—it said "No" to the rest. American Zionists in New York, British Zionists in London and Ben-Gurion's Jewish Agency in Tel Aviv insisted that nothing less than a Jewish state in accordance with the Biltmore Program would do.

As a consequence President Truman was too frightened to say that a Zionist state was out of the question. There simply was not the

political will to implement the recommendations of the Anglo-American Committee to solve the Palestine problem in a way that required the man in the White House to say "No" to Zionism. It might have happened on President Roosevelt's watch if he had lived; but it was not going to happen on President Harry Truman's watch.

In panic, laced no doubt with despair and fear of the future, British and American diplomacy went through the motions of cobbling together another scheme, which was to surface as the Morrison-Grady Plan. (Herbert Morrison was a leader of the British Labour Party and a future foreign minister, and the man some in his party thought should have been prime minister in Attlee's place. Henry F. Grady had been appointed by Truman to serve on his special Cabinet Committee on Palestine. Grady was Dean of the College of Commerce of California, a very successful businessman and, because of his knowledge and abilities, was called upon from time to time to undertake special assignments for the State Department).

The Morrison-Grady plan was, in fact, drawn up with the assistance of the U.S. Secretaries of State, Treasury and War and their British counterparts. It recommended a federal state of Palestine with separate Arab and Jewish cantons and, if the Arabs could not be persuaded to accept that, an Arab state. It rejected the idea of a Jewish state. And the question of immediate Jewish immigration was made conditional upon Arab acceptance. It was Grady who conducted the discussions with the British.

The Morrison-Grady Plan: U.S. and UK Secretaries of State, Treasury and War all rejected the idea of a Jewish state.

President Truman's initial behind-closed-doors response to the Morrison-Grady Plan was that it was "fair."[71] But he backed away from it under Zionist pressure. The pressure was of two kinds.

One was a flood of general messages denouncing the Morrison–Grady Plan as a "sell-out" of the Zionist cause.

The other was a particular message from Paul Fitzpatrick, New York State Democratic Committee Chairman. In a cable to the President on 2 August 1946 he warned (emphasis added): "*If this plan goes into effect, it would be useless for the Democrats to nominate a state ticket for the election this Fall. I say this without reservation and am certain that my statements can be substantiated.*"[72] As Truman would have known, Fitzpatrick's warning had a nationwide as well as New York State implication. With the mid-term elections for Congress approaching, Democratic candidates, if the Morrison-Grady Plan was supported by the President, could forget about Jewish campaign funds and votes (as organised by the Zionist lobby).

Secretary of State Byrnes would subsequently tell his successor, George Marshall, that he had "disassociated" himself from President Truman's decision to turn down the Morrison-Grady Plan.

In his diary on 4 September 1947, Forrestal noted that the President's decision amounted to "a denunciation of the work of his own appointee." It also resulted, the diary entry continued, "in Secretary of State

Byrnes washing his hands of the whole Palestine matter, which meant that it was allowed to drift without action and practically without any American policy."[73]

But there was a hidden hand on the tiller. In the months of drift before Marshall was appointed to succeed Byrnes, the official who was effectively directing what passed for American policy with regard to Palestine was Zionism's own top man in the Truman White House, Niles. And thereafter, as we shall see, he never really lost his grip.

There are a number of indications that President Truman was actually more than exasperated by the Zionists and the pressures to which they were subjecting him. And there were times when he failed to contain his extreme irritation.

As part of its strategy to oblige Truman to kill the Morrison-Grady Plan, Zionism had New York Senators Robert Wagner and James Mead call on the President to present him with a memorandum attacking it. After they had gone, and according to Vice President Wallace, Truman snapped: "I am not a New Yorker. All these people are pleading for a special interest. I am an American."[74] At a subsequent Cabinet meeting during which Wallace warned Truman that the Morrison-Grady Plan was "loaded with political dynamite", the President was said by the Vice President to have blurted out, "Jesus Christ couldn't please them when he was here, so how could anyone expect that I would have any luck."[75]

The same President could and did say the following to American diplomats summoned home from Arab capitals in 1946 to report on growing anti-American sentiments and the deteriorating U.S. position in the Arab world: "*I am sorry, gentlemen, but I have to answer to hundreds of thousands who are anxious for the success of Zionism. I do not have hundreds of thousands of Arabs among my constituents.*"[76] (Emphasis added)

By the autumn of that year (1946) American Zionism's threat to replace its moderate leaders with more extreme gentlemen had been executed. Rabbi Silver was the President of the Zionist Organisation of America (ZOA). On 26 October, and as reported the following day by *The New York Times*, Rabbi Silver said the following to a ZOA conference (my emphasis added).

> I am happy that our movement has finally veered around to the point where we are all, or nearly all, talking about a Jewish state. That was always classical Zionism... But I ask, are we again, in moments of desperation, to confuse Zionism with refugeeism, which is likely to defeat Zionism? ... Zionism is not a refugee movement. It is not the product of the Second World War nor the First. *Were there no displaced Jews in Europe, and were there free opportunities for Jewish immigration in other parts of the world at this time, Zionism would still be an imperative necessity.* [77]

In the light of what was shortly to happen in Congress, I think Rabbi Silver's statement above is the single most revealing statement about the in-America politics of Palestine at the time.

Implicitly but obviously Rabbi Silver was acknowledging that, if legislation was successfully introduced into Congress to allow a great number of European Jewish refugees to enter the U.S.A., Zionism might well be finished. Why? Because, probably, a majority of those Americans who up to this point were supporting Zionism for emotional reasons—on account of the way they had been moved by reports of the slaughter and suffering of Europe's Jews—would have regarded the refugee problem as having been settled. And in that event American popular support for a Jewish state might have withered, at least to the point at which President Truman could have faced the Zionists and said "No" to their demands.

If legislation was successfully introduced into Congress to allow a great number of Jewish refugees to enter the U.S.A., Zionism might well be finished.

Rabbi Silver would have known all there was to know about how his fellow Zionist zealots had been working day and night (since President Truman's instructions on 23 December 1945) to prevent the introduction in Congress of legislation that, if enacted, would give the Truman administration use of the unused visa quotas. He would also have known that Illinois' Congressman Stratton was intending to introduce such legislation and would not be stopped from doing so by any kind of Zionist pressure or threats. In any event, Rabbi Silver's speech was more than a statement. It was an exhortation with a question mark. "But I ask, are we again, in a moment of desperation, going to confuse Zionism with refugeeism, which is likely to defeat Zionism?" In effect Rabbi Silver was saying: "If legislation to solve the refugee problem is introduced into Congress, we must use our influence to make sure it has no prospect of being enacted."

When Congressman Stratton did introduce his Bill, Zionism's chosen weapons for the campaign, to see that it had no chance of being enacted, were an orchestrated and deafening silence and programmed inactivity.

Stratton's Bill called for the U.S. to admit up to 400,000 displaced persons of all faiths. If legislation to allow that had been enacted, all of the Jewish refugees in Europe could have been admitted to America, along with a good number of refugees of other faiths.

The best way to appreciate how American Zionism handled the problem of the Stratton Bill of 1947 is to compare Zionism's response then with how it mobilised to support the Wright-Compton Resolution of 1944. (As we have seen, it called for the establishment of a Jewish commonwealth, a state by another name.)

When the hearings on the Wright-Compton Resolution were taking place (before President Roosevelt had them stopped), there was, as Lilienthal noted, "scarcely a Zionist organisation that did not testify, send

telegraphed messages or have some congressman appear on their behalf."[78] In four days *500 pages* of testimony were produced, the vast bulk by the Zionists and their allies.

When the hearings on the Stratton Bill were taking place, the testimony given by Jewish organisations covered only *11 pages.* Only one witness appeared for all the major Jewish organisations—Senator Hebert Lehman, then the ex-Governor of New York. In addition to Lehman's statement, there was a supporting resolution from the Jewish Community of Washington Heights and Inwood; and the National Commander of the Jewish War Veterans testified (with, I imagine, the private approval of both Eddie Jacoboson and his friend Harry). But from the Zionists there was not a single word on behalf of the displaced Jews of Europe, those for whom the visas were required. And this at the time the Zionists were busy recruiting members and soliciting funds "to alleviate human suffering"—suffering that could have been relieved if Zionism had supported the Stratton Bill.

Congressman Stratton subsequently expressed "surprise" that he had failed to get the support of "certain organisations" that normally would have been most active in liberalising the immigration law. Only a good but very naïve man could have been surprised.

The brutal truth was that Zionism looked upon the Jewish refugees of liberated Europe as manpower and justification for whatever it had to do to create a Jewish state in Palestine.

The brutal truth was that From the Zionists, there was not a single word supporting the Stratton Bill which might have provided U.S. visas for the displaced Jews of Europe. The brutal truth was that Zionism regarded them as manpower for a Jewish state in Palestine.

A Jewish commentary on this episode of Zionism's history was published in 1950, two years after Israel's birth. It appeared in the *Yiddish Bulletin* and was written by Rabbi Philip S. Bernstein. This particular rabbi had served in 1946 as an Adviser on Jewish Affairs to the U.S. High Commissioner in Germany and, as he later confessed, had lied to President Truman. When he met with the President on 11 October (two weeks before Rabbi Silver delivered his exhortation to his fellow zealots), Rabbi Bernstein said that 90 per cent of the Jewish refugees wanted to go "only to Palestine". That, Rabbi Bernstein knew, was not the truth. It was that most Jewish refugees, given the choice, would have opted for America. Rabbi Bernstein said what he said to President Truman because it was what Zionism had required him to say. He was only following orders. It might be that Rabbi Bernstein was motivated to write what he wrote in the *Yiddish Bulletin* to atone for the sin of his lie to President Truman, but even if that was the case, it could not diminish the significance of what he wrote:

> By pressing for an exodus of Jews from Europe; by insisting that Jewish DPs did not wish to go to any other country outside Israel; by not participating in the negotiations on

behalf of the DPs; and by refraining from a campaign of their own—by all this they (the Zionists) certainly did not help to open the gates of America for Jews. In fact, they sacrificed the interests of living people—their brothers and sisters who went through a world of pain—to the politics of their own movement."[79]

So close to the events only a Jew could have written and had published such an explicit condemnation of Zionism's use and abuse of the holocaust card.

As a consequence of being the first to play the Zionist card for reasons of short-term political expediency, and thus by definition without regard for what was morally right or wrong, Britain was, by 1947, in a most dangerous mess from which there seemed to be no escape.

On the ground in Palestine the British were failing to stop the violent confrontation between Arabs and Jews from escalating. Adding to the chaos was the fact that the two main Zionist terrorist organisations had declared war on the British and were winning it. And in America the Zionists (ten out of ten for the brilliance of their propaganda) had succeeded in portraying Britain, for its efforts to stop illegal Jewish immigrants entering Palestine, as an enemy of a kind that most Americans were happy to see defeated by any means.

In Europe Zionism had established a well-organised "underground railway to Palestine". Jews from all over Europe were moved to ports on the Mediterranean. From these ports, in vessels of all kinds, many of them unseaworthy, Jews were being shipped, in conditions of appalling squalor, to Palestine.

A very large proportion of this human freight was brought in from the countries of Eastern Europe; by this time, and as a result of the Big Three's carve-up of Europe, a part of the Soviet Union. Soviet policy-makers were happy to co-operate with the Zionists in this people trafficking because they were keen to have options for securing influence in the Middle East.

At this point in time, Soviet policymakers had no idea about who they would end up backing in the region—the Jews or the Arabs. The Soviet Union's only interest was turmoil in the Middle East, which it hoped to be able to exploit for the purpose of pushing the British out or, at the very least, securing itself a toe-hold in the region. (As we shall see, the truth is that if there had been no Arab–Israeli conflict, the Soviet Union would have remained for the whole of its existence without significant influence on the ground in the Middle East. By culture and values the Arabs were the most unnatural allies of communism in the world; and there was not a more anti-communist leadership anywhere in the world than that of Saudi Arabia's ruling family).

In the shadow of the Nazi holocaust, Zionism's strategy was to dare the British to stop the ships bearing illegal Jewish immigrants at sea and, if they made it to Palestine, to prevent the wretched Jews on board entering the Holy Land. The Zionists knew, of course they knew, that they

were bound to be the winners either way. If they succeeded in getting more Jews into Palestine against the wishes of the Arabs and in defiance of British policy—great. And if the British took action to stop the immigrant ships and prevent Jews from entering Palestine illegally, Britain could be portrayed, in America especially, as a monster. In that event Zionism would achieve a priceless propaganda victory that would put the whole of American public pinion on its side, which would make stopping Zionism from achieving its ambition in Palestine a mission impossible.

The Zionist strategy presented Britain with a stark choice—to confront Zionism on the matter of illegal immigration, which the Anglo-American Committee had said was the necessary and right thing to do, or surrender to Zionism.

For reasons of strategic interest—oil and trade especially—and in the name to some extent of the thing called justice, Britain decided to confront Zionism on the matter of illegal immigration. Official British records were subsequently to show that from 1946 to February 1948, 47 boatloads of illegal immigrants were intercepted and, as a consequence, 65,307 illegal immigrants were interned in detention camps on the island of Cyprus.

The immensely powerful images in words and pictures of that confrontation—armed British forces turning back the immigrant ships and denying their passengers entry—resulted, as the Zionists knew it would, in most Americans seeing the struggle for Palestine as nothing more than a noble, heroic, epic effort by the Jewish survivors of Hitler's gas chambers to claim back their ancient homeland, with every right and justification on their side. The fact that most if not all of the Jewish refugees were the descendants of those who converted to Judaism long after the fall of ancient Israel and who therefore had no claim on Palestine was not known to Americans. And the Arab case was not a factor in the equation because most Americans did not know the Arabs had a case.

When Britain resisted Zionism on illegal immigration, the powerful images of British forces turning back Jewish immigrants caused most Americans to see the struggle for Palestine as a noble, heroic, epic effort by the Jewish survivors of Hitler's gas chambers to reclaim their ancient homeland, with every right and justification on their side.

When Britain terminated all entry into Palestine, popular American sentiments were inflamed by anti-British feelings. As Lilienthal noted, there was no movie house in America that did not carry newsreel footage of the distraught Jewish faces aboard the *Exodus* when it was intercepted by the British and its passengers were forcibly prevented from illegally entering the Holy Land.

The masterful way in which the Zionists orchestrated their anti-British campaign in America would have won them the admiration of Hitler's propaganda chiefs. Americans were told that the war in which Zionism was engaged was the same kind of war the American Revolutionaries

had waged against the very same imperial power, Britain, to secure their own independence and freedom. America's citizens of Irish descent were informed that the British were using in Palestine against Jewish freedom fighters the same ruthless tactics they had used against Ireland's freedom fighters. For each special interest group the Zionists had an appropriate anti-British message.

How different the story might have been if there had been support for President Truman's visa initiative of 23 December 1945; or before that, President Roosevelt's wish for worldwide asylum.

In a last desperate and predictably futile attempt to reconcile the Arab and Zionist positions, Britain called for the admission into Palestine of 4,000 Jews a month for two years, with subsequent admissions depending on the future absorptive capacity of the country. It was a significant shift in Britain's policy and also a way of giving President Truman the 100,000 entry certificates he had requested and which the Anglo-American Committee had called for. The British, no doubt, were hoping that this shift in their stance would be enough to enable Truman to assist them in the business of crisis managing Palestine. But this British offer was never going to be accepted by the Zionists even if the Arabs could have been persuaded to buy it. In Tel Aviv Ben-Gurion's Jewish Agency denounced the British offer as incompatible with Jewish rights to immigration, settlement and ultimate statehood.

The fact that most if not all of the Jewish refugees were the descendants of those who converted to Judaism long after the fall of ancient Israel and who therefore had no claim on Palestine was not known to Americans. And the Arab case was not a factor in the equation because most Americans did not know the Arabs had a case.

At this point Britain decided that the burden of being responsible for the future of Palestine was too big for it to carry; and it dumped the problem of what to do about the Holy Land into the lap of the UN for adjudication by the governments of the member states.

When it was still the number one power in the world Britain had given Zionism what it most desperately needed at the time—recognition and thus a degree of spurious legitimacy, without which the Zionist enterprise would not have been taken seriously by even most Jews. As we have seen, Britain gave Zionism the Balfour Declaration because it needed Zionist influence, and because it believed it could use Zionism to serve and advance the cause of the British Empire.

Forty years on, with the British Empire in terminal decline, Zionism was about to demonstrate that it was not for use by any power on Earth (unless it was in Zionism's interest to be used); and that it was capable, in defiance of international law, and against the wishes of the organised international community, of getting what it wanted. The means to the end it desired were the skilful playing of the Nazi holocaust card, about to be

supported by a campaign of diplomatic subversion to bend the UN to Zionism's will. And, in Palestine, terrorism and ethnic cleansing.

10

ZIONIST TERRORISM AND ETHNIC CLEANSING

When Britain handed the problem of what to do about Palestine to the infant United Nations Organisation, there were two terrorist organisations in the Holy Land—both creatures of Zionism—the Irgun Zvei Leumi (National Military Organisation, NMO), which was founded by Jabotinsky, and Lotiamei Herut Israel (Fighters for the Freedom of Israel). The latter was better known as the Stern Gang.

The gang's leader was Avraham Stern and his operations commander was Yitzhak Yzertinsky (*nomme de guerre* Rabbi Shamir) who, as Yitzhak Shamir, would emerge from Zionism's in-Palestine underground to become, eventually, Israel's foreign minister and then prime minister. The speciality of Shamir, the terrorist leader, was assassination. So far as is known he never pulled the trigger himself. He selected the targets and directed those recruited and trained to make the hits.

Stern, who called himself Yair (after Eleazer ben Yair, the commander at Masada during the revolt against Rome) had 18 "principles" of policy which defined his full objectives and included: a Jewish State with its borders as defined in Genesis 15:18—"from the brook of Egypt to the great river, the river Euphrates"; a "population exchange," a euphemism for the expulsion of the Arabs; and the building of the Third Temple in Jerusalem.[1]

Stern and his followers were initially part of the Irgun but they broke with it in 1940 and went their own way as a consequence of Jabotinsky ruling that action against the British would be called off for the duration of the war. (Before the start of World War II the Irgun had conducted a few actions in response to Britain's 1939 White Paper). When Jabotinsky then urged Jews in Palestine to join the British army for the purpose of getting the training and some of the weapons they needed for the war to come with the Arabs, Stern accused the revisionists of collaborating with the enemy. Stern had been willing to become an ally of the British but only on the condition that London would recognise the sovereignty of a Jewish state on both sides of the River Jordan. Until it did, Stern said the struggle against the British would be continued. When he broke with the Irgun, the majority of its activists went with him and he and they looked upon themselves as the "real" Irgun.

Stern's single-minded belief was that the only possible response to the Jewish catastrophe in Europe had to begin with the ending of Britain's occupation of Palestine. But he was not crazy enough to believe that his forces could drive the British out. So he took what was for him a logical step. In return for their assistance for his cause, Stern offered his Zionist services to Britain's enemies—first to Mussolini's Fascists and then to Hitler's Nazis. That ought not to be true but it is. In fact it was easy for Stern to contemplate such a course of action because he was an admirer of the totalitarian way. Like not a few of Zionism's really hard men, he was, philosophically, without enthusiasm for the thing called democracy.

As documented by Brenner, Stern's first approach to Mussolini's Fascists was made in September 1940 through one of their agents in Palestine, an Italian Jew who also worked for the British police. The Italian agent and Stern drew up an agreement whereby Mussolini would recognise a Zionist state in Palestine in return for Sternist co-ordination with the Italian army. When it seemed that the initiative was going nowhere, Stern, according to one of his associates at the time, Baruch Nadel, wondered if the agreement he had offered to Mussolini was being used by the British to set him up for arrest and execution. It had to be possible, Stern thought, that the Italian Jew with whom he had made the agreement was a double-agent who was more loyal to the British than he was to his Italian intelligence handlers.

As a precaution Stern then sent one of his own trusted agents, Naftali Lubentschik, to Beirut. Lebanon was controlled by the Vichy regime which represented the French in Nazi-occupied France and the French empire who were collaborating with the Nazis. Lubentschik's brief was to negotiate an agreement directly with Mussolini's Fascists and Hitler's Nazis. He made no progress with the Fascists, but in January 1941 he met two very important Nazis. One of them was Otto von Hentig, the head of the Oriental Department of Nazi Germany's Foreign Office. Von Hentig was regarded as a "philo-Zionist" on account of his preference for packing Jews off to Palestine in return for money as an alternative to slaughtering them. The outcome of the discussions they had was nothing less than a Stern proposal for an alliance between his movement and Hitler's Third Reich.

In return for their assistance for his cause, Stern offered his Zionist services to Britain's enemies—first to Mussolini's Fascists and then to Hitler's Nazis. Stern actually went so far as to make a proposal for an alliance between his movement and Hitler's Third Reich.

The document setting out Stern's proposal—one of the most amazing and infamous documents in all of human history—was eventually discovered in the files of the German Embassy in Ankara, Turkey.[2] Dated 11 January 1941, it was headed **PROPOSAL OF THE NATIONAL MILITARY ORGANISATION IRGUN ZVEI LEUMI CONCERNING THE SOLUTION OF THE JEWISH QUESTION IN EUROPE AND THE PARTICIPATION**

OF THE NMO IN THE WAR ON THE SIDE OF GERMANY.

This document—it was authentic, not a forgery—said in part the following (emphasis added):

The evacuation of the Jewish masses from Europe is a precondition for solving the Jewish question; but this can only be made possible and complete through the settlement of these masses in the home of the Jewish people, Palestine, and through the establishment of a Jewish state in its historical boundaries...

The NMO, which is well acquainted with the goodwill of the German Reich government and its authorities towards Zionist activity inside Germany and towards Zionist emigration plans, is of the opinion that:

Common interests could exist between the establishment of a New Order in Europe in conformity with the German concept and the true national aspirations of the Jewish people as they are embodied by the NMO.

Co-operation between the new Germany and a renewed volkish-national Hebrium would be possible and the establishment of the historical Jewish state on a national and totalitarian basis, and bound by treaty with the German Reich, would be in the interest of a maintained and strengthened future German position of power in the Near East.

"Co-operation between the new Germany and a renewed volkish-national Hebrium would be possible and the establishment of the historical Jewish state on a national and totalitarian basis, and bound by treaty with the German Reich, would be in the interest of a maintained and strengthened future German position of power in the Near East."

Proceeding from these considerations, the NMO in Palestine, under the condition of the above mentioned national aspirations of the Israeli freedom movement are recognised on the side of the German Reich, *offers to actively take part in the war on Germany's side.*

This offer by the NMO... would be connected to the military training and organising of Jewish manpower in

Europe, under the leadership and command of the NMO. These military units would take part in the fight to conquer Palestine, should such a front be decided upon.

The indirect participation of the Israeli freedom movement in the New Order in Europe, already in the preparatory stage, would be linked with a positive solution of the European *Jewish problem in conformity with the above mentioned national aspirations of the Jewish people. This would extraordinarily strengthen the moral basis of the New Order in the eyes of all humanity.*

The Sternists also emphasised a statement that was a constant refrain of their dialogue with the Nazis: "The NMO is closely related to the totalitarian movements of Europe in its ideology and structure."[3]

Stern and his leadership colleagues, including Shamir, would not have been uncomfortable with what they proposed because they were aware that the WZO had made its own accommodation with Nazism by means of the *Ha'avara Agreement*. The offer to make a deal with the Nazis was not taken up, but it was an offer seriously made by deluded people.

"The NMO is closely related to the totalitarian movements of Europe in its ideology and structure."

Down the decades that followed, Zionism indignantly denied the Sternist attempt to do business with Hitler's Germany (and Mussolini's Fascists); and Zionism was very successful in getting the truth about that episode (and much else) suppressed. Goys who tried to tell the truth were denounced as being rabidly anti-Semitic; and Jewish writers who tried to tell the truth were condemned as "self-hating Jews", the implication being that they were very sick people.

The most authoritative and irrefutable confirmation of the Sternist attempt to do a deal with Hitler's Germany, and also confirmation of the authenticity of the Ankara document itself, is to be found in *Israel's Fateful Hour*. Harkabi acknowledged the whole thing and added his own observations. Here are two of them.

It is doubtful whether the long history of the Jews, full as it is with oddities and cruel ironies, has ever known such an attempt to make a deal with rabid enemies—of course, ostensibly for reasons of higher political wisdom... *Perhaps, for peace of mind, we ought to see this affair as an aberrant episode in Jewish history. Nevertheless, it should alert us to how far extremists may go in times of distress, and where their manias may lead.*"[4] (Emphasis added).

It was not, however, only Zionists who courted the Nazis. The exiled leader of the Palestinian Arabs at the time, Haj Amin Husseini, the Mufti of Jerusalem, had conversations with Hitler himself. In one, on 21 November 1941, Hitler was said to have told the Mufti two things. The first was that Germany could not call openly for the independence of any Arab possessions of the British and the French, because Germany did not want to antagonise Vichy, which still ran North Africa. The second was that when the Germans had overrun the Caucasus, they would move swiftly down to Palestine and destroy the Zionist settlements there. Whether Hitler had any intention of honouring his promise to the Mufti is not known to me.

As it happened, internal knowledge of Stern's offer to do a deal with Nazi Germany had a consequence that Stern himself did not foresee and showed how out of touch he was with the feelings of his rank and file. Most were so disgusted by what had been proposed that they drifted back to the Irgun, even though it amounted to nothing much after Jabotinsky's death from a heart-attack in America in 1940. The Irgun was waiting for new leadership. It was to be provided by a recently arrived Jewish immigrant who had been the most zealous of Jabotinsky's disciples and, in his Polish homeland, the leader of Betar, the Zionist Youth Organisation founded by Jabotinsky. (Betar was the name of a fortress where Bar Kochba made his last stand against the Romans). The name of this recently arrived Jewish immigrant from Poland was Menachem Begin who, when he eventually became prime minister, would do most to make stopping the countdown to Armageddon something close to a mission impossible.

On arrival in Palestine, and because of the split in its ranks, Begin found revisionist Zionism in a state of total disarray. He called for the reorganisation of the Irgun and was appointed its commander. The only thing he had going for him, initially, was the return to the Irgun fold of those of its former members who had deserted to follow Stern and who were then appalled by his offer to do a deal with Hitler's Germany.

Begin's analysis of the situation was correct. The British were not going to give all of Palestine to Zionism. It followed that a Jewish state in all of Palestine could not possibly be created by politics alone. Task number one therefore, by the use of whatever violence was necessary, was to break Britain's will to stay.

As one would expect of the man who was to become the most successful terrorist leader of modern times, Begin was not bothered by the obstacles he faced. As Brenner noted, he was not bothered by the fact that most of the Jews then in Palestine regarded the Irgunists and the Sternists as "crazy fascists". And he was not bothered by the small number of **Most of the Jews then in Palestine regarded the Irgunists and the Sternists as "crazy fascists".** operatives he had available on both a full and part-time basis. Provided they were prepared to be ruthless enough, there were no limits to the amount of damage his fighters could inflict on the British and their installations.

In appearance Menachem Begin was not, to say the very least, an attractive man. He was as described on the British army's WANTED posters of him. Underneath his picture was this description: "Height, 173 cms; Build, thin; Complexion, sallow; Hair, dark; Eyes, brown; Nose, long, hooked; Peculiarities, wears spectacles, flat-footed, bad teeth; Nationality, Polish."

We have a very accurate and clear picture of Begin's mindset from what he wrote in the Introduction of the English language edition of his book *The Revolt*, his own inside story of the Irgun.[5]

He opened by saying he had written the book primarily for his own people, but it was also for Gentiles "lest they be unwilling to realise, or all too ready to overlook, the fact that out of blood and fire and tears and ashes a new specimen of human being was born, a new specimen completely unknown to the world for over eighteen hundred years, the FIGHTING JEW. That Jew, who the world considered dead and buried and never to rise again, has risen... never again to go down the sides of the pit and vanish from off the earth."[6]

Begin announced a new specimen of human being was born: the FIGHTING JEW.

Begin had all of his Gentile readers in mind but, he said, it was to the British among them that he was addressing a special message. Because they had been conditioned to regard him as "Terrorist Number One", they would ask, "quite sincerely", this question: "What can such a man have to tell us; what message can come from him except a message of hate?"[7]

In a sort of Socratic dialogue he gave this answer: "Let us try, without fear, favour or prejudice, to understand the meaning of the awful word hate in this connection. You may ask me: Was there hate in our actions, in our revolt against British rule of our country? To such a question the sincere answer is Yes."[8]

Begin continued: "It is axiomatic that those who have to fight have to hate—something or somebody. And we fought. We had to hate first and foremost the horrifying, age-old, inexcusable utter defencelessness of our Jewish people, wandering through millennia, through a cruel world, to the majority of whose inhabitants the defencelessness of the Jews was a standing invitation to massacre them. We had to hate the humiliating disgrace of the homelessness of our people. We had to hate—as any nation worthy of the name must and always will hate—the rule of the foreigner, rule unjust and unjustifiable per se, foreign rule in the land of our ancestors, in our own country. We had to hate the barring of our gates of our own country to our own brethren, trampled and bleeding and crying out for help in a world morally deaf. And, naturally, we had to hate all those who, equipped with modern arms and with the ancient machinery of the gallows, barred the way of our people to physical salvation, denied them of the means of individual defence, frustrated their efforts for national independence and ruthlessly withstood their attempts to regain their national honour and restore their self-respect... Who will condemn the hatred of evil that springs from the love

of what is good and just?"[9] If Begin was available for conversation today I would want to ask him a question, after pointing out that his homeland and country of origin was Poland not Palestine. The question would be: Is not the problem that the "new specimen of human being" was without a moral compass? (I would add that I was not necessarily blaming the new specimen, meaning that the absence of a moral compass might be the fault of those who persecuted Jews down the centuries).

I would also challenge Begin on the subject of the "utter defencelessness" of Jews in Europe. Those Jews, I would assert, did not have to be utterly defenceless in the lands of their birth. If, for example, all Jews had joined with other progressive forces struggling for change in their homelands, they could have helped to bring about a New Order which would have included protection of Jews and their rights, to a very large extent and generally speaking. Zionism's crime against the Jews was seeking to abort Jewish participation in that struggle because it, Zionism, saw advantage in offering its services to the Old Order as an anti-revolutionary force. It is at least possible that the Nazi holocaust would not have happened if Zionism, instead of seeing Hitler's anti-Semitism as a gift for the Zionist enterprise, had supported the anti-Hitler forces before he came to power by democratic means.

> **Zionism's crime against the Jews was in seeking to abort Jewish participation in the struggle of progressive forces in their homelands because it saw advantage in offering its services to the Old Order as an anti-revolutionary force.**

The announcement to the world that Zionism's terrorists were in business came in the form of the assassination in Cairo, on 6 November 1944, of Lord Moyne, Britain's Resident Minister for the Middle East. His driver, Corporal Fuller, was also killed. The assassins were two Egyptian-born Jews, Eliahu Betzouri and his friend Eliahu Hakim. They were directed by the Stern Gang's Shamir.

In the House of Commons Churchill responded to Lord Moyne's assassination with these words: "If our dreams for Zionism are to end in the smoke of assassins' guns and our labours for its future produce only a new set of gangsters worthy of Nazi Germany, then many like myself will have to reconsider the position we have maintained so consistently and so long in the past."[10]

Prior to the Stern Gang's assassination of Lord Moyne, Begin's revitalised Irgun had published and distributed throughout Palestine and widely in America its *Call to Revolt*. The document included a lengthy explanation of why the Irgun had decided to take on the British while they were still at war with Hitler. It said: "There is no longer any armistice between the Jewish people and the British administration of Eretz Israel... Our people is at war with this regime—war to the end."[11]

The Irgun's demand was for "the immediate transfer of power in Eretz Israel to a Provisional Hebrew Government". Then came the

commitment: "We shall fight, every Jew in the homeland will fight. The God of Israel, the Lord of Hosts, will aid us. There will be no retreat. Freedom or death."[12]

The call to revolt ended with an appeal to Jews everywhere, in America especially, not to "forsake" the Irgun's fighters when the going got rough. "If you give them your aid you will see in our days the Return to Zion and the restoration of Israel."[13]

The publication and distribution of the Irgun's declaration of war was preceded by a long and agonised internal debate about the wisdom of going public. The Jews, some of Begin's leadership colleagues argued, had had too many promises. They were fed up with mere words. Was there not a risk that the Irgun's declaration would be seen as just more words and that, as a consequence, the Irgun would not be taken seriously? In which case the Irgun would start with a credibility problem. Would it not be better for a revitalised and re-focused Irgun to start with deeds rather than words? Begin decided that it was necessary, if they were to have the support of enough Jews everywhere, and in America especially, to start with an explanation of why they were fighting.

Events were to prove that the Irgun's terrorists were not only as good as their words, they were better. They were quite simply the most ruthless and therefore the most effective terrorists the modern world had seen. In that sense Begin was right. A "new specimen of human being" had indeed been born.

Initially the Irgun concentrated on bombing British installations, facilities and communication networks of all kinds, for the purpose of making government impossible. Initially the British responded by executing, mostly by hanging, the Irgun terrorists they arrested. In retaliation the Irgun captured British army personnel and executed them. As needed, captured British officers and men were used as hostages and bargaining chips.

The Irgun's most spectacular and politically important operation against the British was, on 22 July 1946, the blowing up of the King David Hotel in Jerusalem. The British had taken over the southern wing of this most prestigious hotel to house the central institutions of their administration. It was both Military GHQ and the Secretariat of civil government. In other words, it was the very heart of British authority and power in Palestine.

As a result of an Irgun visit to deliver milk churns containing TNT (that Weizmann had invented for the benefit, at first, of the British), at least 91 people were killed and more than twice that number were injured. And Britain was humiliated.

Behind the front page reports of dynamite, destruction and death there was a truth which could not be told at the time.

In public and private Ben-Gurion had been assuring the Attlee government and the Truman administration that his Jewish Agency and the Haganah were opposed to the Irgun and its terrorism and most certainly did not sanction Irgun operations. The Haganah, Ben-Gurion had insisted, was not involved in any actions except those of a defensive nature—i.e. in

response to Arab attacks. The truth was not only that the Haganah and so the Jewish Agency were colluding with the terrorists. After initially saying "No" to Operation Chick—the codename for the plan to blow up the King David—the Haganah ordered the Irgun to execute it. (In *The Revolt* Begin told of the liaison between the Irgun and the Haganah and named names). In all the circumstances as they were, it is inconceivable that the green light for blowing up the King David could have been given without the approval of Ben-Gurion himself.

After initially saying "No" to Operation Chick—the codename for the plan to blow up the King David—*the Haganah* ordered the Irgun to execute it.

Operation Chick was finally authorised because of Ben-Gurion's reading, no doubt with the assistance of inputs from Niles in the White House, of the overall political situation. The Zionists had quickly destroyed the prospect of the recommendations of the Anglo-American Committee of Inquiry on Palestine being implemented, but another British and American diplomatic effort was underway—the one that resulted in the Morrison-Grady Plan. From Zionism's perspective, and despite the awesome power of its lobby, things were not going too well for the Zionist enterprise; and that might continue to be the case so long as Britain perceived itself to be capable of influencing the situation on the ground in Palestine. So teach the British a lesson—that their grip on Palestine was not as firm as they thought it was—and that they were not safe anywhere.

After the blowing up of the King David and then the lynching by a Zionist mob of two British army sergeants, Ben Hecht, one of America's most influential journalists—he knew everybody in Hollywood and publishing —declared: "Every time you let go with your guns at the British betrayers of your homeland, the Jews of America make a little holiday in their hearts."[14] Ben Hecht was one of the Irgun's biggest supporters in America. Another was Congressman Joseph C. Baldwin, scion of one of New York's oldest families. Baldwin had the distinction of being public relations adviser to the Irgun.

As a consequence of the brilliantly successful propaganda work of Baldwin and Hecht (and many others), organisations were formed across America to support illegal Jewish immigration into Palestine and to raise funds for Zionism's terrorists. As Lilienthal noted: "Their competitive advertisements defended terrorism and stressed tax exemption for contributions to terrorist organisations."

Organisations were formed across America to support illegal Jewish immigration into Palestine and to raise funds for Zionism's terrorists.

If the government in London had ordered the British army to take whatever action was needed to smash the Zionist terror networks, there would have been a tidal wave of protest in America that would have caused

President Truman to order Britain to stop. And he would have had the leverage to make it obey.

As a consequence of World War II, Britain was just about bankrupt and already in debt to America. To have the certain prospect of reconstruction and recovery, Britain was in desperate need of further American financial assistance then under consideration by the Truman administration. It was to come in the form of Britain's share of the $17 billion dollar budget for the American sponsored European Recovery Programme, which became known as the Marshall Plan after its proposer, Secretary of State George Marshall. It was not a matter of charity on the part of America. The view was that if Western Europe was not assisted to recover, the enemies of democracy— trade unions included, it was said—would make great gains everywhere. In short, the Marshall Plan was conceived as the most effective and least expensive way of keeping Soviet-style communism at bay.

In reality Zionism's terrorists were bound to be the winners if they were prepared to be ruthless enough. With the assistance of American money, they were. In all the circumstances is it any wonder that Britain decided to cut and run from Palestine? I suppose not.

But breaking Britain's will to hang on in Palestine was only the first item on the agenda of Zionism's terrorists. The second was driving the Arabs out.

Breaking Britain's will to hang on in Palestine was only the first item on the agenda of Zionism's terrorists. The second was driving the Arabs out.

With the assistance of the Stern Gang, and grenades and other weapons provided by the Haganah for a quite different purpose, the most spectacular and politically important of the Irgun's operations against the Arabs was its first. The target was the village of Deir Yassin.

The full truth about the massacre at Deir Yassin of 254 Palestinians —mainly women, children and old men—is inseparable from the story of the Haganah's attempt to hold another Arab village, Kastel, after it was taken by the Palmach on 2 April 1948. Holding Kastel was considered to be a strategic imperative if the fighting Jews were to succeed in breaking the Arab siege of Jerusalem.

On 29 November the previous year the UN General Assembly, in a rigged vote, had passed a resolution to partition Palestine. The original intention was that partition—the creation of an Arab state and a Jewish state—would come into effect when the British Mandate expired at midnight on 14 May 1948, by which time the British would be gone. But as we shall see in the next chapter, the UN was unable to implement the partition resolution and it was, in fact, vitiated. As a consequence the question of what to do about Palestine was still without an answer so far as the UN was concerned.

That, however, was of no concern to the Zionists in Palestine. They were intending, unilaterally, to declare the coming into being of their state

on 15 May. In other words, they were intending to proceed as though the partition plan had not been vitiated. What was happening at the UN was an irrelevance so far as they were concerned. As we shall also see later, Ben-Gurion was confident, with very good reason, that, if the Arabs opted for war, they, the Zionists, would be able to take more Arab land than had been assigned to them under the partition plan.

The problem for Zionism was that in the UN's partition plan Jerusalem was to be an international city. In the UN's view Jerusalem had too much potential as a cause of strife for it to be an integral part of either the proposed Arab or Jewish state. So Jerusalem was to become a UN trusteeship. This was totally unacceptable to Ben-Gurion. In his view, recreating the Jewish state without Jerusalem as its capital would amount to the resurrection of the body without the soul.

Ben-Gurion's strategy was to build up Jewish population in the old quarter of Jerusalem, then seize all of it as soon as possible after the Jewish state came into being, thus presenting Jewish control of Jerusalem as a *fait accompli*.

By April 1948, as a result of Jewish immigration, legal and illegal, nearly two-thirds of the inhabitants of what had become Greater Jerusalem were Jewish. After the Balfour Declaration the Zionists had given priority to building up their numbers in Jerusalem—i.e. around the Old walled and mainly Arab City. The Jewish extensions were New Jerusalem. It was all part of Ben-Gurion's strategy of creating facts on the ground. His intention was to seize all of Jerusalem as soon as possible after the Jewish state came into being, then to say to the world: "There's no point in discussing the matter of Jerusalem (New and Old) further. We Jews now control all of it. Jerusalem is our eternal capital and the idea of it becoming an international city is dead."

To prevent such a Zionist *fait accompli*, Palestinian resistance fighters under the leadership of Abdul Khader Husseini had set up defensive positions around Jerusalem (the Old plus the New), putting it, effectively, under siege. Their intention was to prevent Jewish forces—the Haganah and the Palmach—reinforcing Jerusalem in sufficient strength to enable Zionism to impose its will on the Holy City.

And that was the context in which the Arab village of Kastel had matchless strategic significance.

Kastel was on the summit of a rocky peak, about 2,500 feet high, that controlled the only approach road to Jerusalem from Tel Aviv. Nobody was more aware of Kastel's strategic importance than Abdul Khader. He was much more than the outstanding Palestinian resistance leader of his time. He was the only Palestinian leader who enjoyed the admiration and affection of the Palestinian masses. He was even respected by Zionism's military commanders.

In December 1947, following the UN's rigged vote on the partition resolution, the news of Abdul Khader's return to his native Palestine had inspired the Palestinian masses to believe for the first time in nearly a decade that their cause was not a lost one.

Abdul Khader had returned in secret because he had been banned from returning by the British. When news of his return was spread, by word of mouth in whispers, it had the effect of lighting a beacon of hope, bright enough to illuminate all of Arab Palestine. In the first glow of that light, hundreds and then thousands of Palestinian peasants committed themselves and their ancient rifles to fighting the Jews when called by Abdul Khader to do so. He had returned to lead the resistance organisation of his exiled cousin Haj Amin Husseini, the Mufti. The banished Haj Amin was also the head of the Arab Higher Committee, which was roughly the Arab equivalent in Palestine of the Jewish Agency.

At the time of his return Abdul Khader was still youngish—he had just turned 40; but he was a veteran of conflict with the British. His father, Haj Amin's predecessor as Mufti, had been deposed by the British in 1920 for his opposition to the Mandate. After graduating in chemistry from the American University in Cairo in 1933, Abdul Khader had participated in his first anti-British demonstration at his aging father's side. His courage on the battlefield was demonstrated during the Arab revolt in Palestine.

As Abu Moussa (his *nomme de guerre*), Abdul Khader was wounded twice in the head while leading his peasant fighters against the British. On the second occasion, in 1938, he was smuggled to Syria bleeding to death on a camel. If he had returned to Palestine when he recovered, he would have been shot by the British on sight. As it happened he was one of a small group sent by Haj Amin to Nazi Germany for training to improve their military skills. (Given that Britain was the enemy, there was nowhere else during the war Palestinians could receive military training).

In appearance—medium height, brown suit and a modest, neatly trimmed moustache—the Abdul Khader who returned secretly to Palestine in December 1947 was deceptive. But for the blue-and-white chequered *kaffiyeh* (traditional Arab headdress), he looked more like a shrewd but inoffensive accountant than the Arab guerrilla leader who had done most on the battlefield to prevent Britain crushing the spirit of Palestinian resistance. Such an impression was strengthened by his gentle manner. He was a man who could control his emotions in public and who, anyway, did not believe in expressing himself in the exaggerated, bombastic language favoured by so many Arab leaders.

The real key to Abdul Khader's hold on his peasant people was his instinctive understanding of both their qualities and their shortcomings. It was this, plus his charisma, that had given him the ability to mobilise his people and to get the best out of them and their woefully limited weaponry during the revolt against the British. His task now was to get the best out of them to prevent a Zionist takeover of their homeland.

To those who welcomed him back to Palestine he said: "Diplomacy

and politics have failed to achieve our goals. We have only one choice. We shall keep our honour and our country with our swords."[15]

Abdul Khader was capable of reading the Zionist military mind and, as a result of doing so, he had warned the Arab League that Kastel would be the first objective of Jewish forces when they made their push to capture and control all of Jerusalem. Abdul Khader was to die in battle believing, I think correctly, that if the Arab states (through the Arab League) had armed the Palestinians to enable them to conduct their own struggle in a serious way, Zionism would not have gotten the upper hand in Palestine.

As it happened, and because the Arab League was not willing to arm the Palestinians (we shall see why later), Zionism's institutional militias—the Haganah and its Palmach strike force—were better armed than the Arabs of Palestine. Abdul Khader might not have been aware of the extent to which the Zionists, with increasing success, were smuggling in small arms and ammunition; but from the skirmishes (it was not yet war) it was obvious that the Haganah and the Palmach were not as short of modern weapons and ammunition as the Arabs of Palestine were.

The Haganah and its Palmach strike force were better armed than the Arabs of Palestine. If the Arab states (through the Arab League) had armed the Palestinians to enable them to conduct their own struggle in a serious way, Zionism would not have gotten the upper hand in Palestine.

Kastel's residents were protected by lightly armed watchmen. In anticipation of an attack by Jewish forces, Abdul Khader had supplemented them with men of his own. They were assigned to guard the approaches to the peak.

To give the Palmach the best chance of taking Kastel with minimum casualties, the Jewish battle plan had called for two diversionary attacks to draw off Abdul Khader's men. The diversionary attacks went according to plan. As a consequence the 180 men of the Palmach's Har-el Brigade took Kastel without a serious fight. The attack went in at midnight in the rain. The lightly-armed Arab watchmen were no match for the well-armed Palmach. The Arab guards exchanged shots with the Palmach as they set about rounding up the villagers and then fled with them into the safety of the night. The first Arab village was in Jewish hands.

At noon the following day, under the command of Latvian-born Mordechai Gazit, 70 men of the Jerusalem Haganah arrived to relieve the Palmach. Gazit's orders were to hold Kastel no matter what the strength of the expected Arab counter-attack when it came.

Abdul Khader was in Damascus when the Palmach made the diversionary attacks that were the prelude to its move on Kastel. He was in the Syrian capital to beg for weapons and ammunition.

Damascus then was the stage on which the leaders of rival Arab factions strutted as they schemed and plotted to determine who among

them would have the biggest say in running their countries and their world.

The main man Abdul Khader had gone to see was Ismail Safwat (a name to remember). He was the 52-year-old Iraqi general who had been selected by the Arab League to prepare a plan for the co-ordinated intervention of the Arab armies in Palestine—IF the Jewish state came into being and IF then the Arabs actually went to war. (For reasons that will become clear in due course, the latter was by far the bigger of the two ifs).

Ismail Safwat was a pompous, arrogant man and a master of hyperbole. Although he was beginning to stockpile weapons and ammunition for a possible war, he refused to make a single bullet available to Abdul Khader. The Palestinian leader was furious. Before storming out he looked the Iraqi general in the eyes and said: "*The blood of Palestine and its people shall be on your head!*"[16]

As it happened Abdul Khader did not return to his Jerusalem headquarters empty handed. Not quite. Syria's President Shukri al Kuwatli presented him with a gift of 50 rifles. They were loaded into the back of Abdul Khader's car, alongside three Bren guns he had purchased with his own money in the souks of Damascus, and he drove to Jerusalem.

The first news Abdul Khader received on his arrival in the Old City was the loss of Kastel. He ordered an immediate counter-attack. Kastel had to be won back at any cost.

The task of organising and leading the counter-attack was assigned to Kamal Irekat. In a few hours he raised a force of 400 volunteers by sending messengers from hamlet to hamlet calling for help to free Kastel. Irekat's mobilising ability was assisted by his status. He was of an old and influential Jerusalem family. He was also an inspector in the Palestine police force.

The Arab attack to push the Haganah out of Kastel started just after sundown. At dawn the following morning Irekat's fighters were reinforced by volunteers led by Ibrahim Abu Dayieh, an uneducated but courageous Hebron shepherd. Then, at the point when it seemed the Haganah was about to be driven out of Kastel completely, the Arabs ran out of ammunition.

While the Haganah took a much-needed breather and regrouped, Irekat sent out for fresh supplies of ammunition. In Ramallah to the north, John Glubb, the English commander of Transjordan's Arab Legion, saw one of Irekat's messengers running through the streets shouting: "Has anyone ammunition for sale? I pay cash." As recounted by Collins and Lapierre in their epic work *O Jerusalem!* Glubb watched as the messenger bought 200 rounds of ammunition—some Turkish, some German, some English—then leapt into his car and set off to repeat the process in the next town.

By sunset Irekat's men had enough ammunition to continue their assault. Shortly after midnight, when they were within grenade range of Gazit's outnumbered and beleaguered Haganah force, Irekat was wounded. The only medic among his volunteers, a hospital employee from Bethlehem, treated the leader with the only first-aid kit they had. Then, ignoring the leader's protests, the medic strapped Irekat onto a mule for the journey back to Jerusalem. What happened next was described by Collins and

Lapierre in this most perceptive passage:

> Irekat knew well the psychology of his village warriors. Products of the hierarchical structure of their villages, they tended to magnify the importance of the leader, to erect around his person a kind of cult. Guided by an able man, those villagers were capable of great acts of bravery. Without a galvanic presence to rally them, however, their organisation risked rapid disintegration... As Irekat had feared, that was exactly what happened on that night of Sunday, 4 April. Gazit and his men, bracing for the Arabs' final assault, saw their foes start to wander off the battlefield. They were going home to their villages. By dawn the next day barely a hundred of them remained. Kastel was still firmly in Jewish hands.[17]

In New Jerusalem the Haganah's thoughtful commander there, David Shaltiel, knew that would not be the end of the fight for control of Kastel, and that the Haganah's luck could not last. The Arabs would be back, led the next time, perhaps, by Abdul Khader Husseini himself. Shaltiel's own forces were stretched so thinly there was no way he could make reserves available to relieve or reinforce Gazit's men. How on earth could they withstand another Arab assault?

Shaltiel's homeland was Germany and he had received his military training with the French Foreign Legion. Before World War II he was arrested by the Gestapo while on a secret Haganah mission to his homeland. While confined and tortured he kept his sanity by teaching himself Hebrew.

It was Shaltiel's fears about the possible loss of Kastel that led to the Irgun and the Stern Gang getting what they needed—weapons and ammunition—for their attack on Deir Yassin.

Shaltiel's adjutant was Yeshurun Schiff. In the pre-dawn darkness of Tuesday 6 April, he had a rendezvous with two men on Jerusalem's King George V Avenue. One was Mordechai Ra'anan, the Irgun's Jerusalem chief. The other was Yoshua Zeitler, the Stern Gang's Jerusalem chief.

Schiff's purpose—they all spoke in whispers—was to establish whether or not the two terrorist organisations would provide support to assist the Haganah in its efforts to withstand the next expected Arab attack on Kastel. The initial response of the Irgun and Stern Gang representatives was not promising. Ra'anan and Zeitler told Schiff they would put his request to their respective leadership colleagues but that in the event of the answer being "Yes", there would be a price to pay. The Irgun and the Stern Gang would expect the Haganah to reward them with a substantial supply of weapons and grenades. Schiff said there would be no problem with the weapons. He would make the arrangements and they could collect.

That night the Irgun and the Stern Gang told Schiff they were ready to assist the Haganah; and they claimed and collected their reward. But

neither the Irgun nor the Stern Gang had any intention of honouring their side of the bargain. They wanted the Haganah weapons to attack a target of their own choice—Deir Yassin.

The two terrorist organisations had calculated that a dramatic victory there would serve their cause in two related ways. It would be the start of a campaign to frighten the Arabs into fleeing from their villages. And, if the attack on Deir Yassin achieved its purpose, it would enable the Irgun and the Stern Gang to claim that they were the most dynamic forces in the struggle on the Zionist side. They wanted to be able to assert that the Return To Zion and the restoration of Israel was due principally to the commitment, zeal and sacrifice of their organisations. The political gain, they calculated, would be that the official Zionist establishment in Palestine —the Jewish Agency and the military leadership of the Haganah and the Palmach—would have to take the Irgun and the Stern Gang seriously and treat them as equals. Begin was, in fact, hoping to put down the markers that would pave for the way for his emergence as a heavyweight figure in the politics of the Zionist state.

Deir Yassin was chosen by the Irgun and the Stern Gang as the target for their first attack on an Arab village for two reasons. The first was its proximity to Jerusalem. Deir Yassin nestled on a rocky promontory west of Jerusalem and could be described as being on the outskirts of the city itself. The second and main reason was the presumption that Deir Yassin offered a soft and easy target.

The reason why the two terrorist organisations needed a soft and easy target had to do with their own limitations. Irgun and Stern Gang cadres, women as well as men, were not experienced in conventional military activities. They were bombers (place and run) and assassins (hit and run). They had little knowledge of how to engage for attack or defence in conventional terms. It followed that if they were confronted by serious opposition, they might not acquit themselves well. And that in turn was why they wanted to be in possession of overwhelming firepower for their first venture in conventional fighting.

Deir Yassin was known as the "stone-cutters" village, this because most of its male inhabitants of working age made their living by cutting Jerusalem's beautiful stone. It was the main ingredient in the construction or the facing of many of the Holy City's buildings of all kinds.

Deir Yassin had done nothing to provoke an attack and, actually, had lived peaceably in a sort of agreement with the Jewish suburbs surrounding it. Shaltiel would later confirm that the village had been "quiet since the beginning of the disturbances", and had not once been mentioned in reports of attacks on Jews. More to the point is that this particular Arab village had collaborated in the past with the Jewish Agency. On at least one occasion its lightly armed watchmen, seven in all, had driven incoming Arab militants out at the cost of the life of the *mukhtar's* (headman's) son.

On the morning of the attack Deir Yassin, innocent and unsuspecting, was at its most vulnerable because many of the men of the village were

absent, away at their work in Jerusalem. Most of their wives and children were sleeping soundly, watched over by the seven guards. Their ancient rifles were mainly used for shooting rabbits and providing a noisy backdrop to village feasts.

At 4.30 a.m. on Friday 9 April the seven guards, unconcerned, were awaiting the arrival of the dawn and, why not, another peaceful day. It might be that war was coming if the United Nations failed to stop the Zionist takeover of Palestine, but in the absence of war the peace of Deir Yassin, nearly perfect in the night, would not be disturbed. "*Insha'Allah*". God willing.

Under the cover of night the attack force, 130 representatives of the "new specimen of human beings", was moving into position for the assault. The Irgun was approaching by way of the nearby Jewish suburb of Bet Hakerem to the south. The Stern Gang was coming from the north. To the east, along the only road leading to the village, a home-made armoured car equipped with a loudspeaker was creeping forward. To symbolise their collaboration the two terrorist organisations had chosen *Achdut* (Unity) as the codename and password for the operation.

On the slopes below his post one of the guards could just about make out the forms of men moving up the wadi. After a double-take, probably, to make sure his eyes were not deceiving him, he screamed, "Ahmed, Yehud ala inou!" ("The Jews are coming!")

All seven of the Arab guards fired in the direction of the advancing Jews, as they would have done if the Jews had been rabbits; and then they raced from door to door giving the alert. Some of the villagers fled to the West with only robes thrown around them.

The Jews took cover just beyond the first row of houses waiting for the arrival of the loudspeaker. They had intended to warn the villagers to flee their homes. Why risk spilling one drop of Jewish blood if Deir Yassin could be emptied of its Arab inhabitants by other means. As it happened the warning could not be given. The armoured car with the loudspeaker had tumbled into a ditch and was out of action, blocking the road. News of that plus the shots from the village caused a heated debate. Deir Yassin was, perhaps, better defended than the Jews had anticipated.

Eventually a burst of machinegun fire tore into the village. That was the signal for the attackers to move forward.

After a first rush, the attack stalled. Quite a few of the old men of the village who were not guards, and who had not fled, possessed ancient weapons of their own. They put up a surprisingly tenacious defence of their homes and their loved ones. Without experience of conventional military tactics Zionism's terrorists were out of their depth. It took them nearly two hours to breach the first row of houses and to reach the center of the village. There the two groups met and celebrated. But their joy, as Collins and Lapierre put it, was of short duration.

> Their ammunition supply was almost gone and the Irgun's homemade Sten guns were jamming one after another.

Although in reality their casualties were light—the attack would cost the two groups only four killed—in the heat of the battle that seemed high to untrained terrorists. [It would have been more accurate to describe them as trained terrorists untrained for conventional military action.] Two key leaders were wounded. There was even talk of withdrawing. No one seemed to have imagined it might be considerably more difficult to conquer a resisting village than it was to toss a bomb into an unarmed crowd waiting for a bus. Giora, the leader of the Irgun Command, rallied his men for another push forward. Then he, too, was wounded. A kind of collective hysteria overtook the attackers. As the opposition to their assault finally waned, they fell with increasing fury on the inhabitants of Deir Yassin.[18]

With the resistance over, the remaining villagers were ordered into the square. Those who came out of their homes were lined up against the wall and shot. They were the lucky ones. Those who remained in their houses were butchered. Many of the Arab women were raped before they were killed.

O Jerusalem! contains a detailed account of what happened as Deir Yassin was submerged, bit-by-bit, "in a hell of screams, exploding grenades, the stench of blood, gunpowder and smoke." The eye-witness testimony of one survivor, the daughter of one of the principal families of Deir Yassin, included this: "I saw a man shoot a bullet into the neck of my sister Salhiyeh, who was nine months pregnant. Then he cut her stomach open with a butcher's knife."[19] According to a corroborating account, another woman was killed when she tried to extricate the unborn infant from the dead mother's womb. A 16-year-old survivor, Naaneh Khalil, told how she saw a man "take a kind of sword and slash my neighbour Jamil Hish from head to toe and then do the same thing on the steps of my own house to my cousin Fathi."[20]

The first investigator to arrive was Jacques de Reynier, the Swiss representative of the International Red Cross. He and his German escort found 150 bodies thrown into a cistern. In all they counted 254 dead, including 145 women of whom 35 were pregnant. In his diary that night Reynier noted that when he arrived the terrorists had not completed their work. One of the Irgun attackers told his German escort that they were still "cleaning up".[21] Reynier wrote: "The first thing I saw were people running everywhere, rushing in and out of houses, carrying Sten guns, rifles, pistols and long ornate knives... They seemed half mad." He also noted his horror at witnessing, "a young woman stab an elderly man and woman cowering on the doorstep of their hut." He also recorded what he had seen when he pushed his way into the first house he reached. "Everything had been ripped apart and torn upside down. There were bodies strewn about...They

had done their cleaning up with guns and grenades and finished their work with knives, anyone could see that." The only thing Reynier could think of at the time, he said, "was the S.S. troops I'd seen in Athens."

On the spot Reynier had seen something moving in the shadows. He bent down and discovered "a little foot, still warm". It belonged to a 10 year-old girl still alive despite her wounds. Reynier picked her up and ordered his German escort to take her to their waiting ambulance. Then, furious, he demanded that he be allowed to continue his search for others who might still be alive. But his presence was too much of an embarrassment for the terrorists. They ordered him back to Jerusalem with the wounded he had managed to pull out of the ruins; and who would have been finished off if he had not been there.

The British High Commissioner, Sir Alan Cunningham, was having a routine daily meeting with his Security Committee when the first report of what had happened at Deir Yassin came through. He knew the Haganah well enough to believe it was incapable of such action. He was certain it had to be the work of the Irgun and the Stern Gang. His own fury was apparent in what he said to General Sir Gordon Macmillan, the commander of British land forces in Palestine. *"At last you've got those bastards. For God's sake, go up there and get them!"*[22] But General Macmillan refused to make a move. He insisted that he did not have enough troops available. That was not the whole truth. By this time Macmillan was committed to a policy of deploying his troops only in pursuit of strictly British interests—protecting British installations and British manpower. Protecting the Arab interest was no longer on the British Army's agenda.

Cunningham believed that the situation was grave enough to require him to take exceptional action. Angrily he turned to his R.A.F. chief and asked him to perform with an air strike. In principle the R.A.F. chief was willing, he said, to give the High Commissioner what he wanted; but there was a problem. The day before—Britain's withdrawal from Palestine was well underway despite the turmoil at the UN and in Truman's administration —the R.A.F. had sent all of its light bombers to Egypt and its rockets to Habbaniya in Iraq (Britain's most subservient client state). It would take 24 hours to get them back.

The evidence suggests that Cunningham would have insisted on an air strike, and quite possibly risked a showdown with London, if a new twist in the fast developing atrocity story had not made the use of air power unthinkable. The Haganah had moved into Deir Yassin to take over the village. And the stage was being set for a possible confrontation between it and Zionism's terrorists.

The first Haganah unit to reach Deir Yassin was led by Eliyaha Arieli. He was the scholarly commander of the Gadna, the Haganah's youth organisation. On account of his six years of service with the British Army, he was also something of a war veteran. He had participated in Britain's retreat from Greece. But nothing in his military experience had prepared him for what he would see when he entered Dier Yassin. It was, he would later

say, "Absolutely barbaric... All of the killed, with very few exceptions, were old men, women and children... The dead we found were all unjust victims and none of them had died with a weapon in their hands."[23] Arieli was, in fact, so appalled by the scene that he refused to allow his youngsters into the village to witness it.

The next and larger Haganah unit to arrive was led by Schiff, Shaltiel's adjutant and the man who had done the deal with the Irgun and the Stern Gang. He later noted that instead of using the weapons he had given them to assist the Haganah, the terrorists "had preferred to kill anybody they found alive as though every living thing in the village was the enemy and they could think only of 'Kill them all.'"[24]

Before reporting to Shaltiel by wireless, Schiff ordered his men to surround the killers. Their organisations had deceived him and he was not intending to take any more chances. The atmosphere as the two Zionist forces eyeballed each other in the village square was one of menace. When he was certain he had the situation under control, Schiff faced the commander of the Stern Gang's contingent and said, "You are swine."

Then he reported to Shaltiel who had already told the Irgun that the Haganah was not going to take the responsibility for "your murders." Shaltiel had said so directly by wireless to the Irgun's commander at Deir Yassin when he asked for a Haganah unit to be sent to take control of the village.

Shaltiel told Schiff to disarm the terrorists. He added: "If they don't lay down their arms, open fire!"

Schiff knew the butchers of Deir Yassin would not give up their weapons without a fight.

In the long silence that followed Schiff had a debate with himself. He was a soul in torment and it is not difficult to imagine that he had never known such agony. He loathed the men and women of the Irgun and the Stern Gang for what they had done, but could he fire on them? Jewish history, Schiff reminded himself, was full of stories of fratricidal strife in the face of an enemy. If Jew started to kill Jew now they would be lost forever. He was not going to be in the instigator of a Jewish civil war.

Eventually Schiff said to Shaltiel, "I can't do it."

Over the wireless Shaltiel snapped: "Don't tell me what you can or can't do, those are your orders!"

"David", Schiff begged, "you'll bloody your name for life. The Jewish people will never forgive you."

Eventually Shaltiel relented and the terrorists were ordered to clean up the village.

As Schiff watched, the killers carried the bodies of their victims to Deir Yassin's rock quarry and laid them on the stones. When they had finished they poured gasoline over the corpses, most of them mutilated, and set them ablaze.

Compared to the horror of what the Nazis had done to Europe's Jews, six million of them, what happened at Deir Yassin was nothing; but in its own tiny way it was another holocaust. And it, too, was to change the course of history.

Unlike the extermination of the Jews of Europe, the slaughter of Arabs by Jews at Deir Yassin was not pre-meditated. It just happened. But it was born of a Zionist intention to dispossess the Arabs of Palestine of their homes, their land and their rights.

From that perspective operation *Achdut* was a far greater success than even Begin in his wildest dreams could have imagined. As Arthur Koestler was to write: the "bloodbath" at Deir Yassin was "the psychologically decisive factor in the spectacular exodus of the Arabs from the Holy Land and the creation of Palestinian refugee problem".[25] Jacques de Reynier agreed. He wrote that after the massacre, and because of the publicity it received, "the exodus (of Palestinians) began and became nearly general."[26]

> **Koestler: The "bloodbath" at Deir Yassin was "the psychologically decisive factor in the spectacular exodus of the Arabs from the Holy Land and the creation of Palestinian refugee problem."**

A group of American correspondents who attended a press conference given by the Irgun and Stern Gang were told that it was "the beginning of the conquest of Palestine and Transjordan."[27]

In America Rabbi Silver was later quoted as saying, "The Irgun will go down in history as a factor without which the State of Israel would not have come into being."[28]

Nearly 30 years later, in an article for *The American Zionist*, Mordechai Nisan of the Truman Research Centre of the Hebrew University in Jerusalem expressed his concern about the failure to understand the major significance of terrorism in the struggle for Jewish sovereignty. He wrote: "*Without terror it is unlikely that Jewish independence would have been achieved when it was.*"[29] (Emphasis added).

It was Begin himself who would give the most vivid description of how well the slaughter at Deir Yassin served the Zionist cause. In *The Revolt* he wrote (empasis added):

> Panic overwhelmed the Arabs of Eretz Israel. Kolonia village, which had previously repulsed every attack of the Haganah, was evacuated overnight and fell without further fighting. Beit-Iksa was also evacuated. These two places overlooked the road and their fall, together with the capture of Kastel by the Haganah, made it possible to keep open the road to Jerusalem. *In the rest of the country, too, the Arabs began to flee in terror, even before they clashed with Jewish forces... The legend of Deir Yassin helped us in particular in the saving of Tiberias and the conquest of Haifa... All the Jewish forces proceeded to advance through Haifa like a knife through butter. The Arabs began fleeing in panic, shouting "Deir Yassin".*[30]

The Jewish Agency disassociated itself from the atrocity at Deir Yassin and condemned it. Ben-Gurion cabled his personal shock to Transjordan's King Abdullah. And the Chief Rabbi of Jerusalem took the extraordinary step of excommunicating the participants in the attack. But... The Jewish Agency posted leaflets descriptive of the massacre in many Arab villages. Loudspeaker vans toured Arab Jerusalem broadcasting in Arabic *"Unless you leave your home, the fate of Deir Yassin will be your fate!"*[31]

Not reported at the time—and not admitted for many years later —was the brilliant way in which the Haganah and the Palmach especially played the Deir Yassin terror card to speed up the Arab exodus while the fate of Palestine was still in the balance so far as the United Nations was concerned.

The truth about how the Palmach capitalised on Arab fears—that what had happened at Deir Yassin would be the fate of all who did not abandon their villages—was eventually told by Yigal Allon, the Palmach's commander and a future deputy prime minister of Israel. In his book on the history of the Palmach, *Sefer ha-Palmach*, he described how he had resorted to "psychological warfare" to "cleanse" the Upper Galilee of its Arabs. He wrote (emphasis added):

> *I gathered all the Jewish* mukhtars *who had contacts with the Arabs in different villages, and I asked them to whisper in the Arabs' ears that a great Jewish force had arrived in the Galilee and that it was going to burn all the villages of the Huleh (the Lake Huleh region). They should suggest to those Arabs that they flee while there was still time.*[32]

It was a tactic, Allon added, that "attained its goal completely." It was also a tactic repeated elsewhere in Palestine in the countdown to Israel's unilateral declaration of independence.

There was one and only one time when General Macmillan deployed his forces to check the Zionist advance before Britain abandoned the Arabs of Palestine. That was in the port of Jaffa, just up the road from Tel Aviv.

The operation to empty Jaffa of its Arabs was conducted mainly by the Irgun, re-invigorated by its triumph at Deir Yassin. As it happened Macmillan intervened only because he was ordered to do so by a very angry British Foreign Secretary. Bevin was stung by mounting Arab criticism of Britain's refusal to act. I imagine he was also deeply ashamed. At a point he gave General Macmillan a direct, unequivocal order "to bloody well put troops in there and get Jaffa back for the Arabs."[33] (In May 2003 declassified British documents of the period revealed that Bevin was targeted for assassination by a Zionist terrorist cell in London).

As usual it was too late. By the time British troops had secured Jaffa, 65,000 of its 70,000 Arab inhabitants had fled.

The total number of Arabs who fled in terror prior to Israel's declaration of independence was about 300,000. But that was only Phase

One of the creation of the Palestinian refugee problem. (As we shall see, the total number of Arabs who were dispossed of their land and their rights by, mainly, Zioniost terrorism and ethnic cleansing, was in excess of 700,000).

The total number of Arabs who were dispossed of their land and their rights mainly by Zioniost terrorism and ethnic cleansing was in excess of 700,000.

Though Zionist terrorism and the use Allon's Palmach made of the fear it inspired were the prime causes of the first Arab exodus, there was also a fateful Arab contribution to the panic on the Arab side so eloquently described by Begin.

When the Arab Higher Committee received news of the slaughter at Deir Yassin, its senior officials agonised for hours about whether or not to make public what had happened. They knew that if they did the consequence would be at least a measure of panic on their side which, at best, would be demoralising and, at worst, might lead to many of their people fleeing. From this perspective the case for not broadcasting the truth about Deir Yassin was overwhelming. But there was another consideration.

The two officials who took the decision to go public with the news—Hussein Khalidi, the Secretary of the Arab Higher Committee and Hazem Nusseibi—were intelligent, sensitive and responsible men. They were also well informed about the true state of affairs in the neighbouring Arab countries. And because they were well informed, they were afraid that the Arab armies, despite the war talk of Arab leaders, would not come to Palestine's aid if and when a Jewish state was declared. As Nusseibi would later say, they took the decision to broadcast the news of the slaughter at Deir Yassin because *"We wanted to shock the populations of the Arab countries into putting pressure on their governments."*[34]

By taking that decision for the best of reasons they unwittingly played into Zionism's hands. The fear inspired by making public the truth about what happened at Deir Yassin helped to guarantee that Allon's "whispering campaign" would be effective beyond his own best expectations.

There was to come a time when Nusseibi would admit that broadcasting the news was "a fatal error". With the benefit of hindsight that was obviously true. And there are today few if any Arabs who would dispute that verdict. But in the circumstances of the time was any other decision possible?

As it happened, the slaughter at Deir Yassin was not the only reason for the growing fear of the Palestinians that Zionism would not be defeated unless the Arab armies intervened when Britain's Mandate expired and the British were gone.

Though nobody (Arab or Jew) was aware of it until the day after the slaughter at Deir Yassin, Abdul Khader was dead.

On his return almost empty-handed from Damascus, and after he had ordered Irekat to waste no time in mounting a counter-attack to drive the Haganah out of Kastel, Abdul Khader sat down and wrote what was to

be his last letter to his wife, Wajiha, in Cairo. With it he enclosed a poem he had written in Damascus to his eight year-old son, Feisal. (When the son died of a heart attack at the end of May 2001, he was the Palestinian Authority's Minister for Israeli-occupied Jerusalem).

This land of brave men
Is our ancestors' land.
On this land
The Jews have no claim.
How can I sleep
When the enemy is upon it?
Something burns in my heart,
My country is calling.[35]

The words of the poem and what happened immediately after he had sealed the envelope make me wonder if Abdul Khader had a premonition of his death. In the light of the great truth he had worked out for himself, it might even have been that he went looking for death with honour.

He summoned one of his lieutenants, Bajhat Abu Gharbieh. This man, a schoolteacher, was later to say that he had never seen his chief so bitter. "*We have been betrayed,*" Abdul Khader told him.[36]

Then, with the anger in his voice becoming more intense, the leader of the Palestinian resistance movement gave Gharbieh an account of his visit to Damascus and the refusal by Safwat, and so the Arab League, to provide the Palestinians with the weapons and ammunition they needed to conduct their struggle against the Zionists without having to rely on Arab intervention. With great bitterness he described the last thing he saw in Syria. It was a warehouse full of arms at Al Mazah Airport for his rival, Fawzi el Kaukji. (He was the Arab League's puppet guerrilla leader and he has his context in the first chapter of Volume Two of this book).

After repeating that they had been betrayed, Abdul Khader said to the schoolteacher: "They (the Arab states as represented by the Arab League) have left us three choices. We can go to Iraq and live in disguise. We can commit suicide. Or we can die fighting here."[37]

Mention of the need for disguise in Iraq was a reference to the fact that Britain still had a military presence there. The implication was that if Abdul Khader gave up the struggle in Palestine and sought refuge in Iraq, he (and others of his known associates) would be arrested by the British if they were not disguised.

In theory the frontline Arab states had achieved their independence —Iraq in 1921, Egypt in 1922, Syria in 1943, Lebanon in 1944, and Transjordan in 1946. In reality these independent Arab states were still utterly dependent on Britain and France for, among other things, their supply of weapons and ammunition and the development of their armed forces and intelligence services. And that meant Britain and France—Britain with Egypt, Iraq and Transjordan—had great arm-twisting ability in their dealings

with key Arab leaders, the Hashemite Faysal in Iraq and the Hashemite Abdullah in Transjordan in particular.

The great truth Abdul Khader had worked out for himself, and which he was conveying in essence to the schoolteacher Abu Gharbieh, was that Britain did not want the Palestinians to be capable of defending their own interests. Britain wanted the destiny of the Palestinians to be controlled by those it thought it could manipulate and control—the leaders, mainly through the mechanism of the Arab League, of the Arab states. (As we shall see, Abdul Khader was right. Effectively the Palestinians were betrayed by their Arab brothers at leadership level).

The newly independent Arab states were still utterly dependent on Britain and France. Britain wanted the Palestinians, too, to be controlled by the Arab League, which they in turn would control.

After he had conveyed his innermost thoughts and fears to Abu Gharbieh, Abdul Khader refocused on the present. Whatever the future might hold, he said, the absolute priority of the moment was the recapture of Kastel. He was intending to throw more of his men at the Haganah and he was going to lead the attack himself.

The hundred or so Arab fighters who had remained engaged at Kastel after Irekat's enforced departure from the battlefield had not made any progress, but under the command of the Hebron shepherd, Abu Dayieh, they were keeping Gazit's force pinned down.

Abdul Khader arrived with reinforcements including four British Army deserters. In Damascus he had asked Safwat to let him have a canon. In the absence of it Abdul Khader was intending to improvise with four mortars. They were to be operated by the British deserters.

In all Abdul Khader had about 300 men to commit to the attack. The omens were good because the Jews holding Kastel were, had to be, on the point of running out of ammunition.

Abdul Khader positioned most of his men directly in front of the village under the command of Abu Dayieh. The others, in two groups, were posted to the flanks.

The Arab attack on Kastel began at ten o'clock on the evening of Wednesday 7 April, a whole day and a few night hours before the Irgun and Sternist attack on Deir Yassin.

After an hour or so of heavy shooting the Arabs had driven Gazit's men from the first row of houses and were barely 100 yards from the Haganah's most strategic position—the house of the village *mukhtar*. Under cover of the mortar fire, an Arab placed a large olive oil can close to the house. It was packed with explosives. In the house Gazit's sergeant major, Meyer Karmiol, called for help. Gazit worked his way to the front of the house and discovered the olive oil can and its unlit fuse. Karmiol's cry for help had obviously disturbed the Arab bomber and caused him to back off before he could light the fuse.

Gazit returned to his command position and, minutes later, he heard Karmiol make a challenge in English, "Who's there?"

The reply in confident, commanding Arabic was, "It's us, boys." Then, as Gazit watched, Karmiol raised his Sten gun and swept the slope in front of the house with a burst of fire. Gazit observed an Arab, silhouetted in the moonlight, fall to the ground.

At dawn the Haganah was still entrenched. And the first news Abu Dayieh received from his eastern flank was bad. A small party of Jewish reinforcements was moving up the hill behind Kastel. It was led by the Palmach's Uzi Narciss, the original conqueror of the Arab village. He was bringing Gazit's beleaguered men 50,000 rounds of ammunition, treasure from the Haganah's latest smuggling operation.

Abu Dayieh was concerned, all the more so because Abdul Khader was nowhere to he found. The assumption was that he had anticipated the arrival of Jewish reinforcements and had slipped away to Jerusalem to raise more men and ammunition. Best to check. Abu Dayieh sent messengers to Jerusalem to establish the whereabouts and intentions of Abdul Khader. But he was not in the Holy City and the rumour that he was missing spread. What happened next was as described by Collins and Lapierre.

> The news leaped from village to village with that special alacrity linked to bad tidings. From Hebron to Ramallah men set out for Kastel to join the search for their leader. In Jerusalem the souks emptied. Everyone who could get a rifle, it seemed, rushed from the city. The price of ammunition shot up to a shilling a bullet. The National Bus Company cancelled its services and devoted its vehicles to hauling volunteers to Kastel. Taxi cab drivers, truckers, the owners of private cars offered their services to get men to the battle site.[38]

By late morning the Jews in occupation of Kastel were under fire from all sides. "What shall we do?" Narciss asked Gazit. "I suggest we get out of here" was the reply. And they did. Kastel was back in Arab hands.

At the summit of their success the Arabs celebrated. The Palestinian flag was raised from the roof of the *mukhtar's* house. The chants of "*Allahu akbar*" ("God is Great") were deafening. But rising above them, and silencing them in an instant, there was a scream of agony. Nadi Dai'es, a coffee boy, had stumbled upon a body.

It was the body Gazit had seen falling to the ground in the moonlight when Karmiol opened up with his Sten gun.

It was the body of Abdul Khader.

The significance of Abdul Khader's death was best reflected in the thoughts of two men.

One was the schoolteacher, Abu Gharbieh. "Abdul Khader was our

chief. Our only chief. We can never replace him."[39]

In Damascus, Emile Ghory, a senior aide to Haj Amin Husseini kept his thoughts to himself. If he had spoken them aloud at the time he would have been accused of being a defeatist and worse. "*This is the end of the Palestine resistance movement.* There is something in our blood that ascribes such importance to the man, such hero worship to the leader, that when he dies, everything collapses."[40]

And that was more or less what happened, The prospect of the Palestinians remaining in control of their own destiny died with Abdul Khader. After that the Arabs of Palestine were at the mercy of the Arab League. It was working, against popular sentiment throughout the Arab world, to the script written for it by Britain. And the script required the Arab League as the umbrella institution of the Arab states to prevent the Palestinian resistance movement becoming a serious factor in a very dangerous equation.

The reason the British gave for their insistence that the Arab League should not arm Palestine's own resistance movement was to do with Haj Amin Husseini's wartime relationship with Hitler and, more generally, the fact that his cousin Abdul Khader, and some of his lieutenants, had had military training in Nazi Germany; and then, in Cairo after the war, had enjoyed a continuing association, for tuition purposes, with a Nazi explosives expert. Behind closed doors the British argument to the Arab League came down to this: In the wake of the Nazi holocaust, and given the support Zionism was enjoying because of it, in America especially, there would little sympathy for the cause of the Arabs of Palestine so long as they were led by "Hitler's collaborators".

What the British meant—how explicitly their diplomats said so was not documented—was that if the Arab states armed those fighting under Haji Amin's banner, Zionism would proclaim to the world that the Palestinian resistance movement was a creature of defeated Nazi Germany and would, if it triumphed, continue Hitler's policy of exterminating the Jews. It did not matter that such a characterisation of the Palestinian struggle would be a grotesque and wicked propaganda lie. It was the propaganda card Zionism would play, (despite its own then secret collaboration with the Nazis); and in the circumstances of the time it was the card that would trump all others. If that happened it might well be politically impossible for Britain to continue supporting the Arab states, and to continue exercising whatever influence it had at the United Nations to try to see that the Arabs of Palestine did not lose everything.

It was an argument the Arab League accepted, mainly because the Arab states were in desperate need of Britain's goodwill and assistance.

As we have seen, the Arabs would have preferred America to be their Big Brother until they could stand on their own feet, but that was not possible because of Zionism's growing ability to influence U.S. policy. Because the Arabs were, generally speaking, fiercely anti-communist for reasons of culture (their values and traditions), they had no choice. If they could not get what they needed from Britain, on more or less Britain's terms, they would be all the way up the famous creek.

If the Arab regimes had said to Stalin, "Help us to defeat Zionism and the Middle East shall be your sphere of influence", the history of the region and the world might have been very different. The Truman administration might have been so frightened by even the prospect of the Arabs playing such a card that it would not have surrendered to Zionism. There is no doubt in my mind that if the boot had been on the other foot—if the Zionists had been the Arabs—they would have played the Soviet card; either for real or as a means of putting pressure on the U.S. to abandon its support for Zionism right or wrong.

There was one significant Arab state, Saudi Arabia, that had favoured arming the Palestinians. King Ibn Saud had been impressed by the steadfastness they had shown in their revolt against the British. His personal view was that the indigenous Arabs of Palestine knew their country better than the incoming alien Jews. By definition that would give a home-grown guerrilla movement a big tactical advantage in the struggle with Zionism. Because they stood to lose everything, the Palestinians were also better motivated than outside Arabs ever could be. It followed, the Saudi monarch had believed, that if the Palestinians were suitably armed and well led, they would acquit themselves better than outside Arabs and, probably, better than alien Jews. The Saudi monarch and his advisers also feared that the direct military involvement of the Arab states in the struggle for the Holy Land would lead to the internationalisation of the conflict, and thus a scenario in which Arab interests would always take second place to the vested interests of the rival big powers. (Which is exactly what did happen).

There was one significant Arab state, Saudi Arabia, that had favoured arming the Palestinians.

It was, however, the collective view of Arab leaders as represented by the Arab League that prevailed.

Ben-Gurion was later to write that the Arab League had been established "under the guidance of the British Foreign Office;" and that its purpose was "to combat Zionism."

In the sense that Britain hoped the Arab League would be the vehicle for co-ordinating Arab efforts to limit Zionism's territorial ambitions, Ben-Gurion was right. But in practice the Arab League became, at Britain's insistence, the vehicle for preventing the Palestinians from exercising with any prospect of success their right to struggle to prevent a Zionist takeover of their homeland. That was the truth Abdul Khader discovered shortly before his untimely death. And that was why he said to Abu Gharbieh, "We have been betrayed."

The whole truth about Britain's calculations at the time remains a matter for speculation. Mine is that British policymaking mandarins and their political masters asked themselves this question: Who is likely to be the most dangerous loser in the struggle for Palestine—the Arabs of that land or Zionism?

If such a question was asked, the answer would have been Zionism.

If the Palestinians lost more than they won, their sense of injustice and the rage it provoked could be managed by the Arab states—provided, under British influence, the Arab League was prepared to pursue a containment policy, a policy with the objective of preventing a resurgence of Palestinian nationalism.

But what if Zionism, by its own yardstick, was the loser?

The probability was that Zionism, if it did not get what it wanted, would create unmanageable problems for all concerned—in the Middle East, America and elsewhere.

The mandarin conclusion? If the worst happened, if the organised international community through the UN was incapable of preventing the doing of an injustice to the Palestinians, they would be required to accept their role as the sacrificial lamb on the alter of political expediency.

Though Zionists were the first to turn to terrorism, they were not without some competition. It was organised by Fawzi el Kutub, one of the Palestinians sent by Haj Amin Husseini to Nazi Germany for military training. He was Abdul Khader's bomb-making expert.

Initially Abdul Khader had rejected (as the Arab League had done) the Mufti's ideas for a bombing campaign against civilian Jewish targets. Abdul Khader had believed it was important that only the Zionists be seen and labelled as terrorists. He had wanted his Palestinians to be seen to be engaged in a conventional and cleanish fight to defend their homeland and their rights. It was only after a wave of successful Zionist terror bombings had threatened to shatter Arab morale that Abdul Khader ordered Kutub to reply in kind.

Kutub's campaign included the blowing up of the *Palestine Post* building; a huge bomb that tore apart Ben Yehuda Street in the heart of Jewish Jerusalem, killing 57 people and wounding 88; and an explosion that seriously damaged the most closely guarded Jewish building in Jerusalem, that of Ben-Gurion's Jewish Agency, killing 13 people.

It is reasonable to suppose that while Abdul Khader lived the Palestinians would not have resorted to terror tactics if the Zionists had not started it.

The events and developments described in this chapter were the in-Palestine background to the unfolding drama that was taking place at the United Nations and in President Truman's White House, while Britain was preparing to get out of the mess it had made in the Holy Land.

Though it is mainly concerned with the politics of what happened far away from Palestine, the story the next chapter has to tell is a very dramatic one. And still today there is a question about why, really, President Truman surrendered to Zionism.

NOTE

Because the scope of this book is so vast, I did not have the space (in the chapter above and the pages to come) to do much more than scratch

the surface of the story of how, really, the Palestinian refugee problem, the cancer at the heart of international affairs, was created. For those readers who would like to know more I recommend *The Ethnic Cleansing of Palestine*, a most remarkable and chilling book by Professor Ilan Pappe, Israel's leading "revisionist" (which means honest) historian. Pappe's book, first published by Oneworld Publications Limited in October 2006, documents in detail the planning and implementation of Zionism's ethnic cleansing policy—a systematic reign of terror which, from December 1947 to January 1949, included 31 massacres. In his Epilogue, Pappe writes: "We end this book as we began; *with the bewilderment that this crime was so utterly forgotten and erased from our minds and memories*" (emphasis added). In a recorded conversation with me in the early summer of 2008, Ilan, then a dear friend and ally in common cause, said this (again my emphasis added): *"Probably more surprising than anything else was not the silence of the world as Zionist ethnic cleansing was taking place in Palestine, but the silence of the Jews in Palestine. They knew what had happened to Jews in Nazi Europe, and some might have seen it for themselves, yet they had no scruples in doing almost the same to the Palestinians."*

11

PRESIDENT TRUMAN SURRENDERS TO ZIONISM

After Britain dumped the problem of what to do about Palestine into the lap of the United Nations, Zionist terrorism on the ground in the Holy Land was matched by a Zionist campaign of intimidation and threats designed to bend the world body to Zionism's will. And there was to come a moment when President Truman would say, (in a memorandum not declassified until 1971), that if the Zionists continued with their pressures "they would succeed in putting the United Nations out of business."[1]

Zionist terrorism on the ground in the Holy Land was matched by a Zionist campaign of intimidation and threats designed to bend the United Nations to Zionism's will.

The UN General Assembly was convened to consider the problem of what to do about Palestine on 28 April 1947. It appointed a Special Committee, UNSCOP, to consider the situation and report back with a recommendation.

The idea was that the recommendation would then be taken forward as a resolution for approval or not by the General Assembly. If it achieved the necessary two-thirds majority there the resolution, *if endorsed by the Security Council,* would represent the will of the organised international community; and the parties to the dispute would be required to accept it as the solution to the Palestine problem. That was the theory. But what would happen in practise if one or both parties (the Arabs or Zionism) refused to accept the solution approved by the General Assembly and endorsed by the Security Council?

There were two possible answers to that question.

One was that the major powers who controlled the UN through the Security Council would summon up the will to enforce the decision of the world body, by a combination of sanctions and military means if necessary.

The other was that the UN would be obliged to accept that the proposed solution was unworkable. In that event, the resolution would be vitiated and the diplomats would have to go back to the drawing board.

Simply stated, the Palestine problem was about to become the

first test of the UN's authority. If it could resolve the conflict of interests in Palestine by diplomatic and political means, or even by enforcement action, the hope that had been invested in the UN as the global institution to oversee the creation of a more fair and better world would be justified and given a boost. If it failed, the outlook was for a continuation of jungle law, with might, as ever, prevailing over right.

While the Truman administration waited for the UN's recommendation, the President took what amounted to a vow of silence.

On 8 August 1947 he told a cabinet meeting that he was not intending to make any announcements or statements on Palestine until UNSCOP had presented its findings. In his report to his diary of the meeting, Forrestal quoted the President as saying that he had "stuck his neck out on this delicate question once" and did "not propose to do so again."[2] The "once", Truman told his cabinet was in the autumn of 1945 when, to appease the Zionists, he had put pressure on Britain to admit 100,000 Jews to Palestine. (My interpretation from reading between the lines is that Truman came to understand that he had made a bad situation for the British worse and, possibly, had wrecked whatever small prospect there was of Britain persuading the Arab League to accept a Jewish homeland that was less than a state).

Truman made his comments after Secretary of State Marshall had presented his assessment of the situation in Palestine. Marshall said his view was that Britain's withdrawal would be followed by "a bloody struggle between the Arabs and the Jews."[3]

On 3 September UNSCOP submitted two recommendations to the General Assembly.[4]

The first, the majority plan, proposed the termination of the Mandate and the partition of Palestine—the creation of an Arab and a Jewish state with economic union between them, and a corpus separatism for the City of Jerusalem. It would become an international city administered by the UN.

The second, the minority plan, put forward by India, Yugoslavia and Iran, also envisaged the termination of the Mandate but it was against partition. It proposed a unitary Palestine—the creation of an Arab and a Jewish state in a federal structure with Jerusalem its capital. (This was effectively the fallback position of those Arab and other Muslim leaders who knew they had to face reality).

When subsequently things started to go wrong at the UN, Britain admitted that the partition plan had "not been impartially conceived."[5] This was the diplomatic way of saying that, by fair means and foul, Zionist influence on the majority of the Special Committee's members had been sufficient to guarantee that their recommendation would favour Zionism at the expense of the Arabs. But this exercise in truth-telling by Britain was not necessary for understanding. The facts spoke for themselves. In a very loud and very clear voice.

The partition plan proposal was that: 56.4% of Palestine should be given for a Jewish state to people (many of them recently arrived alien

immigrants) who constituted 33% of the population and owned 5.67% of the land.

The Arabs were not only the overwhelming majority in the territory allotted to them, they were also a near majority in the territory allotted to the Jews.

And that was not all. The territory allocated to the Jewish state—in size, 10 times the area owned by Jews—included the greater part of the valuable coastal area and other fertile areas, while the Palestinians were left mainly with mountainous and sterile regions.

The Partiion Plan proposed that 56.4% of Palestine should be given for a Jewish state to people (many of them recently arrived alien immigrants) who constituted 33% of the population and owned 5.67% of the land. It was a proposal for injustice on a massive scale.

It was a proposal for injustice on a massive scale. Lilienthal rightly called it the "original sin" which underlies the Arab–Israeli conflict. If approved and implemented, the partition plan would make a complete nonsense of the principle of self-determination, the noble ideal to which the governments of the so-called democratic nations of the West professed they were committed.

The Arabs rejected partition on the grounds that it violated their rights and was incompatible with law and justice. They also challenged the competence or power of the UN to recommend the partition of their homeland and thus the destruction of its territorial integrity.

So far as the legal aspects of the matter were concerned, the Arabs had 100% of the right on their side. Cattan put it this way.

> The UN is an organisation of states which was formed for certain purposes defined in the Charter. At no time did this organisation possess any sovereignty or any other right over Palestine. Accordingly, *the UN possessed no power to decide the partition of Palestine, or to assign any part of its territory to a religious minority of alien immigrants in order that they might establish a state of their own.* Neither individually, nor collectively, could the members of the UN alienate, reduce or impair the sovereignty of the people of Palestine, or dispose of their territory, or destroy by partition the territorial integrity of their country.[6] (emphasis added).

Just as Britain with the Balfour Declaration had had no right to give away what it did not possess, so it was with the UN.

The most explicit statement on the UN's lack of competence was however that delivered by one of its own sub-committees, Subcommittee 2 to the Ad Hoc Committee on the Palestine Question. It was charged with the responsibility of determining whether or not the UN did have the

competence or power to partition Palestine. In its report on 11 November 1947, the Sub-Committee said this:

> A study of Chapter XII of the United Nations Charter leaves no room for doubt... neither the General Assembly nor any other organ of the United Nations is competent to entertain, still less to recommend or enforce, any solution other than the recognition of the independence of Palestine and that the settlement of the future government of Palestine is a matter solely for the people of Palestine... The United Nations cannot make a disposition or alienation of territory, nor can it deprive the majority of the people of Palestine of their territory and transfer it to the exclusive use of a minority in their country.[7]

More to the point, the Sub-Committee was alarmed by the prospect of the United Nations acting without regard for international law—so alarmed that it submitted a draft resolution instructing Secretary General Trygve Lie (pronounced Lee) to transmit the partition resolution to the International Court of Justice in the Hague.[8] The draft resolution raised eight legal aspects of the matter, (a) to (h), on which it believed the Secretary General should have the advisory opinion of the International Court. Of the eight issues, (g) and (h) were the most pertinent. They were as follows:

> (g) Whether the United Nations is competent to recommend either of the two plans and recommendations of the majority or minority of the United Nations Special Committee on Palestine, or another solution involving partition of the territory of Palestine, or a permanent trusteeship over any city or part of Palestine, without the Consent of the majority of the people of Palestine.[9]

> (h) Whether the United Nations, or any of its Member States, is competent to enforce or recommend the enforcement of any proposal concerning the constitution and future government of Palestine, in particular any plan or partition which is contrary to the wishes, or adopted without the consent of, the inhabitants of Palestine.[10]

The draft resolution as a whole was rejected by the Ad Hoc Committee on Palestine by 25 votes to 18, but (h) was rejected by the narrower margin of 21 votes to 20.[11]

As a consequence the Secretary General was not instructed to seek the advisory opinion of the International Court. If he had been so instructed he would have been advised that the partition resolution had no juridical value and that to proceed with it would constitute a denial of justice.

In effect the United Nations was putting itself above and beyond international law.

A most interesting contribution to understanding was made by Dr. W. T. Mallison, Jr., in his Foreword to Cattan's seminal work *Palestine and International Law*. At the time Mallison was Professor of Law at George Washington University. He wrote:

The implicit assumption in the book that international law is relevant to a just solution of both the causal Zionist-Palestinian conflict and the derivative Arab–Israeli confrontation may be an unproven one to many readers. But the answer is that if international law were to be conceived as an exclusive Western system which excludes the vast majority of mankind, it has no creative potential for solving difficult problems. The United Nations Charter, as the fundamental law of the organised world community, repudiates such an exclusivist conception of international law. Its affirmation of self-determination and its repudiation of discrimination do not except the people of Palestine and other victims of colonialism from its worldwide scope... The Palestine problem, as Mr. Cattan demonstrates so persuasively, is not a failure of international law, since universal international law has never been applied to Palestine." [Cattan's argument was that it should be.]

The UN decision in Zionism's favour would not give the Jewish state legitimacy in the eyes of international law. In effect the new international organization was putting itself above and beyond international law.

The most explicit statement of why Israel did not need the sanction or support of international law was to be made by Prime Minister Golda Meir. In an interview with *Le Monde* on 15 October 1971, she said: "This country exists as a result of a promise made by God himself. It would be ridiculous to ask for the recognition of its legitimacy!" Mallison commented, "Needless to say, the concept of the creation and legitimacy of states by divine purpose is unknown in international law."

For their part the Zionists were far from happy with the partition plan proposal because it did not give them the amount of land they wanted, and because Jerusalem was not to be included in the territory assigned to the Jewish state. But Zionism accepted the partition proposal and worked for its approval by the necessary two-thirds majority in the General Assembly. It did so for three related reasons.

First was the anticipated political gain from being seen as an acceptor rather than a rejector of compromise. From here on, and no matter that they had 100 percent of the legal right on their side, the Arabs,

if they did not accept partition, could be portrayed in Zionist propaganda as rejectors of compromise.

No matter that they had 100 percent of the legal right on their side, the Arabs, if they did not accept partition, could be portrayed in Zionist propaganda as rejectors of compromise.

Second was that approval by the UN of the partition resolution would give the Jewish state a birth certificate of sorts and thus the appearance of legitimacy. (It is reasonable to assume that Zionism's best legal minds told Ben-Gurion and his colleagues that a UN decision in their favour would not give the Jewish state legitimacy in the eyes of international law; but that would have been of no concern to the founders of the Zionist state. They would have taken comfort from the truth of the old cliché which says that, in the real world, "possession is nine-tenths of the law.")

Third was Ben-Gurion's confidence that his military forces could beat the Arabs in war—at least to the extent of taking by force more Arab land than had been allotted to the Jewish state in the partition plan. He was happy that "the final struggle would be between the Jews and the Arabs, with military force determining the outcome."[12] In that context, the Jewish state of the partition plan proposal was therefore a necessary starting point. The truth was that Ben-Gurion would have been very disappointed if the Arabs had accepted partition. Ben-Gurion's confidence that his Zionist forces would get the better of the Arabs on the battlefield was due in large part to the money Golda had raised in America. (It, as we shall see, made possible the purchase of military hardware of all kinds that was denied to the Arabs).

Before the minority report recommending a unitary Palestine was consigned to the dustbin of history—to leave only the partition resolution for the vote in the General Assembly, Saudi Arabia's Foreign Minister, Prince Feisal, expressed his willingness to meet with Secretary of State Marshal. With the blessing of his father, King Ibn Saud, Feisal was ready to discuss the possibility of a "reconciliation" with the majority on the Special Committee who had recommended partition.

The implication was that Saudi Arabia, the most important and influential of all the Arab states, was ready in principle to work for Arab acceptance of a UN resolution that would establish a Jewish administered entity in Palestine—provided it was part of unitary Palestine (i.e. was not an independent Jewish state); provided the size of the territory allotted to the Jewish entity was not out of all proportion to the number of Jews then in Palestine and the amount of land they owned; and provided also that there would be agreed limits on future Jewish immigration. Quietly Saudi Arabia was, in fact, thinking the unthinkable—there was need for an accommodation of sorts with Zionism. Why?

Despite what King Ibn Saud had said to President Roosevelt and Churchill, and despite what Feisal had said to American diplomats, the Saudis were realists. They knew that the creation of a Jewish entity in Palestine was now inevitable—because of the Jewish immigration Britain had allowed to give substance to the Balfour Declaration; and because of

the Nazi holocaust and the way the Zionists had exploited it to consolidate their ability to influence the American political process. The Saudis also knew that the frontline Arab states, despite their rhetoric to the contrary, were in no position to fight and win a war to put an end to the Zionist enterprise.

The frontline Arab states, despite their rhetoric to the contrary, were in no position to fight and win a war to put an end to the Zionist enterprise.

Nearly two decades after the events, when he was recognised by all who were seriously well-informed about Arab politics as the most shrewd and wise Arab leader of modern times, it was King Feisal himself who gave me, in private conversation, retrospective insight into the way his mind had been working in 1947. (The private conversation came about because of the question I asked him off-the-record after an hour-long filmed interview, his first ever with a foreign TV correspondent, and in which he said nothing newsworthy. After my camera crew had withdrawn, I dared to ask him why he spoke in riddles. Through an interpreter he replied: "You must understand how difficult and delicate my position is. If I say the wrong thing, or even the right thing in the wrong way, the Middle East could go up in flames.") Apart from Feisal's truly regal bearing and his courtesy, and his splendid semitic nose, the thing I most remember about him is his bloodshot, piercing eyes and the way they undressed you to your soul. If you lied to Feisal he knew, whoever you were, that you were lying. (Which is probably why Kissinger was never comfortable in Feisal's presence).

As his kingdom's foreign minister Feisal foresaw the catastrophe that would happen if the Arabs could not find a way to contain Zionism. He knew the Zionists had no intention of being satisfied with what had been allotted to them in the partition plan and that the name of the game was preventing Zionist expansionism. The only way of doing so was by accepting a self-governing Jewish entity within a unitary Palestine. If the Arabs compromised to that extent, they would enjoy the goodwill of the Western world—the U.S. especially, and that would make it more difficult, and hopefully impossible, for the Jewish entity, once established, to seek to take more Arab land by force. It would not be easy to persuade the Palestinians to agree to give up some of their land in the name of political expediency, but Saudi Arabia's escalating oil wealth would enable it to sweeten that most bitter of pills. And, anyway, the alternative was too terrible to think about. If the Arabs found themselves confined in the rejectionist corner, they would have to fight a war they could not win, and thereafter they would be at the mercy of an expansionist Zionist state, supported no doubt by an America at the mercy of the Zionist lobby.

The other factor pushing Feisal in the direction of some sort of accommodation with Zionism was his fear of the Soviet Union (he was at one with his father on this), and thus the strategic need to have the U.S. as its superpower ally and protector. Feisal's nightmare was the scope

communism would have for penetrating the region and making mischief in it if failure to resolve the Palestine problem led to unending conflict between the Arabs and the Jews.

In the real world (and as the Palestinians would come to understand) those with grievances, nationalist movements as well as states, had to have one of the two superpowers on their side if their grievances were to be addressed. That being so, and if there was an unending state of war between the Arabs and Zionism supported right or wrong by the U.S., a war the Arabs could not win, there would come a point when Arab radicals would seek the support of the Soviet Union, as a counter-balance to American support for Zionism. The radicals would get Soviet support and that would have two predictable consequences.

The first was that a flirtation by Arab radicals with the Soviet Union would divide the Arab world, leading to the creation of a pro-American camp on the one hand, which by definition would consist of the traditional and conservative regimes led by Saudi Arabia; and, on the other hand, a radical camp that would be, more out of need than choice, apparently pro-Soviet and apparently anti-American. Soviet backed Arab radicalism would pose a threat to the stability and perhaps even the very existence of the traditional and conservative Arab regimes upon whom, actually, the U.S. and the West as a whole would be relying for oil to fuel economic growth.

The madness as Feisal saw it was that American support for Zionism right or wrong would create the situation that would pose the biggest potential threat to the continuing flow of the oil the West so desperately needed at the cheapest possible price.

The other consequence of allowing the Soviet Union to have influence in the Arab world would be the creation of a situation that would enable Zionism's entity in Palestine to demand the unquestioning support of all the Western powers on the basis that it, the Zionist entity, was the only secure bastion of anti-communism in the region.

In Feisal's analysis the absolute priority was doing whatever had to be done to prevent the Soviet Union winning friends and influence in the Middle East. If that required the Arabs to make some sort of accommodation with Zionism in order to enjoy the support of America, so be it—provided the U.S would oblige the Zionists to accept a self-governing Jewish entity in Palestine on terms Feisal could sell to his fellow Arabs.

When he expressed his willingness to meet with Secretary of State Marshall to try to hammer out a compromise based on both the majority and the minority recommendations of the Special Committee, Feisal was entertaining the view that he could make common cause with those at Executive level in the Truman administration who were developing U.S policy for containing the Soviet Union.

He also believed he had a strong negotiating card in his hand. It was no secret that the partition resolution would not get the support it needed in the General Assembly. Because the injustice it represented was so obvious, so outrageous, there was no way that two thirds of the member states were going to vote for it.

Feisal's intention was to say to Marshall something like the following: "When the partition resolution fails to achieve the necessary majority in the General Assembly vote, we're all going to have a problem with Zionism; but it's the U.S. that will have the biggest problem because of Zionism's influence on American politics. I can and will help you defuse this crisis, but you must help me by requiring the Zionists to accept a self-governing Jewish entity on terms I can sell to my Arab brothers."

The meeting Feisal wanted with Marshall did not take place. Secretary of State Marshall was a seriously good man with unquestionable integrity, but he knew that Zionism would not consider any compromise Feisal was likely to propose. There was no point in him meeting with the Saudi prince to convey that message.

In cabinet, Marshall's own view echoed that of Defence Secretary Forrestal. It was that partition in the face of Arab antagonism would create serious trouble in the region after Britain's withdrawal; and that the only beneficiary of it, apart from Zionism, would be the Soviet Union. In fact Marshall and Forrestal shared Feisal's analysis.

The top-secret position paper that most informed the official State Department view of the strategic significance of the Arab Middle East was the one Loy Henderson had written in September 1947. It contained the following:

> The resources and geographical position of the Arab Countries are of such a character that those countries are necessarily factors of importance in the international economic field. Arab friendship is essential if we are to have their co-operation in carrying out some of our vital economic programs. During the next few years we are planning to draw heavily on the resources of the area, not only for our use, but for the reconstruction of Europe. Furthermore, we are intending to make important use of the communications facilities in the area.[13]

Henderson also noted that the partition plan proposals "ignore such principles as self-determination and majority rule."

Because he was the prime target of Zionism's campaign of vilification against the State Department, Henderson, when he forwarded that position paper to Marshall, attached a note to it. The note said that despite the views expressed in the position paper, "the staff in my office is endeavouring loyally to carry out the decision (the majority partition report)... and will continue to execute the decision in a manner which will minimise as far as possible the damage to our relations and interests in the Near Middle East" (in the event of the partition plan being approved by the General Assembly).[14]

Two months later, five days before the vote on the partition plan, Henderson wrote another top-secret advice paper for consideration by his masters. It said: "By our Palestine policy we are not only forfeiting

the friendship of the Arab world, we are incurring long-term Arab hostility towards us. What is important is that the Arabs are losing confidence in the integrity of the United States and the sincerity of our many pronouncements that our foreign policies are based on the principles of the Charter of the United Nations."

I think there can be no doubt that *if the Zionists had not had the Nazi holocaust card to play, the views of the U.S. Secretaries of State and Defence, and the various intelligence agencies, would have prevailed.* The American strategic interest—including the need to prevent the Soviet Union winning friends and influence in the Middle East—would have been put first and the partition of Palestine would not have been a runner. If Marshall had been free to act as he thought best, he would have welcomed a meeting of minds with Feisal and, probably, the two of them would have solved the Palestine problem in a way that would have served the best real interests of all concerned. Except those of the Zionists and the Soviet Union.

Feisal's initial assessment of the strength of opposition to the partition resolution was correct. In response to Zionist pressure on the Truman administration, the critical vote on the resolution was postponed twice because the required two-thirds majority was not there.

After the second postponement Zionist leaders decided to do whatever had to be done to secure the necessary two-thirds majority. They were desperate in the extreme. Without the appearance of legitimacy a UN resolution on partition (if approved) would give Zionism, it would be impossible for the Jewish state to import the heavy weapons and military hardware needed to guarantee victory in the coming war with the Arabs. It was, in short, Zionism's moment of truth. If it could bend the UN to its will, a Jewish state would be created and, after its birth, the size of it would be determined on the battlefield. But without a birth certificate of sorts from the UN, the whole Zionist enterprise was doomed. Or very well could be.

As Lilienthal revealed, "Operation Partition", the Zionist strategy to secure the necessary two-thirds majority in the General Assembly, was masterminded by David Niles, Zionism's top man in the White House. His two main associates for the task—fellow conspirators is a fair description— were New York's Judge Joseph Proskauer and the Washington economist, Robert Nathan. All three were men with great prestige and enormous influence who could cause almost any door to be opened, but Niles, because of his position and his role in the White House, was himself the master key.

The trio's mission, with the assistance of other immensely powerful Zionists and a political hit-squad of their supporters in the U.S. Senate, was to persuade a number of target governments to change their voting intention from 'No' to 'Yes' or, failing that, to abstain.

In every communication they had with representatives of the target governments, including in some cases heads of state, the trio took great care to stress that they were speaking as "mere private citizens". They were not speaking for the Truman administration. They said. And that was true. But those on the receiving end of their messages could not be blamed for believing the opposite. Everybody who needed to know

did know that Niles was one of Truman's right-hand men, and that when the President himself was not personally involved, Niles was effectively running the White House show on Palestine. Was it likely that Niles would be applying pressure without at least the unofficial and deniable blessing of the President? Not likely, those subjected to pressure thought. But they were wrong. Niles in particular was demonstrating that most unique of all Jewish qualities—*chutzpah.*

This Yiddish word has no exact translation in English. It is usually said to mean effrontery but there is more to it. The full meaning of chutzpah has to be extracted from all the things effrontery can mean including temerity (rashness, unreasonable contempt for danger), audacity, nerve, cheek, gall, impudence, brazenness, impertinence and insolence. By and large *chutzpah* is, in my opinion, an admirable quality; and I think Jews possess it, uniquely, because of their unique experience of history. The role played by *chutzpah* in first the creation of Israel, and then its expansion, is impossible to exaggerate. One might say that *chutzpah* is the single word that best sums up the whole Zionist enterprise.

After two postponements the critical vote on the partition resolution was scheduled for 29 November. Despite their bullying and their blackmail, Niles and his fellow conspirators could not be completely confident about the outcome until the votes were actually cast in the General Assembly.

As it happened on the day there were 33 votes for the partition resolution—including those cast by the United States and the Soviet Union, 13 against and 10 abstentions. The necessary two-thirds majority was achieved. Just about.

Britain was one of the 10 member states which abstained. It was unwilling to vote for a resolution that did not command the support of both the Jews and the Arabs of Palestine.

But what was the story behind the story? How did the Zionists and their unquestioning supporters in the U.S. Senate turn a General Assembly majority 'No' into a majority 'Yes'?

In *Memoirs* published long after the events President Truman himself was quite frank about Zionist coercion. He wrote:

How did the Zionists and their unquestioning supporters in the U.S. Senate turn a General Assembly majority 'No' into a majority 'Yes'? President Truman himself was quite frank about Zionist coercion.

The facts were that not only were there pressure movements around the United Nations unlike anything that had been seen there before, but the White House too was subjected to a constant barrage. I do not think I ever had as much pressure and propaganda aimed at the White House as I had in this instance. The persistence of a few of the extreme Zionist leaders—actuated by political motives and engaging in political threats—disturbed and annoyed me.

Some were even suggesting that we pressure sovereign nations into favourable votes in the General Assembly. I have never approved of the practice of the strong imposing their will on the weak whether among men or among nations.[15]

Political threats? That was Truman's way of acknowledging that Zionists had let him know that he could forget about being re-elected for a second term if his administration did not put pressure on member states—to guarantee the necessary two-thirds majority for the partition resolution in the General Assembly.

The Zionist threat to the Democratic Party's election prospects had also been invoked at the Cabinet table. Robert E. Hannegan was the Postmaster General. On at least two occasions he pressed the President to take sides with the Zionists in order to protect the flow of Jewish campaign funds. In cabinet on 4 September, the day after the UNSCOP majority report recommended partition, Hannegan said the position taken on Palestine would have "a very great influence and great effect on the raising of funds for the Democratic National Committee."[16] He reminded his Cabinet colleagues that "very large sums"[17] had been obtained from Jewish contributors in the past and they would be influenced "in either giving or withholding by what the President does on Palestine."[18]

In cabinet on 6 October, when the Zionists and their supporters were wanting the Truman administration to "pressure sovereign nations into favourable votes in the General Assembly", Hannegan had again raised the importance of Jewish campaign funds.[19] He said that many who had contributed to Democrat campaigns in the past were "pressing hard for assurances from the administration of definitive support for the Jewish position in Palestine."[20] On that occasion Forrestal quoted the President as telling Hannegan that if those who were pressing would only keep quiet, he thought that everything would be alright; but "if they persisted in the endeavour to go beyond the report of the United Nations Commission, there was grave danger of wrecking all prospects for settlement."[21] Hannegan still pressed the President to give the Zionists definitive assurance of his support. Truman was, Forrestal noted, "adamant"—i.e. he refused to give definitive assurance.

Truman's assertion that his administration at Executive level did not press governments to change their votes from "No" to "Yes" was correct. What many UN delegates understandably but wrongly perceived to be Truman administration pressure was applied by a political hit-squad of 26 pro-Zionist U.S. Senators who were motivated by their needs for Jewish votes and campaign funds. They co-ordinated their activities with Niles and his unofficial "private citizens" group.

The pro-Zionist Senators and their allies targeted the governments of the non-Muslim member states most in need of American assistance, economic and other. France, for example, was asked to contemplate its

future without the economic assistance it was due to receive under the Marshall Aid Plan. Baruch was the conveyer of that message to the French. (Through former ambassador William Bullitt, Baruch also put pressure on China).

Of all the manoeuvres of the Senatorial hit squad, the most effective was a telegram signed by all 26 and sent to the representatives of 12 of the UN delegations a few days before the vote. It helped to change four "No" votes to "Yes" and, crucially, seven "No" votes to abstention. Of the 12, only Greece risked antagonising the U.S. Senate and stuck to its "No" vote.

But the two-thirds majority was still not there. Zionism's last minute calculations indicated the need to turn three more "No" votes into "Yes" votes. The countries re-targeted for the final push were Liberia, the Philippines and Haiti.

To change Liberia's intended "No" vote into a "Yes" vote, the trio sought and obtained the services of Harvey Firestone, the Firestone of the Firestone Tyre & Rubber Company. It had a vast rubber concession in Liberia. Rubber was then the principal source of Liberia's national wealth.

At the bottom of the bulge that is West Africa, Liberia was a very remarkable country. It had been created by American philanthropists wishing to evangelise West Africa and find a permanent home for freed American Negro slaves. They started the re-settlement of the continent of their ancestors in 1818. After it became Africa's first independent republic in 1847, Liberia was (and remained for many years) a model of stability and continuity of government. In 1927 the Firestone Company concluded a 99-year lease agreement with the government of Liberia on a 100,000-acre rubber plantation. Before and during World War II the Firestone Company played a major role in Liberia's economy, accounting for a large proportion of both exports and imports. The Firestone Company was the biggest single employer of labour in the country. The government of Liberia derived most of its revenue from dividends and royalties paid by foreign companies and, in the case of Firestone, from fees paid for the rubber concession. Probably no outsider had greater potential influence on the Liberian government than Harvey Firestone. On behalf of the trio, Nathan asked Harvey Firestone to use his influence. On behalf of Zionism.

Harvey Firestone himself talked to the government of Liberia and then sent a message to his company's chief representative in the country instructing him to press for a vote in favour of the partition resolution. The government of Liberia was left in no doubt that if it did not do what the Firestone Company wanted, its revenue from rubber would suffer.

The government of Liberia was left in no doubt that if it did not do what the Firestone Company wanted, its revenue from rubber would suffer.

The man who discovered how the Firestone Company had been used to intimidate Liberia was Undersecretary of State Lovett. He informed both Secretary of State Marshall and Defence Secretary Forrestal of what he knew; and Forrestal noted what Lovett had told him in his diary.

The starting "No" position of the Philippines could not have been more explicit. In the General Assembly on 26 November, three days before the vote, the head of the delegation from the Philippines, war hero General Carlos Romulo, made this ringing declaration: "I will defend the fundamental rights of a people to decide its political future and to preserve the territorial integrity of the land of its birth!"[22]

Fearing that Romulo might be capable of influencing other delegates, the Zionists hit their panic button; and the Philippines war hero found himself on the receiving end of threats. The fact that he took the next plane back to Manila leaving the permanent representative of the Philippines, Ambassador Elizalde, to cast the "No" vote" might suggest that Romulo believed his life was in danger in New York.

While Romulo was on his way back to Manila, the President of the Philippines, Manuel Roxas, was informed that his country had too much to lose by offending the U.S. Subsequently, and as reported in a lengthy cable from the American ambassador to Manila to the State Department, President Roxas had a telephone conversation with Ambassador Elizalde. Roxas asked Elizalde for his views. Elizalde had been one of the recipients of the telegram from the 26 Senators and was very worried by it. He had also received "messages" from two American judges, Justice Frankfurter and Justice Murphy, strongly urging him to vote for partition. Elizalde told his President that the partition of Palestine was not a wise move but... The U.S. was determined to see it happen and it would be foolish to vote against the U.S. at a time when there were seven bills pending in Congress in which the Philippines had a vital interest.

Under strong Senatorial pressure and with seven Philippines-related bills pending before Congress, the Philippines caved in.

It was President Truman himself who gave the best summary explanation of how the President of Haiti had been persuaded to change his mind about how his country should vote on the partition resolution. On 11 December, 12 days after the vote, an angry Truman said the following in a memorandum to Lovett:

Haiti was pressured using Truman's name, but without his knowledge. Only Niles, Zionism's top man in the White House, could have dared to invoke the president's authority.

I have a report from Haiti in which it is stated that our Consul in Haiti approached the President of that country and suggested that, for his own good, he should order the vote of his country changed, claiming that he *had instructions from me* [my emphasis] to make such a statement to the President of Haiti.

It was perfectly clear, the memorandum added, "that pressure groups will succeed in putting the United Nations out of business if this sort of thing is continued."[23]

Who would have dared to tell the American Consul in Haiti to make such a threat and would have had sufficient credibility to be believed by the Consul when he said he was passing on an instruction from President Truman? The most likely answer, it seems to me, is Niles. The Consul would have known that when President Truman himself was not hands-on, Niles was running the White House Palestine show.

The official record of the General Assembly in session reflected the pressures that were brought to bear on delegates to change their votes from "No" to "Yes".

Lebanon's Camille Chamoun appealed to his fellow delegates to think about the damage that would be done to the United Nations if democratic methods were abandoned. He said:

> My friends, think of these democratic methods, of the freedom of voting which is sacred to each of our delegations. If we were to abandon this for the tyrannical system of tackling each delegation in hotel rooms, in bed, in corridors and ante-rooms, to threaten them with economic sanctions or to bribe them with promises in order to compel them to vote one way or another, think of what our Organisation would become in the future.[24]

And Egypt's delegate, Mahmoud Fawzi, did not mince his words:

> Let us say frankly to the whole world that, despite the pressure that was brought to bear upon delegates and governments in order to vote in favour of partition, *a majority of the United Nations cannot stomach the violation of the principles of the Charter.*[25] (emphasis added)

All the delegates of the member states were aware that some money had changed hands. One Latin American delegate had taken a bribe of $75,000 to vote "Yes" instead of "No". And the delegate of Costa Rica was later to dine out on the story of how, after he had refused a bribe of $45,000, he had been instructed to change his vote. The obvious implication was that somebody higher up the Costa Rica line had taken a bigger bribe.

The partition resolution would not have been approved by the General Assembly if all the member states of the United Nations had been allowed to vote freely.

It can be said without fear of contradiction that the partition resolution would not have been approved by the General Assembly if all the member states of the United Nations had been allowed to vote freely.

Immediately after the vote, the feelings of the true majority of the member states were expressed by Sir Muhammed Zafrullah Khan,

Pakistan's Foreign Minister and the head of his country's delegation to the Special Session of the General Assembly. He said:

> Partition totally lacks legal validity. We entertain no sense of grievance against those of our friends and fellow representatives who have been compelled under heavy pressure to change sides and to cast their votes in support of a proposal the justice and fairness of which do not commend themselves to them. Our feeling for them is one of sympathy that they should have been placed in a position of such embarrassment between their judgement and conscience on the one side, and the pressure to which they and their governments were being subjected on the other.[26]

The delegates and governments of those countries which were obliged by one means or another to change their votes from "No" to "Yes", or to abstain, were convinced that the whole institution of the American government had been responsible for the campaign of intimidation and threats to secure the necessary two-thirds majority. That was not the case. There is more than enough evidence in the record to support the view that the Truman administration at Executive level—the President himself and his cabinet colleagues—played the game by the rules and never did exert any pressure on member governments. The pressure was applied by the Zionists and their stooges in the U.S. Senate; and it was the involvement in the Zionist conspiracy of the 26 Senators that made it appear to be a total institutional American conspiracy when, actually, it was not.

The involvement in the Zionist conspiracy of the 26 Senators that made it appear to be a total institutional American conspiracy when, actually, it was not.

In the decades that followed Israel frequently complained (as it still does today) that the General Assembly of the United Nations is unduly and excessively hostile to it. If my friend Chaim Hertzog was still alive today—this former DMI served for a period as Israel's Ambassador to the United Nations—I would ask him this question: Is it really any wonder that the Zionist state has so few friends at the UN?

When Lovett told Forrestal on 1 December about how the Zionists had achieved their victory in the General Assembly, he said: "The zeal and activity of the Jews almost resulted in defeating the Zionist objectives they were after."[27] (As we will see later in this chapter, the continuing zeal and activity of the Zionists almost resulted in their loss of President Truman's support, provoking a crisis like no other for Zionism; and ultimately for Truman himself).

After noting Lovett's comments in his diary, Forrestal added this:

I remarked that many thoughtful people of the Jewish faith had deep misgivings about the wisdom of the Zionists' pressures for a Jewish state in Palestine, and I also remarked that *The New York Times* editorial of Sunday morning pointed up those misgivings when it said 'Many of us have long had doubts... concerning the wisdom of erecting a political state on the basis of a religious faith.' *I said I thought the decision was fraught with great danger for the future security of this country.*[28] (Emphasis added).

At the time the Zionists and their supporters in the U.S. Senate were bending the General Assembly to their will, Dean Rusk was the Director of the State Department's Office of the United Nations. Months later, behind closed doors, he found exactly the right words to explain the implication of what had happened. He was addressing a meeting of American representatives from UN associations across the country. It really was true, he said, that the U.S. had "never exerted pressure on countries

> **The decision of the General Assembly had been "robbed of whatever moral force it might otherwise have had".**

of the UN", but "certain unauthorised officials and private persons violated propriety and went beyond the law." As a consequence, Rusk told his audience, the decision of the General Assembly had been "robbed of whatever moral force it might otherwise have had."[29]

The task now for the UN, without legal or moral authority, was to implement the partition plan.

Only one thing was certain. Britain would be out of Palestine by midnight on 14 May 1948. That, the General Assembly had determined, was when the British Mandate would end and the partition plan, assuming it could be implemented, would come into effect. What would actually happen in the six months between the General Assembly's approval of the partition plan and Britain's departure from the Holy Land was anybody's guess.

The formal Arab rejection of the partition resolution was voiced by Prince Feisal in a statement to the General Assembly immediately after the vote. He spoke of the pressures that had been applied to secure the two-thirds majority and then said: "For these reasons, the government of Saudi Arabia registers on this historic occasion the fact that it does not consider itself bound by the resolution adopted today by the General Assembly."[30]

Throughout the Arab world governments made a great investment in hope—hope that the partition plan could not and therefore would not be implemented because of the totality of Arab opposition to it.

Arab leaders would have been comforted if they had known that President Truman, in private, was beginning to entertain doubts about the sagacity and practicability of the partition decision. At least of part of him was recognising that Secretary of State Marshall and Defence Secretary Forrestal had been right when they argued that, given the opposition of

the Arab and wider Muslim world, the creation of a Jewish state was not in America's best interests.

On 2 December 1947 Truman hinted at his growing impatience with the Zionists in a letter to one of America's most influential Jews, Henry Morgenthau Junior. Truman wrote:

> I wish you would caution all your friends who are interested in the welfare of the Jews in Palestine that now is the time for restraint and caution in an approach to the situation in the future that will allow a peaceful settlement. The vote in the UN is only the beginning and the Jews must now display tolerance and consideration for other peoples in Palestine with whom they will necessarily have to be neighbours.[31]

It was nine days later that an angry Truman sent the memorandum to Lovett—the one in which the President said he knew that Haiti had changed its vote because its President had been threatened. But telling what he knew about Zionism's dirty tricks to secure the two-thirds majority was not Truman's main purpose in sending that particular memorandum. It, two weeks after the vote in the General Assembly, was to give an instruction that no one in his administration should express any preference on the Palestine question during the on-going discussions at the UN about implementing the partition plan. The extent of President Truman's concern about the activities of the Zionists and their supporters can be judged from this sentence. "*It seems to me that if our delegation at the UN is to be interfered with by members of the United States Senate and by pressure groups in this country, we will be helping the United Nations down the road to failure.*"[32] (Emphasis added).

On 21 January Lovett gave Forrestal sight of a draft of a paper being prepared by the State Department's Policy Planning Staff. Its conclusion was that partition was "not workable". It also said the U.S. was under no commitment to support the partition plan if it could not be made to work without resort to force.

During the conversation they had on this occasion, the Defence Secretary expressed his awareness that the State Department was "seriously embarrassed and handicapped by the activities of Niles at the White House in going directly (on behalf of Zionism) to the President on matters involving Palestine."

Defence Secretary Forrestal was concerned by the prospect of force to implement the partition plan. On the evening of 29 January he met with State Department officials. They said the vote of the General Assembly for partition amounted merely to a recommendation and was not a final decision of the UN. They also said that American support of the General Assembly resolution had been "predicated upon the assumption that it would prove just and workable."

It was neither and Forrestal then asked the obvious question. "Is there not already sufficient evidence to support a statement that the un-workability of the proposed solution would justify a re-examination?"

Subsequently Secretary of State Marshall decided that the honest answer was "Yes", and a re-examination of U.S. policy was underway. It was supposed to be conducted in secret but the efficiency of Zionism's counterintelligence network, with Niles at its hub in the White House, would make that a mission impossible.

The first official indication that they were all on the road to failure came on 16 February 1948. On that day the United Nations Palestine Commission submitted its report to the Security Council, (the world body's top decision-making authority which was controlled by the five Permanent Members—the U.S., Britain, France, the Soviet Union and China, each with the power of veto). **The UN Palestine Commission advised the Security Council that the transfer of power from Britain to the proposed Arab and Jewish states of the partition plan would usher in a period of strife and violence.** The Palestine Commission had been appointed by the General Assembly to implement the partition plan.

In its blunt report to the Security Council the Palestine Commission said it feared that 15 May would usher in "a period of uncontrolled widespread strife and bloodshed." There was no hope for a peaceful transfer of power from Britain to the proposed Arab and Jewish states of the partition plan. The implementation of it would therefore require "military forces of adequate strength." In other words: *if the partition plan was to be implemented, it would have been imposed by force.*

The immediate question arising was the one that Subcommittee 2 to the Ad Hoc Committee on the Palestine Question had wanted the Secretary General to refer to the International Court of Justice: Did the United Nations have the legal authority to impose the partition plan? And that begged an even more pertinent question. With or without legal authority, did the Security Council have the will to do so?

As we have seen, the Ad Hoc Committee had rejected by 21 votes to 20 the draft resolution instructing the Secretary General to seek the opinion of the International Court. On that occasion the matter was not pursued because it was politically too hot to handle—because it raised the prospect of the Truman administration having to say "No" to Zionism's demand for a Jewish state. Now both questions had to be answered. And that set the alarm bells ringing throughout the U.S. Departments of State and Defence and the National Security Council (NSC).

The underlying question from here on was this: Would President Truman do what was legally and morally right and in the national interest, and also the wider Western interest: or would he surrender to Zionism, mainly for domestic political reasons but also, perhaps, out of the fear that Zionism, if it did not get the support it needed from the West, might throw in its lot with the Soviet Union?

On 19 February the intelligence agencies of the U.S. State Department, the Army, the Navy and the Air Force concurred with a report prepared by the CIA. It emphasised the strategic importance of the Middle

East and its vast untapped oil resources. This report then became the basis of an assessment by the NSC which was submitted first to Defence Secretary Forrestal. The NSC's assessment was that the turmoil in Palestine was "acutely endangering the security of the U.S."[33]

The intelligence agencies of the U.S. State Department, Army, Navy, and Air Force concurred with a report prepared by the CIA that emphasised the strategic importance of the Middle East and its vast untapped oil resources. It led to an NSC assessment that the turmoil in Palestine was "acutely endangering the security of the U.S."

At the same time the State Department's Policy Planning Staff under George Kennan, who would later become the U.S. Ambassador to the Soviet Union and a legend, had completed its own assessment. It emphasised the necessity of "preventing the area from falling under Soviet influence."[34] The full assessment included this:

> If we do not effect a fairly radical reversal of the trend of our policy to date (support for the partition plan), we will end up either in the position of being ourselves militarily responsible for the protection of the Jewish population in Palestine against the declared hostility of the Arab world, or of sharing responsibility with the Russians and thus assisting in their installation as one of the military powers of the area. In either case, the clarity and efficiency of a sound national policy for that area will be shattered.[35]

On 21 February Marshall sent a detailed "URGENT AND SECRET" cable to Truman. At the time the President was on board the *Williamsburg* in the Caribbean.

In that cable Marshall set out U.S. policy options in the event of the Security Council being unable "to give effect to the General Assembly resolution on Palestine", and if the Security Council was unable "to develop an alternative solution acceptable to the Jews and Arabs of Palestine."[36]

There were, Marshall stated, three options:

(1) Abandonment of the partition plan.

(2) Vigorous support for its implementation including the use of force.

(3) Referral back to the General Assembly for a review of the entire question.

Marshall's working assumption was that President Truman would go, had to go, for the third option. Why?

The first option—abandoning the partition plan—would require the President, unambiguously, to say "No" to an independent Jewish state. And

that would provoke the mother and father of a confrontation with Zionism and its lobby. The outcome of such a confrontation was unpredictable but it would include the certain defeat of the President if he ran for a second term of office, and the defeat of many Democrats seeking election or re-election to both houses of Congress. This President just might be willing to commit political suicide, but he was not going to risk doing a great deal of damage to his party's election prospects.

There was also the possibility that the Zionists in Palestine, if they convinced themselves that they had been betrayed by America, would play the Soviet card—either to create a bargaining position with the U.S. or for real. It was not too much of a secret that some of the Zionists in Palestine were in favour of dumping America and doing their business with the Soviet Union. It was a possibility the Truman administration at Executive level, gearing up for what was to become the Cold War, could not afford to ignore, all the more so because it was aware that the Soviet Union was wooing Ben-Gurion's Jewish Agency.

Marshall knew that the second option—the use of force to impose the partition plan—was not on for several reasons.

One was that President Truman had given public assurances that he would not send American troops to Palestine. In theory he could get around that commitment if the troops were part of an international (UN) force to impose partition. But there were other considerations.

The unanimous opinion of the American military was that the U.S. was in no position to commit troops to an international force. The top brass had calculated that if more than 15,000 American troops (a division) were required for an international force, the President would have to declare a partial mobilisation.

And then there was the fact that President Truman himself was steadfastly opposed to the creation of an international force to impose partition in Palestine. For two strategic reasons. One was that it could not be done without the approval and participation of the Soviet Union; and there was no way Truman was going to invite the communist superpower into arguably the most strategically important region of the world. The second was that President Truman was opposed to any commitment that would tie down American troops in Palestine when doing so would leave him with insufficient forces to deal with Europe's unresolved post-war problems if the need arose. (Truman's resolve on this was to be reinforced by the communist coup d'etat in Czechoslovakia, which was followed by a Top Secret cable from General Lucius Clay, the U.S. Military Governor of Germany in Berlin. Clay expressed his fears that the Soviet Union might be preparing to make major mischief including war in Europe. Forrestal noted that Clay's message "fell with the force of a blockbuster bomb.")[37]

The third option—referral back to the General Assembly—would require the U.S. to take the lead with a proposal of its own. What should it be? If the Security Council was unable to implement the partition plan, "it would then be clear", Marshall said in his cable of 21 February, "that Palestine is not yet ready for self-government." In that event "some form of

UN trusteeship for an additional period of time will be necessary."

However it was dressed up, the third option was shelving the partition plan.

Marshall's cable included a working draft of the procedures to be followed. They included a discussion in the Security Council which would be led by Senator Warren Austin, America's Ambassador to the UN. If discussion proved that the Security Council was unable to implement the partition plan, the intention thereafter was that Austin, on instruction, would make a statement calling for the Palestine problem to be referred back to the General Assembly and introducing a draft U.S. resolution (to replace the shelved partition resolution) for "a temporary trusteeship for Palestine under the Trusteeship Council of the UN."

In the scenario Marshall outlined to the President, Austin's statement would be the first public announcement of the Truman administration's reversal of its Palestine policy.

Truman's reply to Marshall on 22 February was short and to the point. "Your working draft of recommended basic position for Security Council discussion received. I approve in principle this basic position."[38]

Marshall was fully aware that if and when Austin was instructed to go public with the reversal of America's policy, he, Austin, would become the prime target of a Zionist campaign of vilification and possibly worse. To give the ambassador the maximum possible in the way of comfort before the excrement hit the fan, Marshall sent him a remarkable message. It was the Secretary of State's way of saying: "Whatever happens, trust me. I will stand by you no matter what." The message was also a clear statement of Marshall's own moral code. It said:

> As far as I am concerned and the State Department is concerned, but particularly as far as I am concerned, in this highly emotional period of extreme bitterness and violent attacks, my intention is to see that nothing is done by the State Department in guidance for the action of its delegates to the UN in response to either military threats or political threats, one or the other, nothing whatever. My intention is to see that the action of the U.S. government is to be on a plane of integrity that will bear inspection and a common review and *that there will be no bending to any military or political threat so long as I am Secretary of State.*[39] (Emphasis added).

Marshall's message to Austin was supposed to have been private and secret, but some reporters got to know of it. When asked about the message Marshall said it should not be made public "because we've had enough trouble already."[40]

On 2 March, Austin went through the motions of submitting a draft U.S. resolution calling upon the Security Council "to do everything it can

under the Charter to give effect to the (partition) recommendation of the General Assembly."[41] At issue behind closed doors was whether or not the UN had the legal authority to use force to impose the partition plan. The Security Council was divided on the matter and decided on 5 March not to put it to a vote. With Truman opposed to the creation of an international force for Palestine the discussion was, anyway, academic.

Later that same day, and in accordance with the procedures Marshall had outlined to Truman, the President approved telegrams 107 and 108. They were to be sent by the State Department to Austin. They were his guidance on the kind of statement he would make to announce the U.S. policy reversal when it was clear beyond any doubt that the Security Council could not implement the partition plan. Austin was also instructed that he would not actually make the statement until authorised to do so by Marshall.

While Austin fine-tuned his statement and the text of the draft U.S. resolution for a temporary UN trusteeship of Palestine, he made one more attempt to find a way to implement the partition plan by peaceful means. Four of the five permanent members of the Security Council—the U.S., the Soviet Union, France and China—formed a committee to revisit every possible avenue. Britain refused to participate in this predictably futile exercise.

Meanwhile Dean Rusk was trying and failing (he could not have succeeded) to halt the escalating confrontation between the Zionists and the Arabs in Palestine.

With such vital American and Western interests at stake in the Middle East—at least so far as the U.S. Departments of State and Defence and one of the three Harry Trumans were concerned, Marshall was not intending to allow the committee of the four permanent members of the Security Council an unlimited amount of eleventh-hour time to discover that partition was not a runner. He might well have thought that only the Soviet Union was interested in dragging the futile process out because its leaders were hoping that Ben-Gurion, fearing that he was about to be let down by the U.S., might be ready to throw in his lot with the Soviet Union. There were people on the hard left around Ben-Gurion who were telling Moscow that it was by no means impossible that Israel, after its unilateral declaration of independence, would look to the Soviet Union and not the U.S. for superpower support.

On 16 March, when the committee had been getting nowhere for 10 days, Marshall sent a top secret cable to Rusk authorising the policy reversal statement to be made to the General Assembly "as soon as possible as Austin believed appropriate." Marshall set the agreed policy reversal in motion "since no party to the Palestine problem believes partition can be carried out except by the use of force."[42]

On 17 March, in secret telegram 306, "EYES ONLY", Rusk from the UN indicated his agreement with the Secretary of State. "The (partition) plan proposed by the General Assembly is an integral plan which cannot succeed unless each of its parts is carried out. There seems to be general

agreement that the plan cannot be implemented by peaceful means. This being so, the Security Council is not in a position to go ahead with efforts to implement this plan in the existing situation."[43]

So there was, the Rusk message concurred, no alternative to the establishment of a temporary trusteeship for Palestine; and the need for Ambassador Austin to introduce the U.S. draft resolution on it was urgent.

Effectively the partition resolution was about to be vitiated. But... Before Austin made his statement on 19 March there was a breathtaking Zionist intervention—*chutzpah* at its magnificent best—that was designed to prevent a reversal of American policy.

An End Game to determine who would have the most influence on the President with regard to the future of Palestine pitted the Zionists against the U.S. Departments of State and Defence and the intelligence community.

In retrospect (and with the benefit of declassified documents) it can be seen that Marshall's "URGENT AND SECRET" cable to Truman on 21 February was the beginning of the End Game to determine who would have the most influence on the President with regard to the future of Palestine—the U.S. Departments of State and Defence and the intelligence community or the Zionists.

Through their eyes and ears in the White House and, no doubt, the State Department and the UN, the Zionists were fully aware of what was happening. For them the events set in motion by Marshall's cable to Truman on 21 February represented a crisis like no other before or since. They had clearly lost the political battle to influence Marshall's State Department. So far as they were concerned, Marshall was saying "No" to a Jewish state. As the Zionists saw it, there was only one course of action open to them. They had to have a direct way of putting pressure on the President himself. Only he could prevent the reversal of American policy Marshall had prepared. The problem was that Truman had put the White House off limits to Zionist leaders. He was refusing to receive them or take their telephone calls.

In *Plain Speaking*, published in 1966, Merle Miller quoted Truman in taped conversations as saying the following about Zionism's pressures on him: "Well, there had never been anything like it before and there wasn't after. Not even when I fired Macarthur (who had wanted a nuclear strike on North Korea) there wasn't, and I issued orders that I wasn't going to see anyone who was an extremist in the Zionist cause, and I didn't care who it was... I had to keep in mind that as much as I favoured a homeland for the Jews, there were simply other matters awaiting... that I had to worry about."[44]

Eventually in *Memoirs* Truman said this:

> The Jewish pressure on the White House did not diminish in the days following the partition vote in the UN. Individuals and groups asked me, usually in rather quarrelsome and emotional ways, to stop the Arabs, to keep the British from

supporting the Arabs, to furnish American troops, to do this, that and the other. I think I can say that I kept my faith in the rightness of my policy in spite of some of the Jews.[45]

The weapon the Zionists decided to deploy against President Truman was their leader, Chaim Weizmann. By now he was elderly and ill but still a very, very persuasive gentleman. If anybody could convince Truman to stick with the partition plan it was Weizmann. For such a purpose Weizmann's physical condition—his frailty and his illness—was a bonus. How could President Truman fail to be moved when an old and sick Weizmann made his pitch? David Lloyd-George, the tough British Prime Minister had confessed to being "completely won over" by Weizmann's "charm, persuasiveness and intellectual power."[46] Truman would not be so tough a nut to crack and the prospect of him saying "No" to a meeting with the WZO leader was too small to be considered seriously. Or so the Zionists thought.

Weizmann was brought to America and installed in a suite at New York's Waldorf-Astoria Hotel. America's Zionist leaders then put in a request for President Truman to receive him at the White House. And Truman said "No".

The amazing and true story of how Truman was persuaded to change his mind about meeting with Weizmann might never have been known but for the publication in 1966 of a book written for a limited Jewish audience. Its title was *B'nai B'rith, The Story of a Covenant*. Its author was Edward G. Grusd. B'nai B'rith (Sons of the Covenant) was a non-Zionist, conservative, assimilationist, fraternal Jewish order. Its President of the time was Frank Goldman.

Grusd wrote:

> The word got out that the White House door was bolted against all Zionist leaders, and it is a fact that although many knocked, none were admitted. Meanwhile the United Nations halted all partition implementation measures. During this period, however, the President and Secretary of B'nai B'rith had an audience with Mr. Truman. It had no visible effect, however, and President Goldman called on lodges and chapters to express themselves by letters to Mr. Truman and the United Nations.

> At this critical juncture, B'nai B'rith was able to make an important contribution which broke the log-jam. Dr. Chaim Weizmann, internationally famous scientist and head of the World Zionist Organisation, although he was over 70 and ill, came to the United States to make a personal appeal to President Truman. While he lay bedridden in a New York Hotel, American Zionist leaders again tried to make

an appointment for him at the White House. But President Truman refused.

It came to Frank Goldman's knowledge that one of the President's oldest and dearest friends was an Eddie Jacobson of Kansas City, Missouri. He (Goldman) got in touch with A.J. Granoff of Kansas City, a prominent attorney and a past President of District No. 2. It turned out that Mr. Granoff was Mr. Jacobson's attorney, and he gladly introduced his client to the President of B'nai B'rith. Mr. Jacobson told him he was not a Zionist and that B'nai B'rith was the only Jewish organisation to which he belonged. He had been Harry Truman's close buddy in the Army during World War I, had served in the same artillery unit with him in France, and after the war he and Mr. Truman had been partners in a Kansas City haberdashery. He was so close to the President that all he had to do to see him in the White House was to come to Washington, call up, and immediately be invited to "come on over, Eddie."[47]

Goldman reported his find to America's Zionist leaders and from here on Harry's friend Eddie was under Zionism's control. But the first attempt to make use of the Jacobson-Truman friendship failed.

Jacobson sent a cable to Truman asking him to give Weizmann an audience. Truman did not respond.

In a memorandum Jacobson subsequently wrote, recalling his shock at the time, which was to find its way into the Weizmann Archives and the Harry S. Truman Library, he said: "I suddenly found myself thinking that my dear friend the President of the United States was at the moment as close to being an anti-Semite as a man could possibly be."[48]

Then, on 13 March, while Ambassador Austin was awaiting the arrival of the top secret message from Marshall that would instruct him to make the statement to the General Assembly reversing U.S. policy on Palestine, Eddie telephoned Harry, expressing a desire to see him in the White House.

The President replied: "Eddie, I'm always glad to see old friends, but there's one thing you must promise me. I don't want you to say a word about what's going on over there in the Middle East. Do you promise?"[49] Eddie promised and made his way to the White House.

Just before he entered the Oval Office, Presidential Aide Matthew J. Connelly begged him not to discuss the Palestine question.

According to Truman's account to Miller there came a moment when great tears were running down Eddie's cheeks. The President looked at his oldest and best friend and said: "Eddie, you son of a bitch, you promised you wouldn't say a word about what's going on over there."[50]

Eddie replied: "Mr. President, I haven't said a word, but every time

I think of the homeless Jews, homeless for thousands of years, and I think about Dr. Weizmann, I start crying. I can't help it. He's an old man and he's spent his whole life working for a homeland for the Jews. Now he's sick and he's in New York and he wants to see you, and every time I think about it, I can't help crying."

Truman then said: "Eddie, that's enough. That's the last word!"

After that, Truman told Miller, "we talked about this and that, but every once in a while a big tear would roll down his cheek. At one point he said something about how I felt about old Andy Jackson, and he was crying again. He said he knew he wasn't supposed to, but that's how he felt about Weizmann." (Andrew Jackson, 1767–1845, was a military hero and the 7th President of the United States. As a major general of the Tennessee militia, he defeated the Creek Indians in 1814 and the British in 1815. He was the first American President to be elected by direct appeal to voters).

At some point in the conversation Truman agreed to receive Weizmann. With the decision taken, the President said: "Eddie, you son of a bitch, I ought to have thrown you out of here for breaking your promise; you knew damn good and well I couldn't stand seeing you cry."

Weizmann was smuggled into the White House through the East Gate on 18 March. Eddie Jacobson did not accompany him. In his subsequent memorandum recalling the events, Jacobson quoted the Zionists as saying that he had to be "saved" in case he was needed for another "emergency". And he quoted Weizmann himself as telling him, "You have a job to do." It was "to keep the White House doors open."[51]

The secret meeting between Truman and Weizmann lasted for 45 minutes. Truman was deeply moved by the experience and the two men developed an instant and warm friendship that would survive a quick and very hard knock and, in the critical weeks to come, would serve Zionism well.

Truman could have told Weizmann the truth. It was, broadly speaking, in two related parts. The first was that because of the strategic importance of the Middle East to the U.S. (and the West as a whole), it was not in America's interest that the partition plan be implemented against the will of the Arabs. The second was that it could only be implemented by force and that would require a commitment of troops the U.S. was unable to make, not least because of the possibility of a developing confrontation with the Soviet Union in Europe.

In place of the truth Truman told Weizmann that the U.S. was staunchly supporting partition and would stick to that position.

The Zionists could have been forgiven for thinking they had outflanked Marshall and that he was about to be ordered by the President to abandon the idea of shelving the partition plan and reversing U.S. policy. But... The next day, 19 March, Ambassador Austin delivered his statement calling for the shelving of the partition resolution and the convening of another Special Session of the General Assembly to work out a new solution to the Palestine problem. The one the U.S. would propose, Austin indicated,

was temporary UN trusteeship.

The Zionists denounced Austin's statement as a "shocking reversal of the United States position."

Initially Weizmann must have felt that he had been betrayed by Truman; but almost immediately the story was put about that partition was not a lost cause *because the policy reversal was an unauthorised initiative by pro-Arab officials in a "malevolent" State Department who had been disloyal to the President.*

On 19 March, the US called for the shelving of the partition resolution and the reconvening of the General Assembly to work out a new solution to the Palestine problem: the U.S. intended to propose temporary UN trusteeship.

The inspiration for this completely untrue story, and the Zionist strategy it gave rise to, was a note Truman himself wrote in his calendar diary for 19 March. Though the existence of the note was unknown to all but a few White House insiders until the publication in 1973 of Margaret Truman's book about her father, the note was an important indication of the President's state of mind at the time.

In her book, citing the calendar diary note as evidence, Margaret Truman claimed that Austin's statement had constituted a gross betrayal of her father. The State Department had reversed his Palestine policy behind his back. Margaret had no knowledge of the fact that her father had approved the policy reversal because the documents relating to the decision-making of the period were still, then, classified. Only when they were subsequently de-classified could the ghost of the Zionist lie about the State Department's disloyalty to the President be laid to rest. And then only by those who were aware of the contents of the declassified documents.

Appreciation of the game some people were playing in March 1948 requires knowledge of the fact that on the day Austin announced the reversal of American policy, the State Department's two top people, Marshall and Lovett, were not in Washington.

Truman's calendar note said:

The State Department pulled the rug from under me today. I did not expect that would happen. In Key West or en route there from St. Croix, I approved the speech and statement of policy by Senator Austin to the UN. This morning I find that the State Department has reversed my Palestine policy. The first I know about it is what I see in the paper. Isn't that hell? I am now in the position of a liar and a double-crosser. I never felt so in all my life. There are people on the third and fourth levels of the State Department who always wanted to cut my throat.[52]

What on earth was happening? Who was playing what game?

The men most responsible for spreading the completely untrue story that State Department officers had "disobeyed White House instructions"[53] were Niles behind the scenes and, in public, Clark Clifford, the Special Counsel to the President (who was to play a bigger and bigger hand in the End Game). Their case, essentially, was that with Marshall and Lovett out of town, and by insinuation not in control of events in their Department, disloyal junior officials had taken a policy initiative of their own. Those who spread the story knew it was not true but it served a purpose. It was to create confusion and division, and also to rattle Marshall's cage, to give the Zionists scope and time to put more pressure on Truman to reverse the policy reversal.

Marshall understood the game the Zionists and their supporters were playing and moved quickly to deny them room for manoeuvre.

The day after Austin dropped what Clifford called the "bombshell", the Secretary of State, Mr. Integrity to all but the Zionists and their supporters, went on the record to a Los Angeles press conference with this statement: "The course of action with respect to the Palestine question which was proposed on 19 March by Ambassador Austin appeared to me, after the most careful consideration, to be the wisest course to follow. I recommended it to the President, and he approved my recommendation."[54]

What does the incident tell us about Truman?

Lilienthal wrote that the President "apparently had overlooked, or forgotten, the vital details" (starting with his approval of Marshall's detailed cable of 21 February).[55]

I think the trouble Truman found himself in, and which the Zionists thought they could exploit to keep the partition plan alive, was of his own making. His gut instincts had told him that he should put himself beyond Zionist influence and pressures until the reversal of the Palestine policy was announced. That was why he had closed the White House doors to the Zionists and was refusing to take their telephone calls. The national and wider Western interest had to be put first. Then, emotionally disturbed by his conversation with Eddie Jacobson, he agreed to meet with Weizmann. Then, face-to-face with the physically frail Zionist leader, the President simply could not bring himself, emotionally, to tell the truth. Truman's first response thereafter was to blame somebody else—the people "on the third and fourth levels of the State Department who always wanted to cut my throat." (A decade later Truman told readers of his *Memoirs* that "the suggestion that the mandate be continued as a trusteeship was not a bad idea.")[56]

To the extent that Truman had cause for irritation, it was because he had not been told precisely when Austin would make the policy reversal statement. Having got the President's various approvals, Marshall did not believe that to be necessary: and Marshall himself was not aware of the precise timing of the statement. He had left that to Austin's in-situ judgement of when it was most appropriate and convenient for the General Assembly. There may also have been another consideration in Marshall's mind. The White House was not secure. When you played chess with the Zionists,

you did not signal your next move in advance, if you could avoid doing so.

On 22 March, after talking with Truman, Marshall sent a memorandum to Charles E. Bholen, the State Department's Counsellor. It said the President had been "exercised" (irritated) because, if he had known when the Austin statement was to be made, "he could have taken measures to have avoided the political blast of the [pro-Zionist] press."[57] (Did that mean Truman would have told Weizmann the truth or would not have received him?) Marshall's memorandum to Bholen was obviously for the honest record that would one day be made public.

A few days after Austin's statement, Truman's support for the reversed U.S. policy on Palestine seemed to be rock solid. And he went public with it. At a press conference on 25 March the President said: "Our policy is to back up the UN in trusteeship by every means possible."[58]

That did not necessarily mean American troops would be used, the President said; and the trusteeship proposed was "not a substitute for the partition plan, but an effort to fill a vacuum soon to be created by the termination of the Mandate on 15 May"; and it did "not prejudge the character of the final political settlement."[59]

There was also a strong indication that Truman had taken Marshall's advice to rebut charges that the State Department had been disloyal to the President and had undermined his resolve to support partition. It may have been that Marshall insisted on the President rebutting the charges against the State Department. The rebuttal was, effectively, in the following section of Truman's statement to reporters:

> This country vigorously supported the plan for partition with economic union recommended by UNSCOP and by the General Assembly. We have explored every possibility consistent with basic principles of the (UN) Charter for giving effect to that solution. Unfortunately, it has become clear that the partition plan cannot be carried out at this time by peaceful means. We could not undertake to impose this solution on the people of Palestine by use of American troops, both on Charter grounds and as a matter of national policy.[60]

That was the truth the President could have told Weizmann eight days earlier.

Truman concluded his press conference of 25 March with these words: "If the UN agrees to trusteeship, peaceful settlement is yet possible; without it, open warfare is just over the horizon."[61]

As we shall now see, a prime factor influencing Truman's decision-making in the climax to the End Game—no prizes to readers for guessing correctly—was the need to prevent Zionism denying Jewish campaign funds and votes to Democratic Party candidates, including the President himself, for the elections of November 1948.

It was a state of affairs that led Defence Secretary Forrestal to say in private, and to write in his diary, the following: "I said I thought it was a most disastrous and regrettable fact that the foreign policy of this country was determined by the contributions a particular block of special interests might make to the party funds."[62]

On 30 March, Ambassador Austin formally presented the Security Council with a resolution for the convening of another Special Session of the General Assembly "to consider further the question of the future government of Palestine." In line with Marshall's cable to the President on 21 February, the intention of the Truman administration at Executive level was to seek and hopefully secure the General Assembly's approval of the U.S. proposal to have Palestine governed as a UN trusteeship.

In six weeks the British Mandate would come to its inglorious end. The time for the world body to find a solution to the Palestine problem to protect the best interests of all concerned was nearly up.

American Zionist leaders had not yet abandoned all hope that they could exert enough pressure on President Truman to oblige him to drop the idea of UN trusteeship and return to partition as the only game in town.

On 9 April they played the Weizmann card again. This time it was in the form of a very emotional letter from the master persuader to Truman. It was a plea for the President's understanding of the consequences for the Jews of not implementing the partition plan. "The choice for our people", the Weizmann letter asserted, "is between statehood and extermination."[63] It was the fundamental essence of Zionism's philosophy of doom—the notion of the Jewish state as an insurance policy, the refuge of last resort for Jews anywhere and everywhere in the event of the monster of anti-Semitism going on the rampage again. In the immediate aftermath of the Nazi holocaust, it was reasonable for Zionism's leaders to assume that a man as vulnerable to his emotions as President Truman would not be unmoved by such an appeal.

"The choice for our people", Weizmann asserted, "is between statehood and extermination." On the same day Zionist terrorists in Palestine were slaughtering the Arabs of Deir Yassin.

On the same day Zionist terrorists in Palestine were slaughtering the Arabs of Deir Yassin. (By this time it was clear to those aware of the facts of what was happening on the ground in the Holy Land that Zionist military forces were gaining the upper hand in the escalating conflict with the indigenous Arabs).

As a means of putting pressure on President Truman the Weizmann letter was only the tip of an iceberg.

Zionist and other Jewish organisations across the big country were mobilised to protest against the Truman administration's "sell-out" and to demand that the partition plan be implemented to create a Jewish state. At some big rallies speakers denounced the "politics of oil". The President himself was personally bombarded with appeals to implement the partition plan. And, not surprisingly with elections coming, the Republican Party

jumped onto the Zionist bandwagon. Republicans, especially those soon to run for office, attacked the Truman administration for its "vacillation and inadequacy" with regard to Palestine. At the time the press was preponderantly Republican, so Zionism's messengers had an easy ride. The media was anyway full of stories of the courage of the fighting Jews in Palestine. The Arab case was not for consideration and the violation of Arab rights was not an issue. All in all these were most uncomfortable days for the Truman administration.

Against this background the actual convening of another Special Session of the General Assembly to seek support for UN trusteeship as the only possible solution to the Palestine problem was a test of President Truman's nerve.

America's Zionist leaders were hoping that their pressure would cause Truman to panic, and tell Marshall to instruct Austin to inform the Security Council that the U.S. no longer believed another Special Session of the General Assembly would serve any useful purpose. In that event, the case for putting partition back on the agenda and implementing that plan would become irresistible, or so the Zionists imagined.

They were to be disappointed. Pressed by Marshall to stand firm, Truman's nerve held and the Security Council agreed to the convening of the Second Special Session of the General Assembly. It got down to business on 16 April. There were now four weeks to go before Britain's withdrawal from Palestine would be completed.

The delegates of all the member countries of the UN were aware that if they failed against the clock to come up with an agreed and workable plan for UN trusteeship as the immediate solution to the Palestine problem, there would be set in motion an escalating conflict that might be one without end, and which would bring with it threats to the stability of the global economy and the peace of the world. In private the gravity of the situation was acknowledged by all.

The fact that President Truman did not panic under pressure and did not pull the plug on the convening of the second Special Session of the General Assembly conveyed an implicit message from his administration at Executive level to America's Zionist leaders. The message was something like this: "We are not going to bow to pressure when doing so would require us to endanger the national and wider Western interest. The stakes are too high for game playing of that kind". (That, I imagine, is how Secretary of State Marshall and Defence Secretary Forrestal would have put it).

But... *It was not the member governments of the UN or even America's Zionist leaders who were calling the shots. Ben-Gurion was now in command and control of the action.*

So far as the Zionists in Palestine were concerned, what was happening at the UN was a supreme irrelevance. Ben-Gurion was determined to declare the coming into existence of the Jewish state as soon as the British Mandate ended. In other words, Ben-Gurion was intending to proceed as though the partition plan had not been vitiated, as though there had been no reversal of U.S. policy, and no matter what the General

Assembly decided with regard to trusteeship. The 'us against the world' mindset was now the prevailing one in Ben-Gurion's camp.

With help from the outside, the Zionists in Palestine had succeeded in wrecking Britain's policy of restricting Jewish immigration. Now they were going to demonstrate that they were prepared, if necessary, to defy even the United States of America.

Ben-Gurion was intending to proceed as though the partition plan had not been vitiated, as though there had been no reversal of U.S. policy, and no matter what the General Assembly decided with regard to trusteeship.

Up to this point the man who had had most influence on Truman's Palestine policy was Marshall. This particular Secretary of State was the living American the President most admired on account of his abilities and integrity. As Marshall would have defined it, integrity was about putting America's national interests first and, to the limit of the possible within that context, doing what was legally and morally right. Truman had proudly endorsed Churchill's view of Marshall—that no man had done more to enable the Allies to defeat Nazi Germany, fascist Italy and kamikaze Japan. In theory there was no better man than Marshall to assist Truman to keep Zionism in check. In practice the question now waiting for an answer was this: Would Marshall continue to be the man with most influence on Truman's Palestine policy?

Two men were determined that he would not be. They were Niles, Zionism's top man in the White House, and Clark Clifford. As Special Counsel to the President, Clifford's main task was to advise Truman on what to do for the best if he was to be re-elected for a second term. After the policy reversal on Palestine, Truman's prospects of being re-elected were judged to be so poor that some of his best friends were urging him not to run again.

It was Clifford who pushed the proposition that Truman should put self-interest and the interests of his Democratic party before the national interest. And that meant surrendering to Zionism. But first Clifford had to change his own mind.

In his own initial thinking Clifford had been of the view that, in the long run, there was likely to be greater gain for the President and his party "if the Palestine problem is approached on the basis of far-reaching decisions founded upon intrinsic merit."[64] In other words, Clifford was not convinced, initially, that the best way to win the organised Jewish vote, in New York especially, was by adopting pro-Zionist policies.

By the end of April, with the Second Special Session of the General Assembly getting down to business, and polling day only eight months away, Clifford had changed his mind. He was now of the opinion that Truman's campaign for re-election (and that of many other Democrats) was being jeopardised by the administration's reversal of its Palestine policy.

One of the main events that caused Clifford to let political expediency be his guide was the shock defeat of the Democratic candidate

in a one-off congressional election for the Bronx constituency of New York. This was a 55 per cent Jewish constituency. The Democrats ought to have won without effort. But their candidate lost, not to a Republican but to a fringe candidate representing the American Labour Party, one Leo Isaacson. He had campaigned on a militant pro-Zionist ticket. The conclusion invited was that the voters had soundly repudiated the Truman administration's refusal to implement the partition plan and give all-out support to the creation of a Jewish state.

During that Bronx campaign there were Democrats who said, "Truman still talks Jewish, but acts Arab."[65]

To those responsible for Truman's re-election that was really scary stuff. The importance of the Jewish bloc vote was critical in some key states. New York State had 47 electoral college votes and without them no sitting President, with the exception of Woodrow Wilson, had been re-elected since 1876.

By 4 May, 10 days before British rule in Palestine was going to end, and with the General Assembly still discussing trusteeship as the solution to the Palestine problem, Clifford was aware, according to his own papers, that a Jewish state "will shortly be set up."[66] In other words, he knew that Ben-Gurion was intending to make a unilateral declaration of Israel's coming into being as soon as British rule ended. In Clifford's reasoning Truman's recognition of the Jewish state would be the magic that secured Jewish campaign funds as necessary, won him back the Jewish vote and, come November, would see him re-elected for a second term. If on the other hand the President refused to recognise the Jewish state, he would be politically dead and his party would suffer great damage at the polls. So far as Clifford was concerned, Truman had no choice. He had to recognise the Jewish state: and advising him to do so was now Clifford's passionate priority.

The stage was being set for a dramatic showdown—Clifford v Marshall—in the White House.

On 6 May, after a meeting with Clifford and Max Lowenthal, Niles prepared an initial draft of the statement Zionism wanted President Truman to make, on Clifford's advice, recognising the Jewish state.

Lowenthal was closely associated with the Jewish Agency—he had his own hotline to Ben-Gurion—and Niles had engineered his engagement as a consultant to the White House.

On 7 May Lowenthal sent a confidential memorandum to Clifford. It was "FOR MR. CLIFFORD ONLY". And it carried a caution: "This is for the protection of the Administration, not to be shown in written form to anyone else, under any circumstances."[67]

In that memorandum (and five others sent over five days) Lowenthal called for recognition of the Zionist state before 15 May— i.e. before the expiry of the Mandate and the ending of British rule. Advance recognition Lowenthal said, "would free the Administration of serious and unfair disadvantage" in the November elections. What a nice way of saying, "will remove Zionism's threat to deny President Truman and his party Jewish campaign funds and votes!"

This was a new twist to the extent that other American Zionists and their supporters with access to the Truman administration at Executive level were pressing only for prompt U.S. recognition when the Zionist state unilaterally declared itself to be in existence—i.e. *after* the expiry of the Mandate.

Why was Lowenthal pressing for advance recognition?

I think his demand was an indication that some of Ben-Gurion's leadership colleagues were mightily troubled by the possible consequences of what they were about to do. What if they unilaterally declared their state to be in existence and the U.S. refused to recognise it?

That would highlight in the most public way the new state's lack of legitimacy, and that in turn could have unthinkable consequences.

If the Zionist state was not recognised by the U.S., there was the prospect of it being labelled an 'outlaw' state. In that event it might be difficult, and perhaps impossible, to import the weapons needed to guarantee the new state's survival in the coming war with the Arabs. As part of its effort to stop the violence in Palestine escalating, the Truman administration had embargoed the shipment of all arms to the Middle East. The Zionists had protested bitterly because, they

Without U.S. recognition, the Zionist state might be labelled an 'outlaw' state, impeding its ability to import the weapons needed to guarantee its survival in the coming war with the Arabs.

said, the embargo was hurting the Jews far more than the Arabs. As we have seen, that was not so. As we will see, Ben-Gurion had already purchased the weapons and military hardware needed to win the coming war with the Arab states. The problem would be importing them if Israel, when it declared itself to be in existence, was perceived to be an outlaw state.

In the context outlined above, some of Ben-Gurion's leadership colleagues believed that a unilateral declaration of independence would be too risky unless President Truman could be prevailed upon to give an advance public signal that he intended to recognise the Jewish state when it came into being. Ben-Gurion for his part was determined that there would be a unilateral declaration of independence no matter what, and his response to the doubters in his own camp was: "We have to take the risk. If we don't seize the moment when British rule ends, there may never be a Jewish state."[68]

My speculation is that Ben-Gurion or somebody for him instructed Lowenthal to put pressure on Truman through Clifford in order to be seen by his own colleagues to be doing everything possible to minimise the risk. The Lowenthal memorandum of 7 May plus the five others he sent over five days eventually had the desired effect on Clifford. By 12 May—the day of the showdown with Marshall—he was ready to advise President Truman to approve and make the statement that it was his intention to recognise the Jewish state when it came into existence.

While Lowenthal under the supervision of Niles was working with

Clifford, others were piling the pressure on the President and members of his cabinet. The others included the Democratic National Chairman, Senator Howard McGrath, the man with the greatest institutional need for Jewish campaign funds and votes. And in the State Department General John Hilldring, a long-time Zionist supporter, was doing his best to undermine the influence of all who were cautioning against premature recognition of the Zionist state. Hilldring had been appointed by the President as Special Assistant to Marshall on Palestinian Affairs. Two days before his appointment, in a speech to the Jewish Welfare Board, General Hilldring had declared that he was in favour of partition. It is, I think, reasonable to assume that the President planted Hilldring on Marshall to appease the Zionists—i.e., not, as others have suggested, because Truman himself had stopped trusting the Secretary of State.

High Noon in the White House was actually at 4.00 p.m. on 12 May. In addition to the President himself, those present were: Marshall, Lovett, Clifford, Niles, White House Aide Connelly (the one who had begged Jacobson not to raise the subject of Palestine) and two veteran State Department Foreign Service Officers—Robert McClintock and Fraser Wilkins.

From the parts of the official record that were declassified many years after the event, including Marshall's own memorandum of the discussion, we know something of who said what to whom.

On the table for discussion was the statement Niles had drafted on Zionism's behalf and which Clifford wanted the President to make, either that very day or the following day at his scheduled press conference. If Clifford had his way, President Truman was about to tell the world—before the Mandate and British rule in Palestine ended, *and while the General Assembly was still debating what to do about the Holy Land*—that he intended to recognise the Jewish state when it came into being.

Clifford to his credit admitted that his support for such a policy initiative was based upon consideration of the "political implications involved and the need to improve election prospects." The presidential statement he was recommending would also enable the U.S. to "steal a march on the U.S.S.R. (the Soviet Union)."[69]

Marshall exploded. He deeply resented the fact that Clifford was even present. "Mr. President, this is not a matter to be determined on the basis of politics. Unless politics were involved, Mr. Clifford would not even be at this conference."[70]

The counsel Mr. Clifford was offering, Marshall said, was "a transparent dodge to win a few votes." It was "based on domestic political considerations when the problem confronting them was international."

Marshall was also concerned with the standing of the Presidency itself. If the President did what Clifford was proposing, "the great dignity of the office would be seriously diminished."

According to his own account of the conversation Marshall summed up his position in the following way: "I said bluntly that if the President were

to follow Mr. Clifford's advice and if in the elections I were to vote, I would vote against the President."

Clifford later described himself as being "enraged". Marshall, he said, had spoken "in a righteous God-damned Baptist tone."[71]

While Marshall glared at Clifford, Lovett continued the attack on what the Special Counsel to the President was proposing. It would be, he said, "highly injurious to the UN to announce recognition of the Jewish state even before it comes into existence and while the General Assembly, which was called into being at the request of the U.S., is still debating the future government of Palestine."[72] More or less echoing Marshall, Lovett also said it would be "injurious to the prestige of the President."[73]

Finally, Lovett said, there was this to consider: "To recognise the Jewish state prematurely would be buying a pig in a poke. How do we know what kind of Jewish State would be set up?"[74]

At the back of Lovett's mind and troubling him were the assurances he had sent weeks previously to King Ibn Saud and Egypt's King Farouk. After the rigged vote at the General Assembly in favour of partition, it had fallen to Lovett as Undersecretary of State to give those two monarchs some comfort. In cables to Jeddah and Cairo, Lovett had instructed U.S. Ambassadors to tell them the following:

> It is understood that one of the reasons for Arab resentment at the General Assembly decision is concern lest the Zionists intend eventually to use their state as a base for territorial expansion in the Middle East at the expense of the Arabs. It is the conviction of the U.S. government, based on conversations with responsible Zionist leaders, that they have no expansionist designs and are most anxious to live with the Arabs in the future on cordial terms and to establish with them relations of a mutually advantageous character...
> If at a later time, persons or groups should obtain control of the Jewish state who have aggressive designs against their neighbours, the U.S. would be prepared to firmly oppose such aggressiveness in the United Nations and before world opinion.[75]

I think it is reasonable to imagine that Lovett, when he made his "pig in a poke" comment, was entertaining the fear that the assurances he had given the Arabs would prove to be not worth the paper they had been written on.

President Truman, apparently neutral throughout the confrontation in the White House, brought the meeting to an end by suggesting that he was "inclined to side with Secretary Marshall" and that they should "sleep on it."[76]

At his scheduled press conference the following day, 13 May, Truman did not make the statement Niles and Clifford had wanted. It was later to emerge that he had been impressed by a memorandum from the

State Department's Legal Adviser, Ernest M. Gross. This memorandum confirmed the view Lovett had represented at the showdown meeting— that premature recognition of the Jewish state would be "wrongful in international law"; and that even recognition immediately after Israel came into being "could not meet the State Department's standard requirements for recognition."[77]

After the White House showdown meeting, Lovett had instructed Gross to send the memorandum to Clifford; and Clifford had had no choice but to show it to the President or brief him on it.

The Gross memorandum laid out "the deciding criteria which have in the past been employed in granting or withholding recognition". There were three:

> (a) de facto control of the territory and machinery of the state, including the maintenance of public order;
> (b) the ability and willingness of a government to discharge its international obligations; and
> (c) general acquiescence of the people of the country to the government in power.

It was natural, the memorandum added, that after the creation of a new state, some time would be required to ascertain whether the criteria were being met by the government in power. But there was one consideration above all others. "*A prerequisite for all criteria is receipt of the request for recognition from the government itself.*"

In principle there was no way President Truman could recognise the new Jewish state (if that was to be his decision) unless and until it was in existence and its government had submitted a request for recognition. But that was not the way it happened.

In principle there was no way President Truman could recognise the new Jewish state (if that was to be his decision) unless and until it was in existence and its government had submitted a request for recognition. But that was not the way it happened.

When President Truman did not announce on 13 May that he was intending to recognise the Jewish state, he received another letter from Weizmann.

For several days previously, and as he noted in his diary, Weizmann had been strengthening contacts "with our friends in Washington."[78] The friends were Niles and Clifford; and it was Niles who told Weizmann there was a tactical need for another powerful letter from him to the President. *By this time, it must have been more than obvious to Niles, the President was being torn apart by his desire to work for "the best interests of the whole nation" (Truman's own words) and the necessities of domestic politics—the need to appease the Zionist lobby in order not to lose Jewish campaign funds and votes.*

My guess is that Niles, witnessing Truman's agony, was concerned that the President might not feel able to recognise a Jewish state that came into being on the basis of a unilateral declaration of independence.

I can imagine Niles asking himself: "Are we really about to win (the struggle to determine who would have most influence on Truman) or, finally, will the President be swayed by the argument that the creation of a Jewish state in the face of total Arab opposition is not in America's best interests?" Niles was realistic enough to know that, in normal circumstances, the idea of the President of the United States of America going against the consistent advice of his Departments of State and Defence, and the intelligence community, was preposterous. That was on the one hand. On the other hand, the fact was that the circumstances were not normal because of the Nazi holocaust and leverage it had given the Zionists to influence Truman during the End Game, through Weizmann especially. Praise the Lord for Eddie Jacobson.

In normal circumstances, the idea of the President of the United States of America going against the consistent advice of his Departments of State and Defence, and the intelligence community, was preposterous.

So I can also imagine Niles thinking to himself that another letter from Weizmann was needed at this most critical of moments to tip the balance of the President's mind in Zionism's favour.

Weizmann's letter was a passionate plea for the U.S. to "promptly recognise the Provisional Government of the new Jewish state."[79]

There is nothing in the known record of events to suggest that Truman had made up his mind to recognise the Jewish state (when it came into existence) before his receipt of Weizmann's letter of 13 May. It would seem that the President made his decision in the late evening of that day or the early morning of the next.

My own interpretation is that the Weizmann letter and all it represented emotionally did tip the balance of President Truman's mind. And I think that was as good as confirmed nearly 20 years later (in June of 1965), when former President Truman sent a message to the B'nai B'rith Convention in Tel Aviv. "It is a fact of history", the message said, "that Eddie Jacobson's contribution was of decisive importance."[80] One possible inference was that if Eddie had not persuaded Harry to open his door to Weizmann, the President's final decision might have been a different one. Put another way, Weizmann's influence on Truman—actually on his emotions—was far greater than even the Zionists themselves, with one exception, could have believed. The exception was Niles. He knew that the elderly and sick Weizmann was his trump card and he knew when and how to play it to best advantage.

It was, however, Clifford who masterminded what can be called the *Recognition Sting*.

Precisely what happened and why in Washington on 14 May 1948 remains something of a mystery to this day.

At about 11.30 in the morning Clifford communicated with Eliahu Epstein. He was the representative in Washington of the Jewish Agency and, as Eliahu Elath, would shortly become the first Israeli Ambassador to the U.S. According to John Snetsinger's account in *Truman, The Jewish Vote and the Creation of Israel*, Clifford's communication with Epstein was by telephone. But according to George Elsey, Clifford's assistant, Epstein met with Clifford in the White House.

Clifford informed Epstein that the U.S. was prepared to recognise the Jewish state upon the declaration of its independence but... *The U.S. move would have to be in response to a formal request for recognition from the government of the new state, and the request was wanted that afternoon!*

Initially, Epstein might have wondered if Clifford had taken leave of his senses. Technically the new Jewish state could not come into existence before midnight in Palestine, 6.00 p.m. Washington time (i.e. when the British Mandate formally expired). A provisional government that could not be in existence before then could not submit a formal request for recognition that afternoon! Epstein knew, of course, that Ben-Gurion was intending to make the unilateral declaration of independence at 4.00 p.m. Palestine time, before the start of the Sabbath which would prevent orthodox members of the provisional government-in-waiting from travelling by car or even

The Recognition Sting: In the fabricated letter of request delivered to Clifford at the White House, Epstein said he had been authorised by the (non-existent) provisional government of the (non-existent) Jewish state "to express the hope that your government will welcome the Jewish state into the community of nations."

affixing their signature to a proclamation of independence; but that did not change the technical reality—a unilaterally declared Jewish state would not make a request for recognition until midnight in Palestine, 6.00 p.m. Washington time.

The two men then agreed that Epstein would take responsibility for fabricating a formal request for recognition—i.e. on behalf of a government that did not exist of a state that did not exist.

In the fabricated letter of request delivered to Clifford at the White House, Epstein said he had been authorised by the (non-existent) provisional government of the (non-existent) Jewish state "to express the hope that your government will welcome the Jewish state into the community of nations."

At Clifford's request, in order to improve the prospects of Truman going against the advice of Marshall and Lovett supported by the Gross memorandum, Epstein took upon himself the responsibility for declaring that Israel would accept the boundaries as defined by the partition resolution. (He also knew, of course, that Ben-Gurion had no such intention).

Question: *Why was it necessary to fabricate a request for recognition?* Put another way: Why was it that Clifford (and President Truman?) could not wait for the real thing to come from the provisional government of the Jewish state?

There is only one plausible answer.

The idea to fabricate the letter of request for recognition was born in Clifford's mind. His logic? The instant the Jewish state came into existence (making the proceedings of the General Assembly an irrelevance), Truman would come under the most intense pressure ever to recognise it. If he had then to say he was waiting for a formal request for recognition, his position could easily be misrepresented, all the more so if for any reason the provisional government took time to get its act together or the request for recognition was delayed for whatever reason, including war. In this scenario Clifford feared the cry would go up that President Truman was reluctant to recognise the Jewish state. That would seriously damage his re-election campaign and the prospects of many other Democrats running for office. But with the fabricated letter of request the President would have scope enough, for the sake of appearances, to recognise the Jewish state within minutes of its coming into being. At a stroke that would remove Zionism's threat to the President and his party. There would have been a worst-case scenario in Clifford's mind. If U.S. recognition was delayed for any reason, it might never be given.

The probability is that Clifford was acting entirely on his own initiative to serve what he regarded as his President's best interest. Getting re-elected. But it may well have been that Truman had expressed to Clifford his private fear that, if he did not recognise the Jewish state within moments of its birth, he would be crucified.

The charitable assumption is that Clifford did not ask the President to authorise or in any way approve the fabrication strategy, and that the fabricated letter was not placed before Truman until moments after midnight Palestine time. In other words, Truman assumed it was an actual request from the actual provisional government of Israel.

But would Clifford have taken such an initiative without at least a nod and a wink from the President? If Truman did have advance knowledge of the fabrication strategy, it would have to be said that he was, out of desperation, a party to a conspiracy.

There is no certainty about when others in the Truman administration at Executive level—most notably Secretary of State Marshall—were informed of the President's decision to give instant recognition to the Jewish state. Early in the afternoon, when Epstein was completing his work on the fabricated letter of request, Clifford was still indicating that the President had not made up his mind.

After lunch at the F Street Club, Clifford had a conversation with Lovett whom he, Clifford, regarded as the enemy.

According to Lovett's memorandum of the conversation, Clifford said, "The President is under unbearable pressure to recognise the Jewish state promptly." Then he asked Lovett to "draft appropriate language to put into effect recognition in the event that the President decided upon it."[81]

Lovett cautioned against "indecent haste" and said they ought to wait until they had confirmation of the details of the Jewish state's

proclamation of independence.[82] He was also concerned that there should be proper notification of America's intentions to other governments—the British and French governments in particular, and to Ambassador Austin at the UN. (As Clifford and Lovett were speaking the General Assembly was still in session at the request of the U.S., and Austin and his team were still doing their best to secure support for the American proposal that Palestine should become a UN trusteeship.) Clifford brushed aside Lovett's caution and concern with the comment that the President could not afford "to have any such action leak."[83]

Clifford did not tell Lovett the truth about the President's intentions because he feared the Undersecretary of State might prevail upon Marshall to prevail upon Truman to at least delay recognition of the Jewish state. In fact Clifford's fears on that account were unfounded. Like all of his predecessors as Secretary of State, and in common cause with Forrestal, Marshall had not favoured the creation of a Jewish state in the face of total Arab opposition; but once the President had made his decision to give immediate recognition to the new state, that would be that. Apart from the fact that he was unswervingly loyal to President Truman, Marshall had a healthy respect for the Presidential prerogative, according to the Constitution, to make foreign policy decisions. In other words, Marshall accepted that any president was free to make mistakes. That this one might have catastrophic consequences for Arabs and Jews, for the American and wider Western interest and perhaps ultimately humankind, was not the issue. There was nothing anybody could do about it once the President had made up his mind.

At 5.40 p.m. Washington time, twenty minutes before midnight in Palestine, Lovett was informed (presumably by Marshall) that the recognition announcement was going to be made shortly after 6.00 p.m., and that he should now notify Ambassador Austin at the UN.

Lovett's memorandum for the record, secret for many years, included this: "My protests against the precipitate action and warnings as to consequences with the Arab world appear to have been outweighed by considerations unknown to me. [He knew well what the considerations were but did not believe it was his place to talk about them in an official memorandum for the record that would one day be made public.] I can only conclude that *the President's political advisers, having failed last Wednesday afternoon to make the President the father of the new state, have determined at least to make him the midwife.*"[84] (Emphasis added).

At 6.00 p.m. Washington time, the British Mandate for Palestine expired and Israel's unilateral declaration of independence became effective. At 6.11 p.m the U.S. accorded the new state de facto recognition—in response to Epstein's fabricated request.

At 6.00 p.m. Washington time, the British Mandate for Palestine expired and Israel's unilateral declaration of independence became effective. And at 6.11 p.m the U.S. accorded the new state de facto

recognition—in response to Epstein's fabricated request. The Washington announcement could not have been more low-key. Charles Ross, the presidential press secretary, read a two-paragraph statement to reporters. The message Ben-Gurion received, sent on its way by Lovett, was "The American Government recognizes the Provisional Government of the State of Israel as the *de facto* authority in the new State." (Because of the Gross memorandum, Truman did not give Israel *de jure* recognition until its provisional government was replaced by an elected one, on 31 January 1949).

And so the deed was done. Whatever else happened, Truman could now be certain that he would be re-elected for a second term and that his Democrats would not take a hammering at the polls.

For Ambassador Austin (and all of his team at the UN) it was a public humiliation the like of which no American diplomat had experienced before or has experienced since. Austin himself was so disgusted that he shut himself up in his Waldorf Astoria Towers apartment; and the statement of recognition was read to the General Assembly by a junior member of his mission, with the text of the announcement quoted from a news agency report. Many years later the declassified documentation revealed that Marshall had despatched Rusk to the UN "to prevent the US delegation from resigning en masse."[85]

On the floor of the General Assembly delegates were stunned by this latest and abrupt reversal of American policy. Here they were, at the request of the U.S., still debating UN trusteeship for Palestine (and the internationalisation of Jerusalem) because partition was unjust and unworkable, and bound to be the cause of catastrophe. Now, unilaterally, the U.S. was sanctioning partition. One delegate asked George Barrett of *The New York Times* if he knew exactly what the U.S. position was. Barrett reported himself as replying, "I don't know because I haven't seen an announcement for 20 minutes."[86]

Cuba's Ambassador, Guillermo Belt, had to be restrained from going to the podium to announce his country's withdrawal from the UN. In principle probably none of the major powers would have been too concerned if Cuba had withdrawn from the world body. But if Belt had walked out, and if other delegates had followed him, the very existence of the UN might have been called into question.

The damage that was done to U.S. standing at the UN, and from which it has not yet recovered, was of concern to some thoughtful Americans. Among them was FDR's wife, Eleanor Roosevelt. Unlike her husband she was, or rather became, a supporter of the Zionist cause and had favoured recognising the Jewish State; but she was also a champion of the UN. On 16 May she wrote to Marshall complaining about the way the Truman administration had handled the recognition problem because it had "created consternation in the United Nations."[87] Marshall's reply two days later included this (my emphasis added): "We were aware of the unfortunate effect on our situation at the UN, which is much to be regretted. *More than this I am not free to say.*"[88]

The idea of Palestine as a UN trusteeship was not merely abandoned in haste, it was dead and quickly buried without ceremony.

Before it ended on that most dramatic day, the Special Session of the General Assembly approved a resolution appointing a Mediator "to promote a peaceful adjustment of the future of Palestine." (As we shall see, he was prevented from doing his job by an assassin's bullets).

The recriminations became a matter of public record. In 1961, in *A Prime Minister Remembers*, Clement Attlee, then an Earl in the House of Lords, wrote that "U.S. policy in Palestine was moulded by the Jewish vote and by party contributions of several big Jewish firms."[89]

Truman responded: "The British were highly successful in muddling the situation as completely as it could possibly be muddled."[90]

If Truman had said he would not have had to do what he did if Britain had not played the Zionist card in the first place, he would have had a point. A good point. And it was to be made in 1968 by Arnold Toynbee. Before he was recognised as one of the world's most eminent historians, Toynbee had dealt directly with the Palestine Mandate in the British Foreign Office. In 1968 he delivered this judgement (my emphasis added):

> All through those 30 years [from the Balfour Declaration to the moment Britain dumped the problem into the lap of the UN] Britain admitted into Palestine, year by year, a quota of Jewish immigrants that varied according to the strength of the respective pressures of the Arabs and the Jews at the time. These immigrants could not have come if they had not been shielded by a British *chevaux de frise* [literally translated "the closed ranks of mounted troops"]. If Palestine had remained under Ottoman Turkish rule, or if it had become an independent state... Jewish immigrants would never have been admitted into Palestine in large enough numbers to enable them to overwhelm the Palestinian Arabs in this Arab peoples' own country. *The reason why the state of Israel exists today and why 1,500,000 Palestinians are refugees is that, for 30 years, Jewish immigration was imposed on the Palestinian Arabs by British military power until the immigrants were sufficiently numerous and sufficiently well-armed to be able to fend for themselves with tanks and planes of their own. The tragedy of Palestine is not just a local one: it is a tragedy for the world, because it is an injustice that is a menace to the world's peace.*

It was also Toynbee in *A Study of History, Volume VIII* who offered the most graphic description of Truman's role and its consequences:

> The Missourian politician-philanthropist's eagerness to

combine expediency with charity by assisting the wronged and suffering Jews would appear to have been untempered by any sensitive awareness that he was thereby abetting the infliction of wrongs and sufferings on the Arabs; and his excursions into the stricken field of Palestine reminded a reader of the *Fioretti di San Francesco* [The Little Flowers of St. Francis of Assisi] of the tragic-comic exploit of the Juniper, who, according to the revealing tale, was so effectively moved by a report of the alimentary needs of an invalid that he rushed, knife in hand, into a wood full of unoffending pigs and straightaway cut off a live pig's trotter to provide his ailing human being with a dish that his soul desired, without noticing that he was leaving the mutilated animal writhing in agony and without pausing to reflect that his innocent victim was not either the invalid's property or his own.[91]

A year after his fateful decision, Truman was visited by the Chief Rabbi of Israel. According to what the President himself told Miller on tape, the Rabbi said: "God put you into your mother's womb so that you could be the instrument to bring about the rebirth of Israel after two thousand years."[92] Then, apparently, great tears started to roll down Harry Truman's cheeks.

The Chief Rabbi's words were undoubtedly a source of great comfort for President Truman; but he may not have been so comforted by the words of another distinguished visitor from Israel.

On his last visit to America as Israel's Prime Minister, Ben-Gurion was reported to have said the following to Truman: "You have a secure place in the history of Israel, but I do not know how you will stand in American history"[93] One possible implication is that Ben-Gurion was thinking but not saying something like: "Your place in your own country's history might not be so secure if why you did what you did becomes a matter of public knowledge."

Lilienthal was to make an observation with which I agree. "It is to the credit of the Zionists' acumen that they grasped their chance. But it is perhaps less to the credit of America's non-Zionist Jewry that it permitted its self-appointed Zionist leaders to bet the future of American Judaism on the roulette of power politics."[94]

But I go further than Lilienthal. *What I think was bet on the roulette of power politics was not just the future of American Judaism but Judaism in its entirety.*

It was, in fact, President Truman himself who committed to paper the most honest statement of why events unfolded as they did. In a memorandum to Niles he said: "We could have solved this Palestine thing if U.S. politics had been kept out of it."[95]

That memorandum, written on 13 May 1947, went on: "Terror and (Rabbi) Silver are the contributing causes of some, if not all, of our troubles."

The terrorism to which Truman was referring was, as we have seen, Zionist terrorism.

Rabbi Silver's single greatest contribution to the catastrophe-in-the-making was the inspiration and direction he gave to American Zionism's campaign to kill Truman's visa initiative which, if the legislation the President needed had been forthcoming, would have allowed all or virtually all of Europe's uprooted and displaced Jews to start a new life in America. Which was the option most of them would have taken if they had been given the choice. At the end of his account of President Truman's role in the creation of the Arab-Israel conflict, Lilienthal offered this thought: "In ignoring the advice of three of his Secretaries of State and of Secretary of Defence James Forrestal, Truman may have written U.S. foreign policy's 'American Tragedy.'"[96]

When Lilienthal first put those words into print (1978), I would have agreed with him. But after the events of 11 September 2001 and all they symbolised, I would replace "Truman may have written" with "Truman wrote."

There remains a most intriguing question, one that is still not asked in politically correct circles. It is provoked by Marshall's comment to Eleanor Roosevelt—"More than this I am not free to say."

What was it that Marshall was not free to say to her or even hint at in confidence?

I cannot see that he would have had any difficulty saying: "It's politics, Jewish campaign funds and Jewish votes. We may not like it, but that is the way it is."

In my view, it is not unreasonable to speculate that Ben-Gurion had Truman informed that if the U.S. did not recognise the Jewish state as soon as it came into existence, the Soviet Union would, and Israel would then look to it, not the U.S., as its superpower friend and ally. In short, I think it possible that Ben-Gurion played, or had played for him, the ultimate blackmail card. In that light, Clifford's remark at the showdown meeting about "stealing a march on the U.S.S.R." would not be quite the throw-away line it can appear to be.

And if that was the threat Ben-Gurion made or had made for him, I can imagine Truman asking Marshall a question something like this: "Is he (Ben-Gurion) bluffing or would the son of a bitch actually do it—throw in his lot with the Soviets?" And I think Marshall's answer would have been something like: "We had better proceed on the assumption that he's not bluffing."

If Ben-Gurion did play or had played for him the ultimate blackmail card—the threat that the Jewish state would look to the Soviet Union as its friend and superpower ally, it may well have been that, in the last hours of the long struggle to determine who would make U.S. policy for Palestine, Truman and Marshall were not on opposite sides. I mean it is possible in the last hours that Marshall said to Truman something like this: "The absolute priority is preventing the Zionist state from throwing its lot in with the Soviet Union. If that means the U.S. must be the first to recognise a unilaterally

declared Jewish state, do it."

The saddest truth of all is that there was one great and good man of principle who worked to have the Palestine problem taken out U.S. domestic politics before it was too late for all concerned. That man was James Forrestal, the first U.S. Secretary of Defence.

The understanding this book seeks to promote would not be complete without some knowledge of Forrestal's efforts to persuade both the Democrats and the Republicans at leadership level to take the Palestine problem out of U.S. domestic politics. Out of the pork-barrel that impaired and corrupted the judgement all who dipped into it.

My decision to put the Forrestal story into a chapter of its own means that, to some extent, we will be going over the same ground covered in this chapter, but from an insider's uniquely informed perspective and thus with remarkable and, I think, chilling insight into the way American politics worked and still works.

As we shall now see, Forrestal was not allowed to succeed. Whether his despair at his failure, together with the harassment he endured at the hands of the Zionists for having tried, contributed to the depression that led him to suicide is a fair question. It also has to be said that further questions have been raised as to whether his death was suicide. These are questions with only speculative answers, but that is not a good enough reason for not addressing them, especially in the light of the events of 11 September 2001 and all they symbolised as blowback from years of pro-Zionist American policy in the Middle East.

12

FORRESTAL'S "SUICIDE"

In the unexpurgated story of the making of the Arab–Israeli conflict the significance of James Vincent Forrestal can be summarised in two short statements.

One: He was the man with executive responsibility in the Truman administration who dared to draw the line in the proverbial sand and say that the best interests of America, the Free World and Jews everywhere dictated that Zionism should not be allowed to determine U.S. policy for the Middle East.

Forrestal was the man with executive responsibility in the Truman administration who dared to draw the line in the proverbial sand and say that the best interests of America, the Free World and Jews everywhere dictated that Zionism should not be allowed to determine U.S. policy for the Middle East.

Two: If there was one man above all others most likely to succeed in getting the Palestine problem lifted out of the pork-barrel of partisan American domestic politics, that one man was Forrestal.

We know from his diaries that he had President Truman's green light for his initiative to try to do so. (An important fact to keep in mind).

Because they contain the most incontrovertible evidence that there was a very serious attempt to take the Palestine problem out of U.S. domestic politics, some brief background on the diaries as published after Forrestal's death is necessary.

Their editor in book form was Walter Millis. After Forrestal's suicide *The New York Herald Tribune* acquired the rights to publication from his estate. That newspaper then appointed Millis, its assistant chief editorial writer, to turn the material into a book which was published under the title *The Forrestal Diaries*. In the Preface to it Millis wrote:

> On leaving office Forrestal, already seriously ill, went for recuperation to Hobe Sound, Florida. From there he sent instructions that the diary, together with a few detached

documents, should be deposited at the White House. This was an unusual request. One can only infer that it reflected his awareness of the confidential nature of much of this material and his desire to insure it, under any eventualities, against irresponsible publication.

Even casual examination of the diary notes makes it evident that they were not dictated with textual publication in mind. They were probably set down, among other reasons, as material for the book which Forrestal at one time or another thought of writing, in which he would exercise his own judgement as to inclusions, omissions or explanations. He was not to enjoy this opportunity. By sending the papers to the White House he left them safeguarded in responsible hands: he had scrupulously discharged his own obligation to prevent improper or careless disclosure.[1]

The diaries were nothing less than an insider's summary account of the agony of decision-making at the time the United States, in part because of the unravelling of the British Empire, was coming face-to-face with the awesome responsibilities of being the leader of what was called the Free World. Many of the entries were made immediately after Forrestal returned from meetings of the Cabinet, various committees of his Defence Department and the National Security Council.

Millis also noted that Forrestal's diaries recorded "many confidential statements given in haste or without thought of the possible public effect." That the statements Forrestal quotes, including his own, are of the un-spun kind is one of the reasons why his diaries, even in their edited form for publication, are of such value to seekers of the truth.[2]

As the first U.S. Secretary of Defense, Forrestal's main professional concern was Soviet power given the vacuum left in Europe and the Far East by the defeat of Germany and Japan and uncertainty about Moscow's intentions.

As a leading and very successful investment banker he understood: (1) that the U.S. would have to generate the wealth to fund the Marshall Plan for the reconstruction of war-devastated Western Europe; and (2) that in the wealth creation process to put capitalism back on its feet in Western Europe and Britain, the uninterrupted and escalating flow of Arab oil at the cheapest possible price was the most critical factor. And that in a word, OIL, was the prime source of Forrestal's interest as Secretary of Defence in the Palestine problem and how it should be handled by the administration he served.

The buck ultimately stopped with President Truman but the executive responsibility for keeping Arab oil flowing, in the context of seeing to it that the U.S. could protect its own interests and had the capability of keeping the Free World free, was Forrestal's, in association with Marshall and Lovett at the State Department.

And that was the context in which Forrestal (and Marshall and Lovett) regarded the creation of a Jewish state in the face of Arab and wider Muslim opposition as a threat to the U.S. national interest and, in the even bigger picture, America's ability to perform in accordance with its global responsibilities and obligations.

That Forrestal's strategic view was shared by Marshall, the other leading American public servant of the time with unquestionable integrity, made it all the more remarkable that, when the crunch came, President Truman chose to surrender to Zionism, with consequences that are still with us today and are becoming more and more menacing.

As it happened Forrestal was not President Truman's first choice as America's first Secretary of Defense. (In the summer of 1947 America's separate armed services were to be reorganised and coordinated, hence the new Cabinet post of Secretary of Defense). The President's first choice had been Judge Robert Patterson, the Secretary of War in the old system. But, as the President told Forrestal when he offered him the job, Bob Patterson "wouldn't take it."[3] He was, the President said, "so hard put to it for money that he felt he was unable to stay longer in government." Forrestal, on the other hand, was wealthy by his own efforts.

It was on 26 July 1947 that President Truman invited Forrestal, then Secretary of the Navy, to take on the burden Judge Patterson could not afford to carry. That was five weeks before the General Assembly's Special Committee (UNSCOP) came forward with the majority recommendation for the partition of Palestine.

On that July day President Truman had time to kill. He was waiting for the bill from Congress, approved and expected at any moment, that authorised the reorganisation and coordination of the military; and he was anxious to get away to be with his dying mother. So the two men made big small talk. Forrestal asked: "How do you account for Hitler's decision to make war in 1939 when he actually had in his hands all the cards necessary to dominate Europe?"

Truman answered: "The man simply became drunk with power. He made two great mistakes. One was the decision to attack Poland. The other was the failure to invade England after the fall of France."

The fact that Forrestal was not Truman's first choice as the first U.S. Secretary of Defence was in no way a reflection on his experience and his formidable abilities and qualities. In public service and before that private enterprise, his record of achievement to this point was most impressive, even by the standards of America's best and brightest.

To understand why Secretary of Defence Forrestal was the one most likely to succeed in getting the Palestine problem taken out of U.S. domestic politics, we must know the man and where he was coming from.

Of Irish descent, James Vincent Forrestal was born in 1892 in what was then Matteawan and became a part of Beacon, a Hudson River town, in the state of New York. That made him 55 when his appointment as the first U.S. Secretary of Defence was confirmed by Congress.

Forrestal's father, also James, had come from Ireland as a boy in the 1850s. Just nine years old he had crossed the ocean alone to join his mother who had emigrated earlier to prepare a place of survival. This James the first took up carpentry and by 1875 had established what was to grow into a substantial contracting and construction business. He married Mary Toohey and James Vincent was the first of their three sons.

James the elder became very active in local Democratic Party politics and was cultivated by Franklin Roosevelt when he was running for the Senate. The Roosevelts and the Forrestals became good friends.

But party politics were not for "Vince" Forrestal as he was then called. When he graduated from Matteawan High School in 1908 at the age of 16, his ambition was to make himself a career in newspaper journalism. Three years of local journalism taught him that he needed a college education if he was to advance in his career. He entered Dartmouth and then transferred to Princeton. In his senior year there he was voted by his class as the one "most likely to succeed". And he was to be remembered for his generosity in giving unpublicised financial help to students in need.

It was at Princeton that Forrestal declared himself to be "without political affiliation."

Forrestal was not excited by academic study and went to work for the Tobacco Products Corporation, selling cigarettes. In 1916, at the age of 24, he joined the investment banking house of William A. Read & Co., which became Dillon, Read & Co. And then there was no stopping him. He quickly established himself as one of the most able men on Wall Street and his rise to the top was inexorable: 1923—partner in the firm; 1926—vice president; 1938—president.

By those who worked with him and for him at Dillon, Read & Co., Forrestal was to be remembered not only for his success but also his energy and his scrupulous fairness, in particular his refusal to take credit that belonged to his subordinates. (At Princeton he was described by his friends as a *rara avis*—a rare bird. His friends were right).

In 1938, as president of Dillon, Read & Co., Forrestal had wealth, the power that came with it, and position. What more could a 46-year-old man want? A seat in the Senate and after that, perhaps, a run for the presidency? No thanks. Party politics was not for Forrestal. It was a game he could have played and funded without having to put himself in hock to any vested interest, but playing it would have required him to sacrifice too many of his principles on the altar of political expediency.

In June 1940, with World War II underway and America again neutral, many on Wall Street were stunned by the news that Forrestal had resigned from Dillon, Read & Co. in order to enter Roosevelt's New Deal administration and serve as a special administrative assistant to the President.

The astonishment in the financial community was due in large part to the fact that many of its leading lights had been hostile to President Roosevelt's New Deal programme. New Deal was the phrase coined to

describe President Roosevelt's policies and legislation to rescue America from the great depression. Essentially it was a programme of action by the Federal government to reduce unemployment, to equalize wealth and opportunity, to control banking and credit, and to protect small-scale industry, agriculture and labour against the measures thought necessary by large-scale business and banking for survival in a time of little economic activity. At a point the Supreme Court had ruled that many of the measures were unconstitutional. The financial community had perceived them to be not in its interest and the President to be something of an anti-capitalist. In that context Forrestal's decision to serve in the administration of the New Deal President was a great shock.

By inviting one of the financial community's most successful sons to serve in his administration, Roosevelt was demonstrating his skill as a politician *par excellence*.

In May 1940, fully aware that the popular mood in his country was opposed to America's participation in the war, Roosevelt knew it was only a matter of time before the U.S. would have to become involved: and he called for a major effort of rearmament and war production. (If he had not done so, Germany and Japan might well have been the victors of World War II). But like President Wilson before him in World War I, Roosevelt also knew that the necessary rearmament and war production effort would not succeed without the wholehearted co-operation of the large industrial and financial interests. In Roosevelt's case they were the interests which had been in conflict with his New Deal programme. It followed that to get their wholehearted co-operation Roosevelt needed to broaden the base of his administration, to have in it, at his side, people who could assist him to mobilise all the necessary financial and industrial resources for war.

Forrestal was an obvious candidate. He had never taken any part in politics but he was from a Democratic background: and he had taken a more liberal view than others in the financial community of the reforms which the New Deal had imposed on Wall Street. Could Forrestal be persuaded to put the national interest before self-interest and commit himself to a spell of public service?

As it happened, Forrestal did not have to be persuaded and events were to explain why. He was first and foremost a patriot in the best sense of the term. In public service he was to demonstrate a deep sense of duty which permitted no compromise for the sake of political manoeuvre or personal prestige with what he felt as an overriding obligation to the interests of the United States. And that was why, in a time to come, he would seek to have the Palestine problem taken out of U.S. domestic politics, in order to prevent Zionism becoming a threat to American interests in a region of the world as vital to them as the Middle East.

Forrestal was, in fact, one of six special administrative assistants appointed to serve President Roosevelt. They were known to insiders as the "secret six" and they were to serve, as Roosevelt himself put it, with complete loyalty and "a passion for anonymity."

As part of his effort to broaden the base of his administration, President Roosevelt also appointed two eminent Republicans to the Cabinet. One was Frank Knox who became Secretary of the Navy. Some weeks later Forrestal woke up to find himself undersecretary of the Navy and facing the most daunting challenge—preparing the peacetime Navy to meet the enormous demands of global war.

Forrestal was not a complete stranger to the military. When America entered World War I he took temporary leave of Dillon, Read & Co. and, then aged 25, enlisted as a seaman in the Navy. Quite quickly he transferred to the aviation branch, but because the training facilities were still in a rudimentary state, he was sent to Canada to train with the Royal Flying Corps. There he was passed as Naval Aviator Number 154, and then returned to the U.S. to receive his ensign's commission. But he did not see action. He was posted to the office of Naval Operations in Washington. There he may have learned something of Zionism's contribution to bringing America into World War I and the role played by Baruch, President Wilson's Mr. Mobilisation.

When Forrestal became undersecretary of the Navy on 22 August, his office was a completely new one. It was without staff, tradition and general acceptance by the Navy. Under Forrestal, and in large part because of his own very great abilities, it became the controlling centre of the whole industrial and procurement side of the Navy's vast wartime effort.

As Millis put it, there was, obviously, no one man who came anywhere near to "building" the wartime Navy. That was a gigantic co-operative achievement. But Forrestal was the one man more responsible than any other for "buying" it. He was "the major link connecting the military demand to the civilian productive system and, in turn, connecting the civilian economy to the military uses of its products."

Though Baruch did not serve in Roosevelt's administration, he played as an adviser to Roosevelt a very significant background role in the mobilisation for World War II; and almost certainly Forrestal would have benefited from Baruch's experience and advice. (As we shall see, Baruch's role in the determination of Forrestal's fate was the critical one).

Through it all Forrestal as perceived by others was grim-faced, tight-lipped and pugnacious. (He boxed to keep himself fit and had a flattened nose to show for it). He did not suffer fools gladly and was at times abrupt. But he was, apparently, a great deal more subtle and sensitive than many supposed. He was not any kind of dictator. He preferred to ask questions, to understand and adjust rather than rush to conclusions and issue orders. The secret, he once said, was in knowing that nine-tenths of administration lay in "the removal of human frictions." Forrestal proved himself to be the master of that art.

On 28 April 1944, Secretary Knox died suddenly of a heart attack. Nobody had to think about who his successor should be. Forrestal was sworn in as Secretary of the Navy on 19 May.

Despite his preoccupation with naval administration, Forrestal never

lost sight of its ultimate purpose or of the fighting men. He refused to be isolated from the action and at Iwo Jima he was the first Secretary of the Navy to land under fire in the midst of a still undecided amphibious operation.

It was at Iwo Jima that Forrestal spoke of his "tremendous admiration and reverence for the guy who walks up beaches and takes enemy positions with a rifle and grenades or his bare hands."[4] A politician (I mean a party political animal) might have been playing to the gallery. Forrestal, I imagine, was not.

When he succeeded Knox as Secretary of the Navy, Forrestal continued to say he was nothing more than an investment banker and that his Washington address was "temporary." The implication was that he was expecting to return to Wall Street when the reorganisation and unification of the armed services was approved by Congress in principle. But it was not only fate in the shape of Patterson's desire for a greater income than the government could provide that determined otherwise. As Millis noted, "High office and, what was more important to Forrestal, its high and heavy responsibilities to the American people, had claimed him."[5]

It was no less a figure than General (and future President) Eisenhower who said that Forrestal had "inborn honesty" as well as "a very great desire to serve his country well." Eisenhower served for a period as Forrestal's full-time principal military adviser, an experience that qualified him to speak with authority and insight about the quality of the first U.S. Secretary of Defence.

The greatest gift Forrestal brought to the Pentagon was his ability and will to think constantly ahead, to anticipate the circumstances in which future decisions would have to be made. Such a man was bound to be concerned to the point of alarm about where Zionism, if it was allowed to have its way, might take the Middle East and the U.S.

Forrestal's capacity for foresight would inevitably have made him concerned to the point of alarm about where Zionism, if it had its way, might take the Middle East and the United States.

When his appointment as America's first Secretary of Defence was announced he received many letters of congratulations from old friends. His reply to one included the following: "Thanks for your note and good wishes. I shall certainly need the latter—and probably the combined attention of Fulton Sheen and the entire psychiatric profession by the end of another year!"[6]

A premonition of how his life might end? Probably not. Most likely is that Forrestal was joking to make a point but, as we shall see, he was to need psychiatric help when despair turned to clinical depression.

In terms of the integrity needed for the task of taking the Palestine problem out of U.S. domestic politics, Forrestal was matched by Secretary of State Marshall; but as the man with the executive responsibility for preparing the U.S. to play the leading role in containing and if necessary fighting the Soviet Union, Forrestal had more influence than Marshall with the leaders

of both the Democratic and Republican parties. By influence I really mean that his position and responsibilities, his experience and his integrity were such that you had to be a complete fool, or a Zionist stooge, if you did not consider seriously what he said.

On 2 May 1947 Forrestal had lunch with Senator Owen Brewster, chairman of the Joint Congressional Aviation Policy Board. After it the Secretary of Defence made this diary note:

> I said that Middle East oil was going to be necessary for this country not merely in wartime but in peacetime, because if we are going to make the contribution that it seems we have to make to the rest of the world in manufactured goods [to put capitalism back on its feet] we shall probably need very greatly increased supplies of fuel. Brewster said that... Europe in the next ten years may shift from a coal to an oil economy, and therefore whoever sits on the valve of Middle East oil may control the destiny of Europe. He expressed considerable misgivings about the capacity of American forces to keep Russia out of Arabia if they decided to move there.[7]

At this moment in history, when Zionism was seeking to have U.S. policy for the Middle East committed to serving its interest no matter the consequences for all other parties with interests of their own, the fate of the nations of war-devastated Western Europe and virtually bankrupt Britain was in the balance. Without the massive American assistance they were to receive under the Marshall Aid Plan, reconstruction (dependent to a great extent on the continuing and escalating flow of cheap Arab oil) would be delayed and painfully slow. In that event there would be the danger of widespread discontent leading, probably, to civil unrest and the creation of an unstable economic, political and social situation that communism's strategists in Moscow, through their fellow travellers in Western Europe and Britain, could and would exploit. (If the worst had happened, and if the U.S. Departments of State and Defence had not advocated a policy designed to prevent it happening—a policy that included not surrendering to Zionism—Marshall and Forrestal would have been charged, rightly, with gross incompetence and the most massive dereliction of duty to the U.S. to the "Free World" of Western terminology).

At a cabinet meeting on 7 November, three weeks before the vote in the General Assembly on the partition plan, Marshall presented the State Department's review of the international situation.

Top of the list of U.S. concerns was the Soviet Union and its intentions. There was reason to believe, the State Department assessment said, that the advance of communism in Europe had been stemmed. The Soviets did not appear to want to risk confrontation there. But that could easily change if the Soviet economy turned down or Soviet leaders

perceived themselves to be in trouble politically. The Middle East? It, the State Department review said, was "a tinder box".[8] Marshall's view was that a fire started there might never be put out.

The State Department review said the Middle East was "a tinder box". Marshall's view was that a fire started there might never be put out. Forrestal repeatedly pointed out that a serious attempt to lift the Palestine problem out of American politics needed to be made, since no question was more charged with danger to United States security.

After that cabinet meeting Forrestal made the following note about one of his own contributions:

I repeated my suggestion, made several times previously, that a serious attempt be made to lift the Palestine problem out of American partisan politics. I said there had been general acceptance of the fact that domestic politics ceased at the Atlantic Ocean, and that no question was more charged with danger to our security than this particular one.[9]

Forrestal was, in fact, already proceeding with his campaign to take Palestine out of American partisan politics. The day before he had an unsatisfactory meeting on that subject with Rhode Island's Senator J. Howard McGrath—National Chairman of the Democratic Party and therefore the man whose support Forrestal most needed on the Democratic side of the fence.

It was not Forrestal's way to be anything less than straightforward. He said to McGrath: "No group in this country should be permitted to influence our policy to the point where it could endanger our national security."[10]

McGrath was not encouraging. His reply, Forrestal noted, was that there were "two or three pivotal states which could not be carried without the support of people who were deeply interested in the Palestine question."[11]

Forrestal retorted: "I would rather lose those states in a national election than run the risks that might develop in our handling of the Palestine question." [12]

The U.S. Secretary of Defence was depressed by McGrarh's position but decided to have another go at him. On 26 November, three days before the partition vote, they had lunch together. At the start of it Forrestal produced his own hors d'oeuvre in the shape of a secret report on Palestine prepared by the CIA. And he read parts of it to the senator.

But McGrath had a secret of his own to reveal. The fact was, he said, that "Jewish sources were responsible for a substantial part of the contributions to the Democratic National Committee."[13] Many of the contributions were made "with a distinct idea on the part of the givers that they will have an opportunity to express their views and have them seriously considered on such questions as the present Palestine question." And there

was more. There was a feeling among the Jews "that the United States was not doing what it should to solicit votes in the General Assembly in favour of the partition of Palestine."

Forrestal interrupted McGrath's flow to say that was "precisely what the State Department wants to avoid." The U.S., he added, had gone a very long way indeed in supporting partition but "proselytising for votes and support will add to the already serious alienation of Arab goodwill." (As we have seen, President Truman had given an instruction that nobody in his administration should express a preference for or against partition).

The Jews expected the United States to do its utmost to implement the partition decision if it was voted by the UN, through force if necessary.

McGrath continued as though Forrestal had not spoken. "Beyond this the Jews expect the United States to do its utmost to implement the partition decision if it is voted by the UN, through force if necessary."

Forrestal stuck to his line that if they were talking about lifting foreign affairs out of domestic politics, "there is nothing more important to lift out than Palestine." At the end of what must have been an uncomfortable and distressing learning experience for the Secretary of Defence, he almost begged Senator McGrath to give the matter "a lot of thought," because it involved "not merely the Arabs of the Middle East, but also might involve the whole Muslim world with its four hundred millions of people in Egypt, North Africa, India and Afghanistan." (The four hundred millions of then are today about 1.4 billion and rising; a quarter of humankind).

McGrath said he would read carefully the CIA report and come back to Forrestal.

Before he tackled the Republican leadership, Forrestal talked strategy with Jimmy Byrnes who, disillusioned, had resigned as Secretary of State in January to be replaced, eventually, by Marshall. Over lunch on 3 December, four days after the General Assembly's rigged vote on partition, Forrestal asked Byrnes what he thought about the possibility of getting Republican leaders to agree with the Democrats to have the Palestine problem taken out of party politics.

Byrnes was "not particularly optimistic" for two reasons.[14] One was the success Rabbi Silver was having in persuading the Republicans that the Zionist card could be of use to them, too. The other was the sabotaging influence behind the scenes of Niles in the White House. Byrnes said it was Niles who had been chiefly responsible for persuading Truman to reject the Morrison-Grady Plan; a decision, Byrnes told Forrestal, that had placed Attlee and Bevin "in a most difficult position."[15] Niles had told Truman that if he supported the Morrison-Grady Plan, the Republicans would come out with a statement favouring the Zionist position on Palestine.

It was after that lunch that Forrestal made the diary entry I quoted in the previous chapter and which bears repeating. "I said I thought it was a most disastrous and regrettable fact that the foreign policy of this country

was determined by the contributions a particular block of special interests might make to the party funds."

A week later Forrestal made his first attempt to get Republican support for his campaign to take Palestine out of party politics. On 10 December he talked with Senator Arthur Vandenberg. This very influential Republican said that he himself had tried to "keep aloof" from the matter but there was, he told Forrestal, one obvious difficulty. "There is a feeling among most Republicans that the Democrat Party has used the Palestine question politically and the Republicans feel they are entitled to make similar use of the issue."[16]

At the Gridiron Dinner three days later Forrestal had the opportunity to engage with New York's Governor Dewey, the Republican presidential candidate. Forrestal told the Governor that "the need to take the Palestine problem out of party politics is a matter of deepest concern to me as Secretary of Defence in terms of the security of the nation."[17]

Dewey said he agreed with Forrestal in principle but that it would be difficult to get results for two reasons. The first was "the intemperate attitude of the Jewish people who have taken Palestine as the emotional symbol." The second was that the Democratic Party "will not be willing to relinquish the advantages of the Jewish vote."

It was also the case, Dewey said, that he had become "very cynical about entering into gentlemen's agreements" because of his experience of the 1944 election campaign. He had had a very clear agreement with Roosevelt not to raise the question of the use of force by the United Nations. (Roosevelt had feared that public opinion would be against U.S. membership of the new world body if Americans were expected to fight and die for it.) But late in the election campaign, when President Roosevelt believed he could play the UN card to his advantage, he had broken his word to Dewey and raised the question of the use of force by the world body.

Forrestal, a good listener, replied that he was well aware of the past actions and attitudes, political and otherwise, which would make a non-partisan approach to the Palestine problem difficult to achieve. And then he said: "I consider that I would be derelict in my duty if I did not try." He added that although he was not authorised to speak for President Truman "beyond the fact that he agreed to let me present my view of the matter to Republican leaders", he was certain that Truman would honour any agreement he might make with Dewey.

Vandenberg had sat next to Dewey at the dinner and after it Forrestal asked him if the Governor's attitude had been at all responsive. Vandenberg replied, "Responsive but sceptical."

Forrestal's account of his conversations that evening included a contribution of great insight from Senator Vandenberg.

Dewey had said he thought the U.S. was "already committed to an unfortunate course" in Palestine, and he had asked Forrestal "what can we do now?" The Defence Secretary had replied that as things were, two things would inevitably be coming up—a Zionist demand that the U.S.

arm the Jews to fight the Arabs, and a Zionist demand for unilateral action by the U.S. to impose the partition plan by force if necessary. At this point Vandenberg had interjected to say with passion that he was "completely and unequivocally" against such action because, in his opinion, "it would breed a wave of violent anti-Semitism in this country."

By inference Vandenberg was saying he was aware of how fickle American public opinion was. At the time they were speaking, and because of the Nazi holocaust and Zionism's brilliant exploitation of it, probably the majority of all Americans were emotionally in favour of the creation of an independent Jewish state; but the mood could change, Vandenberg was implying, with terrifying consequences for Jews in the U.S., if Americans had to fight and die for the Zionist cause.

The support of the American people could change, Vandenberg was implying, with terrifying consequences for Jews in the U.S., if Americans had to fight and die for the Zionist cause.

As 1947 was drawing to its close and he was waiting for a response from the party politicians to his Palestine initiative, Forrestal was pre-occupied with the awesome challenge of defining how the U.S. could best provide the leadership that was required to prevent the spread of Soviet communism to the "Free World" of western terminology. It was a monumental task that required everything he had to give in terms of energy, intellect, vision and the political skills to sell to the military and Congress whatever policy proposition he came up with. And the proposition he had come up with was not to the military's liking. It offended many of those who were part and parcel of the Military Industrial Complex or MIC for short—the name subsequently given by President Eisenhower, as we shall see later in these pages, to the most powerful of all the vested interests.

In Forrestal's view, expressed in a letter to Chan Gurney, chairman of the Senate Armed Services Committee, what happened in war-devastated Europe would be the key to national and global stability and security. In the face of the Soviet Union's military might and uncertainty about Soviet intentions, world stability would not be restored until the vacuum created by the destruction of German power and the weakening of the power of Western Europe as a whole had been filled. Forrestal had the vision to see, and the courage to say, that mighty though the U.S. was, it could not do three things simultaneously—"finance European economic recovery, European rearmament and a defence of Europe by American forces."[18] So?

Forrestal's policy required the U.S. to spend less on the military in order to have more to spend on financing Europe's economic recovery. In short, the name of the investment banker's game was preventing the spread of communism not by the deployment of troops in great strength (which would require mobilisation and might provoke the Russians), but by assisting ruined Western Europe to become prosperous again. The logic was sound. Free and prosperous peoples would see no virtue in Communism and, in time, would contribute progressively more to their own defence.

Forrestal knew that he was requiring the U.S. to take a "calculated security risk", but he justified taking it with these words: "As long as we can out-produce the world, can control the sea and can strike inland with the atomic bomb, we can assume certain risks otherwise unacceptable in an effort to restore world trade, to restore the balance of power—military power—and to eliminate some of the conditions which breed war."[19]

Unfortunately dramatic events were to be set in motion by the Russians which caused the calculations on which Forrestal's strategy was based to be revised. The first dramatic event was (as I noted in the previous chapter) the Communist seizure of power in Czechoslovakia on 24 February, just three days after Marshall sent his "URGENT AND SECRET" cable to President Truman saying that if it was not possible to implement the General Assembly's recommendation for the partition of Palestine, there would have to be a reversal of U.S. policy—by implication no matter how much that would offend the Zionists. The second dramatic event on 31 March, the day after Ambassador Austin introduced the American resolution for Palestine to become a UN trusteeship, with Jerusalem an international city, was the beginning of the Soviet blockade of Berlin.

Those events were to require Forrestal to become immersed in crisis management without, he hoped, compromising his strategic vision too much. He had to go for a bigger military budget; and he had to prevent the Defence Department being torn apart by inter-service rivalries and disputes over which of the services and which of their requirements should have priority. The very last thing he needed was to have to be concerned with Palestine and Zionism's outrageous demands.

But even without the demonstrations of hostile intent by the Russians, there was a downside to spending less on the military in order to spend more on the reconstruction and development of Western Europe, in order to assist it to become an anti-Communist bastion. The U.S. would not have the military manpower capacity for emergencies outside Europe. Reality check. There was simply no way that the U.S.—unilaterally or under a UN umbrella—could provide more than a token number of troops to impose the partition plan or to enforce the preferred policy option of UN trusteeship. Conclusion? The Palestine problem just HAD to be solved by diplomatic and political means. Lifting it out of American domestic politics, in order to prevent Zionism calling the policy shots, in order for there to be at least the prospect of a solution in the real interests of all concerned, was now more vital than ever; and becoming more urgent because the end of the British mandate was fast approaching.

Telling the Zionists "No" was politically possible only within the framework of a non-partisan approach to the Palestine problem.

Put another way: If the U.S. was not to risk losing the goodwill of the Arab and wider Muslim world and all that implied in terms of oil, strategic anti-Communist defence alliances and trade in general, the Zionists would have to be told "No" to an independent Jewish state. Telling them was politically possible only within the framework of a

non-partisan approach to the Palestine problem.

The Zionists would say they had been betrayed but that would not be the truth. A solution "in the best interests of all concerned" meant one that would provide for the creation of a Jewish home in Palestine as envisaged by the Balfour Declaration (assuming it could be taken at face value). With time fast running out for all concerned the probability was that the Arab leaders who mattered most would accept a Jewish home in Palestine that was less than a state, provided there were agreed limits on further Jewish immigration. If that kind of Jewish home could be delivered at the eleventh hour by diplomacy and politics, there was no way the Zionists—in the light of what they had actually been promised—could get away with the claim that they had been betrayed. That President Truman himself shared this analysis in private is indicated by his memorandum that the "Palestine thing" could have been solved if...

As January (1948) advanced Forrestal was alarmed by the absence of any considered response to his Palestine initiative from either McGrath for the Democrats or Governor Dewey for the Republicans. In the early days of that first month of the most fateful year in Palestine's history, the Defence Secretary had told senior officials of the State Department over lunch that without access to Middle East oil "the Marshall plan could not succeed, we could not fight a war and we could not even maintain the tempo of our own peacetime economy."[20]

On 21 January, Forrestal decided to make a determined effort to enlist the support of the State Department. That morning he cleared his mind of all other matters and wrote a paper that he intended to run past Lovett later in the day before presenting it to Marshall.

"It is doubtful", he wrote, "if there is any segment of our foreign relations of greater importance or of greater danger in its broad implications to the security of the United States than our relations in the Middle East."[21] On that basis, Forrestal's paper continued, it would be "stupid to allow the situation to develop in such a way as either to do permanent injury to our relations with the Muslim world or to end in a stumble to war."

For the first time Forrestal revealed that he had had "permission from the President" to make an informal attempt to secure Republican agreement to lift the Palestine problem out of U.S. domestic politics. Then, summing up the results of his initiative to this point, he wrote:

> I have had encouragement from Senator Vandenberg, accompanied by scepticism as to the ultimate outcome, somewhat less encouragement from Governor Dewey, and complete agreement as to the desirability of the objective from various other Republicans not in the leadership such as John Taber, James W. Wadsworth, Dewey Short and Everett Dirksen.

What, if any, progress had he made on the Democratic side? He had encountered, he wrote, a realisation "of the importance and danger of the situation", but a "consciousness" that a substantial part of Democratic campaign funds "came from Zionist sources inclined to ask in return for a lien upon this part of our national policy."

In legal terminology a "lien" is a right to retain possession of another's property until a debt is paid. Forrestal's meaning—it could hardly have been more explicit—was that in return for campaign funds, the Zionists expected to call the policy shots for the Middle East.

Having reviewed his own efforts to date, Forrestal then suggested that the Secretary of State should talk to the President about the matter, with a view to Marshall himself taking on the task of advancing negotiations between Republican and Democrat leaders.

In the end section of his paper, Forrestal anticipated the Zionist pressure to which the Truman administration would be subjected in the very probable event (which came to pass as we saw in the previous chapter) of the UN being unable to implement the partition recommendation. The purpose then of Zionist pressure would be to force the U.S. to implement the partition plan unilaterally. And that, Forrestal stated, was a question he had discussed "with a number of people of the Jewish faith, who hold the view that the present zeal of the Zionists can have most dangerous consequences, not merely in their divisive effects in American life, but in the long run on the position of Jews throughout the world."

Forrestal wanted Marshall to be in no doubt that there were some American Jews, and perhaps many, who, despite their emotions of the moment, were unspeakably frightened by the possible consequences, sooner or later, of Zionism having its way.

When Forrestal and Lovett met later that day, the Undersecretary of State read the paper and said he "agreed in general with the conclusions." He then produced a paper from his own Department's Policy Planning Staff. It concluded that the partition plan was "not workable" and that the U.S. was under no commitment to support the plan if it could not be made to work without resort to force; that it was against the American interest to supply arms to the Jews "while we were embargoing arms to the Arabs", or to accept unilateral responsibility for carrying out the UN recommendation; and that the U.S. should take steps as soon as possible to secure withdrawal of the partition proposal. (As we have seen this, the Keenan paper, was one of the two assessments which prompted Marshall to send his "URGENT AND SECRET" cable to President Truman; and, in due course, was to lead to

Ambassador Austin announcing the reversal of U.S. policy and introducing the resolution for the Holy Land to become a UN trusteeship).

Forrestal told Lovett that he had originally proposed himself to the President as the one to take on the task of lifting the Palestine problem out of U.S. domestic politics because somebody with executive responsibility had to do it. But he had come to the conclusion, he said, that it was "neither appropriate nor proper" for the Secretary of Defence to be conducting the negotiations, and that they should continue "under the aegis of the Secretary of State." Forrestal then said it was his view that "the Secretary of State cannot avoid grasping the nettle of this issue firmly because it is too deeply charged with grave danger to this country to allow it to remain in the realm of domestic politics."

Less than two weeks later Forrestal had the first indications that there were some in the Democratic Party who were seeing him as a liability in election terms.

On 3 February Forrestal agreed to receive Franklin D. Roosevelt Junior. You didn't say "No" to a request for a meeting from the son of the illustrious father, even if you didn't have too much respect for the son.

Drawing off the work of two other writers, Joseph Lash and Richard Crossman, Lilienthal offered fascinating insight into the private differences in the Roosevelt family over Zionism.

As I have previously noted, President Roosevelt, privately, was not in favour of Jewish statehood; and within the confines of the White House he was quite open in his criticism of Zionism. Initially Eleanor shared her husband's view that trusteeship was the answer. But she became a rabid supporter of Israel. The question is—why?

Crossman did not exempt Eleanor from his famed observation that "everyone shares a *soupçon* of anti-Semitic prejudice."[22] And Lash told of how Eleanor, in a letter to Sara, her mother-in-law, complained that she had attended a party given by Admiral William Harris for Bernard M. Baruch, which was attended by "mostly Jews" and "which I'd rather be hung than seen at."[23] Two days later she wrote, "The Jew party (was) appalling. I never wish to hear money, jewels... and sables mentioned again."[24]

Lilienthal added this: "The persistent strivings of Mrs. Roosevelt, particularly as former First Lady, to advance the Israeli cause could have stemmed from an unconscious atonement for her secret feelings of earlier years. *So many other persons of her social class and era likewise jumped from a near-anti-Semitic stance to a virulent pro-Israel position.*"[25] (Emphasis added).

The discussion between Forrestal and Roosevelt Junior quickly became a confrontation and the following was Forrestal's summary account of it.

> Visit today from Franklin D. Roosevelt Jr., who came in with
> a strong advocacy of the Jewish state in Palestine, that we
> should support the United Nations 'decision', and in general

a broad, across-the-board statement of the Zionist position. *I pointed out that the United Nations as yet had taken no 'decision', that it was only a recommendation of the General Assembly, that any implementation of this 'decision' by the United States would probably result in the need for partial mobilisation, and that I thought the methods that had been used by people outside of the Executive branch of the government to bring coercion and duress on other nations in the General Assembly bordered closely on scandal.* He professed ignorance on this latter point and returned to his general exposition of the case of the Zionists.

He made no threats but made it very clear that the zealots in this cause had the conviction of trying to upset the government policy on Palestine. I replied that I had no power to make policy but that *I would be derelict in my duty if I did not point out what I thought would be the consequences of any particular policy which would endanger the security of this country.* I said that I was merely directing my efforts to lifting the question out of politics, that is, to have the two parties agree they would not compete for votes on this issue.

He said this was impossible; that the nation was too far committed and that, furthermore, the Democratic Party would be bound to lose and the Republicans gain by such an agreement.

I said I was forced to repeat to him what I had said to Senator McGrath in response to the latter's observation that *our failure to go along with the Zionists might lose the states of New York, Pennsylvania and California, and that I thought it was about time that somebody should pay some consideration as to whether we might not lose the United States.*[26] (Emphasis added).

Roosevelt Junior's real message was that the campaign to lift Palestine out of U.S. domestic politics had to be stopped in order to prevent serious damage to the Democratic Party's election prospects.

Question: Was it a message from a maverick or was the politically lightweight son of the late President reflecting the view of others with real influence?

Forrestal did not have to wait more than an hour or two for the answer. It came with lunch the same day.

It was one of those occasions when what was said had profound significance because of who said it.

"Had lunch", Forrestal noted, "with B.M. Baruch."[27]

Now 78, the same Bernard Mannes Baruch we met in Chapter Seven was a living legend in the eyes of those insiders who knew about real power—economic, political and military—and how to exercise it, especially for the benefit of vested interests.

As the Chairman of the War Industries Board on President Wilson's watch, this man of infinite discretion had established himself as the leading authority on mobilising the financial and industrial resources of the United States for war.

When President Roosevelt realised that he would not be able to keep America neutral, he, too, had turned to Baruch (as well as Forrestal) for assistance in the task of mobilising the necessary financial and industrial resources for war. Baruch did not hold an administrative post in Roosevelt's administration, but as an adviser to the President his inputs would have been substantial. Perhaps even critical given that the vested interests of American finance and big business had been hostile to Roosevelt because of the way he had clobbered them with his New Deal measures.

The Jewish American gentleman who, in a sense, had done most to make two world wars possible was, by definition, a man with influence far greater than that of any elder statesman in the conventional meaning of the term.

After World War II Baruch was given the responsibility for formulating U.S. policy at the UN with regard to the control of atomic energy. In that capacity his working relationship with the first U.S. Secretary of Defence would obviously have been a close one.

It is therefore reasonable to suppose that the conversation over lunch was conducted in a civilised manner. Baruch had only one item on his agenda—Forrestal's campaign to take the Palestine problem out of domestic politics. Forrestal's brief but tantalising diary note of the conversation (as edited by Millis for his employer) included the following (my emphasis added):

Baruch had only one item on his agenda— Forrestal's campaign to take the Palestine problem out of domestic politics.

He took the line of advising me *not to be active in this particular matter* and that I was already identified, to a degree that was *not in my own interests*, with opposition to the United Nations policy on Palestine. He said he himself did not approve of the Zionists' actions, but in the next breath he said that *the Democratic Party could only lose by trying to get our government's policy reversed.*[28]

As Baruch knew, partition was not what he stated it to be—UN "policy". It was, as Forrestal had pointed out to Roosevelt Junior, only a rigged recommendation of the General Assembly. It would not become UN policy until the Security Council was satisfied that partition could be

implemented. Only the Zionists were asserting that partition was already UN policy. Despite his protestation to the contrary, Baruch had come out fighting for them. And obviously with the deniable support of the Democratic Party's top management.

By telling Forrestal that it was not in "his own interests" to pursue the matter of lifting Palestine out of U.S. domestic politics, Baruch could have meant by implication (if he did not say so openly) only one of two things, and perhaps both. One was that the Zionists had enough influence in Congress to deny him the legislative and fiscal support he needed to make a success of managing the newly created Department of Defence. The other was that the Zionists had enough influence with the Democratic Party to have Forrestal removed from office.

Baruch implied to Forrestal the Zionists had enough influence in Congress to deny him the legislative and fiscal support he needed to make a success of managing the newly created Department of Defence—and enough influence with the Democratic Party to have him removed from office.

The bottom-line of Baruch's "advice" to Forrestal could not have been more clear—the election prospects of the Democratic Party had to given priority, and that meant abandoning the campaign to lift Palestine out of U.S. domestic politics.

Given Baruch's stature, prestige and influence, Forrestal was being subjected to the maximum possible pressure by civilised means.

It was all to do with the fact that Forrestal had President Truman's blessing for his initiative. The known record of subsequent events as they happened suggest Baruch believed that if Forrestal could be persuaded to accept the idea that his campaign was not in the Democratic Party's interest, Marshall, probably, would not take a different view, and that even if he did, the President could be prevailed upon to refrain from giving Marshall his blessing to continue the negotiations with the leaders of the parties. It followed that if Forrestal could be neutralised, the campaign to take the Palestine problem out of U.S. domestic politics would be terminated.

On the same day, 3 February 1948, Forrestal received word that the Republican Party was ready to have negotiations with the Democratic Party to take the Palestine problem out of U.S. domestic politics.

One of the greatest and most tragic ironies in the whole story of the creation of the Arab–Israeli conflict is that on the same day, 3 February 1948, Forrestal received word that the Republican Party was ready to have negotiations with the Democratic Party to take the Palestine problem out of U.S. domestic politics.

Back in his office Forrestal took a telephone call from Winthrop Aldrich, chairman of the Chase National Bank in New York. At Forrestal's request Aldrich had been continuing the dialogue the Secretary of Defence had started with Governor Dewey at the Gridiron Dinner.

Aldrich now reported that Dewey thought Forrestal was "doing just right"; was "in entire sympathy" with his campaign; and would "co-operate in any way for the best interests of the country."[29]

And that was not all. Dewey had suggested, Aldrich told Forrestal, that discussions of co-operation should be handled by Marshall and John Foster Dulles. (At the time Dulles was one of the most brilliant and successful lawyers in the U.S., specialising in international law. Under President Eisenhower after Truman he would emerge as the most powerful and controversial Secretary of State, controversial because of his anti-Communist zeal. He believed in pushing the Russians to the brink. He once declared, "If you are scared to go to the brink, you are lost."[30])

In his conversation with Forrestal at the Gridiron Dinner, Dewey had remarked to the Secretary of Defence that "Politics looks very simple to the outsider, whether he is a businessman or a soldier", but "it is only when you get into it that all the angles and hard work become apparent."[31] The fact that Dewey wanted Dulles to be involved implied two things. One was that Dewey would be relying on Dulles to see "all the angles"—i.e. to guarantee that any agreement reached with the Democrats was one without a unilateral escape clause for them. Dewey did not want to be screwed by another Democratic President. The other was that Dewey was serious about wanting negotiations to lift the Palestine problem out of U.S. domestic politics.

Forrestal was pleased with Aldrich's news. On the telephone he said to him: "I appreciate that a lot, Winthrop. It's a long road, but that's a good beginning. I think he (Dewey) is correct. I think from now on it ought to be in channels that are, let's say, more correct."[32]

And then... Within a matter of days the prospect of negotiations to lift the Palestine problem out of U.S. domestic politics was killed.

How did it happen?

It remains a mystery that seekers after the truth have to solve for themselves, with only minimum assistance from Forrestal's diary and papers as edited and published.

Forrestal sent a transcript of his conversation with Aldrich to Marshall (having previously suggested to the Secretary of State that he should take on the responsibility for managing the negotiations between the party leaders).

Within a matter of days the prospect of negotiations to lift the Palestine problem out of U.S. domestic politics was killed. How did it happen?.

That done Forrestal drew up a memorandum for President Truman. The edited version of *The Forrestal Diaries* as published did not reveal what this particular Forrestal memorandum said. Millis merely noted that it summarised Forrestal's findings.

It is reasonable to speculate that the memorandum was positive on the basis that the Republicans at leadership level were "Go" for negotiations with the Democrats. It is also reasonable to speculate that Forrestal

expressed the view that there was now a real chance of making progress; of actually getting the Palestine problem out of the pork barrel of domestic politics and thus opening the door to the prospect of a solution that would be in the best real interests of all concerned, including the Jews of the world (if not the all-or-nothing Zionists in Palestine).

According to the only published version of what happened next, the Forrestal memorandum "apparently" was not submitted to the President. So said Millis in his own summary of events. His explanation was the following (emphasis added).

> Forrestal probably had to admit to himself that Baruch was essentially right. The crusade to take Palestine out of politics, high-minded as it was in its inspiration, had *insufficiently grasped the powerful emotional factors involved*. It was *accomplishing very little of practical value*: it was at the same time *impairing Forrestal's own usefulness and bringing down on the Secretary of Defence a volume of criticism to which he could not, in fairness, subject that office*. He made two appeals to Marshall, on February 12 and 18, to find a non-partisan policy. But these ended his active efforts towards that end. He never changed his opinion while his interest in Palestine never flagged—it could not, since the area was too deeply involved in every strategic and logistic calculation that he was required to confront. Occasionally and with vehemence he continued to speak of the strategic importance of Palestine and of the danger of letting domestic political manoeuvres determine our course there. But his proselytising in the matter was at an end.[33]

In my view that explanation of why Forrestal did not "apparently" submit his memorandum to President Truman and why, in effect, he bowed to those who were conspiring to have his campaign consigned to the dustbin of history, begs more questions than it answers. In some important respects it is also flatly contradicted by the quoted evidence of Forrestal's diary.

The main problem with the Millis explanation is its statement that Forrestal's crusade to take the Palestine problem out of U.S. domestic politics "was accomplishing very little of practical value... " That was more or less the truth as it could have been stated to be up to 3 February—i.e. before Forrestal was informed by Aldrich that the Republicans at leadership level were willing to have serious negotiations with the Democrats. The truth after 3 February, while Forrestal was preparing his memorandum for the President, was different. There was then a real prospect of the campaign Forrestal had started leading to something of practical value—if Democratic Party leaders and managers were willing to negotiate an agreement with the Republicans for a non-partisan Palestine policy.

The Millis statement that Forrestal had insufficiently grasped the powerful emotional factors involved strikes me as being very odd. The inference is that the first U.S. Secretary of Defence would not have proceeded with his campaign if he had sufficiently grasped the powerful emotional factors involved. That cannot be right. Forrestal was a patriot and, with the exception of the President, the one above all others who had the responsibility to protect not only America's interests but to keep the Free World free, at a dangerous time of great uncertainty about Soviet intentions. In that context the Millis suggestion that Forrestal's judgement about how the Palestine problem should be handled would have been any different if he had fully grasped the emotional factors involved seems to me to be nonsense. Any Secretary of Defence of the time who allowed his judgements to be swayed by the emotions of others would have been a terrible liability to his country and quite possibly the whole world.

There was then a real prospect of the campaign Forrestal had started leading to something of practical value—if Democratic Party leaders and managers were willing to negotiate an agreement with the Republicans for a non-partisan Palestine policy.

So far as his own emotions were concerned, Forrestal suppressed them. His almost desperate desire to serve his country to the very best of his ability told him that emotions were a luxury he could not afford to entertain as Secretary of Defence. In that respect he was much too harsh on himself. By suppressing his emotions on account of his sense of duty he denied himself a safety valve, the one thing all human individuals need if, when they are under enormous pressure, they are to remain of sound mind. It may well have been that his lack of an emotional safety valve contributed to the disturbance of his mind that led him, after he became clinically depressed, to suicide.

If Millis had said that Forrestal the investment banker had started out with an insufficient grasp of political reality—the dependency on Jewish votes and campaign funds of not a few of those seeking election or re-election, Democrats especially, and that if Forrestal had had a sufficient grasp of that reality at the outset he might not have embarked on his campaign, he, Millis, might have been right. But I cannot buy even that. Had Forrestal had a sufficient enough grasp of political reality at the outset, I think he would have devised a strategy to take account of it and, probably, would have been more direct and more urgent in his approach to the problem.

And what of the Millis statement that Forrestal's crusading was impairing his usefulness as Secretary of Defence? That simply was not true. (The Millis account offered no evidence to back the assertion because there was none.) There is a strong case for saying that Forrestal would have bought down a volume of (Zionist-driven) criticism to which he could not in fairness subject his office if the campaign to take Palestine out of U.S. domestic politics had stayed on the road, and if Forrestal had continued to

lead it. Conducting negotiations with Republican and Democratic leaders would have taken far too much of his time and energy; and, as Baruch had warned over lunch, would have given the Zionists scope to make life difficult for him in Congress. But Forrestal had been the first to see that danger. That was why, before his lunch with Baruch, he had decided it was not right and proper for him as Secretary of Defence to play the leading role, and that the campaign should continue under the aegis of the Secretary of State. The only sense in which Forrestal's campaign was impairing his usefulness as Secretary of Defence was that it made him a political liability in the eyes of Democratic Party managers, those with the chief responsibility for soliciting Jewish campaign funds and votes.

In my analysis the Millis explanation as a whole—it may not have been his own—was a political one, effectively a cover-up, for the purpose of closing the Forrestal file on the matter of taking the Palestine problem out of U.S. domestic politics. I mean closing it in a way that, by offering an explanation, would, it was hoped, obviate the need for unwanted further questions about why, really, Forrestal's initiative was killed.

The truth about what really happened and why has to remain a matter for speculation because we don't know what Secretary of State Marshall said to Secretary of Defence Forrestal sometime between 3 and 7 February. Given that on the third or fourth day of that month Forrestal sent a transcript of his conversation with Aldrich about Dewey's position to Marshall, it is inconceivable that Marshall did not respond in some way to Forrestal, by telephone or in the flesh when they had a private moment together. My guess is that Marshall said something like the following to Forrestal:

> I agree with you in principle. The Palestine problem ought to be lifted out of U.S. domestic politics... but it isn't going to happen because the Democrats are not going to give up the Zionist card and the benefits it brings in terms of cash and votes; and the President is not going to override them on this matter. I'm sad to say you're wasting your time. Don't bother to send your memorandum to the President.

There can be no doubt that if Truman had asked Marshall to continue with Forrestal's initiative, he would have done so without flinching. His own sense of duty and loyalty to the President. would not have permitted him to do otherwise. My guess is that Marshall made that clear to Forrestal, but after making it clear I think he would have added, "The President is not going to ask me."

My own view is that the Millis account could not have been more wrong in its assessment that Forrestal "probably had to admit to himself that Baruch was essentially right." The reality that Forrestal did admit to himself, probably with the assistance of Marshall's input, was that lifting the Palestine problem out of the pork barrel of U.S. domestic politics was a mission impossible—no matter that failure to come up with a bi-partisan

policy for Palestine would most likely have catastrophic consequences for all concerned in the years to come. Forrestal's conclusion? There was no point in asking the President to do what he would not do for understandable if deplorable reasons.

A sensational development three weeks later would have removed from Forrestal's mind any lingering doubt about the certainty that some in the Democratic Party would stop at nothing to prevent the loss of Jewish campaign funds and votes.

On the morning of 26 March, Marshall called Forrestal with disturbing news he had just received from the White House. That afternoon Franklin Roosevelt Junior was to make a statement, to the effect that the Democratic Party would have to draft General Eisenhower as its nominee for the presidency. (The Democratic convention to confirm or deny President Truman the opportunity to run for a second term was scheduled for

A sensational development three weeks later would have removed from Forrestal's mind any lingering doubt about the certainty that some in the Democratic Party would stop at nothing to prevent the loss of Jewish campaign funds and votes.

June). At the time General Eisenhower, "Ike" as he was known with affection, was the most admired and popular figure in America. From a poor family and with not too much in the way of formal academic achievement until he entered the United States Military Academy at West Point, he had risen through the ranks to become the Supreme Commander of Allied Forces in World War II. When America entered the war he was only a colonel. By the time Germany surrendered on 7 May 1945 he was a five-star general. His rapid promotion had happened because Marshall as Chief of Staff had recognised his outstanding abilities and qualities. Eisenhower's speciality was transforming strategic theory into effective action. One of the keys to his success was his winning personality—his ability to persuade, to mediate and to be agreeable. He had intended to retire from military service after the war but, at President Truman's request, he had agreed to replace Marshall as Chief of Staff, to allow Marshall to become Secretary of State.

The main point in summary is that the White House was Eisenhower's for the taking, if he wanted it, because influential people in both parties, Democrats and Republicans, were wooing him. Victory for either party in the coming election was guaranteed with Eisenhower the standard bearer.

When Marshall called Forrestal with news of Roosevelt Junior's intention, his concern was not on account of any worry about how President Truman might feel about the prospect of being dumped by his party. Both Marshall and Forrestal were aware from their private conversations with him that Truman, actually, was not so enthusiastic about a second term. Deep down Harry Truman had had enough of the pressures to oblige him to put Zionism's interests before those of the nation. The cause of Marshall's alarm was the possible consequences for America's ability to protect its global

interests. An attempt to draft Eisenhower now would obviously be interpreted abroad as a lack of support at home for the Truman administration, and that could tempt the Soviet Union or China or others to make menacing moves which the U.S. was not in a position to counter. (Because of its financial commitment to the reconstruction of Europe and the political constraints on mobilisation in peacetime).

At a Cabinet meeting two weeks earlier, Marshall had summarised America's whole dilemma in one explicit sentence. "We are playing with fire (in the Middle East especially) and we have nothing with which to put it out!"[34] The longer version of the same statement was that on nearly every front they faced essentially the same grim alternatives—to withdraw; to attempt to stand pat on positions obviously untenable; simply to confess—as Marshall favoured in the case of China—that the problem was "unsolvable"; or to take vigorous action. The problem with the latter option was that the means and the men did not exist.

In that context Marshall believed that Roosevelt Junior was irresponsible beyond polite description. The purpose of his call was to ask Forrestal for suggestions about how to stop the Roosevelt statement being made.

Forrestal's diary entry for that dramatic day included the following: "The sensational factor here, of course, was the implication of revolt, led by the late President's son."[35]

The date (26 March) was the key to understanding. It was after Ambassador Austin's announcement of the U.S. policy reversal—the decision to shelve partition, and four days before he was due to introduce a new resolution calling for Palestine to become a UN trusteeship with Jerusalem an international city.

Forrestal told Marshall he would be glad to talk to "young Roosevelt" but did not believe that anything he could say to him would be effective. The Secretary of Defence then suggested that he should call Eisenhower and ask him to speak to Roosevelt Junior. The Secretary of State thought that was a good idea.

For background it is essential to know that two months previously Eisenhower had asked Forrestal for advice about a statement he had drafted and wanted to release. It was Eisenhower's announcement that he would "not permit his name to be put forward for the presidency."[36] (Without consulting Eisenhower, somebody had entered his name for the New Hampshire primaries). When he showed the statement to Forrestal, Eisenhower said it was entirely his own work—he had not asked anybody to help with the drafting of it, and that he had come to Forrestal because he didn't know anybody else he could turn to for advice. Eisenhower then told Forrestal that his only misgiving about ruling himself out as a candidate for the presidency had been that "a construction could be put upon it of its constituting a refusal to respond to a duty." What did Eisenhower mean? His whole life had been built around responding to the call of duty and there were many youngsters in the country who, whether with reason or not, had

made him more or less a symbol of the duties and obligations, as well as the opportunities, open to American youth, and he was truly worried about the responsibility of, in effect, telling them that there was a limit to any man's conception of his obligation to respond to the call of duty. In his diary for the day Forrestal said there was no question in his mind about Eisenhower's sincerity, and that his proposed statement reflected "the outcome of a genuine moral struggle within himself." Forrestal told Eisenhower that his statement would put him in a position of tremendous influence, "above the battle", and that in this role he could still perform a great service to the country. "I told him that I thought the letter, both in its content and style, was splendid, and that I would not recommend changing anything in it." Eisenhower released the text of his statement the following day, 24 January.

On 26 March, convinced that Roosevelt Junior would take no notice of him, Forrestal telephoned Eisenhower and asked him to tell the late President's son not to make his statement. The General was very reluctant to call Roosevelt Junior. He feared that if he had any contact with him at that moment in time, some people would say that he was party to a conspiracy to dump Truman. On that basis Forrestal was reluctant to press Eisenhower and did not do so. There was, however, some comfort in what Eisenhower had said. If Forrestal called Roosevelt Junior, he could quote the General as saying that he would be "greatly distressed" if the late President's son made any such move and public declaration.[37]

Forrestal then telephoned Senator McGrath. That was not an easy thing for the Secretary of Defence to do because McGrath had not delivered on his promise to give a considered reply to Forrestal's plea for the Democrats to play their part in lifting the Palestine problem out of U.S. domestic politics.

McGrath said there was no point in Forrestal calling Roosevelt Junior. Nothing the Secretary of Defence could say would have any affect because Roosevelt Junior was "very set in his ideas and determined to go ahead." Translated that meant: "*The Party needs a winner and that ain't going to be Truman if he does not reverse the policy reversal and stick with the partition plan.*"

I imagine Forrestal consulted with Marshall before taking his next step.

At 2.15 p.m. Forrestal called Eisenhower again, reported the situation to him, and said, in effect "You've got to make that call."

Eisenhower said, "Okay. I'll do it."

And ten minutes later he called back to say he'd done it.

From Eisenhower's report to Forrestal it was clear that the former Supreme Commander of Allied Forces had been as forceful as he could be. He told Roosevelt Junior that any action now of the kind he was proposing, in the middle of delicate situations in various countries abroad, could have "dangerous consequences and might negate American policy." Any statement which might be interpreted abroad as implying failure to support the President at this most critical time, or indicate deep and serious splits

in public opinion would be "detrimental to the country." Eisenhower also told Roosevelt Junior that he was giving his thoughts without reference to any political considerations, particularly as they affected himself. He had added: "When I made my public statement some weeks ago, I meant what I said, I am sorry some people don't believe me."

Roosevelt Junior still went ahead and made his statement.

Fortunately the repercussions abroad and at home were less serious than Marshall, Forrestal, Eisenhower and Truman himself had feared they could be.

Unless he was stupid, Roosevelt Junior knew there was no prospect of drafting Eisenhower for the election then only eight months away. So why did he still go public with his call? There is only one possible answer. He was firing a warning shot across President Truman's bows. Effectively he was saying to the man in the White House: "Stick with partition or you'll take the party down with you. Some of us are not prepared to let that happen."

As we have seen, Truman stuck with partition.

When Eisenhower allowed himself to be persuaded to run for the presidency in 1952 it was on the Republican not the Democratic ticket. Whether or not such a thought crossed his mind, it was effectively a magnificent and mighty "Screw you" gesture to Roosevelt Junior and other Democrats who had raised the flag of revolt against President Truman when they feared he was not going to do Zionism's bidding.

I also think it is not difficult to imagine that Eisenhower was profoundly disturbed by the Democratic Party's complicity in the destruction of one of America's most outstanding public servants. Suicide implies self-destruction but there was much more to Forrestal's death than that, as Eisenhower, because of the nature of his professional and personal relationship with the first U.S. Secretary of Defence, would have known better than most.

Forrestal plunged to his death from the 16th floor of the Naval Hospital at Bethesda, Maryland, at about 1:45 am on 22 May 1949.

Perhaps because he had been informed that President Truman was intending to remove him from office in response to Zionist pressure for his removal, Forrestal had resigned as Secretary of Defense seven weeks earlier. By then there were warning signs of disturbance in his mind. According to *Who Killed James Forrestal?* the Internet file of David Martin, also known as DCDave (more about him later), Forrestal, officially said to be suffering from "nervous and physical exhaustion" with a condition diagnosed as "depression" or "reactive depression", was committed to the Bethesda Naval Hospital "apparently against his will".

On the night of 21–22 May, according to the story proclaimed by the media before there had been any kind of investigation and which the media still promotes today, Forrestal had obviously been unable to sleep and was reading Mark Van Doren's Anthology of World Poetry. In what were to be the last moments of his life, he was copying or transcribing from it Praed's version of Sophocles's dark and solemn Chorus from Ajax:

Fair Salamis, the billows' roar
Wander, around thee yet;
And sailors gaze upon thy shore
Firm in the ocean set.
Thy son is in a foreign clime
Where Ida feeds her countless flocks,
Far from thy dear, remembered rocks,
Worn by the waste of time—
Comfortless, nameless, hopeless—save
In the dark prospect of the yawning grave...
Woe to the mother, in her close of day,
Woe to her desolate heart, and temples grey,
When she shall hear
Her loved one's story whispered into her ear!
'Woe, woe!' will be the cry—
No quiet murmur like the tremulous wail
Of the lone bird, the querulous nightingale.

At that point Forrestal was said by some—media people at the time and a number of authors later—to have stopped writing, walked to a small kitchen on the same floor and, as Millis put it, "fell to his death from its unguarded window."[38]

If the media's version of the story is to be believed, one possible interpretation is that the poem triggered an unconscious impulse and that he went unwittingly to his death.

Another possible interpretation is that he had taken a conscious decision to end his life and had been searching for a poem that reflected his inner feelings and even, perhaps, justified to himself what he was about to do. Some evidence that the latter might have been the case is that he was responding well to treatment. By the end of April he had seemed to be his old self to the friends and associates, including President Truman, who visited him. Millis wrote that he was still having moods of depression but with decreasing frequency and severity; and that was the reason why his brother Henry was due to arrive on what turned out to be the day of his death to take James out of the hospital.

I think there can be no doubt that a contributing cause of the depression that led to Forrestal's breakdown was a Zionist campaign, conducted through the media as well as behind closed doors, for his resignation after Truman's re-election—when American Zionism believed itself to be, and actually was, more influential than ever because of its contributions to Truman's unexpected victory. The fact that some Zionists wanted revenge in the shape of Forrestal's resignation really got to him. It is not hard to imagine why, given that all he had been trying to do to the best of his ability was his patriotic duty—protecting the national interest and preventing the spread of Soviet communism.

But the main cause of the turmoil in his mind was, I speculate, the fact that doing what was necessary to protect America's best longer term interests had not been possible, especially with regard to the Middle East, because of the pork-barrel nature of American politics, which Zionism was (and still is) exploiting so brilliantly.

It is possible that in Forrestal's mind the most pertinent line in the poem was "Thy son is in a foreign clime"; the meaning for him being that he felt like a foreigner in his own homeland because he had not been allowed by the politics of expediency to do his job to the best of his ability. The real madness, he might well have told himself, was putting the nation's security at risk for the sake of Zionist-organised Jewish campaign funds and votes.

If (it bears repeating) the media version of events is to be believed, it's not unreasonable to speculate that Forrestal might have decided, consciously, to commit suicide for a combination of two reasons.

One might have been his realisation that by selling out to Zionism, America's pork-barrel politicians, the Democrats especially, had created a situation in which for decades to come, and possibly for all time, the United States of America would be a hostage to conflict in the Middle East. By definition America as hostage would not be free to make the decisions necessary for the best protection of its own security.

I think Forrestal would not have been surprised, as I was not, by the events in New York and Washington on 11 September 2001. While he lived he could not have imagined that anti-Americanism would manifest itself in such a spectacular and horrific way, but he was aware, as were many of those with whom he worked at executive level, that, given the opposition of just about the entire Arab and Muslim world (its masses, not their leaders), America might pay one day a terrible price for its support of Zionism right or wrong.

I also think that Forrestal would have endorsed the words of the courageous columnist, William Pfaff, writing in the *International Herald Tribune* of Wednesday 12 September 2001. Under the headline ATTACKS SHOW THAT COURAGE IS THE ONLY REAL DEFENCE, he wrote this (emphasis added):

> For more than 30 years the United States has refused to make a genuinely impartial effort to find a resolution to that (Israeli-Palestinian) conflict. It has involved itself in the Middle East in a thousand ways, but has never accepted a responsibility for dealing impartially with the two sides —locked in their shared agony and their mutual tragedy…
> *If current speculation about these bombings proves to be true, the United States has now been awarded its share in that Middle Eastern tragedy.*

A second and related reason for Forrestal's decision to end his life might well have been his belief that as the first U.S. Secretary of Defence he could and should have done more to try to prevent the surrender to

Zionism. By his own standards—the highest possible—he had failed in his patriotic duty.

What more could he have done? The answer is another question.

How would Truman have responded if Forrestal, shortly after his lunch with Baruch, had gone quietly to him and said something like the following: "Mr. President, I believe that continued support for Zionism right or wrong for reasons of short-term, domestic political considerations will have catastrophic consequences for America in the longer term... and also the Free World as a whole and ultimately the Jews of the world. I feel it would be a gross dereliction of duty on my part if I did not say this to you, and I regret that I will be obliged to resign if you are not prepared to insist that the Palestine problem be taken out of U.S. domestic politics, to enable us to solve this problem before it becomes unmanageable—for future generations if not us."

In that light it's not unreasonable to speculate that Forrestal might have gone to his grave tormented by the belief that he could and should have fought longer and harder, to the point of resignation if necessary, for the Palestine problem to be taken out of partisan American domestic politics.

There is no way of knowing how President Truman would have responded to such an ultimatum from America's first Secretary of Defence. He might have found the courage to confront Zionism or he might not.

But now the question. Did Forrestal really commit suicide, or, was he strangled with the sash of his bathrobe and bundled out of the window by a person or persons unknown?

A reviewer of all the evidence with regard to the assertions that Forrestal committed suicide and the lack of evidence, is David Martin as mentioned above. He describes himself as a Washington economist and political commentator whose media career went into "abeyance" because of his preference for truth, and who, as a consequence, found himself "on freedom's last redoubt, the Internet." His Internet file *Who Killed James Forrestal?* is comprehensively sourced and fully documented when he is quoting from newspapers, books and official documents. I accessed his work by putting "David Martin also known as DCDave" into Google's search box; and my readers can do the same if they wish.

One of several reasons for legitimate doubt about the assertion that Forrestal committed suicide lies in the fact that the Navy kept the full transcript of its official investigation and report secret for 55 years.

As Martin notes, one of several reasons for legitimate doubt about the assertion that Forrestal committed suicide lies in the fact that the Navy kept the full transcript of its official investigation and report secret for 55 years.

The review board to investigate the first U.S. Secretary of Defence's death was appointed the day after it, on 23 May 1949, by Admiral Morton D. Willcutts, the

head of the National Naval Medical Center. The board completed its work eight days later on 31 May, but its brief summary report of five points in 17 lines was not published until 11 October. No explanation was offered for the delay. Despite the fact that the media had conditioned the public to believe that Forrestal had taken his own life, there was no conclusion or even a mention of suicide in the board's summary report. As reported by *The New York Times* on 12 October, it merely stated that Forrestal had died "as a result of injuries, multi extreme, received incident to a fall from a highpoint in the tower, Building 1."

In other words, the notion that Forrestal committed suicide was a media assertion—a Zionist-driven assertion?—and nothing else.

The summary report did not address the matter of what might have caused Forrestal to fall or the fact, confirmed by the coroner, that when his broken body was recovered from the third-floor passageway roof on which it landed—skull crushed, abdomen split and lower left leg severed—the sash from his bathrobe was still wound tightly around his neck. In the media-asserted version of how Forrestal committed suicide, he took the sash from his bathrobe, tied one end to the radiator under the window and the other around his neck, opened a securely locked window and climbed out. The obvious implications are that he was intending to hang himself and fell only because either the sash could not take the strain of his weight or he made a lousy job of tying it to the radiator. There was no evidence of any kind that a sash had been tied to the radiator.

The complete report of the review board was not made public until April 2004 and even then its most important exhibit—Forrestal's alleged handwriting on the night of his death—might have remained secret for all of time.

The complete report of the review board was not made public until April 2004 and even then its most important exhibit—Forrestal's alleged handwriting on the night of his death—would not have been released (would have remained secret, probably for all of time) but for the fact that Martin succeeded on his third attempt to make the Freedom of Information Act work for complete and full disclosure.

As Martin subsequently noted in his Internet file: "Among the discrepancies between the report and the accounts given in the principal Forrestal biographies are that the transciption of the poem by Sophocles *appears to many to have been written in a hand other than Forrestal's.*" (Emphasis added).

There is no evidence of any kind to support the notion that before his death Forrestal was reading a book of poems and copying or transcribing by hand lines from one of them. As Martin also notes: "The book of poems, which was described in great detail in the newspapers, down to the colour of its binding, does not show up in the exhibits at all." And not one witness who appeared before the review board had seen the book.

What did show up (the exhibit Martin forced into the open by making best use of the Freedom of Information Act) was a piece of brown paper on

which it was asserted that Forrestal had written the lines from the Sophocles poem. Martin compared that handwriting with various letters Forrestal was known to have written. He concluded: "It [the handwriting of the exhibit] doesn't look the least bit like Forrestal's handwriting, as one can plainly see at http://www.dedace.com/article4/041103.htm."

In his Internet file, under the heading *The Cover-up Collapses,* Martin added the following:

> One hardly needs an expert to tell him that the person who transcribed the poem is not the same person who wrote the various letters that are known to have been written by Forrestal. The most obvious difference is that Forrestal writes his words and letters straight up and down, while the poem transcriber writes with a more conventional, consistent lean to the right. Forrestal, on the other hand, is more conventional in how he writes his small r's, making either a single hump or an almost imperceptible double peak, while the transcriber has a very distinctive, exggerated first peak in almost every one he makes. The transcriber is a very conventional "archer" in the manner in which he makes his small m's and n's. Forrestal, on the other hand, is a typical "swagger", sagging down between peaks, as opposed to rounding over arches.

> *What's most amazing is the complete brazenness on display.* One can truly say that the transcition of "Chorus of Ajax" is not a forgery. *Not the slightest effort was made to mimic James Forrestal's handwriting.* The perpetrators must have been completely confident that no attempt would be made by the Navy to authenticate the note, and, in fact, that no question would ever be raised either by the press or anyone with a public forum as to the authenticity of the handwriting in the transcription. (Emphasis added).

One can truly say that the transcription of "Chorus of Ajax" is not a forgery. *Not the slightest effort was made to mimic James Forrestal's handwriting.*

On the matter of the handwriting, a possible conclusion invited, or so it seems to me, is that the story of Forrestal and Sophocles's dark and solemn poem was fabricated to create the impression that Forrestal had written an implied suicide note.

The complete report of the review board also revealed a fact that had not previously been reported and, so far as I am aware, was not reported by the media after it was revealed. Broken glass was found in Forrestal's bed. That could be indicative of a struggle, violent at least to some degree.

There are two other observations by Martin which I think should be considered by all with doubts about the circumstances of Forrestal's death.

> For over a year he had been subject to a vilification campaign in the press the like of which hardly any public figure has ever had to endure in America. Leading the campaign, from the left and the right respectively, were America's two best known and most powerful syndicated columnists, Drew Pearson and Walter Winchell. They painted Forrestal as a corrupt tool of Wall Street and the oil companies who put the interests of his cronies ahead of concern for the wellbeing of refugees from European persecution. [Elsewhere Martin noted that Pearson's protégé, Jack Anderson, later asserted that Pearson "hectored Forrestal with innuendos and false accusations."] His big offense was that he was outspoken in his opposition to the creation fo the state of Israel. He had received threatening telephone calls and complained of being followed and electronically bugged.

Author Arnold Rogow wrote *James Forrestal, A Study of Personality, Politics and Policy* (Macmillan,1963). Relying largely on information obtained in interviews with some of Forrestal's fiercest critics inside and outside the Truman administration, the book supported the theory that Forrestal committed suicide. But even Rogow was to state in a note on page 181 of his book that "it is entirely possible that he (Forrestal) was 'shadowed' by Zionist agents in 1947 and 1948."

A possible implication by extension and within the context of the whole Forrestal story is that Zionist agents of one sort or another might have been involved in Forrestal's death. Some and perhaps many readers will be outraged by that observation of mine, but there are facts to be faced. One, generally speaking, and as we have seen and will see, is that Zionism has resorted to targeted assassinations when it considered they would serve its purpose, still does resort to targeted assassinations and probably always will. Another fact, a particular one revealed by documents de-classified in 2006, is that British intelligence thwarted a very serious attempt by Begin's Irgun to assassinate Foreign Secretary Ernest Bevin in 1946.

Martin also offered this observation:

> One might argue that because Israel had already been recognised by the United States by the time Forrestal died, and because he had been removed from the Truman cabinet and discredited by his breakdown and hospitalization, he was no longer a threat to supporters of Israel. But he was a man of prominence, wealth and determination who intended to buy a newspaper and write

a book that threatened to expose a number of Roosevelt-Truman administration secrets, especially related to the machinations that brought the United States into World War II and the wartime policies that advanced the interests of the Soviet Union. His voluminous diary was confiscated by the Truman White House and its full contents have never been revealed. [As we have seen, Millis maintained that it was on Forrestal's own instructions that his diaries and documents were sent to the White House for safekeeping. Millis and Martin can't both be right].

In the jury of my own mind, the answer to the question of whether Forrestal committed suicide or was murdered is an open one.

By the time of Forrestal's death Zionism's child was one year old and had established itself as the military master of the region; and it had done so in a manner that gave substance to Forrestal's fear that the surrender to Zionism might well come to be viewed as the most monumental and catastrophic failure of government in America's history.

By the end of its first year of its existence Israel had:

- Won its "war of independence";
- Was in occupation of more Arab land than had been allotted to the Jewish state in the vitiated partition plan; and
- Having created the Palestinian refugee problem was rejecting the international effort, supported initially by President Truman, to solve it.

In the course of the first three chapters of Volume Two of this book, we shall see how these developments came about; and how the bullets fired by a Zionist assassin killed the prospect of a solution to the Palestinian refugee problem before it became, together with Israel's arrogance of power, the source of unending and escalating conflict; with the real prospect of it going all the way to Armageddon.

ENDNOTES

Appeal to the American People

[1] So far as I am aware the term "Israeli occupied" media was first coined by Philip Giraldi in an article posted on Anti-War.com on 12 August 2008. It was subsequently used by a number of commentators.

[2] Arabs as well as Jews are Semites, so unless qualified anti-Semitism means prejudice against and even hatred of Jews *and* Arabs. In this book I follow common practise in the Western world and use the term anti-Semitism as though it means only prejudice against and even hatred of Jews.

[3] Hajo G. Meyer, *An Ethical Tradition Betrayed, The End of Judaism* (G. Meyer Books, 2008).

[4] Ilan Pappe, *The Ethnic Cleansing of Palestine* (Oneworld Publications Limited, October 2006).

Prologue: Waiting for the Apocalypse

[1] Golda Meir, interview with author for BBC's Panorama programme, April 1971

[2] Lenni Brenner, *Zionism in the Age of the Dictators* (UK Croom Helm, 1983), Preface.

[3] Alfred M. Lilienthal, *The Zionist Connection II: What Price Peace?* (North American, 1982), pp. 403–404.

[4] Yehoshafat Harkabi, *Israel's Fateful Hour* (Harper & Row, 1988), Preface, p. xix.

[5] Ibid., Preface, p. xvii.

[6] Ibid., pp. 219–220.

[7] Senator William Fulbright on CBS's Face the Nation, 15 April 1973.

[8] Paul Findley, T*hey Dare to Speak Out* (Westport, Connecticut, Lawrence Hill, 1985), pp. 93. Until Zionism mobilised for his defeat in 1982, Findley was a United States Congressman and had been for 22 years, and was, by the time of his punishment (for daring like Fulbright to speak out), a senior member of the House Middle East Committee.

Chapter One: A Voice from the Grave

[1] For this and quotes on the following page see author's Panorama profile, August 1972.

[2] Recalled by Golda in private conversation with author

[3] Golda Meir, *My Life* (Weidenfeld and Nicholson, 1975), pp. 174–175.

[4] Ibid.

[5] Ibid.

[6] Author's Panorama Profile.

[7] Ibid

[8] Ibid 563

[9] This and related quotes taken from conversation in Prime Minister's outer office.

[10] Golda Meir, *My Life,* p. 379.

[11] Quotes here and on subsequent three pages taken from private conversation

with author unless otherwise noted.

12 Golda Meir, *My Life*, p. 358.

13 For this and what follows see Golda Meir, *My Life*, pp. 357–358, p. 385, p. 360.

14 Private conversation with author.

15 As recalled by Golda in private conversation with author.

16 This quotation and those on the following two pages are taken from a private conversation with the author unless otherwise noted.

17 Panorama interview with author.

18 Private conversation with author.

Chapter Two: Britain Plays the Zionist Card, Eventually

1 Translated by Harry Zohn, edited by Raphael Patai, *Complete Diaries of Theodore Herzl* (New York, 1960), Vol II, p. 581.

2 Ibid.

3 George Friedmann, *The End of the Jewish People?* (Doubleday Anchor Books, 1968), p. 279 as quoted by Cattan in *Palestine and International Law* (Longman Group).

4 Harry N. Howard, *The King-Crane Commission: An American Inquiry in the Middle East* (Beirut, Khayats, 1963); and J. C. Hurewitz, *Diplomacyin the Near and Middle East, Vol II* (Van Nostrand, New York, 1956), p.70.

5 House of Lords, *Hansard's Reports*, 21 June 1922, p. 121.

6 Cited by Philippe de Saint Robert, *Le Jeu de la France en Mediterranee* (Julliard, 1970), p. 222.

7 Alfred M. Lilienthal, *What Price Israel?* (Chicago, Henry Regnery, 1953), pp. 220-22.

8 Alfred M. Lilienthal, *The Zionist Connection II*, op. cit., pp. 760-62.

9 Arthur Koestler, *The Thirteenth Tribe: The Khazar Empire and Its Heritage* (New York, Random House, 1976).

10 Alfred M. Lilienthal, *The Zionist Connection II*, op. cit., pp. 760-62. Ibid., p. 873.

11 Ibid.

12 Ibid.

13 *Encyclopaedia Britannica*, 1977 edition, Vol. 10 (Knowledge in Depth), "Jewish Philosophy", p. 210. Alfred M. Lilienthal, *The Zionist Connection II*, op. cit., pp. 761.

14 Alfred M. Lilienthal, *The Zionist Connection II*, op. cit., pp. 761.

15 Ben-Gurion, Israel, *Annees de Lutte* (Paris, Flammarion, 1964), p. 9. is quoted by Larry Collins and Dominique Lapierre, *O Jerusalem!* (Weidenfeld and Nicholson, 1972.

16 Quoted by Larry Collins and Dominique Lapierre, *O Jerusalem!* (Weidenfeld and Nicholson, 1972), p. 22.

17 Memorandum of Board of Deputies of British Jews and the Anglo-Jewish Association, published in *The Times*, 24 May 1917.

18 British Cabinet records 1915-1920 (made public 1970), Edwin Montagu memorandum, Cabinet No. 2A/24, 13 August 1917.

19 Related by David Lloyd George, *The Truth About the Peace Treaties* (Victor Gollanz, 1938), pp. 1133-1134 and quoted by Lilienthal op. cit.

20 Henry Cattan, *Palestine and International Law*, 2nd edition (Longman,1973), p.10.

21 Alfred M. Lilienthal, op. cit., p. 11.

22 Theodore Herzl, *Tagebucher* (Tel Aviv, 1934); and Nevil Barbour, *Palestine: Star or Crescent?* (New York, Odyssey Press, 1947 as related by Brenner, op. cit.).

23 *Complete Diaries of Theodore Herzl*, op. cit., Vol III, p. 729.

24 As related by Brenner, op. cit., extracted from *Vladimir Medem: The Life and Soul of a Legendary Jewish Socialist*, pp. 295–98.

25 Ibid.

26 M. Lowenthal, *Diaries of Theodore Herzl* (New York, Grosset and Dunlop, 1962), p. 71 as related by Brenner, op. cit.

27 The first source of this Weizmann quotation was Meyer Weisgal (Editor), *The Letters and Papers of Chaim Weizmann, Letters Vol III*, p. 81. Immediately after the Nazi holocaust Weizmann himself could not reveal the anti-Semitism of Balfour, the first of Zionism's three godfathers, but he, Weizmann, subsequently changed his mind and told of Balfour's anti-Semitism in his own book, *Trial and Error* (New York, Harper & Brothers, 1949).

28 Henry Cattan, op. cit., p. 58.

29 Sol M. Linowitz, *Analysis of a Tinderbox: The Legal Basis of the State of Israel* (*American Bar Association Journal*, 1957), Vol 43, p. 522–523.

Chapter Three: Britain Betrays the Arabs

1 Alfred M. Lilienthal, op. cit., p. 18.

2 David Lloyd George, op. cit., pp. 1131–41.

3 Ibid. 565

4 J. C. Hurewitz, op. cit.

5 Reported by Al Sharq, 23 January 1917; and noted by George Antonius, *Arab Awakening* (Philadelphia, Lippincott, 1939), p. 208 originally cited in Al Sharq.

6 T. E. Lawrence, *Seven Pillars of Wisdom* (London, Jonathan Cape, 1935), p. 275.

Chapter Four: Why Britain played the Zionist Card

1 House of Commons, Parliamentary Debates, Vol 326, col 23330.

2 Emanuel Neumann, *The American Zionist*, 5 February 1953.

3 J. A. R. Marriott, *The Evolution of Modern Europe* 1453–1932 (London, Methuen, 1953), p. 403.

4 Winston Churchill, *Illustrated Sunday Herald*, 8 February 1920, p. 5.

5 Yale's report to the State Department, dated 11 March 1918, Document 763.7211/1741, Diplomatic Branch (NNFD) National Archives and Records Service.

6 Weizmann, op. cit., p. 192.

7 Ibid.

8 Edward Montagu, British Cabinet Paper, No. 2A/24, dated 13 August 1917.

9 Alfred M. Lilienthal, op. cit., p. 766.

10 Paul Goodman (editor), *Chaim Weizmann, A Tribute on his Seventieth Birthday* (London, Victor Gollancz, 1945), p. 199.

11 Documents on British Foreign Policy 1919–1939, Vol IV, HMSO.

Chapter Five: Ahad Ha-am and the False Messiah

1 Ahad Ha-am, *Am Scheideweg*, Vol 1 (Berlin, 1923), p. 107; and essay by Hans Kohn, Zion and the Jewish National Idea (Menorah Journal, Vol XVI, 1958).

2 Ahad Ha-am in a letter to a colleague, quoted by Christopher Mayhew and Michael Adams in *Publish it not...The Middle East Cover-Up* (London, Longman, 1975), p. 143.

3 *Palestine: A Search for Truth* (Washington, Public Affairs Press, 1970), p. 68.

4 Yehoshafat Harkabi, op. cit., pp. 138–9.

5 Ibid.

6 Naomi Winer Cohen, *The Reaction of Reform Judaism to Political Zionism 1897-1922* (Philadelphia, Publications of the American Jewish Historical Society, June 1951), p. 365.

7 Ibid., p. 368.

8 Alfred M. Lilienthal, op. cit., p. 771.

9 Ibid., p. 368.

10 First published in *Menorah Journal*, February 1918, and reprinted in the Autumn of 1950, pp. 116–18.

11 Henry Mogenthau, Sr., *All in a Lifetime* (New York, Doubleday, Page & Co., 1921/22), p.385.

12 Alfred M. Lilienthal, op. cit., p. 770.

Chapter Six: The Honest Zionists

1 British Command Paper No. 1700, *A Survey of Palestine 1945–1956*, Vol 1, pp.87–90.
2 Ibid.
3 House of Commons, *Hansard's Reports*, 4 July 1922, pp. 3–4.
4 Albert M. Hyamson, op. cit., footnote, p. 112.
5 British Command Paper No 1700, op. cit.
6 Ibid.
7 Weizmann, op. cit., p. 119.
8 Alfred M. Lilienthal, op. cit., p. 19.
9 Ibid.
10 Nahum Sokolow, *History of Zionism,* p. xxiv as cited by Lilienthal op.cit.
11 Weizmann, op. cit., p. 100.
12 Barbour, op. cit., p. 214.
13 Alfred M. Lilienthal, op. cit., p. 24.
14 Yaacov Shavit, T*he Attitudes of the Revisionists to the Arab Nationalist Movement* (Forum on the Jewish People, Zionism and Israel), p. 102.
15 Vladimir Jabotinsky, *The Iron Wall* (O Zhelzroi Stene), Rassvet, 4 November 1923; and *The Iron Law, Selected Writings of Vladimir Jabotinsky*, published in South Africa, 1962. This quotation is originally cited by Schoennam in *The Hidden History of Zionism* (Veritas Press, 1985).
16 *The Complete Diaries of Theodore Herzl*, op. cit., Vol 1, p. 88.
17 Report in Davar (Israeli newspaper), 29 September 1967; and cited by Uri Davis and Norton Mezvinsky (editors) in Documents from Israel 1967-1973, p. 21.
18 Lilienthal's account, op. cit., p. 124, is based on a translation of an original report in *Al-Hamishmar* (Israeli newspaper), dated 7 September 1976. The translation was in *Swasia*, a Hebrew-language weekly digest published in Washington DC. on 15 October 1976. Schoenman's account, in *The Hidden History of Zionism* (Santa Barbara, Veritas Press, 1988), p. 31–2, is based on the complete Al-Hamishmar original report.
19 Gad Becker, *Yediot Ahronot* (Israeli newspaper), 13 April 1983, and *The New York Times*, 14 April 1983.
20 Ibid.
21 Robert Gessner, 'Brown Shirts in Zion', *New Masses*, 19 February 1935, p.11.

Chapter Seven: America Retreats from the Moral High Ground

1 For this and what follows, see *Encyclopaedia Britannica* (1977 edition).
2 Again, for that referred to on this page see Encyclopaedia Britannica (1977 edition).
3 Ibid.
4 Ibid.
5 James Joll, *The Origins of the First World War*, 2nd edition (the Silver Library Series, 1992), p. 3.
6 Alfred M. Lilienthal, op. cit., p. 29.
7 Ibid.
8 *The New York Times*, 5 March 1919; and additional insight from Lilienthal, op. cit., pp. 768-9.
9 Ibid.
10 Ibid.
11 Alfred M. Lilienthal, op. cit., pp. 29-30.
12 Papers Relating to the Foreign Relations of the United States, the Paris Peace Conference, 1919, xi, pp. 15-55.
13 For quotations on this and the following page see, Harry N. Howard, op. cit., pp. 348–352; and J. C. Hurewitz, op. cit., p. 70.

14 Alfred M. Lilienthal, op. cit., p. 771.

Chapter Eight: Britain Admits, Too Late, "We Were Wrong"

1 Henry Cattan, op. cit., p. 65.
2 House of Lords, *Hansard's Reports*, 21 June 1922, p. 997.
3 Ibid.
4 Henry Cattan, op. cit., p. 65. 568
5 Ibid., p. 66
6 Ibid., p. 68
7 House of Lords, *Hansard's Reports*, 21 June 1922, p. 1000.
8 Robert Lacey, *The Kingdom* (Hutchinson & Co., 1981; Fontana Paperbacks, 1982), p. 183.
9 Ibid.
10 Nevil Barbour, op. cit., footnote p. 240.
11 Report of the Committee, British Command Paper No. 5974, 16 March 1939, p. 11.
12 Ibid.
13 For this and quotations on the following two pages, see British Command Paper No. 6019, 17 May 1939.
14 *The Palestine Post*, 18 May 1939. (The headline across the whole of the front-page read: NEW POLICY WINDS UP MANDATE AND JEWISH NATIONAL HOME).
15 David Ben-Gurion, *Israel, A Personal History* (first English-language hardback edition by New English library, Times, Mirror, 1972),p. 54.
16 Sir John Hope Simpson, "The Palestine Mandate", published in *The Fortnightly* (London), December 1944; reprinted in Middle East Perspective (New York),April 1970. This quotation cited by Lilienthal op.cit.
17 Ibid.

Chapter Nine: Holocaust—Jewish Death, Zionist life

1 M. Lowenthal, op. cit., p. 7.
2 Ibid.
3 Ruth Bondy, *The Emissary: A Life of Enzio Sereni*, p. 141.
4 Novick, *Zionism Today*, p. 5.
5 Ari Bober (editor), The Other Israel, p. 171.
6 Encyclopaedia Britannica.
7 Morris Ernest, *So Far So Good* (New York, Harper, 1948), pp.170–77
8 Brenner, op. cit., p. 147.
9 Alfred M. Lilienthal, op. cit., pp. 35–6.
10 Morris Ernest, op. cit.
11 Ibid.
12 FR (abbreviation for Foreign Relations of the United States, Diplomatic Papers), *1943: The Near East and Africa* (Washington D.C., 1964), Vol IV, pp. 776–77.
13 Ibid
14 FR 1942, Vol IV, pp. 538–44.
15 FR 1942, Vol III, p. 699.
16 David Ben-Gurion, op. cit., p. 54.
17 Ibid.
18 Ibid.
19 Hoskins' memorandum of 31 August 1943, in FR 1943, Vol IV, p. 809
20 Ibid.
21 Alfred M. Lilienthal, op. cit., p. 44.
22 Hoskins' memorandum, op. cit.
23 Alfred M. Lilienthal, op. cit., p. 37.
24 FR 1945, Vol VIII, p. 679.
25 Ibid

26 Neumann, *The American Zionist*, 5 February 1953.
27 William Eddy, *F.D.R. Meets Ibn Saud* (New York, American Friends of the Middle East, 1954).
28 FR 1945, Vol III, pp. 2-3.
29 Ibid.
30 FR 1945, Vol III, p.690.
31 Ibid.
32 Ibid.
33 Labour Party's Annual Conference Report 1944, p. 9.
34 Mayhew and Adams, op. cit. p.35.
35 FR 1945, p. 689.
36 Ibid.
37 Ibid.
38 Ibid., pp. 694–95
39 Ibid.
40 Alfred M. Lilienthal, op. cit., p. 42.
41 *The Forrestal Diaries*, edited by Walter Millis (Cassell & Co., 1952), p. 25.
42 Neumann, op. cit.
43 Ibid.
44 Ibid.
45 FR 1945, Vol VIII, pp. 704–5.
46 Ibid., p. 707.
47 "Dr. Stephen Wise on Policy of World Jewry", *World Jewry* (London, 24 August 1934), p. 395.
48 Ibid.
49 Brenner, op. cit., p. 67.
50 Nahum Goldmann, *Autobiography*, p. 148 as cited by Brenner op. cit.
51 Ibid
52 FR 1945, Vol VIII, p. 709.
53 FR 1945, Vol VIII, p. 714.
54 Ibid.
55 Ibid.
56 FR 1945, Vol VIII, pp. 716–17.
57 Ibid., p. 722.
58 Ibid., pp. 727–33.
59 Henderson letter to Lilienthal, 13 March 1977.
60 FR, Vol III, p. 771.
61 Ibid., p. 775.
62 Ibid, pp. 777–78.
63 Ibid.
64 FR, Vol III, pp.828-29.
65 Ibid., p. 829.
66 Anglo-American Committee of Inquiry, Report to the United States Government and His Majesty's Government of the United Kingdom, preface.
67 *The Times* (London), 15 November 1945.
68 Dean Rusk letter to Lilienthal , 27 July 1977.
69 Ibid.
70 Anglo-American Committee of Inquiry, op. cit., Recommendations.
71 Dean Acheson, *Present at the Creation: My Years at the State Department* (New York, W. W. Norton, 1969), p. 176 as cited by Lilienthal op. cit.
72 Telegram, Fitzpatrick to Truman, 2 August 1946. Official file 204 Miscellaneous Truman papers, Harry S. Truman library.
73 *The Forrestal Diaries*, edited by Walter Millis (Cassell & Co., 1952), p. 299.
74 Robert J. Donovan, *Conflict and Crisis: The Presidency of Harry S. Truman, 1945-1948* (New York, W. W. Norton, 1977), p. 319.
75 Ibid.
76 William Eddy, op. cit., p. 37.

77	Speech of Rabbi Silver to the 49th Annual Convention of the Zionist Organisation of America, *New York Times*, 17 October 1946.
78	Alfred M. Lilienthal, op. cit., p. 56.
79	Rabbi Bernstein, *Yiddish Bulletin*, Free Jewish Club, 19 May 1950.

Chapter Ten: Zionist Terrorism and Ethnic Cleansing

1	Geula Cohen, *Women of Violence*, p. 232 as recorded in Brenner op. cit
2	Brenner, op. cit., pp. 267–78.
3	"Grundzuege des Vorschlages der Nationalen Militacrishen Organisation in Palestina (Irgun Zvei Leumi) betreffend der Loesung der jeudischen Frage Europas und der aktiven Teilnahme der NMO am Kriege an der Seite Deutschlands", David Yisrael, T*he Palestine Problem in German Politics 1889-1945* (Bar Ilan University, 1974), pp. 315–7.
4	Harkabi, op. cit., p.214.
5	Menachem Begin, *The Revolt* (Los Angeles, Nash Publishing, 1972).
6	Ibid., Introduction, p.xi.
7	Ibid.
8	Menachem Begin, *The Revolt* (Los Angeles, Nash Publishing, 1972), p. xii.
9	Ibid.
10	Alfred M. Lilienthal, op. cit., p. 362.
11	Menachem Begin, op. cit., pp. 42–3.
12	Ibid.
13	Ibid.
14	Alfred M. Lilienthal, op. cit., p. 58.
15	Larry Collins and Dominique Lapierre, *O Jerusalem!* (London, Weisenfield and Nicolson,1972), pp.87-8.
16	Ibid., p. 260.
17	Ibid., p. 255.
18	Ibid., p. 274.
19	Ibid., p. 275.
20	Ibid.
21	Jacques de Reynier, *A Jerusalem un drapeau flottait sur la ligne de feu* (Neuchatel, Editions de la Baconniere, 1950), p. 213. The prime sources of the Collins and Lapierre account of events at Deir Yassin were de Reynier's report to the International Red Cross and reports of the incident forwarded to the Chief Secretary of the Palestine government, Sir Henry Gurney, by Richard C. Catling, Assistant General of the Criminal Investigation Division on 13, 15 and 16 April, bearing the dossier number 179/110/17/GS and designated "Secret".
22	Collins and Lapierre, op. cit., p.279.
23	Ibid.
24	For this quotation and those on the following page, see Collins and Lapierre, op. cit., p.280, unless otherwise noted.
25	Arthur Koestler, *Promise and Fulfilment, Palestine 1917–1949* (London, Macmillan, 1949), p. 160.
26	Jacques de Reynier, op. cit., p. 213
27	William R. Polk, David M. Stamler and Edmund Asfour, *Backdrop to Tragedy* (Boston, Beacon Press, 1957), p. 291.
28	*The American Zionist,* issue of May–June 1976.
29	Ibid.
30	Menachem Begin, op. cit., pp. 164–5 as quoted by Lilienthal op. cit.
31	Bertha Spofford Vester, *Our Jerusalem: An American Family in the Holy City* (New York, Doubleday, 1950); G. Kirk, *The Middle East 1945–1950* (Oxford University Press, 1954), p.262; S. N. Fisher, *The Middle East* (London, Routledge and Kegan Paul, 1960), p. 589.
32	Yigal Allon, *Ha Sepher Ha Palmach*, Vol 2, p. 286 as quoted by Lilienthal op. cit.
33	Collins and Lapierre, op. cit., p. 336.
34	Ibid., p. 281.

35	Ibid., p. 261.
36	Ibid., p. 263.
37	Ibid., p. 264.
38	Ibid., p. 263.
39	Ibid., p. 264.
40	Ibid., p. 265.

Chapter Eleven: President Truman Surrenders to Zionism

1	FR 1947, *The Near East and Africa, Vol V* (Washington D. C., U.S. Government Printing office, 1971), p. 1309.
2	*The Forrestal Diaries*, edited by Walter Millis (Cassell & Co., 1952), p. 294.
3	Ibid.
4	UN Document A/364, 3 September 1947.
5	Henry Cattan, op. cit., p. 22.
6	Henry Cattan, op. cit., p. 75.
7	Official Records of the Second Special Session of the General Assembly, Document A/AC 14/32, 11 November 1947, pp. 276–78.
8	Official Records of the Second Special Session of the General Assembly, pp. 299–301.
9	Ibid.
10	Ibid.
11	Relevant UN Documents are: A/AC 14/21, 14 October 1947; A/AC 14/24, 16 October 1947; A/Ac 14/25, 16 October 1947; and A/AC 14/32, 11 November 1947.
12	Ben-Gurion's own writings contain many expressions to this effect.
13	FR 1947, Vol V, pp. 1153–58.
14	Ibid. (Footnote).
15	Harry S. Truman, *Memoirs, Vol II, Years of Trial and Hope* (New York, Doubleday, 1958), p. 225 as quoted by Lilienthal op. cit.
16	*The Forrestal Diaries,* op. cit., p. 299.
17	Ibid.
18	Ibid.
19	*Forrestal Diaries*, op. cit., p. 311.
20	Ibid.
21	Ibid.
22	Official Records of the General Assembly, 1947, Vol II, p. 1426.
23	FR 1947, Vol V, p. 1309.
24	Official Records of the General Assembly, 1947, Vol II, p. 1341.
25	Ibid., p. 1330.
26	Ibid., p. 1426.
27	*The Forrestal Diaries,* op. cit., p. 331.
28	Ibid., pp. 331-32.
29	Alfred M. Lilienthal, op. cit., p. 67.
30	Official Records of the General Assembly, 1947, Vol II, p. 1425.
31	FR 1947, Vol V, p. 1309.
32	For this paragraph and what follows on the next four, see *The Forrestal Diaries,* op. cit., pp. 343-44.
33	FR 1948, Vol V, Part 2, pp. 666–75.
34	Ibid., p. 657.
35	Ibid.
36	Ibid., pp. 637-41. Part of Marshall's message to Truman was not in the text as declassified. The missing part was subsequently identified by Lilienthal as "White Four" in papers at the Harry S. Truman library.
37	*The Forrestal Diaries*, op. cit., p. 367.
38	FR 1948, Vol V, Part 2, p. 645.
39	FR 1949, *The Near East, South Asia and Africa, Vol VI* (Washington D.C., 1971), p. 1074.

40 Footnote to FR 1948, Vol V, pp. 665-66.

41 From the Austin statement to the Security Council, reported in FR 1948, Vol V, part 2, pp. 675–76.

42 FR 1948, *The Near East and Africa, Vol V, Part 2* (Washington D.C., 1976), p. 729.

43 Ibid., telegram 309, from New York to the Secretary of State, "Eyes Only for McClintock from Rusk."

44 Merle Miller, *Plain Speaking* (New York, Berkley Publishing, 1966), pp. 216–7.

45 Harry S. Truman, op. cit., p. 130.

46 David Lloyd George, *Memoirs of the Peace Conference, Vol II* (Yale University Press, 1939), p. 722.

47 Edward E. Grusd, B'nai B'rith: *The Story of a Covenant* (New York, Appleton-Century, 1966), p. 244.

48 Memorandum, Jacobson to Dr. Josef Cohn, 1 April 1952, Weizmann Archives, Harry S. Truman Library as quoted by Lilienthal op. cit.

49 Harry S. Truman, op. cit. "Eddie Jacobson," Truman wrote, "had never been a Zionist, but was deeply touched by the sufferings of the Jewish people".

50 For here and what follows on this page, see Merle Miller, op. cit., p. 217.

51 Memorandum, Jacobson to Cohn, op. cit.

52 Margaret Truman, op. cit., p. 388.

53 Subsequently reported by the *Washington Post*, 19 December 1976.

54 FR 1948, Vol V, part 2, pp. 748–49, editorial note.

55 Alfred M. Lilienthal, op. cit., p. 70.

56 Harry S. Truman, op. cit., p. 163.

57 FR 1948, Vol V, part 2, note 3, p. 750.

58 Ibid., p. 759.

59 Ibid.

60 Ibid.

61 ibid., pp. 759–60.

62 *The Forrestal Diaries*, op. cit., p. 332.

63 Alfred M. Lilienthal, op. cit., p. 88.

64 Ibid.

65 *The New York Times*, 11 and 16 February 1948.

66 FR 1948, Vol V, Part 2, p. 906, editorial note.

67 John Snetsinger, *Truman, The Jewish Vote and the Creation of Israel* (Stanford, Hoover Institute Press, 1974), p. 103–4.

68 From notes of George M. Elsey, Clifford's assistant, who had revised the text drafted by Niles to include suggestions in another Lowenthal memorandum—the seventh in five days.

69 Patrick Anderson, T*he President's Men, White House Assistants of Harry S. Truman, Dwight D. Eisenhower, John F. Kennedy and Lyndon B. Johnson* (Garden City, New York, Doubleday, 1968), pp. 118–19.

70 This and the following four quotes from the Memorandum of the conversation by Secretary of State Marshall, FR 1948, Vol V, Part 2, pp. 972–76.

71 Patrick Anderson, as quoted by Lilienthal op. cit.

72 Marshall's memorandum, op. cit.

73 Ibid.

74 Ibid.

75 FR 1947, *The Near East and Africa, Vol V* (Washington D.C., Government Printing Office, 1971), p. 1321, message to Cairo; FR 1948, Vol V, p. 571, footnote 3, message to Jeddah.

76 As stated by Clifford (and not disputed by others) in an address to the American Historical Association in Washington on 28 December 1976.

77 FR 1948, Vol V, pp. 964–65.

78 Weizmann, op. cit., p. 477.

79 Ibid.

80 Grusd, op. cit., pp. 244–45.

81 FR 1948, Vol V, Part 2, pp. 1005-07, Lovett's memorandum of his conversation

82 with Clifford.
82 Ibid.
83 Ibid.
84 FR 1948, Vol V, Part 2, p. 1007.
85 Ibid., p. 999, editorial note.
86 Alfred M. Lilienthal, op. cit., p. 87.
87 FR 1948, Vol V, Part 2, p. 1015, footnote 2.
88 Ibid.
89 Frances Williams, *A Prime Minister Remembers* (London, Heinemann, 1961), p. 181 as quoted by Lilienthal op. cit.
90 Alfred M. Lilienthal, op. cit., p. 97.
91 Arnold Toynbee, *A Study of History, Vol III* (Oxford, Oxford University Press, 1954), p. 308.
92 Merle Miller, op. cit., p. 218.
93 Alfred M. Lilienthal, op. cit.
94 Ibid., p. 61.
95 Memorandum, Truman to Niles, 13 May 1947, File of President's Secretary, Palestine, 1945–1947 folder, Box 184, Harry S. Truman Library.
96 Alfred M. Lilienthal, op. cit., p. 100.

Chapter Twelve: Forrestal's Suicide

1 *The Forrestal Diaries*, edited by Walter Millis (Cassell & Co., 1952), p. 9.
2 *The Forrestal Diaries* in book form were never widely available to the general reader. For this reason Author Alan Hart and his Publisher have decided that for research and reference purposes all Forrestal quotations should be allocated their specific page reference.
3 This and all other quotations on this page taken from *The Forrestal Diaries*, op. cit., pp. 286-87, unless otherwise noted.
4 *The Forrestal Diaries*, op. cit., p. 22.
5 Ibid.
6 *The Forrestal Diaries*, op. cit., p. 291.
7 Ibid. p. 266.
8 Ibid., p. 327.
9 Ibid.
10 *The Forrestal Diaries*, op. cit., p. 330.
11 Ibid.
12 Ibid.
13 This and all remaining quotes on this page, see *The Forrestal Diaries*, op. cit., pp. 330–31, unless otherwise noted.
14 *The Forrestal Diaries*, op. cit., p. 332.
15 Ibid.
16 *The Forrestal Diaries*, op. cit., p. 333.
17 For this quote and those following until otherwise noted, see *The Forrestal Diaries*, op. cit., pp. 333–34.
18 *The Forrestal Diaries*, op. cit., pp. 335-36.
19 Ibid.
20 *The Forrestal Diaries*, op. cit., p. 342.
21 For this and what follows until otherwise noted, see *The Forrestal Diaries*, op. cit., pp. 343–45.
22 Richard H. Crossman, *A Nation Reborn* (New York, Atheneum, 1960), p. 14 as quoted by Lilienthal op. cit.
23 Joseph P. Lash, *Eleanor and Franklin* (New York, W.W. Norton, 1971),p. 214.
24 Ibid.
25 Alfred M. Lilienthal, op. cit., p. 43.
26 *The Forrestal Diaries*, op. cit., pp. 346-47.
27 Ibid., p. 347.

28 Ibid.
29 Ibid.
30 *Encyclopaedia Britannica.*
31 *The Forrestal Diaries*, op. cit., p. 347.
32 *The Forrestal Diaries*, op. cit., pp. 347-48.
33 Ibid., p. 348, Millis explanation.
34 Ibid., p. 355.
35 Ibid., p. 382.
36 For here and what follows until otherwise noted, see *The Forrestal Diaries*, op. cit., pp. 243–49.
37 For work referred to here and onwards until otherwise noted, see *The Forrestal Diaries*, op. cit., p. 383.
38 *The Forrestal Diaries*, op. cit., p. 516.

Index

Volume II
THE REAL GOLIATH

34593144R00191

Made in the USA
Lexington, KY
12 August 2014